ADVANCED CREATIONS

LIMITED WARRANTY AND DISCLAIMER OF LIABILITY

THE CD WHICH ACCOMPANIES THE BOOK MAY BE USED ON A SINGLE PC ONLY. THE LICENSE DOES NOT PERMIT THE USE ON A NETWORK (OF ANY KIND). YOU FURTHER AGREE THAT THIS LICENSE GRANTS PERMISSION TO USE THE PRODUCTS CONTAINED HEREIN, BUT DOES NOT GIVE YOU RIGHT OF OWNERSHIP TO ANY OF THE CONTENT OR PRODUCT CONTAINED ON THIS CD. USE OF THIRD PARTY SOFTWARE CONTAINED ON THIS CD IS LIMITED TO AND SUBJECT TO LICENSING TERMS FOR THE RESPECTIVE PRODUCTS.

CHARLES RIVER MEDIA, INC. ("CRM") AND/OR ANYONE WHO HAS BEEN INVOLVED IN THE WRITING, CREATION OR PRODUCTION OF THE ACCOMPANYING CODE ("THE SOFTWARE") OR THE THIRD PARTY PRODUCTS CONTAINED ON THE CD OR TEXTUAL MATERIAL IN THE BOOK, CANNOT AND DO NOT WARRANT THE PERFORMANCE OR RESULTS THAT MAY BE OBTAINED BY USING THE SOFTWARE OR CONTENTS OF THE BOOK. THE AUTHOR AND PUBLISHER HAVE USED THEIR BEST EFFORTS TO ENSURE THE ACCURACY AND FUNCTIONALITY OF THE TEXTUAL MATERIAL AND PROGRAMS CONTAINED HEREIN; WE HOWEVER, MAKE NO WARRANTY OF ANY KIND, EXPRESS OR IMPLIED, REGARDING THE PERFORMANCE OF THESE PROGRAMS OR CONTENTS. THE SOFTWARE IS SOLD "AS IS " WITHOUT WARRANTY (EXCEPT FOR DEFECTIVE MATERIALS USED IN MANUFACTURING THE DISK OR DUE TO FAULTY WORKMANSHIP);

THE AUTHOR, THE PUBLISHER, DEVELOPERS OF THIRD PARTY SOFTWARE, AND ANYONE INVOLVED IN THE PRODUCTION AND MANUFACTURING OF THIS WORK SHALL NOT BE LIABLE FOR DAMAGES OF ANY KIND ARISING OUT OF THE USE OF(OR THE INABILITY TO USE) THE PROGRAMS, SOURCE CODE, OR TEXTUAL MATERIAL CONTAINED IN THIS PUBLICATION. THIS INCLUDES , BUT IS NOT LIMITED TO, LOSS OF REVENUE OR PROFIT, OR OTHER INCIDENTAL OR CONSEQUENTIAL DAMAGES ARISING OUT OF THE USE OF THE PRODUCT.

THE SOLE REMEDY IN THE EVENT OF A CLAIM OF ANY KIND IS EXPRESSLY LIMITED TO REPLACEMENT OF THE BOOK AND/OR CD-ROM, AND ONLY AT THE DISCRETION OF CRM.

THE USE OF "IMPLIED WARRANTY" AND CERTAIN "EXCLUSIONS" VARY FROM STATE TO STATE, AND MAY NOT APPLY TO THE PURCHASER OF THIS PRODUCT.

ADVANCED BRYCE CREATIONS

R. Shamms Mortier

CHARLES RIVER MEDIA, INC.
Hingham, Massachusetts

Copyright 2001 by CHARLES RIVER MEDIA, INC.
All rights reserved.

No part of this publication may be reproduced in any way, stored in a retrieval system of any type, or transmitted by any means or media, electronic or mechanical, including, but not limited to, photocopy, recording, or scanning, without prior permission in writing from the publisher.

Production: Publishers' Design and Production Services
Cover Design: The Printed Image
Cover Image: Shamms Mortier
Printer: Malloy Lithographing, Inc.

CHARLES RIVER MEDIA, INC.
20 Downer Avenue, Suite 3
Hingham, MA 02043
781-740-0400
781-740-8816 (FAX)
info@charlesriver.com
www.charlesriver.com

This book is printed on acid-free paper.

Advanced Bryce Creations: Photorealistic 3D Worlds
Shamms Mortier
ISBN: 1-58450-035-2

Library of Congress Cataloging-in-Publication Data

Mortier, R. Shamms.
 Advanced Bryce creations : photorealistic 3D worlds / Shamms Mortier.
 p. cm.
 ISBN 1-58450-035-2 (paperback w/diskette : alk. paper)
 1. KPT Bryce. 2. Computer graphics. 3. Three-dimensional display systems. 4. Computer animation. I. Title.
 T385 .M6685 2001
 006.6'93—dc21
 2001000970

All brand names and product names mentioned in this book are trademarks or service marks of their respective companies. Any omission or misuse (of any kind) of service marks or trademarks should not be regarded as intent to infringe on the property of others. The publisher recognizes and respects all marks used by companies, manufacturers, and developers as a means to distinguish their products.

Printed in the United States of America
01 7 6 5 4 3 2 First Edition

CHARLES RIVER MEDIA, INC.titles are available for site license or bulk purchase by institutions, user groups, corporations, etc. For additional information, please contact the Special Sales Department at 781-740-0400.

Requests for replacement of a defective CD must be accompanied by the original disc, your mailing address, telephone number, date of purchase and purchase price. Please state the nature of the problem, and send the information to CHARLES RIVER MEDIA, INC., 20 Downer Avenue, Suite 3, Hingham, MA 02043. CRM's sole obligation to the purchaser is to replace the disc, based on defective materials or faulty workmanship, but not on the operation or functionality of the product.

Dedication

This book is dedicated to Diane—my partner, my spouse, my beloved—through whose nurturing, creativity, and love I have seen many worlds evolve

 This book is also written in honor of Salvador Felipe Jacinto Dali, who inspired me so long ago with a single painting and a ride on a Cosmic Elephant

Contents

PREFACE	xvii
INTRODUCTION	xix
PART I BRYCE MODELING	1
CHAPTER 1 BRYCE PRIMITIVES	3
WHAT YOU NEED TO KNOW	4
PRIMITIVE MAN	4
THE CREEPY CRAWLER	9
PRIM TOWER	11
PRIM CITY	14
A BASIC ARCHWAY	17
IMPORTED MODELING ELEMENTS	18
OBTAINING 3D OBJECTS	19
TRAVELING ON	20
CHAPTER 2 BRYCE BOOLEANS	**21**
LOADING BOOLEAN OBJECT PRESETS	22
SAVING BOOLEAN OBJECTS TO THE LIBRARY	23
A MOUNTAIN TUNNEL	24
TERRAIN CUTS TERRAIN	25
A COMPLEX BOOLEAN STRUCTURE	26
WINE GLASS	27
BOOLEAN CHAIR	28
BOOLEAN ARCHWAY	29

INTERGALACTIC SHIP	30
TRAVELING ON	30

CHAPTER 3 MASTERING TERRAIN EDITOR TERRAINS 31

WHAT YOU NEED TO KNOW	32
VOLCANO	32
GENTLE HILLS	34
VERTICAL CLIFF FACE	34
CUTTING A RIVER	35
CRATERS	36
TRAVELING ON	37

CHAPTER 4 MASTERING TERRAIN EDITOR OBJECTS 39

WHAT YOU NEED TO KNOW	41
A PARTITIONED HOUSE	41
TABLE AND CHAIRS	43
FANCY COLUMNS	45
A COMPLEX WHEEL	46
ARCHITECTURAL DETAILS	49
TRAVELING ON	51

CHAPTER 5 2D PICTURE OBJECTS AND PROCEDURAL MATERIALS 53

WHAT YOU NEED TO KNOW	54
MASTERING THE TEXTURE SOURCE EDITOR CONTROLS	55
CREATING 2D PICTURE CONTENT	57
ALPHA TO 3D OBJECTS	59
CREATING MOSS AND MOLD	61
MULTI-ALPHA TERRAIN	62
SLIME, OH WONDROUS SLIME	63
ALPHA/IMAGE CHARACTER PLACEMENT	64
IMAGE MAPPED PANORAMAS	65
USING THE WRONG MATERIALS FOR THE RIGHT REASONS	66
CREATING CUSTOMIZED MATERIALS	67
SURFACE MATERIALS CREATION TIPS	67
VOLUMETRIC MATERIALS CREATION TIPS	69
BITMAP MATERIALS CREATION TIPS	70
ALPHA STAND-ALONES	70

Contents

Placing the Bitmap in a Channel	70
Bitmapped Logos	72
Bitmap/Procedural Combination Materials Tips	72
Exotic Laminates	73
Multiples of One	74
Employing the Creative Mistake	75
Using the Wrong Materials for More Reality	75
Using the Wrong Materials for a Personalized Reality	78
Simulating Materials Surrealism	79
Traveling On	**80**

Chapter 6 Infinite Planes and Lights — 81

What You Need to Know	82
The Tunnel of Eternity	82
Dawn Beach	84
Canals	85
Fire Lake	86
The Water Sandwich	88
Water over Rocks	89
Sky Options	90
Tweaking Procedural Image Content for the Default Sky Plane	91
Tweaking Procedural and Bitmap Image Content for an Infinite Sky Plane	94
Addressing Procedural Content	95
Addressing Bitmap Content	97
Lights	98
The Bryce Lighting Technician	98
Create a Street Lamp	99
Editing Lights	101
Volumetric Lights	101
Altering Light Attributes	102
Gels	102
Radial Light f/x Samples	106
Addendum Light Topics	109
Traveling On	**112**

Contents

PART II: EXTERNAL MODELING APPLICATIONS — 113

CHAPTER 7 3D MODELING TOOLS — 115
- Extrusion — 116
- Creating an Extruded and Deformed Column for Bryce — 117
- Lathing — 118
 - Other Lathing Parameter Explorations — 119
- Lathing a Complex Tower for Bryce — 119
- Boolean Operations — 122
- Creating a Bryce Boolean Mystery Door — 123
- Lofting — 125
- The Spring — 125
- Deformation F/X — 127
 - Deformed Objects for Bryce — 127
- Boolean Deforms to Bryce — 127
- Vertex-Level Editing — 130
- Lattice Objects — 131
 - Linking and Grouping — 132
- Deformation Mapping — 133
- Deformation Snapshots for Bryce — 133
 - Particle Snapshots for Bryce — 135
- Creating Bryce Particle Arrays — 135
- Traveling On — 136

CHAPTER 8 HELPFUL HANDSHAKING — 137
- Amorphium — 138
- Amorphiumizing a Terrain — 138
- Tree Professional — 142
- TreePro and Amorphium — 144
- CuriousLabs' Poser — 146
 - The Statue — 146
 - Go No Further! — 147
- Customizing Poser Textures — 150
- Impulse' Organica — 151
- 2D Bitmap F/X — 156
- Plug-Ins for Bitmap Applications — 156
- The Painter Image Hose — 159
- Plug-Ins You Just Gotta Have — 160
 - The Corel KPT Collection — 160

Contents

Gradient Designer	**161**
Texture Explorer	**163**
EyeCandy 4000	166
Xaos Tools Terrazzo	168
Traveling On	**170**

Part III: Eight StoryWorlds — **171**

Chapter 9 The Great Blue-Ice Throne Room — **173**

The External Environment	**174**
How Will My Camera Appreciate This World?	175
Creating the External Environment	**176**
The Internal Environment	**181**
Finalizing the Composition	188
Traveling On	**190**

Chapter 10 The Temple of the Sand Masters — **191**

The External Environment	**193**
Ground	193
Sky	194
Oasis	195
Ruins	197
The Old Temple	198
The Internal Environment	**200**
The Flat Mesa	201
The Fortress Enclosure	201
Weapons Shed	205
Cannon	206
The Tower	206
Recapping Important Matters	**211**
Traveling On	**212**

Chapter 11 Sanctuary of the Sargasso — **213**

The Rough Sketch	**215**
Surface Components	**217**
ISP and IWP Layers	217
The Sea Mount	221
Abandoned Lighthouse and Shack	222
Other Surface Components	226

UNDERSEA COMPONENTS	**226**
SEA-BOTTOM PLANE	226
CAVE AND DOME	226
MEROPOLIS	228
CRAFT	229
THE SUNKEN SHIP	231
LOD AND FISH	**232**
TRAVELING ON	**232**
CHAPTER 12 THE CAVE OF THE FAERIE QUEEN	**233**
THE ROUGH SKETCH	**234**
SURFACE COMPONENTS	235
CAVE COMPONENTS	235
SURFACE COMPONENTS	**236**
ISP	237
IGP	238
ROLLING HILLS	239
WOODS	240
THE BIG OLD TREE	242
THE DOOR	245
SYMBOL ABOVE THE DOOR	247
STREAM	248
PLANTS AND GRASS	249
CAVE COMPONENTS	**250**
THE CAVE	250
LIGHTS	254
THRONE IN AN AMPHITHEATER	256
HANGING ROOTS	258
WATERFALL AND POOL	258
TABLE OF GEMS	259
TEACUP OF BERRIES	260
JUST ONE MORE THING	261
COMPLETING THIS PROJECT	**262**
TRAVELING ON	**266**
CHAPTER 13 HOUSE OF THE FIRE EATERS	**267**
THE ROUGH SKETCH	**268**
THE FIREWORLD	270
THE FIRE EATERS' HOUSE	272

Contents

FIREWORLD COMPONENTS	**273**
SKY	273
GROUND	275
VOLCANOES	276
THE TEMPLE OF SACRIFICE	279
BACK TO THE CENTRAL VOLCANO	280
RIVER OF FIRE	282
BUBBLING POOL	284
FILL-IN ELEMENTS	284
THE FIRE EATERS' HOUSE	**285**
THE STRUCTURE	285
THE HELI-VEHICLE	290
FINISHING UP	**294**
TRAVELING ON	**295**

CHAPTER 14 THE JADE PAGODA — 297

THE ROUGH SKETCH	**298**
THE ENVIRONMENT	300
THE PAGODA ENCLOSURE	300
THE ENVIRONMENT COMPONENTS	**301**
SKY	301
GROUND	302
DISTANT PEAKS	304
FOREGROUND TERRAIN	305
RIVER	306
BRIDGE	306
VILLAGE	311
WATERFALL	313
ADDITIONAL ELEMENTS	314
THE PAGODA ENCLOSURE	**316**
PAGODA STRUCTURE	316
DETAIL INSIDE	319
BUDDHA STATUE	320
ADDITIONAL ELEMENTS	320
PUTTING IT ALL TOGETHER	**321**
TRAVELING ON	**324**

Chapter 15 Abode of the Lizard Master — 325
The Rough Sketch — 326
- Supportive Environment — 327
- The Abode — 327
Supportive Environment Components — 328
- Sky — 328
- Ground — 329
- Ground Fog/Mist — 330
- Distant Peaks — 331
- Items on the Ground — 332
- The Main Mountain — 333
- The Old City — 335
- Mist around the Mountaintop — 337
- Something Borrowed — 338
The Abode — 339
- The Hedge — 339
- Habitat — 342
- Altar and Water Source — 344
Putting It All Together — 348
A Necessary Correction — 348
Final Renders — 350
Traveling On — 351

Chapter 16 The Hall of Clouds — 353
Rough Sketch — 354
- Supportive Items — 355
- Cloud Stuff — 355
Supportive Items — 356
- Sky — 356
- Ground — 357
- Distant Islands — 361
- Undersea Power Source — 361
- Items on the Island — 363
- Lighthouse — 366
Cloud Stuff — 367
- The Cloud Structure — 367
- Teleporter — 369
- The Great Hall — 369
- The Observatory — 373

Putting it all Together	374
Final Renders	374
The Eight Worlds	378

Appendix A About the CD-ROM — 383
CD Folders — 383
- Col_Pl — 383
- Movies — 383
- Projects — 383
- System Requirements — 384

Appendix B Vendor Information — 385
Corel's List — 385
- Painter — 385
- PhotoPaint — 386
- CorelDraw — 386
- KPT Plug-Ins — 386
- Jungle 3D — 386
- Other Plug-Ins for Painter/PhotoPaint — 386

Electric Image Amorphium — 387
CuriousLabs Poser — 387
Maxon Computer's Body Paint — 387

Index — 389

Preface

Bryce has its hooks in me. No matter the other enterprises that call for my attention, the other books that center on 3D software magic, I look for any excuse to return in any way possible to Bryce. What is it about this software that is so magnetic, so mesmerizing? I have come to the inescapable conclusion that Bryce, more than any other electronic creative environment, allows me to realize the full potential of my visions and dreams. More than that, whatever structures and plans I have deliberately and precisely sketched out in great detail beforehand are always altered and deepened once I engage with Bryce. I have written and illustrated two Bryce books before this one. Although they were well received, it is in this book that I will explore the full measure of what creating Bryce worlds is all about, and how absolutely thrilling this creative journey can be. If you are a Bryce addict already, then I am surely just preaching to the choir. If you are not, then I hope that this book will alert you to how you can travel to the worlds you now only imagine, worlds begging to be brought to fruition before your eyes. Bryce is an artist's tool, an electronic paintbrush and palette that is in part controlled by you, and in part leads you on. It is hard to find the exact dividing line between the artist and the tool in Bryce. This book is structured far differently from any other book that references Bryce, focusing upon how to visualize, structure, and create environments suggested by stories. I hope that you will find the book informative, and that it will inspire you to use Bryce to do deep explorations of your own worlds of wonder.

Shamms Mortier

Introduction

When I was a very young man, I used to journey to the Art Institute of Chicago at least once a month. I lived in the city, so the trip didn't take that long. Upon entering the great galleries, all of the noise of the outside world (and the turmoil and chaos of my own post-puberty mind) was silenced. Standing in the empowering presence of the paintings and sculpture of the ages was both inspiring and overwhelming. When you find yourself in the proximity of truly great art, nobody has to assure you that it is just that. Great art evokes a physiological response, a shiver up your spine, a deepened breathing, a motionless awe, a reverent silence.

On each visit to this magnificent place, I would make sure to take in one painting whose power was hypnotic for me. The painting was tucked away in a side gallery. It was a small work by Salvador Dali. I don't recall the name of the piece, but it did have the words *Banquet* and *Nightmare* in the title. There were no ropes to stop an observer from getting inches away from it to study the brushstrokes, and no alarms to keep you at any set distance. The painting displayed a group of diverse people sitting at a long banquet table, with a giraffe on fire in the background. The work was absolutely photorealistic, or rather surrealistic. Surrealism is the process of taking the impossible and making it seem real, which was a hallmark of most of Dali's work. It was only during the last part of his life that Dali incorporated techniques that were more abstract. Because of this one painting, and the lasting impression it made upon me, I was inspired to explore my own creative capabilities.

It wasn't until 1999 that Dali re-entered my life in a similarly powerful way again. I had been involved in computer arts for about 15 years, and was enjoying a trip to Florence with my wife. Florence is the most astounding place you will find on this globe as far as being a repository for the art of Michaelangelo

and other masters. I was there to capture images in order to compile them into a CD collection, so a lot of walking was necessary, since great works of art are located all over Florence. On the way back from the Ufizzi Gallery to the hotel, we happened to be walking by the Florence School of Art. Gazing in the street-level window, we could see that there was a small gallery near the entrance. The school was closed, but the gallery seemed to be open to the public. We entered. Most of the lights were out, so appreciating the detail of the paintings was, to say the least, difficult. There was one small area, however, that was lit by a single overhead spotlight. Sitting on a framed bed of gravel was a wood sculpture, with a nameplate attached to one side of the frame. With some difficulty, we read it: *Cosmic Elephant* by *Salvador Dali*. I was awestruck, and almost fell over. Without realizing it, I shouted my pleasant surprise.

Not only did it seem that my attraction to Dali's work had come full circle, but the design of the *Cosmic Elephant* told me something else. The design said clearly that Dali would definitely be involved in computer graphics if he were alive today. The *Cosmic Elephant* sculpture looks exactly as if it was modeled with Metaballs in a 3D application. The *Cosmic Elephant* bridges the gulf between traditional approaches to art and electronic tools.

Why am I starting the introduction to this Bryce book by telling you all of this, besides the fact that it is enjoyable to trace some of the important moments in my personal epiphanies? There are two main reasons.

First, as I have hinted already, I am sure that Dali would have included computer art applications in his resource toolkit if they were as advanced in his time as they are today. Knowing a bit about him, he was always exploring new ways to develop his visions. Knowing his style and his admiration of certain forms, I can even guess exactly what software he would select, and that Bryce would surely be among these applications.

My second reason for telling you this story has to do with the term *photorealism*, a word that is part of the title to this book. The style of photorealism that we are about to walk you through in this book definitely verges on the surrealistic; the ability to take fantastic components of nonreality, elements and environments far from your everyday experience, and transmute and blend them in renderings that will look surprisingly "real," as if we carried a camera into the dream world. This ability to confuse or blur reality and dream is the very definition of the surreal, and it is something at which Bryce excels.

 There are over 16,500 Dali referenced sites on the Web. Just insert the keyword Dali *in your search engine.*

INTRODUCTION

How This Book Is Structured

Please note that this book assumes that you have read and worked through the Bryce documentation, and perhaps referenced a separate Bryce book as well (see my Charles River book on Bryce 3D).

PART I: BRYCE MODELING

This part lists the important Bryce modeling tools and process you have to be working-familiar with to understand and complete the tutorials in this book. The chapters are concerned with enhancing the knowledge you obtained from reading the Bryce documentation. This part is tutorial based to prepare you for the final projects.

Chapter 1: Bryce Primitives
This chapter details the use of Bryce Primitives in the construction of composited objects.

Chapter 2: Bryce Booleans
In this chapter, you can refresh your knowledge concerning how Booleans work and what types of objects can result from their use.

Chapter 3: Mastering Terrain Editor Terrains
Bryce is well known for its Terrain creation capabilities. This chapter reinforces your knowledge of how this is accomplished.

Chapter 4: Mastering Terrain Editor Objects
Although only taken advantage of by advanced users, the Terrain Editor can also be used to create very complex non-Terrain objects. Here's how.

Most of this information cannot be found in any other Bryce book on the market to date.

Chapter 5: 2D Picture Objects and Procedural Materials
2D Picture Objects allow you to load a scene with content, while being kinder and gentler to the size of the scene file. Bryce Materials are referenced differently from materials in other applications, so there are some facts to observe.

Chapter 6: Infinite Planes and Lights
One of the hallmarks of Bryce is its ability to generate seemingly infinite Ground, Water, and Sky planes, resulting in the creation of true endless virtual

worlds. Light placement and controls add emotional content and a final touch of photorealism to any scene.

PART II: EXTERNAL MODELING APPLICATIONS

It may seem paradoxical, but the best way to get the most out of Bryce is to use additional software in conjunction with your Bryce projects. Part of this is because Bryce lacks certain modeling capabilities. It is also true that the extra software we recommend is unique in its own right, offering you state-of-the-art inspirational new approaches to modeling. This part is tutorially based to prepare you for the final projects. We suggest the use of the external applications discussed in the following parts.

Chapter 7: 3D Modeling Tools

This chapter looks at some of the 3D modeling processes you must be working-familiar with in order to maximize your Bryce experience. These tools are not found in Bryce, but in other professional 3D applications. The tools rather than specific software are important, as long as the software you use writes out to a format Bryce can import.

Chapter 8: Helpful Handshaking

This chapter includes a series of tutorials that focus on Bryce handshaking with other recommended software. This is in addition to a professional 3D application that contains the modeling tools mentioned in the last chapter.

Amorphium

Amorphium, from Electric Image, is a very valuable modeling application when it comes to customizing and deforming models used in Bryce scenes.

Tree Professional

Tree Pro from Onyx Software is a valuable add-on for Bryce creations. A plug-in version of Tree Pro, Tree Storm, is available for 3DS Max users as well.

Poser is vital to complex Bryce environment creations when it comes to adding sculptural elements that reference anatomical data.

Other Modeling Alternatives

Additional tools and utilities useful to Bryce creations are constantly appearing on the market. A favorite few are detailed here.

PART III: EIGHT STORYWORLDS

This is the core of the book, showing you how eight environmental ideas can be translated into Bryce 3D environments. All of these Bryce project files are con-

tained on the CD that accompanies this book. Some are quite large. Each project starts with a narrative that talks about the specific world involved. From there, we show you how to translate the narrative from rough sketches into the final 3D imagery, using some external applications when called for.

Chapter 9: The Great Blue-Ice Throne Room
A world of eternal ice and snow. This is a visit to the ancient Blue-ice palace.

Chapter 10: The Temple of the Sand Masters
A world of hot sun, dryness, and never-ending dunes. Bryce makes a visit possible.

Chapter 11: Sanctuary of the Sargasso
This is an undersea world, containing a multi-domed habitat. This world is created in Bryce with the aid of external applications.

Chapter 12: The Cave of the Faerie Queen
This is an underground cavern situated in the deep woods, with giant mushrooms and other flora and fauna. To create this world in Bryce, external applications are also called upon.

Chapter 13: House of the Fire Eaters
This palace exists in a land of fire and smoke, heat and lava. A combination of applications is used to create this eerie Bryce world.

Chapter 14: The Jade Pagoda
The Jade Pagoda exists in an Eastern land amidst towering snow-capped mountains. The reader is taken through all of the necessary Bryce tools and techniques used to develop this hidden and mysterious realm.

Chapter 15: Abode of the Lizard Master
The Lizard Master and her minions live deep in the tropics, at the top of a haze-covered mesa. This chapter takes you through all of the necessary applications and processes to bring this somewhat nasty world to 3D life.

Chapter 16: In the Hall of Clouds
The Hall of Clouds is part of a palace that floats in the air. The reader is taken through all of the necessary Bryce tools and techniques used to develop the required modeled components.

The Color Gallery

The Color Gallery of the book displays the StoryWorlds in blazing color for you to browse and reference.

Appendixes

Appendix A: About the CD-ROM

Appendix A details the contents of the CD-ROM. Suffice it to say here that the CD-ROM contains a large amount of value-added content useful to Bryce creators.

Appendix B: Vendor Information

Appendix B lists what I consider absolutely essential applications for serious Bryce work.

HOW TO USE THIS BOOK

How you use this book depends upon who you are, what you are looking to do with your knowledge, and your previous experience with Bryce.

BRYCE USERS

Bryce users should walk over coals to add this book to their resource and reference collection. If you are a new Bryce user, read and work through this book in its entirety. If you are an experienced Bryce user, you may want to skim Part One. Work through Part Two if the listed applications are new to you, but spend most of your time working through Part Three on the StoryWorlds projects. Investigate all of the material on the CD-ROM as well.

COMPUTER ARTISTS AND ANIMATORS WHO ARE NOT BRYCE ENABLED

First, purchase Bryce, and read and work through the documentation. Since the book details techniques that can be translated and utilized with the majority of 3D software applications, read and work through the entire book. If you have experience with other 3D applications, your learning will progress much faster.

MOVIEMAKERS, SET DESIGNERS, AND FILM EFFECTS PEOPLE

Read the entire book. Pay special attention to Part Three, and see if any of these projects resemble one that you need to work on.

The Fantasy and Fiction Audience

Pay special attention to the StoryWorld narratives, and see if you can dream up alternate visual ideas for illustrating the stories.

Game Designers

See how the Bryce worlds in Part Three are put together, and imagine how these environments might be used as gaming world designs.

Traditional Artists and Animators

Bryce is an excellent choice for your first exploration of 3D computer graphics and animation. Read the book in its entirety after purchasing Bryce, but precede this by a thorough study of the Bryce documentation.

Art Book Collectors

Peruse the images displayed in the Color Gallery. Leave the book in a prominent place in your home or office, allowing others to get pleasure from viewing the visual works.

The "How Things Are Done" Audience

This audience seems to be growing by leaps and bounds, as proven by the expanding interest in documentaries on how films are made. Use this book to learn about the use of computer graphics in broadcasting and film.

Lovers of "Coffee Table" Books

This book has something to attract everyone, so leave it in a conspicuous place in your home or office.

Schools and Colleges

If you are a student or teacher at an academic institution that offers computer graphics courses, think about using the tutorials and other data in the book as the basis for a class.

People Who Are Tired of the "Run-of-the-Mill" Computer Books

Sadly, many of the largest publishers of computer books demand that their authors create works based on strict preset marketing formulas, with no variance allowed. This book sets a new paradigm for how computer books can (and should) be created, thanks to the artistic freedom nurtured by Charles River Media. This book folds in general and specific information about 3D software and its operation, while integrating storytelling and creating complex 3D illustrations. The tutorials are meant to incite the reader to push the envelope fur-

ther. Projects are included on the CD-ROM Yes! They are all there—that you can explore and, where desired, alter and customize. This book was designed to be as much of an art book as an instruction manual, which is why it has been so much fun to do. Hopefully, you will have fun adding it to your library.

Now it's time to move ahead to the real deal . . .

PART 1

Bryce Modeling

CHAPTER 1
Bryce Primitives

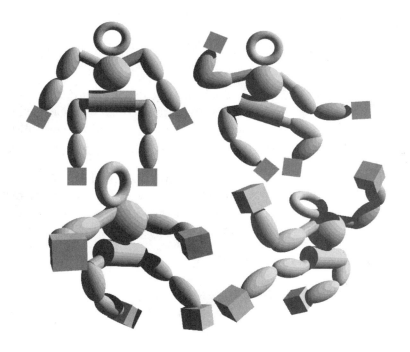

What You Need to Know

In order to do the preparatory tutorials in this chapter, you need to know the following:

- How to access the Camera Controls
- How to go to different Views
- Where the Bryce Primitive objects are, and how to access them
- How to Link and Group Objects
- How to Rotate and Resize Objects
- How to Show and Move Origin Handles
- How to apply Materials to a selected object
- How to do a render by clicking the Render button

The 3D Models in your Bryce world are actors on a stage. They give life to a scene, and their interactions with each other and their environment are interpreted as meaningful acts by the onlooker. Your models make a Bryce scene real, whether they emulate organic creatures or mechanical artifacts.

It is assumed that you have read the Bryce documentation and worked through the tutorials, and have some degree of extended personal interaction with Bryce. Where necessary, Tips and Tricks are provided for accomplishing specific modeling results.

TUTORIAL

Primitive Man

What do we mean when we say "*primitive*" in a 3D application? A primitive is a 3D object that can be brought into a scene by clicking on its icon or an associated button. Different 3D applications have varying numbers of primitives. The common ones shared by all are the cube, sphere, and cone. Bryce goes beyond that by adding variations of these volumes and other primitives. To view and activate the Bryce primitives, click on their associated icons in the Create toolbar.

Figure 1.1 *Click on the "A" symbol after selecting the Camera.*

Chapter 1 Bryce Primitives

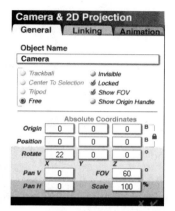

FIGURE 1.2 *Use these values for the Camera settings.*

FIGURE 1.3 *Click on the Sphere Primitive in the Create toolbar.*

Our Primitive Man is neither Neanderthal nor Cro-Magnon, but refers to an anthropological model built entirely of Bryce Primitives. This is one way to create simple characters for populating a Bryce world, without importing more complex character models. Do the following:

1. Open Bryce. Delete any ground plane that may be in the Bryce document by selecting it and pressing Delete.
2. Select the Camera. Click on the "A" symbol to bring up the Camera Controls window. See Figure 1.1.
3. Use the Camera settings displayed in Figure 1.2.
4. Go to the Front View. Click on the Sphere Primitive in the Create toolbar. This places a sphere on the screen. See Figure 1.3.
5. Use the same process to create a Torus Primitive. Center the Torus over the Sphere. Clink on the Link symbol with the Torus selected, and Link the Torus to the Sphere. Do a test render. See Figure 1.4.
6. Create a Cylinder. Center it below the Sphere, and Resize and Rotate it (90 degrees on the X-axis). Link it to the Sphere. Refer to Figure 1.5.
7. You can move everything by selecting the Sphere, which is now the Linked "parent" of the other two objects. Move these objects out of the way by moving the Sphere. Now it's time to create an arm.
8. Create the object displayed in Figure 1.6. This object is made from a Cube (hand), two Ellipsoids (lower and upper arm), and a Cylinder (shoulder).
9. Link the Cube (hand) to the bottom Ellipsoid (lower arm), and the bottom Ellipsoid (lower arm) to the top Ellipsoid (upper arm). Link the top Ellipsoid (upper arm) to the Cylinder (shoulder). The Cylinder (shoulder) is now the Parent object in a Linked chain.

Advanced Bryce Creations

FIGURE 1.4 *This is how your character should appear at this point.*

FIGURE 1.5 *The Cylinder will act as the pelvic area of the character.*

 When you resize or rotate the Parent object, scaling and rotation is passed down the Linked chain to the Child objects.

10. Resize the Cylinder (shoulder) so that the Linked chain looks proportional to the rest of the character. Rotate as displayed. Link the shoulder to the Sphere. Your character should now resemble Figure 1.7.
11. Duplicate the Linked chain of the arm by selecting the shoulder and going to Edit > Duplicate. In the Edit toolbar, click on the downward

FIGURE 1.6 *Create this object, composed of Primitives, for the character's arm.*

FIGURE 1.7 *The arm is Resized, Rotated, and Linked to the Sphere (chest/abdomen).*

CHAPTER 1 BRYCE PRIMITIVES

pointing arrow next to the Resize tool, and select Flip X from the list. This creates the flipped duplicate for the other arm. Move the other arm into place. It is already Linked to the Sphere, since it duplicates the Linkage of the source arm. See Figure 1.8.

12. Click on one of the shoulder Cylinders, and Duplicate. We want to remove the Linking, so while the duplicated shoulder Cylinder is selected, click on the "A" symbol. This brings up the Cylinder's Object Attributes window. Under the Linking tab, select None from the Object Parent Name list. This removes the Link. Click on the check mark to complete this operation. See Figure 1.9.

13. We are going to use the Linked arm chain duplicate we just created for creating the legs as well. Move the new leg object into place on one side of the character's body, and Rotate as displayed. Duplicate and Flip to create the other leg. Both leg Cylinders are then Linked to the pelvis Cylinder of the character. When completed, your character will resemble Figure 1.10.

14. Since all of the body parts are Linked, rotating any Parent object also rotates all of the Child objects in the hierarchy below it. Let's rotate the Left Forearm, which should bring the Hand along. Click on the Left Forearm (which is really the arm on the right side of your screen, considering that the character is facing front). Rotate it. See Figure 1.11.

15. The forearm rotates and the hand accompanies it, but something is radically wrong: the forearm detaches from the upper arm. We have forgotten one important item: the object's Origin Point placement. The Origin Point is the fulcrum of all objects, the point that determines the center of rotation and scaling.

FIGURE 1.8 *Now our Primitive Man has two arms.*

FIGURE 1.9 *Remove the Link in the Object Attributes window under the Linking tab.*

ADVANCED BRYCE CREATIONS

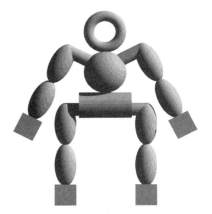

FIGURE 1.10 *The completed Primitive Man model.*

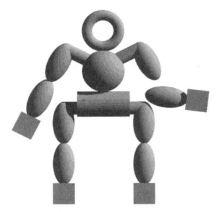

FIGURE 1.11 *The Forearm is rotated, but it looks strange.*

16. Bring up the forearm's Object Attributes window. Under the General tab, click the Show Origin Handle option. Close the window by clicking on the check mark. See Figure 1.12.
17. You will see a bright green dot on the selected object. This is the Origin Handle (also called Origin Point and Pivot Point interchangeably). Rotate the object back into position. Use a selection marquee, and surround the entire character. Go to Objects > Show Object as Box. All of the character's parts are now displayed as boxes. Select each part, one by one, and Show Origin Handle. Now you see boxes, with each showing its Origin Handle. See Figure 1.13.
18. You will want to move each component's Origin Handle to the place from which that component will rotate; for instance, the forearms

FIGURE 1.12 *Select Show Origin Handle.*

FIGURE 1.13 *All of the character parts are displayed as boxes, with each part's Origin Handle visible.*

should rotate from the elbow. First, however, you have to correct something. Moving Origin Handles in a Linked Hierarchy moves the Child objects. Therefore, you have to UnLink everything, move the Origin Handles, and then ReLink. Sorry about that, but this teaches you that certain processes in developing a Linked object must happen in a specific order. Mistakes are the best way to learn creative processes so you won't forget the lesson again. See Figure 1.14.

19. Now, rotate selected parts to pose the character. Everything should work perfectly! See Figure 1.15.

This is called an Articulated Model. Use a metallic gold Material on all of the Primitive Man's components, with Object Mapping.

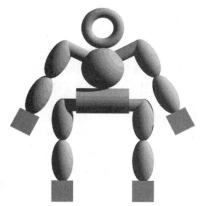

FIGURE 1.14 *The parts are UnLinked, the Origin Handles are moved into place, and everything is ReLinked.*

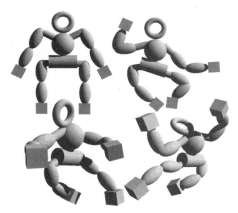

FIGURE 1.15 *Now you can pose the character as you like.*

TUTORIAL

THE CREEPY CRAWLER

The Creepy Crawler is a centipede-like creature, built from Primitives. Do the following:

1. Create a Sphere and a Squashed Sphere. Resize the Sphere to make it smaller, and place it to the right of the Squashed Sphere. Select Objects > Group, and name the new grouped object *Section*. Move the Origin Handle of this grouped object to the right far end of the Sphere part. See Figure 1.16.
2. Go to the Top View and Duplicate. Move the duplicated Section to the position shown in Figure 1.17.

FIGURE 1.16 *The Grouped* Section *object.*

FIGURE 1.17 *Move the duplicated Section as shown here (Top View).*

3. With the Duplicate selected, go to Objects > Multi-Replicate. Set the Quantity to 6, and check Scale Translation. Set Offset X to 24, and XYZ Size to 90% for all. You are creating an array of Section objects for the multipeed's body. See Figure 1.18.
4. Go to the Front View, and see the model you have created. The body sections get smaller from front to back. See Figure 1.19.
5. Time to Link. Link the sections from the right to the left, tail to head, one by one. When completed, if you move the section on the far left, the entire body should move.
6. Select the leftmost section. Map it with the Miscellaneous/Yellow Noise Material, and use Parametric mapping. Edit > Copy Material, and select the next section. Edit > Paste material. Repeat this operation until all sections are mapped with the Yellow Noise Material. See Figure 1.20.
7. Create a simple leg from two resized cones, rotated to fit together. Use a Black Material on the leg, and move the Origin Handle to the end so it connects to the body. See Figure 1.21.
8. Work in the Top View. Duplicate and Rotate the leg, placing the duplicates at the left side of the body. When completed, Group the legs and Link to the leftmost section. Duplicate the grouped legs, and Flip Z. Move into place. Use Figure 1.22 as a guide.

FIGURE 1.18 *Use these values in the Multi-Replicate window.*

FIGURE 1.19 *This is the model created by Multi-Replication.*

CHAPTER 1 BRYCE PRIMITIVES 11

FIGURE 1.20 *Map all sections with the Yellow Noise Material.*

FIGURE 1.21 *The leg is composed of two grouped Cones.*

If you want to pose this critter, each pair of legs will have to be Linked to its own section of the body.

9. Use an Ellipsoid for the head, and group it with two spherical eyes and two antennae created from resized Cones. Link the frontmost body section to the head. You can create other components to make the model more complex, but this is the basic finished form. See Figure 1.23.

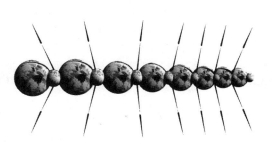

FIGURE 1.22 *The creepy crawler now has legs.*

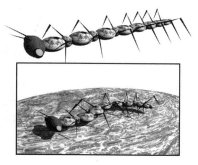

FIGURE 1.23 *The completed basic form of the Creepy Crawler.*

PRIM TOWER

TUTORIAL

One of the best uses for object Primitives is to use them to create towers and buildings. This can range from castles to skyscrapers, and include unique buildings of your own fantasy design. Here's what I mean:

In this exercise, the assignment of Materials is up to you.

1. Place a Stretched Cylinder on the screen. Go to the Top View, and Move the Origin Handle away from the object about 6 widths of the object. Select Edit > Multi-Replicate. Select a quantity of 4, and a Y rotation of 72 degrees. See Figure 1.24.
2. From the Top View, you will see that you have created a perfectly symmetrical pentagonal array of columns. See Figure 1.25.

FIGURE 1.24 *Use these values in the Multi-Replicate window.*

FIGURE 1.25 *The pentagonal array as seen from the Top View.*

3. Place a Cylinder at the center of the column array. Resize it so that it is about 2/3 as wide and deep as the columnar array, and equally as high. Use any Material you like on it—I prefer Wild & Fun/Office Building 2 with Object Mapping. See Figure 1.26.
4. Add a flattened Cylindrical base, a bit wider than the columnar array. See Figure 1.27.

FIGURE 1.26 *A mapped Cylinder is placed at the center of the columnar array.*

FIGURE 1.27 *A Cylindrical base is added.*

5. Cap the model with a Duplicate of the flattened Cylinder. Group everything, and name it Part_01.
6. Multi-Replicate the object. Set Quantity to 4, and Size to 90% on the X- and Z-axes. Move the replicates so that you create a stack of objects. Cap everything with a Pyramid Primitive, and group everything and name it Building. See Figure 1.28.

FIGURE 1.28 *The building.*

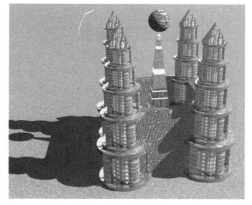

FIGURE 1.29 *The finished building becomes one of the core objects of another more complex model.*

Once you have one fancy building, you can duplicate it to create other configurations, such as this walled fortress. See Figures 1.29 and 1.30.

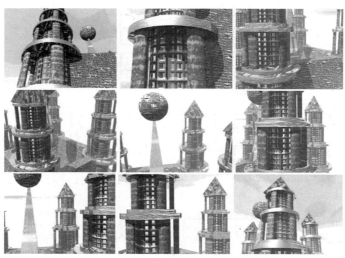

FIGURE 1.30 *Frames from an animation showing the multiple towers.*

Advanced Bryce Creations

 Play the QuickTime movie in the Anims folder on the companion CD-ROM for an animated view of the towers.

Prim City

Let's use Bryce primitives to construct a futuristic cityscape. Here's how to do it:

1. Go to the right-hand toolbar and turn on the Grid in the background paper display. This gives you a way to place objects in a geometric pattern. Remove the Ground plane for now, and start your work in the Top View.
2. Click on various object primitives to place your structures in the city. Click on them one by one, and move them into place on the grid. Use more than just rectangular primitives to give your cityscape a more interesting look. Resize some of the primitives from the Top View to vary the buildings (Figure 1.31).

 Remember that spherical primitives contain more polygons than other objects, so use them sparsely to cut down on storage space for the file.

FIGURE 1.31 *As your city takes shape, different primitive objects are moved into place (Top View).*

CHAPTER 1 BRYCE PRIMITIVES 15

3. Apply a solid color material to all of the objects (Simple and fast—Blue metal), and create a ground plane mapped with Planes and Terrains: Mud and Snow. Take a look at it from a perspective camera view. See Figure 1.32.
4. Select any spheres you have in the scene and move them down so that they show only their top half, like geodesic domes.
5. Next, edit the sizes of some of your similar shapes (cubes for instance) so they give more variety to the scene. Make some taller, and some shorter.
6. Add a few more primitive shapes on top of some of the buildings. Especially effective is the addition of smaller rectangles on top of larger ones, and pyramidal shapes on top of rectangles. Experiment. Render a preview to judge your efforts thus far (Figure 1.33).
7. After you have adjusted all of your buildings so they seem right for the scene, there's one more step. Cities have roadways, and they might even have street lamps and other details. For this project, lots of detail is not warranted. For our roads, we'll simply add a few rectangles, squashed so they're close to the ground and elongated beyond the city's borders, coloring the roads with a black Simple and Fast material. Do it. See Figures 1.34 and 1.35.

FIGURE 1.32 *When seen in perspective, the cityscape begins to take on a more believable appearance. The city so far has only 1219 polygons, and renders quickly because it has a simple material mapped.*

FIGURE 1.33 *By varying the buildings even more, we move the scene into a more realistic space.*

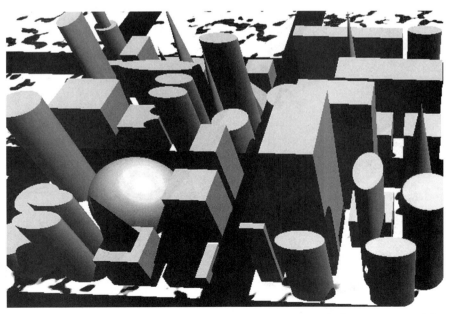

FIGURE 1.34 *With the addition of roads, this simple cityscape is ready for an animated flyover.*

CHAPTER 1 BRYCE PRIMITIVES 17

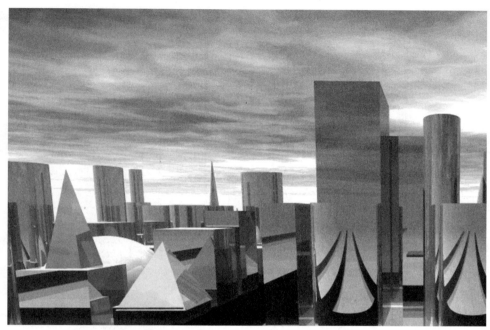

FIGURE 1.35 *Rendered against a cloudy sky from a head-on view, with a Haze setting of 60, gives us another appreciation on this simple cityscape. In this case, the reflection was set to 40 for all buildings, causing them to mirror each other.*

TUTORIAL

A BASIC ARCHWAY

Archways can be used outside as part of a garden scene, inside a domicile between rooms, or enlarged to bridge a river. However you use them, basic archway objects can be constructed using primitive objects. Here's one example:

1. Create two columns with four cubes in each, similar to the illustration in Figure 1.36.
2. Create a Torus primitive, and place it so that its outer radius touches the outer edges of the columns. We will use this as a template, and erase it when our task is accomplished. See Figure 1.37.
3. Place seven cubic blocks, using the Torus as a template. When finished, delete the Torus. Your archway should look similar to the one in Figure 1.38.
4. Apply any material you desire, or even a mix of materials. The reason we did this with smaller blocks is so that the materials would look mapped individually, and not to the whole form at once. See Figure 1.39.

ADVANCED BRYCE CREATIONS

FIGURE 1.36 *Two columns constructed from four cubes each begin the archway.*

FIGURE 1.37 *The torus is created, resized, and placed as shown.*

FIGURE 1.38 *The arch blocks are placed using the Torus as a template.*

FIGURE 1.39 *The archway is textured for a finished look. This example uses a Pitted Concrete material from the Rocks and Stones library, with three duplicate archways placed for effect and a 60% haze applied.*

IMPORTED MODELING ELEMENTS

Bryce allows us to import objects in the DXF, OBJ (WaveFront), 3DMF, DEM, HF, LWO and LWS, COB, VRML, VSA, and 3DS (3D Studio) formats. 3DMF files are cross-platform, though more common on the Mac. Bryce presently has a minimum of modeling tools and options. Professional modeling applications offer many more choices for creating objects of every description, including

human, animal, and other organic forms. If you are a professional computer artist and animator, you already have an advanced degree of familiarity with 3D applications that are more suitable for creating 3D objects. The only question that remains is, "does the application I use export objects in a format compatible with Bryce 3D?" If the answer is yes, than you have all you need to create infinite object content to place in Bryce. Imported objects and object elements look cleaner and more professional.

 The general rule is to use primitive objects to construct background elements in Bryce or for compositing mechanical objects whose parts are grouped and linked.

OBTAINING 3D OBJECTS

In addition to importing objects created in your 3D modeling software, there are dozens of commercial CD-ROM libraries with a variety of 3D objects in a number of formats available for purchase. Most of these libraries contain objects suitable for your Bryce work. See Figures 1.40 and 1.41.

FIGURE 1.40 *Here is a selection of 3DS and DXF objects from the Light ROM 5 CD-ROM Collection, imported and rendered in Bryce 3D.*

FIGURE 1.41 *This 3DS object, also found on the Light ROM 5 Collection CD-ROM, was very faceted when imported. By applying maximum smoothing, it is transformed into an object that can be used to populate some spectacular Bryce worlds.*

TRAVELING ON

In this chapter, you learned about modeling with Primitives, and how to use various Bryce tools to make your work easier. We also reminded you that Bryce can import a number of 3D object file formats. In the next chapter, we move on to reinforce your knowledge of how Booleans can help you in your modeling pursuits.

CHAPTER 2
Bryce Booleans

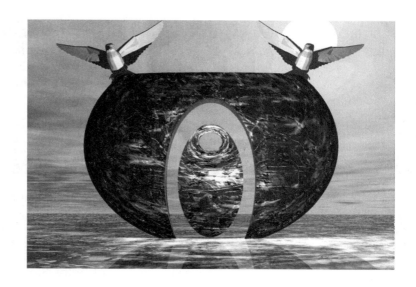

If you already have a good working knowledge of working with Bryce Boolean operations, you may want to skip this chapter. You could also skim the tutorials first to see if there is any new information here that might be useful for you.

What You Need to Know

In order to do the preparatory tutorials in this chapter, you need to know the following:

- How to access the Boolean Objects Library
- How to Save and Load from the Boolean Objects Library
- How to create a variety of Boolean Objects
- How to place a Terrain in the workspace

This chapter walks you through the creation of a few Boolean object creations in Bryce, but the projects at the core of this book use just a few objects created with Bryce Booleans. That's because there are other applications that Bryce can handshake with that are more useful when it comes to object creation. Nevertheless, it is important that you are aware of how to manipulate Bryce Booleans.

Loading Boolean Object Presets

There is a number of preset Boolean objects in the existing Boolean Library. This first exercise is simple. Do the following:

1. Open the Boolean Library by clicking on the right arrow next to the word *Create* in the toolbar. Select the first item in the list—*Boolean Objects*. This opens the Boolean Library. See Figure 2.1.
2. Look at the selections. Click on a selection to create a component to build a Boolean tower. Click on the check mark to accept your choice, and close the Library. Do this four more times until you have five components.
3. All of your components have been placed on top of each other in the workspace. To separate them and build the tower, select each one in the stack and move it vertically until the tower contains the components stacked one on the other in the order you desire. The tower is complete. Render to preview. Do not delete the objects yet. See Figure 2.2.

CHAPTER 2 BRYCE BOOLEANS

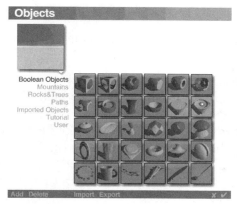 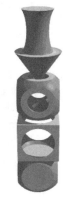

FIGURE 2.1 *The Boolean Objects Library opens.*

FIGURE 2.2 *The Boolean Tower. Yours may look different due to your selection of components.*

SAVING BOOLEAN OBJECTS TO THE LIBRARY

Saving your Boolean Objects to the Boolean Objects Library means that they can be accessed in any future Bryce project. Do the following:

1. Place a selection marquee around all of the objects in the tower. Group them (Objects > Group Objects).
2. Open the Boolean Objects Library with the group selected. Click Add. Name the new Boolean Object as *Tower_01*. It now appears as a selection in the thumbnail previews. See Figure 2.3.

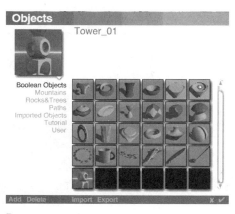

FIGURE 2.3 *Save the Tower object to the Boolean Objects Library.*

A Mountain Tunnel

It is important that you know how to use Boolean operations to drill holes in Terrain objects. Here's a preparatory exercise. Do the following:

1. Go to the Create toolbar, and click on a Terrain object icon. This places a Terrain in your workspace. Use the Front View and zoom in on the Terrain object so it fills the screen.
2. Go to the Create toolbar again, and place a Cylinder in the workspace. Enlarge it so that it can be used to cut a tunnel in the Terrain. Map the Terrain with any Terrain Material in the Materials Editor (Parametric Mapping), and map the cylinder with the Wild and Fun>Carnival Tent Material. Rotate the cylinder and Resize it so that it is embedded in the Terrain, and you can see it poke out the other side. See Figure 2.4.
3. Select the cylinder, and open its Attributes window. Click on *Negative* and *Transfer Material of Negative Boolean*. This means that the striped material will be mapped to whatever negative space is involved. Click on the check mark to apply the settings. See Figure 2.5.
4. Select the Terrain object, and open its Attributes window. Click on Positive, and click on the check mark to apply the settings.
5. Use a selection marquee to select both the Terrain object and the cylinder, and Group. When you Group Boolean objects, they interact. You have just created a striped tunnel through the Terrain object. If you did not check the *Transfer Material of Negative Boolean* attribute for the cylinder (the Negative Boolean), the tunnel would have the same material as the rest of the Terrain object. See Figure 2.6.

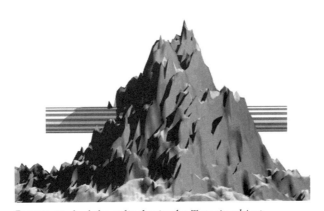

FIGURE 2.4 *Embed the cylinder in the Terrain object.*

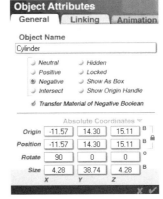

FIGURE 2.5 *Configure the cylinder's attributes.*

CHAPTER 2 BRYCE BOOLEANS 25

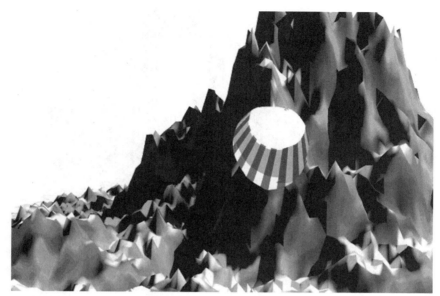

FIGURE 2.6 *The finished tunnel through the Terrain object, ready to admit any traveling objects.*

 If you are familiar with Bryce Booleans as compared to the Boolean operations in other 3D applications, you realize that they work very differently. The Boolean objects in Bryce maintain their individuality, so that you can select the separate components of a Boolean Group at any point for relocation, rotation, or scaling.

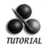
TERRAIN CUTS TERRAIN

Using a cylinder to cut a tunnel or a cave into a Terrain object is interesting, but not if you want the look of a natural object. When wind or water cuts a tunnel or cave, there are uneven pieces in the mix. When you want a more natural model, you can use a more natural object to create the Boolean cut. Do the following:

1. Go to the Create toolbar, and place two Terrain objects in the scene. Resize one so that it is cylinder-like for use as a cutter. Make it a Negative Boolean, and map it with a Terrain Material of your choice. Check *Transfer Material of Negative*, and apply the settings.
2. Make the other Terrain object a Positive Boolean. Place the cutter in position to create a tunnel or cave, and group both Terrain objects. The cut now looks more jagged and natural. See Figure 2.7.

FIGURE 2.7 *The cut looks more jagged and natural this time.*

A Complex Boolean Structure

TUTORIAL Using Primitive objects and Boolean operations, you can create very complex objects. Do the following:

1. Place any number of diverse Primitive objects in the scene, and go to the Front View. See Figure 2.8.
2. Decide which objects are to be Positive or Negative, and apply the necessary attributes. Move the objects together to form a construct that takes advantage of the Positive and Negative components. See Figure 2.9.

FIGURE 2.8 *Place your choice of diverse objects in a scene.*

FIGURE 2.9 *Apply Positive and Negative attributes, and move the objects so they overlap according to your designer's eye.*

CHAPTER 2 BRYCE BOOLEANS

FIGURE 2.10 *Group to create the Boolean structure.*

FIGURE 2.11 *Your painting will look different from this example, although we have both followed the same general rules.*

3. Objects > Group Objects to create the Boolean Structure. See Figure 2.10.
4. When your object is designed to your liking, duplicate it to create a family of objects. Place them in accordance with your designer's eye to create a surrealist painting. See Figure 2.11.

WINE GLASS

TUTORIAL

1. Create an elongated sphere for the body of the glass, and map it with a Standard Glass material. Use a light-blue color in the Diffusion channel to tint it. Make the elongated sphere Positive in the Attributes dialog.
2. Create a cube that intersects the elongated sphere about halfway down. Make the cube Negative, and group it with the elongated sphere. Your object should resemble the one at the left of Figure 2.12.
3. Duplicate the object, and make the duplicate 10% smaller. Place the duplicate inside the original object, and apply a red glass material to it. This is the liquid, as illustrated in the middle of Figure 2.12.
4. Create the glass stem and the base. The stem is a cylinder, and the base is a squashed sphere. Use their Attributes dialogs to check Boolean Intersecting, and group both together. Place them in position, and group the entire glass. The result should be similar to the right illustration in Figure 2.12.

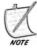

NOTE

Be aware that glass exacts a severe rendering time penalty, because Bryce 3D has to trace all of the lights that interact with the object's refraction and reflection. Glass objects can cause a scene to render 5 to 10 times slower, depending how large they are and if anti-aliasing is on or off. One solution is to render the scene without the Glass objects, and then to Plop Render only the Glass objects on top of the background.

Advanced Bryce Creations

FIGURE 2.12 *The Wine Glass object, from start to finish.*

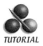

Boolean Chair

TUTORIAL

1. Start by placing a cube in your workspace. Resize it to twice as high as it is wide and deep. Apply a Wood material to it in Object Space. In its Attributes dialog, make it Positive. Refer to the left illustration in Figure 2.13.
2. Create three elongated rectangular blocks to be used to cut away spaces for the legs and top from the Right View. Give each block a negative Boolean attribute. Place the blocks so they cut away unwanted parts of the Positive block, and group all together. Render a preview. Refer to the middle of Figure 2.13.

FIGURE 2.13 *Creating a Boolean Chair.*

Chapter 2 Bryce Booleans

3. Ungroup everything. Create two more blocks to cut away unwanted parts of the chair from the front to back, and make them negative Booleans. Create cutaways for the back of the chair slats, and make each a negative Boolean. For the last negative Boolean, create a cube that cuts away the excess from the bottom of the chair. Place a shiny red cushion on the chair by adding another cube resized to fit. Now, group everything together for the final render. Refer to the right-hand illustration in Figure 2.13.

Boolean Archway

Using Booleans on archways produces more complex models than simply gluing primitives together. Using the same techniques as those used to create the chair in the Boolean Chair tutorial, you can cut away primitive objects (and imported ones) in seconds to produce extremely complicated models. See Figure 2.14.

Figure 2.14 *Another variation of the archway; this time, created with Boolean operations.*

INTERGALACTIC SHIP

Space ships go hand in hand with computer graphics, and using the Boolean techniques we have investigated, you can create mega vehicles in Bryce. It's one thing to create a small planetary ship, but an intergalactic ship requires enhanced levels of believability. A ship of this type must be perceived as massive, something strong enough to weather the star storms and spiraling time tornadoes that whip through the void. Study Figure 2.15, and try to use it as a guide to create your own version of a cosmic craft with Booleans.

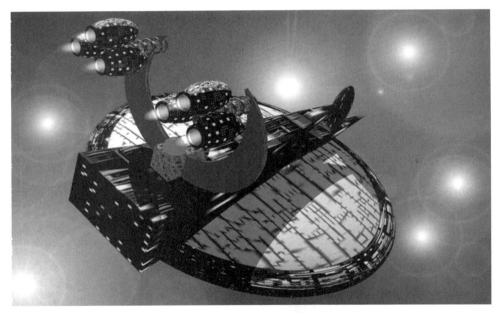

FIGURE 2.15 *The Galact1 star cruiser is a force to be reckoned with, and it's no wonder it can stand the tremendous forces that a jump to lightspeed entails.*

TRAVELING ON

In this chapter, you have completed a series of preparatory exercises to polish your Boolean skills. In the next chapter, we'll explore Bryce Terrain uses.

CHAPTER 3
Mastering Terrain Editor Terrains

Advanced Bryce Creations

One of Bryce's most evocative features is its ability to create any type of Terrain. Instrumental in this capability is the Terrain Editor, and your knowledge and mastery of its tools and options. In this chapter, we'll run you through a few exercises that will sharpen your ability to create Terrains not noted in the documentation. You must have a basic knowledge of Terrain Editor tools and options to follow along, so make sure you read the documentation before doing these exercises. Five tutorials are included in this chapter.

What You Need to Know

In order to do the tutorials in this chapter, you need to know the following:

- How to place a Terrain in a scene
- How to access the Terrain Editor
- What the names of the Terrain Editor tools and options are, where they are located in the Terrain Editor, and some knowledge of their basic use
- How to create and position Radial Lights
- How to create an Infinite Plane
- How to create a Symmetrical Lattice
- How to access the *Convert Selection To* operation

TUTORIAL

Volcano

This tutorial walks you through the creation of a basic Terrain volcano. Do the following:

1. Place a Terrain in a new Bryce scene, and open the Terrain Editor in the Edit toolbar.
2. Your Terrain can now be edited. In the Terrain Editor, set the size of the Elevation Brush to about 1/8 of the horizontal width of the Elevation View. Use a Hardness set to Maximum (the hardness icon will become solid), with Flow turned up all the way. Set the level all the way down as far as it goes. This creates a solid black, which can be used to cut a hole in the Terrain. Leave the Grid setting at its default.
3. Click about 10 times over the center of the Terrain in the Elevation View. Watch the 3D preview, and you'll see a hole being cut into the Terrain to form the volcano crater. See Figure 3.1.
4. Now let's build up the sides of the volcano a bit. Set the size of the Elevation Brush to about 1/2 of the Elevation View. Set the Level about 1/2

Chapter 3 Mastering Terrain Editor Terrains 33

FIGURE 3.1 *A hole is cut into the Terrain with the Elevation Brush set to a low level.*

FIGURE 3.2 *Paint Bubble Ridges around the base of the volcano.*

the way up the scale, to create elevations about midway between the lowest and highest Terrain altitudes.

5. Select *Paint Effect* from the Behavior menu below the Elevation View.
6. Click once on Bubble Ridges in the Elevation Types list at the bottom left of the Elevation View window. This applies a large bubble ridge over the entire elevation. We don't want that, so click Undo once. Because you have the Paint Effects Brush activated, you can now paint Bubble Ridges around the entire base of the volcano. Do that. See Figure 3.2.
7. Leave the default material as is. Create a Radial Light from the Create toolbar, and place it at the bottom of the crater. Turn the amount to 150, and change the color to red. The volcano is complete. Select a good camera angle and do a test render for preview. When rendering parameters are set, render and save to disk. See Figure 3.3.

FIGURE 3.3 *The crater glows ominously.*

 ## GENTLE HILLS

Here's how to create Terrain that emulates a gentle, rolling landscape. Do the following:

1. Drop a Terrain in the scene, and enter the Terrain Editor. Click New to erase the Terrain from view.
2. Make sure the Paint Effect brush is selected. Click once on Blob Maker, and then quickly on Undo. This sets the effect you will paint to the Blob Maker. Click on the grid to set the grid size, and select 256 (Fine).
3. Set the Brush Size to Full, and turn Hardness all the way down. This creates hemispherical elevations. Gently paint in the hills, and watch the 3D preview to get an idea of what they are looking like. See Figure 3.4 as a reference.
4. From the Top View, duplicate the Terrain twice. Rotate the duplicated Terrains over the source Terrain to get some random variance. Use a grassy material on the Terrains. Set the Camera view, render, and save to disk. See Figure 3.5.

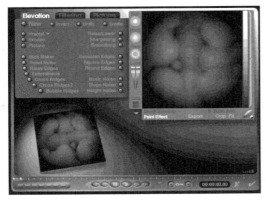

FIGURE 3.4 *Paint in the hills as shown.*

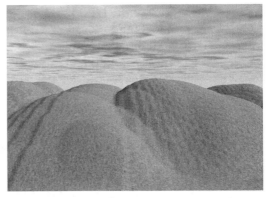

FIGURE 3.5 *Gentle, rolling hills evoke a sense of peace.*

 ## VERTICAL CLIFF FACE

Just because the Terrain Editor works on Terrains from an Elevation View doesn't mean you can't use it to create vertical Terrain elements. Do the following:

1. Place a Terrain in the scene, and go to the Terrain Editor.
2. Click New. Under Brush Behavior, select the Elevation Brush, and use a brush of maximum size.

Chapter 3 Mastering Terrain Editor Terrains

3. Grid should still be set to 256. Click on the *Mounds* Brush type three times. This creates a blotchy Elevation View. See Figure 3.6.
4. Select Chaotic from the Fractal list, and use the Fractal control to apply the effect to the elevation.
5. Apply a Pocked Fractal type to the elevation. Both of these Fractal applications flatten the mounded image. Use other Fractal types of your own choice to apply to the Terrain. When you are satisfied with the look, exit the Terrain Editor by clicking on the check mark to accept the alterations.
6. Rotate the new Terrain so that it is standing on end, and use a Wet Rock material on it. See Figure 3.7.

 You can create a series of Terrains and compose them all in an interlocking group to create larger surfaces when you need them. The options in the Fractal list in the Terrain Editor are worth exploring.

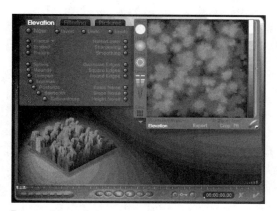

FIGURE 3.6 *Mounds are created.*

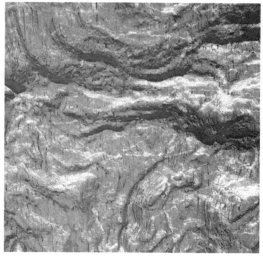

FIGURE 3.7 *This Terrain makes an excellent cliff face, and can be used to create interesting components for the inside of a cave.*

 ## Cutting a River

There are many ways to create a river cut in a Terrain, but here's one of my favorites. Do the following:

1. Place a Terrain in the scene, and go to the Terrain Editor. Set the grid at 256 if it is set to another value. Set the Brush Size to one step higher than the lowest size, and Hardness all the way down. Set Flow to about 1/3, and make sure Behavior is set to the *Elevation Brush*.
2. Click on the Erosion control and drag to the right to the maximum. Do this twice again. This creates a smoother Terrain.
3. Set the Level all the way down, and paint in a river cut. Refer to Figure 3.8, or simply experiment on your own.
4. Use a Veiny Stone material on the Terrain. Place an elongated cube at the bottom to represent the water, and use a reflective Water Material on it. Place the camera inside the cut, and render. See Figure 3.9.

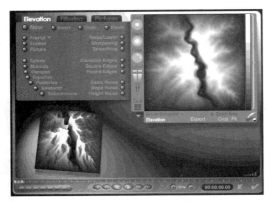

FIGURE 3.8 *Paint in a river cut in the Elevation window.*

FIGURE 3.9 *The river reflects the cliffs on either side.*

TUTORIAL

CRATERS

This exercise uses both the Terrain Editor and Boolean operations, so it's a good ending tutorial for this chapter. Do the following:

1. Drop a Symmetrical Lattice in the scene, and open the Terrain Editor. Use three maximum Erode operations on it, and return to the scene.
2. Use the Convert Selection To operation on the Symmetrical Lattice. This operation is accessed by clicking and holding on the small double-pointing arrow at the top-right of the Edit toolbar, and selecting an object type to convert to. We'll use this operation more times in the next chapter. Convert the Symmetrical Lattice to a Terrain.

NOTE

We start with the Symmetrical Lattice because it has no planar base as the Terrain does. When we convert it back to a Terrain, it still lacks a base.

Chapter 3 Mastering Terrain Editor Terrains

3. Reduce the vertical size of the Terrain by about 2/3, and rotate it vertically by 180 degrees.
4. Create an Infinite Plane. Place the inverted Terrain on top of it so the Terrain top (what was the original Terrain's bottom) is even with the Plane's top (use the Right View).
5. Make the Terrain a Negative Boolean, and the Plane a Positive Boolean, and Group them. Now you have a depression in an Infinite Plane that resembles an impact crater. Use your selection of Materials on the components of this group, render, and save to disk. See Figure 3.10.

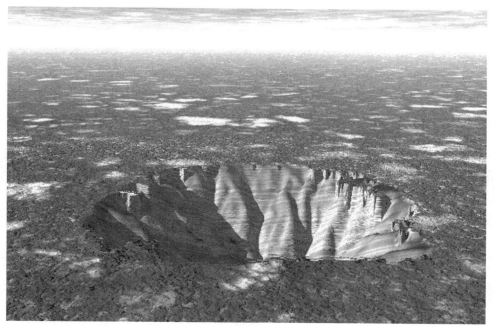

FIGURE 3.10 *The crater tells a story of an ages-old event.*

Traveling On

Using the Terrain Editor is vital for creating natural elements such as mountains, rivers, craters, and more in Bryce. However, if you thought that the Terrain Editor was limited to these and similar constructs, just wait until you do the tutorials in the next chapter!

CHAPTER 4
Mastering Terrain Editor Objects

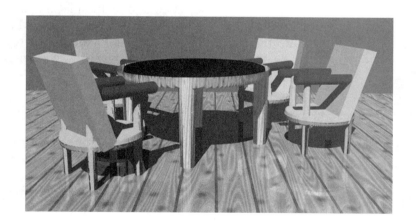

As any experienced Bryce user knows, the Terrain Editor can be used to generate a much wider array of diverse modeling elements than just naturalistic Terrains. The Terrain Editor is a virtual cornucopia that can pour out endless 3D content into your Bryce worlds. The obvious catch is that you have to know how to coax it to do it. There are two views on just how the Terrain Editor came to have these expanded capabilities. The first conjecture is that it was secretly designed in this fashion, allowing users to discover new ways to work as their explorations progressed. The second view is more pragmatic, placing the Terrain Editor potentials on the fact that Bryce lacks so many of the standard modeling tools that experienced users literally forced the Terrain Editor to do things it was never designed to do. It doesn't matter which stance is correct in the end, however. What really matters is that there are ways to create all kinds of modeled elements if you know your way around.

The single most important aspect of preparing to use the Terrain Editor to create non-Terrain object content is the placement of a Symmetrical Lattice object. To demonstrate this, open Bryce and go to the Create toolbar. Click on a Terrain to place it in the scene, and then click the Symmetrical Lattice icon. Move them so that they are side by side in the Camera view, and compare them. See Figure 4.1.

As you can see, both of these components are written to the scene with default mountains as their core content, but there are other obvious differences. The Terrain has a single default mountain placed on a plane. The Symmetrical Lattice has a default mountain that is perfectly mirrored on its vertical axis, and there is no plane attached. Because there is no plane attached, the Symmetrical Lattice can be used as a template to create free-standing object content. Because mirroring is involved, we can be sure that all Symmetrical Lattice-based object

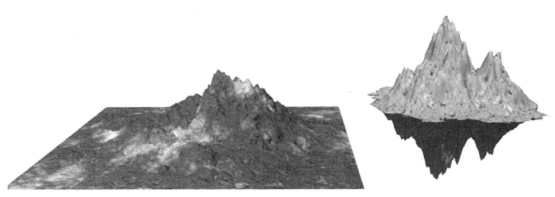

FIGURE *With a Terrain and Symmetrical Lattice side by side, compare their features.*
4.1

Chapter 4 Mastering Terrain Editor Objects

content will be perfectly symmetrical on the vertical plane. Keep both of these facts in mind as you go through the five preparatory tutorials in this chapter.

What You Need to Know

In order to do the tutorials in this chapter, you need to know the following:

- How to drop a Symmetrical Lattice into the scene
- What the names of the tools in the Terrain Editor are, and where they are located
- How to jump from one tabbed window to another in the Terrain Editor
- How to create an image in Photoshop, or a Photoshop-compatible application, in a format Bryce can import
- How to import bitmap picture content into the Terrain Editor
- How to load a Picture Texture in the Diffuse Channel of the Materials Lab

A Partitioned House

This tutorial walks you through the creation of a basic Terrain Editor object, based upon linear parts. Do the following:

1. Drop a Symmetrical Lattice into your Bryce scene, and go to the Terrain Editor.
2. Once the Terrain Editor appears, click New. This removes the default Symmetrical Lattice object from view, although it is still there as a template.

 Notice that the background in the preview window is a deep red. This tells you that there is no plane involved. Selecting New when a Terrain is involved presents you with a black background, telling you that a plane is present. There is a big difference.

3. Select a 512 Ultra-Fine Grid. Select the smallest Brush Size with maximum Hardness and Flow, and set the level at the top for a solid white.
4. Hold down the Shift key (which constrains any lines you draw to either the vertical or horizontal), and draw a floor plan for a basic enclosure in the Elevation Preview window. Leave some spaces for doorways. See Figure 4.2.
5. Click on the check mark to accept your creation. Once back in the scene, you'll notice a slight bulge in the object, indicating the invisible

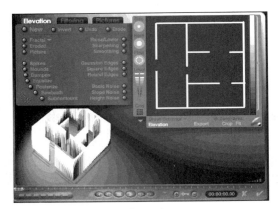

FIGURE 4.2 *Draw a basic floor plan.*

FIGURE 4.3 *The partitioned space is created.*

plane that separates the two mirrored halves. Get rid of it by using the *Convert Selection To* operation, and convert the Symmetrical Lattice to a Terrain. Now you have a perfectly straight building with no bulges, but it is too tall. Reduce the vertical height by one-half. See Figure 4.3.

Keep the Convert Selection To *in mind whenever you create an object based on a Symmetrical Lattice. Substituting the Symmetrical Lattice for a Terrain at the last step always removes the noticeable bulge.*

6. If you lived in this house, you would definitely be claustrophobic, since there are no windows. Let's create some. The first step is to go to this object's Attributes window, and click on Positive (making it a Positive object in a Boolean operation).
7. Create a cube that will act as a Boolean cutter for a window, and size as required. Duplicate to create more windows as needed, and make them Negative objects.
8. Place the window cubes where the cuts are to be made, and Group them with the rest of your house. See Figure 4.4.
9. Now the house has good ventilation, but with no roof, it is still exposed to the vagaries of the weather. Let's create a roof. Place another Symmetrical Lattice in the scene, and go to the Terrain Editor. Select New.
10. In the list at the bottom left of the control options, click once on Cross Ridges 2, and see what happens. An instant roof object is created. Click and drag on Square Edges, and drag all the way to the left. This closes the ends of the roof. Click on the check mark to accept this object.

CHAPTER 4 MASTERING TERRAIN EDITOR OBJECTS 43

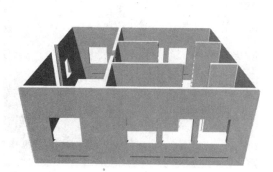

FIGURE 4.4 *Now our house has windows.*

FIGURE 4.5 *The house as created in the Terrain Editor.*

11. *Convert To Terrain,* and reduce the vertical size by half. Resize to fit the rest of the structure and move into place. Group everything, and save the house to your Objects Library as House_01. See Figure 4.5.

TABLE AND CHAIRS

TUTORIAL

Let's use the Terrain Editor to create a round table. Do the following:

1. Place a Symmetrical Lattice in a new scene and open the Terrain Editor. Click New.
2. Set Brush Size, Hardness, and Flow to Maximum. Set the Level to the first black dot at the bottom of the Level stack, but not lower. Set the Grid Size to 128. Click down four times in the Elevation View without moving your brush. The top of the table is created. See Figure 4.6.
3. Set the Brush Size to its smallest value, and move the Level indicator all the way up to solid white. Leave the other settings at their default. Paint in four legs in the Elevation View. See Figure 4.7.
4. Go to the Front View of the Bryce scene. Select the Table object, duplicate it, and move the duplicate away from the source object. Select the source object, and *Convert To Terrain.* See Figure 4.8.
5. Create a top for the table by using a new Symmetrical Lattice, and creating the same round object in the Terrain Editor. Then move the top into place, sizing it so that the top edge of the original table is not covered. This will allow you to use two separate materials on the table later. There will be a small groove that separates the two tops.

FIGURE 4.6 *The top of the table is created.*

FIGURE 4.7 *The table's legs are painted in.*

6. If you look at the duplicated object created from the original source object, you can see that it is almost a chair as it is, but lacks a back and arm rests. Use two rotated cylinders for arms, and a tilted stretched cube for a backrest. When in place, Group with the rest of the chair.
7. Duplicate the chair to get four chairs, and move them in respect to the table. See Figure 4.9.

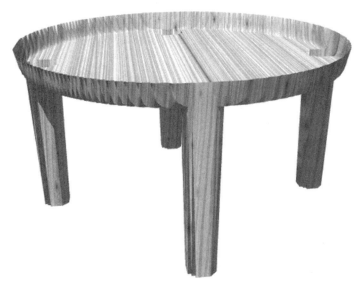

FIGURE 4.8 *At this stage, the table has an open top, making it look more like a pool table.*

CHAPTER 4 MASTERING TERRAIN EDITOR OBJECTS 45

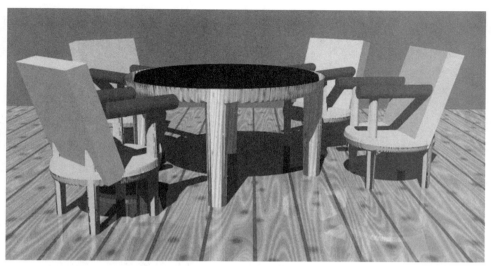

FIGURE *The finished table and chairs.*
4.9

TUTORIAL

FANCY COLUMNS

Here's how to create some columns for a palace or temple. Do the following:

1. Place a Symmetrical lattice and go to the Terrain Editor. Select New.
2. Click Invert. A solid block appears. Click New again, but this time hold the left mouse button down and drag to the right to reduce the vertical height of the solid block to about 25% (watch the 3D preview).
3. Size a White Level Brush to the maximum, and paint down to create a solid white circle.
4. Use a Brush sized to the second lowest size, and set the Level color to match the gray of the block at the base. Paint out eight edges of the circle. Do this again with the smallest brush, working in between the large cubes. Refer to Figure 4.10.
5. Convert To Terrain. Texture with the Veiny Stone Material from the Materials/Rocks and Stones Library, using an Object Map. Render, and save to disk. See Figures 4.11 and 4.12.

FIGURE 4.10 *Create this design in the Elevation View.*

FIGURE 4.11 *The finished column.*

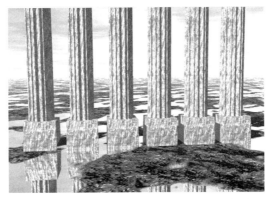

FIGURE 4.12 *An array of columns on a rain-soaked plain.*

A COMPLEX WHEEL

TUTORIAL

Here are two ways to create a complex wheel model, using the Terrain Editor. Do the following:

1. Create a Symmetrical Lattice, and go to the Terrain Editor. Click New.
2. Use a Grid Size of 64. Create a ring by first painting down a dark gray circle, and then paint a dark red circle inside of it. The dark red color is chosen by moving the Level indicator as far down as possible. See Figure 4.13.
3. Change to a Grid Size of 256; Minimize the Brush Size. Use a gray that matches the color of the ring, and holding the Shift key down, draw two

CHAPTER 4 MASTERING TERRAIN EDITOR OBJECTS

lines to form spokes. Move the Level up to about 1/2, and create a smaller circle at the center of the larger one. See Figure 4.13.

4. Using your imagination, paint down a series of circles at different sizes and gray levels. One example is shown in Figure 4.14.
5. Accept the design. Use the Rustic Vein material from the Wild and Fun Library on the wheel. This method can be used to create thousands of different machine parts. See Figure 4.15.

FIGURE 4.13 *Create this design.*

FIGURE 4.14 *Create a more complex design.*

Here's an alternate way to create wheel objects:

1. Open Photoshop. Create a new graphic that is 512 × 512 pixels in size at 72 dpi. Create any wheel design that you can imagine, using different gray levels and brush sizes. Save when complete. One example is shown in Figure 4.16.

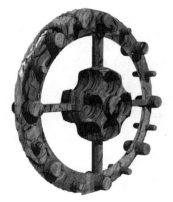

FIGURE 4.15 *The finished wheel.*

FIGURE 4.16 *Create any wheel design you like in Photoshop.*

FIGURE 4.17 *The object is created from the imported image.*

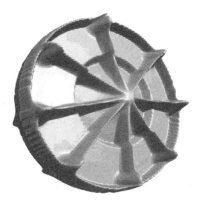

FIGURE 4.18 *Any design you create in Photoshop can be translated into an object in the Bryce Terrain Editor.*

2. In Bryce, place a Symmetrical Lattice in the scene, and go to the Terrain Editor. Click New.
3. Go to the Pictures tab. Click Load over the first thumbnail, and load the image you just created. Click Copy below the first thumbnail, then click Paste below the second thumbnail. Click Apply, and the object is created from the image. See Figure 4.17.
4. Accept the design. Scale the vertical dimension of this new wheel to about 20%. Apply any selected material (metals work very well), and render. See Figure 4.18.
5. You can also use Adobe Illustrator file, saved in the TIF format, to read into the Bryce Terrain Editor in the same way. See Figures 4.19 and 4.20.

FIGURE 4.19 *An Illustrator file imported into the Terrain Editor.*

FIGURE 4.20 *The resulting object.*

Chapter 4 Mastering Terrain Editor Objects

 ## Architectural Details

 The following process is important to understand, and will be used to create elements in some of the detailed worlds in the final sections of this book.

Since any grayscale image content can be used to create a 3D object, using the Symmetrical Lattice template in the Terrain Editor, there is no reason that the content can't be taken from a photograph. From there, other magic can happen. Do the following:

1. Select a photo from a magazine, or from your personal collection, that displays some architectural detail of a structure. For this example, I selected a personal photo of a detailed relief on Buckingham Palace, taken in 1999 with my trusty SONY Mavica. Digitize the image if it is not already in digital form, and save it.
2. Place a Symmetrical Lattice in a scene, and go to the Terrain Editor. Click New.
3. Use the highest Grid value of 1024. Go to the Pictures tab, and load the image into the first thumbnail. Copy and Paste it into the second thumbnail, and click Apply. The image is transformed into a 3D model. See Figure 4.21.
4. Go to the Materials Lab for the object, and place a button in the Diffuse Channel's first texture space. Click on the Picture option in the Channel selector, and click the Texture Source Editor button. This opens the Picture Editor.

FIGURE 4.21 *The image is transformed into a 3D model.*

FIGURE 4.22 *Load the image into the first thumbnail preview of the Picture Editor, and make the second thumbnail area solid white.*

FIGURE 4.23 *The 3D object now has more photographic detail, due to the texture.*

5. Load the image you saved to disk. Load it into the first thumbnail. Make the second thumbnail solid white. See Figure 4.22.
6. Return to the Materials Lab. Notice that a mapping type of Parametric is automatically selected. Most image-based textures should be applied parametrically. Accept the Material. Render your object from the Top View, and you will discover that it is much sharper than before, since the photographic image has now been mapped to it. See Figure 4.23.
7. Note that the bottom of the object looks rather ragged. To fix this, Group a Negative Boolean Square with it, making the object itself Positive. Now it looks better! See Figure 4.24.

FIGURE 4.24 *The squared-off block.*

CHAPTER 4 MASTERING TERRAIN EDITOR OBJECTS

8. Rotate the object –90 degrees on the X-axis. Duplicate to create more blocks. Build a wall with them on an infinite ground plane. Shine a spotlight on part of the wall, and render. This method creates extremely realistic 3D models for your Bryce worlds. See Figure 4.25.

FIGURE 4.25 *A symbol-emblazoned wall created from the initial photograph.*

TRAVELING ON

In this chapter, we walked through five tutorials to bring you up to speed in the creation of diverse objects, using the Terrain Editor. The next chapter tutorially reviews your knowledge of the development of 2D Picture Objects.

CHAPTER 5
2D Picture Objects and Procedural Materials

What is a 2D Picture Object? Simply described, it is an image mapped to a plane in Bryce. Using 2D Picture Objects, you can add hundreds of elements to a Bryce world without the memory overhead that would be necessary if all of those elements were 3D models. There is a problem, however. The liability is that 2D Picture Objects have no real depth, or Z dimension. If a 2D Picture Object is mapped to a flat plane (which is usually the case), placing the camera at an angle other than perpendicular to the plane will result in the image warping. If the output is to be an image, this can be compensated for by rotating the plane so it remains perpendicular to the camera. The real problems arise in an animated view of the scene; any movement of the camera may reveal that the 2D Picture Object is not a 3D model, but merely an image map. As long as the camera doesn't rotate to reveal the "edge" of the mapped 2D Picture Plane, an animation can be carefully constructed without any anomalies.

If you have worked through the Bryce documentation, you know that the 2D Picture Object icon is located in the Create toolbar, and that it is shaped like a Hermetic Man with multiple limbs. See Figure 5.1.

Clicking this icon will place a 2D Picture Object plane in the scene, and automatically open the Texture Source Editor so you can find the image you want to reference.

FIGURE 5.1 *The icon for the 2D Picture object.*

WHAT YOU NEED TO KNOW

IN ORDER TO DO THE TUTORIALS IN THIS CHAPTER, YOU NEED TO KNOW THE FOLLOWING:

- How to place a 2D Picture Object in a scene
- How to place content in the Texture Source Editor
- How to create Alpha Channel images or Layers in a paint application
- How to use Alpha Channel data in Bryce
- What the general mapping procedures for Bryce Materials are
- How to work with Photoshop Plug-ins
- How to create a Stone with the Stone icon
- How to use *Poser* (and that you own it)

CHAPTER 5 2D PICTURE OBJECTS AND PROCEDURAL MATERIALS 55

TUTORIAL

MASTERING THE TEXTURE SOURCE EDITOR CONTROLS

In this tutorial, you will refresh your knowledge concerning the image controls in the Texture Source Editor, as they apply to placing a texture on a 2D Picture Object. Do the following:

1. Click the 2D Picture Object icon in the Create toolbar to place a 2D Picture Object in the scene. The Texture Source Editor opens automatically, waiting for you to locate the image content. See Figure 5.2.
2. Take note of the three large image areas. The first is for the image content and color, and the second represents Alpha Channel data. Alpha Channel data determines the transparency of the final image. The image and the Alpha Channel data, when combined, create the final image. The final image is displayed in the third image area to the right of the other two. By default, the second image area is solid white. White in the Alpha area means that any content represented by white is opaque. Since the Alpha Channel area is solid white, the result is no transparency. This being the case, the content in the first image area is the same as the final image at the right. It's like saying 1 + 0 = 1.
3. Go to the controls at the top of the Alpha Channel image area, and click on the black circle. This tells Bryce to give the entire image a solid black Alpha Channel, which says that in the final image at the right, no image data will be apparent. Notice that this is exactly the case. This is like saying that 1 − 1 = 0.
4. The Alpha Channel image area can reference images as well as solid blocks of color. Click Copy below the first image area, and then click Paste below the Alpha Channel image area. A version of the Hermetic

FIGURE 5.2 *The Texture Source Editor opens, displaying the default image.*

FIGURE 5.3 *The blacks have dropped out.*

FIGURE 5.4 *The transparency/opacity is reversed in the final image.*

Man image is pasted in the Alpha Channel image area. Look at the final image area to the right. The final image shows the blacks dropped out, so that only the lighter areas remain. See Figure 5.3.

5. What has really happened is that the image in the Alpha Channel area is a grayscale image. Solid blacks in the image are now transparent, and solid whites are opaque. Every other shade of gray has some degree of transparency. Click on the half black/half white circle above the Alpha Channel, and the whole scheme is reversed in the final image. See Figure 5.4.

NOTE

There are two reasons why the reversal control is included in the Alpha Channel area. One is that it's a neat way to create transparency effects for your scene. The other is that different graphics and animation software define 100% transparency as either black or white, so this allows you to adjust your imported image data accordingly.

6. Note that you also have black and white circle controls over the first image area. Using these controls results in the final image being based entirely on the content in the Alpha Channel area, and in a grayscale image. Use this method to create very fast Alpha Channel information. As you know from your work in previous chapters, the Terrain Editor translates grayscale data to 3D object height data, so the Texture Source Editor can be used in a roundabout way to create 3D object data. Explore this possibility now.

CHAPTER 5 2D PICTURE OBJECTS AND PROCEDURAL MATERIALS 57

7. Click on any one of the small squares at the bottom of the Texture Source Editor. A File window opens up, allowing you to locate the image content that will be placed in the first image area. You can have a lot of image content ready to use for Material channels by filling these slots, and then applying the images as you like in the Materials Editor.

CREATING 2D PICTURE CONTENT

TUTORIAL

Creating your own image content for use on a 2D Picture Object is required when you are developing original scenes. Do the following:

1. Open Corel Painter, Photoshop, or any other 2D painting application. I prefer Painter for this exercise because of its unique Image Hose tool. If you are using Painter, create an Image Hose composition of flowers on a white or black background. If you are using Photoshop or another application, create a freehand painting of your choice on a black or white background. In either case, do not use the background color in the painting. See Figure 5.5.
2. Next, you want to select the background color wherever it appears, and then select Inverse (which selects the image and not the background). Paint the image solid black. If the background is black, paint the image solid white. You'll wind up with a silhouette of the image content. See Figure 5.6.

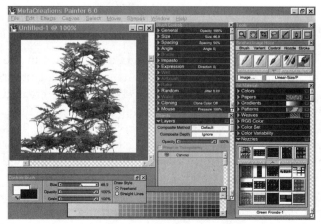

FIGURE **5.5** *Here, the Image Hose in Painter is used to create a picture of Green Fronds on a white background.*

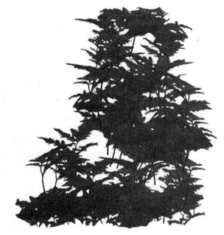

FIGURE **5.6** *A silhouette of the image content.*

3. The silhouette is your Alpha Channel content, so save the image with an "A" at the end. For instance, if your original image was saved as "Leaves," name this image "LeavesA." That will tell you what the content is when you look for it later.
4. In Bryce, place a 2D Picture Object in the scene. When the Texture Resource Editor opens, click on a new slot. Place the color image in the first preview area, and load the Alpha image into the Alpha Channel area. Click the reverse control if you need to, and the content without the background will appear in the final image area. See Figure 5.7.

FIGURE 5.7 *The final image will be the data without the background.*

5. Accept the texture. Duplicate the 2D Picture Object a few times in the scene, and move the duplicates at random distances from each other front to back. Keep the camera level with the objects. You have created a large amount of image data for the scene without taking up anything near the amount of memory that a similar 3D object would require. This is the best way to create details in the distance, like forests or crowds or flocks, saving the placement of your 3D objects for the foreground. See Figure 5.8.

Image/Alpha content mapped to a plane will cast shadows and reflections just as a 3D object does, although camera placement must be taken into consideration.

CHAPTER 5 2D PICTURE OBJECTS AND PROCEDURAL MATERIALS

FIGURE 5.8 *Although only you will know that the content is just an image mapped to a plane, the viewer will see this as a collection of 3D objects.*

ALPHA TO 3D OBJECTS

TUTORIAL

 The rest of the tutorials in this chapter will use the Fronds.tif, FrondsA.tif, Moss1.tif, and Moss1A.tif images in the Projects/Chapter_05 folder on the companion CD.

Is the 2D Picture Object the only Bryce object to which you can map an image and Alpha? No. The 2D Picture Object is nothing more than a convenience. Bryce figures that you are going to map Alpha/image data to planes because you want to use the resulting object as non-warped background content. However, what if you know that the content will warp, and in fact are planning on it? Then, of course, your creative options suddenly become almost infinite. Let's explore this a bit. Do the following:

 The advantage of mapping objects as opposed to planes is that they exist in 3D. That means that no matter where the camera is placed, the object will still be appreciated, although you may have to adjust the initial texture placement to make sure everything looks okay from selected vantage points. Please note that strictly

speaking, whether the targeted object is a 2D Picture Plane or another 3D object, the result is a Picture-based object.

1. Place a sphere in the scene. Open the Sphere's Materials Lab.
2. Go to the Texture Resource Editor in the Sphere's Materials Lab.
3. Place buttons in the Texture A column for Diffuse, Diffusion, and Transparency, as shown in Figure 5.9.
4. Go to the Texture Resource Editor. Load the Fronds.tif image in the first image area, and the FrondsA.tif image in the Alpha Channel area. Make sure the finished image displays the Fronds without a background. See Figure 5.10. This is what your Texture should look like in the Texture Resource Editor.
5. Set Spherical Mapping in the Materials Lab, and accept the texture. Render the sphere. See Figure 5.10.
6. Rotate the sphere on its vertical axis, and render again. You will notice that the texture wraps all the way around. Try the following in the sphere's Materials Lab to alter the look of the sphere's texture:

 - Alter the texture's Scale, Rotation, and Offset values with the Edit Texture controls.
 - Alter the Mapping Type to Cylindrical, Object, Parametric, Random, or any of the other Mapping Types, and preview the results. Select the one that looks best for your needs.

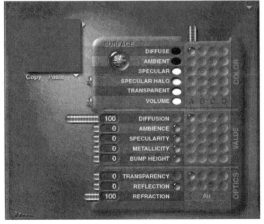

FIGURE 5.9 *Place the buttons as shown here.*

FIGURE 5.10 *The sphere, mapped with the Fronds image and Alpha data.*

CHAPTER 5 2D PICTURE OBJECTS AND PROCEDURAL MATERIALS 61

You will notice that the texture appears a bit blurry. This is because the original image was created at 300 × 300 pixels. To get a sharper texture, create images at larger resolutions. 1024 × 1024 and 2048 × 2048 pixels will create sharper images for the textures, and sharper-edged Alphas as well.

CREATING MOSS AND MOLD

Here is a very interesting way to enhance your Bryce objects. By using this Alpha technique, you can create all types of moss and mold textures on any selected object. Do the following:

1. Click the Stone icon in the Create toolbar to place a stone in the scene.
2. Use a Pitted Concrete Material (from the Rocks & Stones Materials Library) with Object Mapping to texture the stone. See Figure 5.11.
3. Use your favorite bitmap paint application to create an image sized 1024 × 1024 pixels to create your idea of some moss. Save the image, and then create and save its Alpha as described previously. As an alternative, you will find Moss1.tif and Moss1A.tif in the Chapter 5 folder in the Projects folder on the companion CD.
4. Back in Bryce, Duplicate the stone, and enlarge the duplicate so it extends just a bit around the source stone object. Open the Texture Resource Editor for the duplicated and enlarged stone, and Load the Moss1.tif and Moss1A.tif images (or load the ones you created). See Figure 5.12.

FIGURE 5.11 *The stone is mapped with the Pitted Concrete Material.*

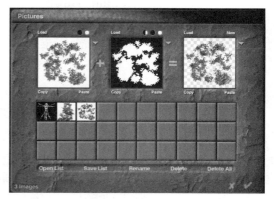
FIGURE 5.12 *The Moss and its Alpha image are loaded into the Texture Resource Editor.*

FIGURE 5.13 *The dripping moss texture is overlayed on the original stone texture.*

5. Use a Parametric mapping to smear the texture at the bottom of the stone. Place the stone on a reflective water surface, and then render and save. See Figure 5.13.

MULTI-ALPHA TERRAIN

One complaint that users have about Bryce is that there is no way to map foliage to a Terrain. This is not true, since there is a way to do it using Alpha imagery. Do the following:

1. Place a Terrain in the scene, and use a New Mexico Cliffs material on it. We are using this material because it is devoid of foliage. See Figure 5.14.
2. Duplicate the Terrain, and enlarge the duplicated version about 5%, just enough to make it extend beyond the source Terrain's boundaries.
3. Load the Trees1.tif texture and the Trees1A.tif images in the Texture Resource Editor to create the image content needed for the foliage. Map it to the duplicated Terrain. Use a Parametric mapping with XYZ Scaling set to 15. The result will be a Terrain that from a distance will seem to be covered with patches of foliage. See Figure 5.15.

CHAPTER 5 2D PICTURE OBJECTS AND PROCEDURAL MATERIALS

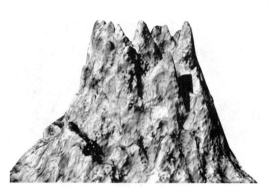

FIGURE 5.14 *The Terrain is devoid of foliage.*

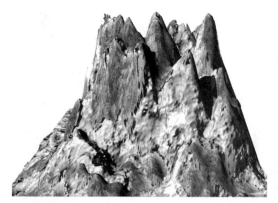

FIGURE 5.15 *The bare Terrain now supports a thriving green matte.*

SLIME, OH WONDROUS SLIME

TUTORIAL

In your study of the Bryce documentation, as well as through your personal explorations, you realize that Bryce offers you two texture modes: Surfaces and Volumes. Although, as we have shown so far, you can create some interesting texture concepts by using Alpha/image textures in standard Surface mode, there are a few effects that are far more effective when applied in Volume mode. One of these is a super slime material, which can also emulate mold and rust as well as other material effects. Do the following:

1. Place a stone in the scene, and map it with the Archeological Find Material from the Rocks & Stones Library. Use Object Space mapping.
2. Create a duplicate of the stone. Open the duplicate's Materials Editor, and switch to Volume mode. Use Random Mapping, and an XYZ Scale of 3%. Use the Trees1.tif and Trees1A.tif images in the Texture Resource Editor. Set the parameters as shown in Figure 5.16.
3. Render to preview. You can alter the values in the Materials Editor, but the ones noted are good defaults. See Figure 5.17.

NOTE

The Random mapping type creates whorls such as those produced by viscous elements in motion. These are also called Caustics *in some applications.*

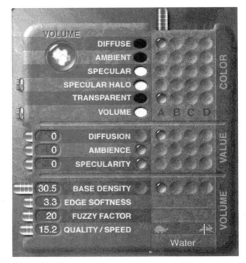

FIGURE 5.16 *Set the controls as shown here.*

FIGURE 5.17 *The result will look like a combination of alien slime and melted pistachio ice cream.*

ALPHA/IMAGE CHARACTER PLACEMENT

TUTORIAL

It's time to return to the 2D Picture Object for this exercise. Let's see how we can create character elements for a scene that are very memory friendly. Do the following (note that this exercise requires that you own and know how to use CuriousLabs' *Poser* software):

1. Open Poser. Create a side view of a figure (any figure will do). Pose it in five different stages of walking or running. Save out each image. See Figure 5.18.
2. Go to Photoshop or another image editing application, and create the Alpha images from these five graphics, using the techniques we discussed previously. Save each with an "A" added to the name. See Figure 5.19.
3. Place a 2D Picture Object in the scene, and load all five Char images and CharA images in the Texture Resource Editor. Select Char1 and Char1A for the 2D Picture Object. See Figure 5.20.
4. Duplicate the 2D Picture Object four times, and move each of the duplicates to a different position to create a group scene. See Figure 5.21.

These images are on the CD that accompanies this book, listed as Char1 to 5, and Char1A to 5A, for those of you who are Poser deprived.

CHAPTER 5 2D PICTURE OBJECTS AND PROCEDURAL MATERIALS

FIGURE 5.18 *Create five frames of a Poser character walking or running.*

FIGURE 5.19 *Create the Alpha images in an image editor.*

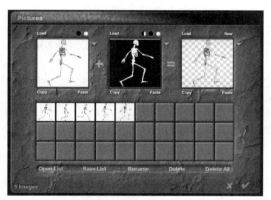

FIGURE 5.20 *Load the five images and their Alpha components to the Texture Resource Editor.*

FIGURE 5.21 *Using this method, you can generate all of the background characters needed to fill out a scene, and save on storage requirements at the same time.*

IMAGE MAPPED PANORAMAS

There is one more important use for Alpha/Image mapping that we want to mention here: the creation of Panoramic backgrounds. A Panoramic background is used to give viewers the sense that they are surrounded by scenic content. Of course, you can do this by using a circle of 3D objects, but that can get rather memory intensive, and the storage for a scene that uses so much 3D data can get huge very quickly. Here's a way to take your 2D Alpha/Image mapping skills to another important level, one that we will return to in some of the complex worlds we will create later in the book. Do the following:

FIGURE 5.22 *Place and enlarge a cylinder, and place the Camera at its center.*

FIGURE 5.23 *The mapped cylinder emphasizes the LOD effect.*

1. Create a cylinder in your scene. From the Top View, enlarge the cylinder and place the camera at its center. Refer to Figure 5.22 for the relative sizes.
2. Use any Alpha/Image texture you prefer on the cylinder. Use cylindrical mapping, and try different Scale percentages, since no two images will respond the same way. Render, and you will see that the mapping is blurred. This is because the cylinder is so big, and it is exactly what we want.

 A blurred background simulates what is known as Level Of Detail (LOD). *Neither the eye nor the camera sees distance objects with the same detail as foreground objects.*

3. Place another image closer to the camera, and map it with a detailed material. This emphasizes the effect. No matter which way you rotate the camera, a view of the cylinder mapping will be there. See Figure 5.23.

USING THE WRONG MATERIALS FOR THE RIGHT REASONS

An artist needs to know all of the definitions and rules when working within any medium. As a computer artist and animator, you need to know how to use your computer—how to turn it on, and how to load and use selected software. As a Bryce user, you need to read the documentation thoroughly, so you are aware of what to do when the creative idea hits you. However, there is another reason for learning the rules when it comes to working within the constraints presented

by your chosen medium: you need to know the rules so you can purposely break them when the time comes.

This is especially true when it comes to customizing and applying procedural materials, the materials found within the Materials Editor, and in associated libraries. If you use only the materials you are "supposed to," those most logical for the task, then how will your work differ from everyone else's? It won't, and your work will have no discernible signature of originality. This is actually the central criticism leveled at computer art, because it is seen as the programmer's signature, not the artist's. Bryce is no exception, especially since it's so easy to accomplish basic tasks that look great. Click on a sky parameter, and the sky is painted in. Place primitive objects in the scene, and they magically appear. Without a little bending and stretching of the rules, it won't matter who is responsible for the resulting artwork—you, another person, or the computer itself.

Every time you spend part of your creative juices on customizing the components of a scene, you start to develop work that bears the mark of your own mind and hand. That is why Bryce is such a massive creative tool. You are given every opportunity to stray from the expected path, and to mark the resulting work with your personal visual signature. The objects that you create, the way you compose them in space and time, and the global parameters of your scenes—all of these play a part in your personal artistic watermark. One area that especially stands out in Bryce as having the potential for customization and surrealistic exploration is that of tweaking and twisting the parameters of Procedural Materials.

CREATING CUSTOMIZED MATERIALS

At the start of your Bryce experience, you will probably be in a hurry to see your rendered worlds. Some of the more subtle aspects and options may be passed over in a rush to render. As you become more familiar with how fast you can do the basics, the subtitles may start to attract you, and you will spend more time tweaking the finer features. In your visits to the Materials Lab, and by working through the documentation, you have no doubt already explored the ways in which materials can be composed through the use of multiple channels, and even customized further by using a channel's Deep Texture Editing and Picture Editor processes. Perhaps you have already attempted some materials creation on your own, and you may even have a personal library that contains hundreds of your own material creations. Let's reinforce and deepen your general knowledge concerning materials before we push the topic to a more creative edge.

SURFACE MATERIALS CREATION TIPS

When creating Surface materials of your own, here are some points to note:

- Think of *"Ambient"* as *"Glow."* Ambient color will act as a glow color, especially when the object is placed against a dark backdrop and when lights

are dimmed or off. Any part of the object that is in a shadow, even a self shadow, will show the Ambient color, while the part of the object that remains in the light will show the Diffuse color. If the Ambience Value is taken from an assigned channel texture, then that texture will glow wherever the object is in the dark or shadow. If you are using a pattern from a channel texture, keep the Ambience Value related to the value, and the Ambient Color related to the color palette. This gives you a patterned texture that will be visible in both light and dark environments.

- As a general rule, keep a texture size set from 0 to 10 if you want to see the details of the texture. Larger sizes are good for effects, but look very speckled when targeted to small objects (especially without anti-aliasing on).
- Multicolor patterns (like RGB Fabric) can behave better in the light and dark by attaching both the Diffuse and Ambient colors to the channel texture, while leaving the Value set to the color palette.
- Keep the Ambience Value to 50% or less when applying a deep Bump map (50% and higher), or the Ambience will wash out the Bump map shadowing. See Figure 5.24.
- Any smooth metallic texture looks like worn metal when you assign a Bump map from an appropriate texture channel. See Figure 5.25.

 If you add the Bump map referenced in Figure 5.25 in an animation, with 0% at the start and 100% at the end, the object will look like it is being blistered by heat. A great use for this would be a ring of rocks too close to a departing rocket.

- Set the Ambient color to a darker hue (dark blue or even black) to preserve the underlying texture pattern, even when the Ambience Value is set at 100%.

FIGURE 5.24 *On the left, the Ambience is set to 30%, while on the right it is set to 100%. In both cases, the Bump map is set to 100%. Keep the Ambience setting low to emphasize the Bump map.*

FIGURE 5.25 *On the left is the default gold metallic material, while on the right it has been modified by adding a texture channel Bump Height map (the texture used was* Black *and* White *from the Basic folder in the Materials Lab).*

Chapter 5 2D Picture Objects and Procedural Materials

- With Transparency set to 100% and all other sliders set to 0%, the color of the transparent object will be a blend of its Transparent Color and the Volume Color. Moving the Diffusion value slider up at this point adds the Diffuse Color to the blended mix. Setting the Transparent Color to black effectively makes an object opaque, no matter what the other colors are set to.
- There may be a time when you want to turn on an object in the dark as if it were a light. This can be done with or without textures in the Ambient Color channel, since the Ambient Color will represent the light as a color or a texture. All you have to do is to set the Ambience Value to 100%, and use the Transparency Optics slider as the "light switch." The higher the transparency setting, the dimmer the object light; therefore, at a transparency of 100%, the light will be invisible. Material Options should be set to blend Transparency.

Volumetric Materials Creation Tips

Be very careful about applying volumetric materials to large objects, as this will send rendering time through the roof. As a caution, make objects mapped with volumetric materials no more than 15% of your total screen size. Here are some points to take note of when creating Volumetric materials:

- Multilayered volumetric materials can be used as layers with holes in them by controlling the material's Base Density. These are best used unanimated since the rendering times are very high. Make sure that shadowing is on to increase the depth perception of the layers.
- Do not push the Quality/Speed slider all the way to the left, or you will be in danger of hanging up your system, because the preview render will take too much time.
- Setting the Fuzzy factor to 0 produces the most brilliant texture colors.
- By simply switching from Surface to Volume in the Materials Lab, all of your procedural surface materials can become volumetric.
- Use Flat Shaded Volumetrics for layered objects with holes in them, and Full Shaded Volumetrics if you are going to move the camera through them. See Figure 5.26.

FIGURE 5.26 *The same volumetric material appears flat shaded on the left, and full shaded on the right. Full Shading creates 3D material pieces, but rendering times are much longer.*

BITMAP MATERIALS CREATION TIPS

The first step in creating interesting materials that use bitmap pictures is to create or customize interesting bitmap pictures in your paint application. In general, they should be defaulted to 72 dpi for use in Bryce, with a size of 640 × 480 or 420 × 240. Use the larger size when the camera is going to zoom in on the material, and use the smaller size when the material will remain a backdrop element. You can use any dpi ratio, but 72 dpi will suffice in most cases. Here are some points to take note of when creating bitmap-based materials on your own:

- Bitmap images will tile when you use any mapping but the Random option if they are resized to address the object more than once. The higher or lower you alter their size in the Materials Lab, the smaller the tiles will be.
- Using Random Mapping with a bitmap creates color patterns from the bitmap that can substitute for similar procedural texture looks. This works best if the image is constrained to no more than one hue, since more color results in a random dot pattern (unless you are looking for a random dot pattern, of course).

ALPHA STAND-ALONES

An Alpha image is a mask, and it does not have to have an accompanying cloned color image to be a valuable tool in the creation of a material. It can also serve to mask out an underlying procedural texture, or a totally different bitmap image. In this way, you can create bitmapped areas on an object (like labels and other effects), mapped over another bitmap or a procedural textured material. See Figures 5.27 and 5.28.

PLACING THE BITMAP IN A CHANNEL

Normally, the Bitmapped picture activates the Diffuse Color channel, so that all of the color data in the image comes through. You can exercise other options,

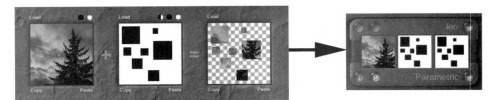

FIGURE 5.27 *The color image was loaded on the left, and the rectangular Alpha image in the center. The result is an image that displays parts of the color image inserted in rectangular areas, as shown in Figure 5.28.*

CHAPTER 5 2D PICTURE OBJECTS AND PROCEDURAL MATERIALS 71

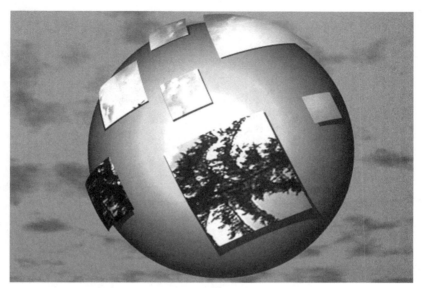

FIGURE 5.28 *The Alpha masked image shown in Figure 5.27 inserted in a Bryce 3D scene, wrapped on a sphere with a color sphere inside.*

however, Figure 5.29 shows the bitmapped attached to different channels on the Material Editor.

FIGURE 5.29 *The same bitmapped image as addressed to the following channel attributes: Diffuse (Transparency = 100%), Ambient, Transparent, Bump, Reflection, and Diffuse Random.*

FIGURE 5.30 *A plane tiled with bitmapped logos casts shadows on another plane below, mapped with a procedural texture material.*

BITMAPPED LOGOS

Tiling bitmapped logos are a rage on the Web, used most often for a page backdrop. Using the bitmap techniques already described, you can create infinite logo backdrops in Bryce. See Figure 5.30.

BITMAP/PROCEDURAL COMBINATION MATERIALS TIPS

The bitmap/procedural material effect uses a bitmapped picture in one or more Color, Value, or Optics channels (Surface) in the Materials Lab. Here are some points to take note of when creating bitmap/procedural materials on your own.

- The most common way to fold in the bitmap is in the Diffuse Color channel, since this allows you to get all of the color from the image. Another suggested alternative is to apply the bitmap as a bump map, especially if it is composed of an image that can be recognized in silhouette. This creates an embossed effect, and is especially attractive when tiled.
- The cloned object method allows you to paste the bitmap to a clone of the original object that is a few percentage points larger than the original object. This makes the bump-mapped image look like a solid cutout above the object. See Figure 5.31.
- The multiple channel method allows you to mix procedural and bitmapped textures in one material, so the effect is a blend rather than a segmented layering. Use the following parameters to create the material displayed in Figure 5.32: Channel A and B are activated for Diffuse Color and Diffusion Value. Channel B is also activated for Ambient Color and Ambience Value. Channel A holds the bitmap image (the default LEO pic-

Chapter 5 2D Picture Objects and Procedural Materials 73

FIGURE 5.31 *This bitmapped object is mapped to a clone of the original object, sized a few percentage points larger. Notice its 3D appearance, especially at the edges.*

FIGURE 5.32 *An example of multiple channel mapping.*

ture), which uses Object Front mapping. Channel B holds the galaxy texture from the Basics Library. Diffusion and Ambience sliders are set at 100%. See Figure 5.32.

Exotic Laminates

True laminated materials present a different problem. A laminate is a combination of two materials, both of which must be present on the object. You cannot create two different materials in Bryce using just the Materials Lab, so another way has to be found to accomplish this effect. The elegant solution incorporates the use of the Advanced Motion Lab. Here's how:

1. Select one material, or create one, for frame 1 of an animation (animation length is your choice), and map it to an object. Select or create a second material for the last frame.
2. Open the Advanced Motion Lab with the object selected. Find the object in the list, and click on Material. For all of the parameters listed under Material, draw a straight horizontal line midway in the Motion Curve area. This effectively blends the two materials into one for the entire animation.

Use this technique to create the following exotic laminates: Double Wood, Wood-Stone, Double Stone, Cloud-Stone, Water-Cloud, Water-Stone, Rock-Psychedelic, Mirror-Wood, Cloud-Metal, and more. See Figure 5.33.

FIGURE 5.33 *From upper left to bottom right, these exotic laminates blend Rock and Wood, Red Fractal and Vortex, Carnival Tent and Clown Collar, and Gilded Cage and Disco Kelp.*

MULTIPLES OF ONE

I have called this "Multiples of One" because you need only one material mapped to a selected object to achieve this effect. It allows you to maximize the variability of one assigned material, by using it up to four times in different ways in each of the four (ABCD) channels in the Materials Lab. Do the following:

1. Place a sphere in your scene, and select it. Open the Materials Lab.
2. Activate the A, B, and C channels for Diffuse and Ambient Color, and Diffusion and Ambience value (click on channel C for these attributes with Shift/Control held down). Activate the D channel for Bump height.
3. Use only one texture of your choice in all four channels. Vary the size, rotation, and mapping type in each channel. You now have a four-layered material that is based on different elements of the same texture. See Figure 5.34.

FIGURE 5.34 *Startling material maps can result when you use the same material configured in different ways in each of the four ABCD channels in the Materials Lab, like this quadruple mapping of the Abalone texture from the Psychedelic folder on the CD. Each channel can also be independently animated, producing complex layered movements as shown on the CD-ROM in "MTHORP.MOV" in the movie's folder.*

EMPLOYING THE CREATIVE MISTAKE

Why would you want to use the "wrong" materials on an object in the first place? There are two reasons. The first is that the "wrong" material might have a more "right" look than the "right" material. Let's look at a simple case in point. Bryce features both a Terrain/Plane Materials Library and a Rocks/Stones Materials Library. Placing material on a mountain, however, especially in the foreground, may work better if you use a Rocks/Stones material than one meant specifically for terrain. The Rocks/Stones material may display a more "realistic" and discernible texture at some distances than the "right" material from the Terrain Materials Library options.

The second reason to explore assigning the "wrong" material is more personal. It may be that a certain material expresses your compositional and aesthetic needs more than a standard material. You may want to assign a cloud material to a solid in order to make the composition appear more ethereal or alien, or the opposite, assigning a metallic or rock material to a cloud plane. Both are valid reasons for using the "wrong" materials.

USING THE WRONG MATERIALS FOR MORE REALITY

"Reality" is a nebulous affair at best. Reality can be a monster that lurks in your bedroom, until the light reveals a bundle of clothes draped over a chair. Reality

is broken all of the time by what we perceive at the moment. If you have been taught that red is evil, then the most striking red sunset will have overtones of evil intent for you. Some aspects of perception are ingrained in us because of what we have been taught, so reality can depend upon mental and emotional attitudes as well. "Reality" also depends on experience. You might discover that the swastika has a deep history as a symbol of transformation in Indian culture, but if your parents escaped the terror of the Nazis, the "real" nature of the swastika will be forever colored by the stories you were told, and the horrors that the swastika of experience evokes. Reality is not neutral ground, but is colored by suspicion, education, cultural bias, personal experience, and more.

How might all of this affect your work in Bryce when you are deciding what material to apply to an object? The answer might depend upon whom you are doing your work for. If you are creating art or animation for a client, then you have to listen carefully to *their* critiques. If they say that your "brick doesn't look like real brick," you have to find out what their definition of "real" brick is, and reshape the composition accordingly. If the Bryce work you are involved in is to bring your own vision to pass, and the brick material you just rendered doesn't look or feel "real" enough for you, then your own exploration will continue until it does.

Knowing this means that some of the following suggested alterations for achieving greater reality, or optional reality, may not work for all of your perceptive needs. If these suggestions leave you feeling unsatisfied, then simply use this as a procedure for exploration, and seek further for examples that satisfy you.

Simulating Materials Realism

Materials Realism is a term invented by a sculptor friend of mine (Dave Huber) to indicate that the materials used in a sculpted piece are to be used as is, and not painted or hidden. I am using it in a slightly different context to indicate that what a material's name is does not always determine its uses in a Bryce 3D composition. There is an alchemist's way of perception that also is used as the basis for this exploration—"like begets like." Keeping in mind all of the perceptual inconsistencies already discussed, there is one cardinal rule when you want to use the "wrong" materials to simulate an enhanced realism in your Bryce work.

The Cardinal Rule: Eyes before Mind

When you need to assign a material to an object in your Bryce world, do not read the names of the materials. Instead, look at their thumbnails and see which ones "look like" the real-world material you have in mind, and select them accordingly.

A General Cloud Formula

If you load a Cloud material from the Materials Library, you will see that only its Bump Height and Transparency are allocated to a texture channel. The rest of

Chapter 5 2D Picture Objects and Procedural Materials

the texture draws its look from color palette assignments, with both Diffusion and Ambience sliders set around 30%. This emphasizes the wispy nature of a cloud or smoke. The type is always set to fuzzy. If you follow these standard settings, you can apply more than the standard Cloud textures to the Bump and Transparency channels.

You can, for instance, apply a Rock texture, as long as you make sure it has Alpha and Bump attributes. Color doesn't matter, because clouds normally draw their color references from diffuse and ambient palette settings. If your alternate texture doesn't have Bump and Alpha attributes, just add them in the material's Deep Texture Editor. See Figure 5.35.

FIGURE 5.35 At the left is the Cloud texture LowSmog5; in the middle is the Rock texture StuccoBump. On the right is a texture from the Bump folder, Polychrome Bump. All make interesting clouds.

 Stand-alone "realistic" clouds in the Bryce 3D sky are normally addressed to spheres, distorted spheres, or grouped spheres. Stand-alone clouds also work great in an animation when you set them in motion so they cast shadows across a landscape.

"Realistic" Planets

Just about any material wrapped to a sphere can emulate a planet, except perhaps a logo. There are some materials, however, that work better than others for this purpose, and many are not in the standard planetary categories (rocks and other terrains). What features does a material need to possess to be believable as a planetary texture, according to what we have been trained to expect of "reality?"

- It should fall into one of the three basic planetary classes: cratered, gas, or potentially "habitable" (by humanlike creatures). Habitable planets look more believable if they have cloud-like atmospheres and show some water areas.

ADVANCED BRYCE CREATIONS

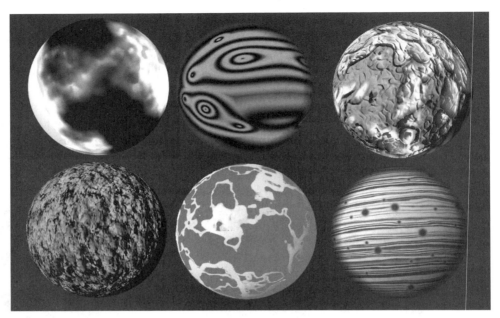

FIGURE 5.36 *Here is a selection of planetary objects (left top to right bottom), created with the following "wrong" materials: Red Fractal, Mushrooms, Barnacles (Sand), Cliffy Sand, Foamy Water, and Bleached Wood (recolorized in the Deep Texture Editor).*

- The features should not be too small, or the lack of detailed areas will detract from their believability.
- "Strange" anomalous features should be confined to smaller areas of the display (like the red spot on the planet Jupiter). If stranger features dominate, they can detract from the believability factor.

For Gas Planets, make the sphere a Fuzzy type. See Figure 5.36.

- If you want a planet to show the lights of civilization when it rotates into darkness, use an Ambient texture with small gridded artifacts to map its dark side. The Ambience elements will not show when the planet is in the light.
- To create snowy poles on planets, embed spheres at the Northern and Southern Hemispheres, and use a snowy material map.

USING THE WRONG MATERIALS FOR A PERSONALIZED REALITY

Whose reality is it anyway? If you purchased Bryce in order to simulate only what your camera sees on a summer afternoon on Earth, you are missing a major part of the creative fun and mesmerizing surrealistic explorations. Bryce is capable of more horizons than the one we see when we look out on our every-

day world. Bryce is a creative tool for the surrealistic artist and animator. The goal of surrealism is to use seemingly identifiable elements to construct dreamlike visions, and Bryce (with a modicum of creative effort on your part) fits this role perfectly. Yes, you can use Bryce to generate lovely artwork that takes you for a ride on the Colorado River, with the Grand Canyon rising up majestically on each side. However, pushed just a bit further, you can also be riding on a lake of liquid mercury, past empty shards of lost civilizations. It is when you select a more personalized experience that your creation, customization, selection, and use of stranger, more variable materials can come into play.

SIMULATING MATERIALS SURREALISM

There are few rules that will guide you in the application of surrealistic materials; only the persistence of your own visions and dreams. Some Bryce users will move toward a radical materials approach, while others will prefer to subtly alter the materials in their scenes. In my experience, I find myself pushing materials toward more radical variations, and then adjusting them until I feel satisfied that the scene looks and feels right. Exactly what "right" is eludes any verbal description, because each Bryce world is so potentially unique. See Figure 5.37.

FIGURE 5.37 *These scenes are based on the same composition, with only the materials differentiating the three. The materials give each variation a totally different look and feel.*

The three variations shown in Figure 5.37 are mapped as follows (from the top):

- Terrain = Office Building; Ground = Leopard; Figure = Mirror (Reflection turned down).
- Terrain = Green Bump Glass; Ground = GridRock; Figure = Water Puddles.
- Terrain = Dreams of Xanades Lake; Ground = Tyrell Building; Figure = Dali Bee Stripes.

TRAVELING ON

In this chapter, we explored 2D Picture Object mapping, as well as the use of Alpha/Image textures on 3D objects. In the next chapter, we move on to Infinite Planes, the crowning jewel of simulating photorealistic reality in Bryce.

CHAPTER 6
Infinite Planes and Lights

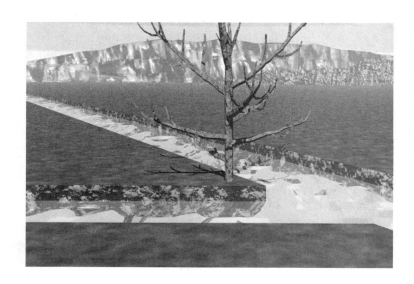

Advanced Bryce Creations

This chapter concerns things about Bryce Infinite Planes and the placement and configuration of Skies and Lights that you may not be aware of, or if you are, you still may not fully appreciate their importance in shaping unique Bryce worlds. This is also the last chapter in the preparatory section, which as a whole has concerned itself with tools and techniques that you should be familiar with in order to bring your own fantastic worlds to like (and that you must have under control in order to understand and complete the complex tutorials in Part Three of the book).

What You Need to Know

In order to do the tutorials in this chapter, you need to know the following:

- How to locate the icons that trigger the placement of Infinite Ground, Water, and Cloud Planes in the Create toolbar
- How to rotate Infinite Planes on any selected axis
- How to choose between Surface and Volume Infinite Planes
- How to use Multi-Replicate
- How to place a Stone in the scene with the Stone icon
- How to use the Sky&Fog toolbar
- How to use the Sky Lab

The Tunnel of Eternity

In this tutorial, we will focus on the placement of multiple Infinite Ground Planes, and how they can be used to create a never-ending tunnel. No matter how far into the tunnel you place the camera, you will never get any closer to the end of the tunnel, which remains an infinity in the distance. Do the following:

A similar effect was used to great advantage in the 1960s Surrealist European film Last Night at Marianbad.

1. Place a Infinite Ground Plane (IGP) in the scene, and World Space map it with a Pitted Concrete material. Use a Bump Height of –888, and a Scale Size of 8.5% on the XYZ axis.
2. Duplicate the IGP twice, and rotate and move the duplicates to form a triangular opening at the end, as seen in the Camera View. Try to center

Chapter 6 Infinite Planes and Lights

the view on the opening, and rotate the camera so that it can see the "floor" of this tunnel as it recedes into the distance.

3. Add a sky (your choice). Add a light-blue haze of 10. This will add a ghosted effect to the triangular opening, blurring the distant edges, and adding to the eeriness of the scene.
4. Center a sphere at the bottom of the tunnel. Map it with a reflective material.
5. Multi-Replicate the sphere so that 75 duplicates recede into the background. For this exercise, I used the following values in the Multi-Replicate dialog: Quantity = 35, and Z Offset = 75. To really "reach" the end of the infinite distanced opening, I would have had to create an infinite string of spheres. This might be a bit much for anything but a system with an infinite amount of RAM (!).
6. Render to preview, and adjust as necessary. See Figure 6.1.

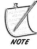 *A standard illustration technique used to emphasize or "force" the appreciation of perspective in a 3D scene is to replicate the same object as many times as needed, and to make the replicates recede into the background or toward the horizon. This was why the sphere was added to this scene.*

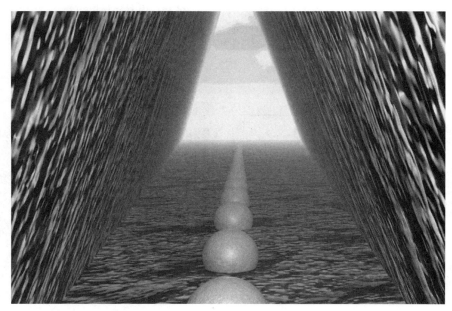

Figure 6.1 *The finished tunnel. No matter how far in you place the camera, you will never get any closer to the opening at the end.*

ADVANCED BRYCE CREATIONS

TUTORIAL

DAWN BEACH

There are times when you will not want the Infinite Planes to define the horizon line. This exercise is a case in point. Do the following:

1. Create the Terrain Editor form displayed in Figure 6.2 from a Symmetrical Lattice.
2. Reduce the vertical scale of this object when it appears in your scene until it is very thin.
3. Work in the Top View. Duplicate two more, and layer and overlap them, rotating the duplicates so they appear to have some randomness as seen by the camera.
4. Place a Water Material on them with Object Space mapping. Set Reflectivity to around 40%. Place a button in the Channel A Transparency spot, so the Material takes its transparency cue from the procedural Material.
5. Create an elongated cube, and squash it. This will be the "water" horizon in the distance.
6. Now for the beach. We could use another primitive object, like a cube, but I want to demonstrate how an Infinite Ground Plane can be used here. Place an IGP in the scene, and set its height just below the "water" level. If you render a test view from the camera, a strange effect occurs. Beyond the water-mapped cube, the ground plane continues to another horizon line. We do not want this. Go to the Right View and tilt the IGP down about 2 degrees. That way, it will not be seen in the Camera View beyond the water-mapped cube, since it will be covered by the water objects. See Figure 6.3.

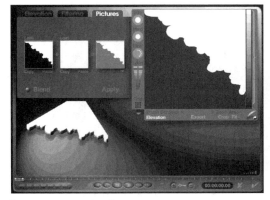

FIGURE *Create this form.*
6.2

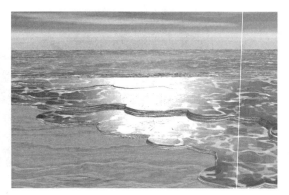

FIGURE *The initial beach scene.*
6.3

CHAPTER 6 INFINITE PLANES AND LIGHTS

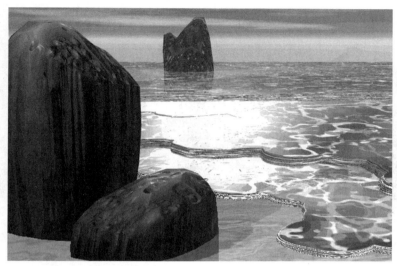

FIGURE 6.4 *The finished Dawn Beach scene.*

7. It looks OK for a start, but a little bland. Click the Stone icon in the Create toolbar to place a rock in the foreground, and another different one farther into the water. Texture, and render. See Figure 6.4.

CANALS

Here's a way to create straight cuts in an IGP that are themselves infinite:

1. Place a Volume IGP in the scene, and make it a Positive Boolean.
2. Duplicate it twice, and rotate the duplicates 90 degrees on the X-axis. Make them Negative Booleans.
3. From the Top View, adjust the sizes of the Negative Boolean planes so that they equal the width of the canals to be cut. Move and/or Rotate them into position.
4. Group all three volumetric IGPs. See Figure 6.5.
5. Place a Surface Infinite Water Plane at the level you want the water to be in the canal, and use a suitable material to texture it. Render. See Figure 6.6.

This has the look of an artificial and manicured cut, so do not use it for rivers. This technique can also be used to create sunken roadways.

FIGURE 6.5 *The canals are cut.*

FIGURE 6.6 *The canals are ready to irrigate the land, or to act as causeways for boats. The tree is from the Bryce Objects/Rocks&Trees Library.*

 ## FIRE LAKE

TUTORIAL

We will use a similar effect to this one in the world tutorials in Part Three. Do the following:

1. Infinite Planes of any type look fake if left flat. Create an IGP. Place low-scaled Symmetrical Lattice terrains on the IGP, duplicated and rotated for variety. Place them near the camera. Map the Symmetrical Lattices and IGP with the same material texture so they match.
2. In the Sky Lab, configure a sky that shows a large moon object shining on the scene, and explore the cloud settings until you develop a picture that has a yellowish cast. Render for preview. See Figure 6.7.
3. Select all of the Symmetrical Lattices and the IGP, and make them Positive Booleans.
4. Create another Symmetrical Lattice, and open the Terrain Editor.
5. Click New. Create a solid-white block.
6. Select Round Hills from the Fractals list, and apply the Fractals modifier. Select Round Edges and apply it. Your Terrain Editor should resemble Figure 6.8.
7. Accept the object. Place it so that it intersects the foreground Symmetrical Lattice in the group, and make it a Negative Boolean. Group everything. Edit the position and size so that a crater is formed in the foreground. Place an appropriate rocky Material on it. See Figure 6.9.
8. Place a cylinder in the crater to emulate the contents. Map the cylinder with the Santraginus V selection from the Water & Liquids Library. Enter

Chapter 6 Infinite Planes and Lights

FIGURE 6.7 *The initial scene takes shape.*

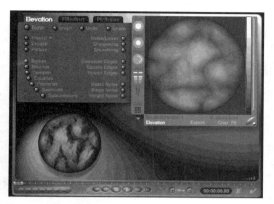

FIGURE 6.8 *Your Terrain Editor should resemble this.*

the Deep Texture Editor, and change the colors of the material to reds and yellows.

9. Place a large sphere in the crater, with a diameter that covers the crater's diameter. Enlarge its vertical scale by 200%. Go to the Materials Lab, and select the Volume Library. Apply the Fire Material. Use the parameters displayed in Figure 6.10.

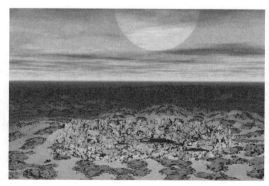

FIGURE 6.9 *Create a crater.*

FIGURE 6.10 *Use these parameters for the Volume/Fire Material.*

10. When the render is complete, you will see flames rising from a lava-like lake. See Figure 6.11.

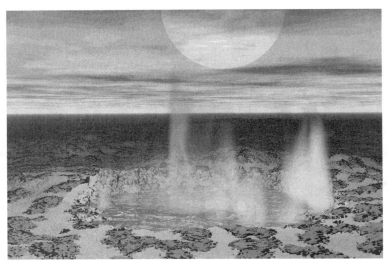

FIGURE 6.11 *The finished image.*

 Be aware that all large volumetric mapped objects take an inordinate amount of render time, so use them sparsely. We used volumetric fire instead of surface fire here because it looks better.

THE WATER SANDWICH

There is one important alternative to consider when you are need to create water (or any other alternative liquid component) in a scene: your ability to layer different strata of mapped planes together. You rarely call upon this option for Infinite Ground Planes, given that most ground attributes require one surface to act upon. You may use this technique with Infinite Sky Planes (ISP), though it is not usually required. When it comes to water, it is a different matter. That's because water, even moreso than air, has a personality based on degrees of transparency. In a shallow stream, water is transparent enough to allow you to see through to the underlying bed of pebbles and stones. In deeper water, you may see down to the tops of a bed of seaweed or coral, or even further to some dark hint of an ancient ruin.

 When you apply an Infinite Water Plane (IWP), always consider using two or three layers to achieve more realism.

CHAPTER 6 INFINITE PLANES AND LIGHTS 89

TUTORIAL

WATER OVER ROCKS

You can adapt this tutorial to any situation that requires the viewer to appreciate that the water exists over a more solid surface. Do the following:

1. Create an IGP, and map it with a rocky Material (Gilliam's Barnacles from the Miscellaneous Library works well) that has a high level of Bump mapping. Angle the camera so it is looking down at the surface by about 45 degrees. You won't see the horizon. See Figure 6.12.
2. Embed five or six Stone objects in the plane to give it some variance. One should be large enough to rise above the water surface. See Figure 6.13.
3. Add an IWP over the IGP. The closer you can place it without revealing too many hidden rocks, the better. Add a water Material to it (the Caribbean Resort material from the Liquids Library works well when the transparency is increased to 100%). See Figure 6.14.

The more you rotate the camera to look straight down on the water, the more the underlying content will be revealed.

Adjusting the transparency of a water surface and the angle of the camera can produce some interesting results. See Figure 6.15.

Avoid using volumetric IWPs in your composition. They take an eternity to render, and have no real use. You can always use tints to colorize underwater scenes.

FIGURE *A rocky material applied to an IGP.*
6.12

FIGURE *Add some Stone objects.*
6.13

FIGURE 6.14 *The streambed.*

FIGURE 6.15 *The textured sphere is seen through the surface, and includes the underlying textured plane.*

SKY OPTIONS

When it comes to creating Ground for your scene, you have three options: using a very large object (like a huge resized cube or Terrain), a Surface Infinite Ground Plane, or a Volumetric Infinite Ground Plane. The Material you use determines the look of the ground primarily by the content (color or procedural/bitmap Material) in the Diffuse and Bump channels. The same three options hold for Infinite Water Planes. When it comes to ISPs (Infinite Sky Planes), however, it's a different matter. ISPs can incorporate Surface and Volumetric materials, as well as any object selected. There is another option, though, that is addressed when you select a preset sky from the Sky & Fog Library. The ISP that is addressed from these presets cannot be rotated or otherwise transformed. It is, in fact, unreachable. To prove this, open the Camera & 2D Projection window, and change the Y position value to 99,999 (the maximum). Make sure the camera is pointing straight down at an object. Make sure a sky preset is loaded, one with a high quantity of clouds and cloud quantity set to 100%. Render the Camera View. You will not see any clouds below the camera; just the IGP and an object that appears as a speck.

When you create an ISP Surface or Volume plane, it can be placed at any set level in the scene. In that case, you can place the camera above it and actually look down through breaks in the clouds. You can use a Volumetric ISP (also called a *slab*) and create an animation that allows you to fly through 3D clouds. Like water volumes, however, this is cautioned against because of slow rendering, no matter how fast your system is.

TWEAKING PROCEDURAL IMAGE CONTENT FOR THE DEFAULT SKY PLANE

The Default Sky in Bryce takes its appearance cues from the Material mapped to it. This Material is usually procedural based, but can also be bitmap-image based. It is also possible, as with any material, to mix procedural and image data in different channels, or even in the same channel. What we are concerned with here is your ability to draw upon your own procedural libraries for inclusion in the sky look. You do this by default when you select a preset sky from the Sky&Fog Library. See Figure 6.16.

What we want to do is configure our own sky image data, so we can create unique cloud patterns and save them out as presets we can draw upon at any time. Here are two ways to do it:

1. Go to the Sky&Fog window, and select the Simple White Background preset. Accept it.
2. Open the Sky Lab, and click on Cloud Cover at the top. Activate Stratus. Clouds will appear in your preview window. Note that the Clouds controls configure the Diffuse and Alpha channels of the Cumulous and Stratus cloud patterns, along with the quantity, height, and other controls. See Figure 6.17.
3. The next control you will activate is the most important step in configuring your own sky and cloud patterns. Note that there is a small Edit control at

FIGURE 6.16 *When you select a sky preset from the Sky&Fog Library, you are really selecting a procedural-based image to be mapped to the sky.*

FIGURE 6.17 *Activate both Cumulous and Stratus components.*

FIGURE 6.18 *You are transported to the Deep Texture Editor.*

the lower right of both the Stratus and Cumulous preview windows. Click Edit beneath the Strata preview window. It takes you directly to a mode in Bryce that you should already be quite familiar with: the Deep Texture Editor! See Figure 6.18.

4. In the Deep Texture Editor (refer to Figure 6.18), you will see that your sky and clouds are presently made from a one-component Alpha image. Color is taken from Component 4, the Combination image data window. Click the button that protrudes from the top right of the Combination data window. A Textures Library window appears. This is where Deep Textures are saved and loaded from. Select the Cloud Textures option. See Figure 6.19.

5. We could select any of the texture presets displayed here, and use it to configure a new cloudy sky, but let's get a bit more creatively risky than that. Open the Psychedelic Library option, and select the Electronic pattern. See Figure 6.20.

6. Back in the Deep Texture Editor, note that the pattern now resides in the Component 1 window and in the Combination window. See Figure 6.21.

7. Click the C button in the Component 1 window, because a sky needs only the Alpha Channel data ("A" should still be selected). Color is applied back in the scene.

8. Accept this pattern, which returns you to the Sky Lab. In the Stratus window, click on the Plus sign at the upper right three times to add chaos to the pattern. Accept this Stratus setting, and return to the scene.

9. Click Cumulous off in the Sky&Fog Options list. Set the Sky Color to dark blue, and the Horizon Color to purple. Set a light-blue Haze of 3, a Cloud Height of 50, and a Cloud Cover of 12. Render to preview, and edit in any way that pleases you. If you like this sky, save it to the Sky&Fog presets library. See Figure 6.22.

Chapter 6 Infinite Planes and Lights

FIGURE 6.19 *The Cloud Textures option in the Texture Library window, accessed from the Combination window in the Deep Texture Editor.*

FIGURE 6.20 *Select the Electronic pattern.*

10. Now for a variation. This time, open the Sky Lab/Clouds window, and activate Cumulous. Leave Stratus off. Click Edit to alter the Cumulous pattern. Select IceBump from the Bump Library as the pattern, and make sure that it appears as an Alpha ("A") only image in Component 1 and 2. See Figure 6.23.
11. Tweak color and other parameters to your liking back in the scene. See Figure 6.24.

FIGURE 6.21 *The Electronic pattern as seen in the Deep Texture Editor.*

FIGURE 6.22 *This sky has a strange, quilted appearance.*

94 ADVANCED BRYCE CREATIONS

FIGURE **6.23** *IceBump uses Components 1 and 2, so they should be Alpha only for a sky configuration.*

FIGURE **6.24** *The IceBump patterned sky.*

 By saving the same Texture, this time with color ("C") on in both Components 1 and 2 to the Textures Library, you can call on it to map any object in addition to the sky. Procedural sky textures appear very differently when mapped to other scene components. See Figure 6.25.

FIGURE **6.25** *Believe it or not, the same texture was used to map the sphere and the sky, although the results appear very different.*

TWEAKING PROCEDURAL AND BITMAP IMAGE CONTENT FOR AN INFINITE SKY PLANE

What about place bitmap image content on the default sky plane? Sorry. The default sky plane cannot accept bitmaps, only procedurals. Well, then, how can

CHAPTER 6 INFINITE PLANES AND LIGHTS

you create a sky/cloud pattern that makes use of bitmap content? Easy—just use an Infinite Sky Plane (Surface or Volume, though Volumes are not recommended). Do the following exercises.

ADDRESSING PROCEDURAL CONTENT

The Infinite Sky Plane is a special object, but an object nevertheless. As with any object, it can be addressed with textures configured from Materials in the Materials Lab—any Materials. Your creative options for placing textures on an Infinite Sky Plane far outweigh those allowed by addressing the default sky plane. Do the following:

1. Place a Surface ISP in your scene. Open the Materials Lab and map it with a Plank Wood Material, using World Top mapping. See Figure 6.26.
2. Go to the Deep Texture Editor for the Plank Wood Material. See Figure 6.27.
3. Open the Noise dialog for Component 1 by clicking the green button at the left of the dialog. A configuration window opens. See Figure 6.28.
4. Right now, the Type option is Spots, which creates the knots in the wood. Click and hold on the word *Spots* to bring up the options list. Select Techno from the list. Now, instead of spots, the wood texture has an embedded Techno pattern. Use the Noise dialog's configuration controls to alter the structural patterns in Components 2 and 3 in the same way, selecting whatever options you like. Keep an eye on the Combination window to see the results of your explorations. See Figure 6.29.
5. Place an object on the ground in the scene, and use the same Material on it. Render the scene. See Figure 6.30.

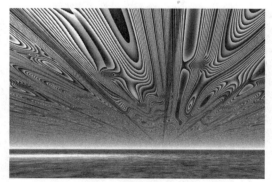

FIGURE 6.26 *An ISP mapped with a wood material. Unlike the default sky plane, materials mapped to ISP objects use all channel data, including color.*

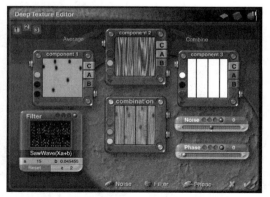

FIGURE 6.27 *Plank Wood's Deep Texture Editor.*

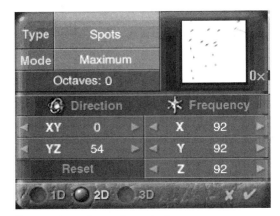

FIGURE 6.28 *A configuration window opens.*

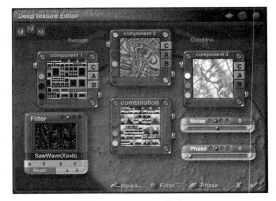

FIGURE 6.29 *Alter the patterns in all three Component areas.*

NOTE ISPs usually take World and World Top mapping best, while an object may look best with Object or Parametric mapping. This is one reason why the same material can appear so different when mapped to a sky plane and an object.

FIGURE 6.30 *The same Material is mapped to an ISP and a pyramid.*

Chapter 6 Infinite Planes and Lights

Addressing Bitmap Content

Addressing an ISP with a bitmap image material is simple; it's just a matter of selecting the bitmap and configuring it in the Picture Editor of the Materials Lab. From there, however, complexities can be added. Do the following:

 Bitmap image content in the Materials Lab always prefers Parametric or Parametric Scaled mapping types.

1. Place an ISP in the scene and open the Materials Lab Use the default Hermetic Man as the Diffuse and Ambient image for it, with Procedural mapping and the scale set to 0. See Figure 6.31.
2. Change the mapping type to Random. See Figure 6.32.

Figure 6.31 *The ISP mapped with the default Hermetic Man bitmap image.*

Figure 6.32 *Random mapping the ISP creates a golden web effect in the sky.*

Figure 6.33 *Unique skies are best created with bitmap/procedural mixes.*

3. Now we will explore a unique way to configure an ISP texture by using both bitmap and procedural components. Leave the image at its present settings in the Texture A slot in the Materials Lab. Activate channels A and B for the Diffuse component. For Texture B, use the RedLayers texture from the Texture Library in the Deep Texture Editor. Render, and tweak as needed. See Figure 6.33.

LIGHTS

Light not only illuminates worlds, it also allows us to appreciate its opposites, shadows and darkness. For any visual artist, darkness and shadow are the defining principles of 3D perception. Shadow causes us to imagine that we are seeing 3D shapes on a 2D screen. All of the information we have covered thus far concerning the application of Materials to objects, especially materials that look three dimensional because of Bump-mapped elements, take light and lighting into consideration. With the right lighting, materials and textures jump off the screen. With the wrong lighting, materials and textures look flat and washed out, erasing all of your long hours of effort. Lighting also lends emotional content to what we see. This can be best appreciated by looking at a model of the human face with different lighting methods applied, as seen in Figure 6.34.

THE BRYCE LIGHTING TECHNICIAN

You are given all of the tools you need to become a master lighting technician, setting and modifying light sources for your Bryce 3D worlds. Bryce handles nature-oriented light sources, the Sun and the Moon, and also an array of other lighting types at your disposal. The four light types in Bryce are Radial, Spotlight, Square Spotlight, and Parallel Light. Each has its uses, and each affects a scene in a different way.

Radial Light

The Radial Light is represented by the spherical Light icon in the Create toolbar. The Radial Light is spherical, and throws its illumination in all directions equally. It's perfect for use as a light in a lamp. When you need light that illuminates everything in a scene equally from a light source, use a Radial Light. Radial Lights also throw illumination on the ground plane, something no other light does. You might describe a Radial Light as one that is constructed from an infinite number of Spotlights, since the illumination it throws off is represented by a circular patch on the objects that receive the light. If you placed a Radial Light in a cubic room, you would see a circular patch of light on each wall, the ceiling, and the floor. Drop a Radial Light in the calendra of a volcano to illuminate

CHAPTER 6 INFINITE PLANES AND LIGHTS

FIGURE 6.34 *For 3D interest, a face with full front lighting looks flat when compared to lighting that casts partial shadows. Lighting also influences our perception of the actor and the story being told.*

the calendra and anything that might be ejected out of it. Use a Radial Light as a placed Sun in your sky. Use a Radial Light as a Lamp. Place it inside of a Lightbulb object, and Link it to that object. The lamp can also be a street lamp. Use a Radial Light reduced in size, inside of a candle flame. Use a Radial Light inside of any fire material, useful for campfires or larger conflagrations.

CREATE A STREET LAMP

TUTORIAL

To create a street lamp that uses a Radial Light, do the following:

1. Create a series of objects in your scene that will be illuminated by the lamp. Leave room in their collective center for the lamp.
2. Create a pole from a stretched cylinder primitive, and place it on the ground in the center of your objects. Place a sphere on top of the pole. Use a Gold material on the pole, and a light-blue material for the globe. Make the globe 65% transparent. Move the globe to the top of the pole.
3. Place a Radial Light in the center of the globe. Make the Radial Light a Volumetric light in its Edit dialog, so you can see it. See Figure 6.35.

FIGURE 6.35 *A street lamp scene.*

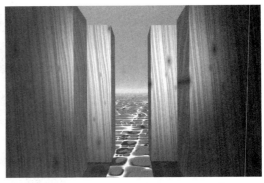

FIGURE 6.36 *The Spotlight illuminates a scene from a specific direction; in this case, from the camera position.*

Spotlight

Spotlights illuminate the scene from a specific direction. See Figure 6.36.

Spotlights are used for two main purposes. The first is to target a specific element in your scene, perhaps by moving across it to reveal it in steps. Second, use the Spotlight to emulate various light sources, including vehicle headlights, searchlights that move across the sky, mysterious light sources emanating from an ET ship, for the eyes of a robot to add extra excitement, and inside the nozzle of a rocket, adding extra punch to the exhaust.

Square Spotlight

Square Spotlights work very well when you need to render a light streaming through a window. See Figure 6.37.

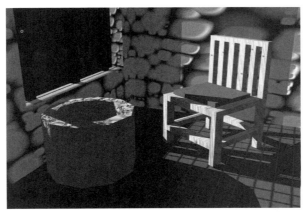

FIGURE 6.37 *The Square Spotlight is the best light to choose when you need light to stream through a window into a darkened room to illuminate the contents.*

Square Spotlights are good for global illumination. They cast a squarish illumination, but not as defined as Parallel Lights. The beam tends to smear and be somewhat rounded. Its best use is for general scene illumination from a specific direction. If you wanted to have light streaming through a window to light all of the objects in its direction, the Square Spotlight would be a wise choice, as shown in Figure 6.37.

Parallel Light

Parallel Lights are perfect for projecting Gel images onto a scene. Though you can do this with any of the four light types, Gels projected through a Parallel Light look like square-edged slides from a projector.

EDITING LIGHTS

Use the Light Edit dialog to edit your lights. Here are some tips to think about when using the Light Edit dialog:

- Keep the Light Intensity to 50 or below if you want to see the light color (as long as it is anything but white, which is always visible).
- Setting the Light Intensity at 100 or above, and the Color to black, produces some interesting dark light effects. Use the effects to add subtle mystery to a scene.
- Preview with the *Render in Scene* option if you're not sure about the parameters you're setting. This takes a little time, but it shows you how your intensity and other changes are affecting the scene itself. Most of the time, you will use the default *Render Against Neutral*, especially when you are experienced enough with light settings to intuit what the results of your tweaking will be.
- Only in rare circumstances would you push the light intensity above 100%. This is because it causes a hot spot on objects that washes out their materials. When this occurs, move the light back some distance from the object(s).
- Never leave the color white when using the softened light aura. Always apply a color, even if only a subtle pastel.

VOLUMETRIC LIGHTS

Volumetric Lights have volume as compared with surface lights. They can be made to take on 3D materials just like any other object. Normally, the materials they accept are provided by the Volume Library in the Materials Lab; however, this is not a hard-and-fast rule or limitation. You can also explore adding textured materials to a Volumetric Light, or any volumetric, within the framework of the Surface environment of the Materials Lab. When applying textured materials to lights, there are a few cautions to observe so that you can avoid long rendering times.

- Avoid super close-ups (larger than 1/4 screen) of Volumetric Lights that display a textured material.
- Make alterations in the light's Edit dialog before you do anything in the Materials Lab. Never return to the Edit dialog after you have customized material in the Materials Lab, or you will undo the Material Lab customization.
- The highest rendering time cost applies to transparent textured materials. You don't have to avoid them; just be aware of this fact.

Altering Light Attributes

Lights have an Attribute dialog like any other object. There is one important setting in the Attributes dialog that has a major effect on light effects—size. Whether you resize a light from its Attributes dialog or from the Resize icon in the Edit toolbar, the spread of the light cone is projected larger when the light object is larger. You can resize a light to compensate for Falloff setting amounts, so that a larger light will cast its spread wider in a scene. Moving a light closer or farther from specific target objects also affects its spread and the intensity of illumination.

The Falloff attributes are listed in the light's Edit dialog. The most common is Linear Falloff. Linear Falloff is based on distance from the intended light target. The more distance between the light and target, the less illumination. Sometimes, depending on the lighting effect you want to create in a scene, selecting No Falloff becomes necessary. Using No Falloff will cause the light to illuminate everything in its projection beam evenly, so that objects in the far distance are illuminated the same as objects close to the light. Use No Falloff for effects like explosion flares, pseudo sun or moon elements, and surrealistic effects.

Gels

A Gel is an image that can be projected by any light source. Bryce differentiates between bitmap-based Gels and procedural-based Gels. A bitmap Gel is defined as any graphic that Bryce can import, which can then be used as a Gel. When you access a bitmap Gel, you are presented with the Picture Editor from the Materials Lab, so that you can manipulate the Alpha channel as necessary. Procedural texture-based Gels use elements you configure from procedural materials. These can be either presets from the Materials Library or your own customized materials. Gels are normally accessed from the light's Edit dialog.

Preset Gels

The Gel Folder in the Bryce Directory contains a number of ready-to-assign image Gels, though you can also use any of your own bitmap images. The unique thing about the Gels in the Bryce folder is that they are all two-color silhouettes, perfect for emulating shadows from invisible objects such as trees and

Chapter 6 Infinite Planes and Lights

Figure 6.38 *Here, a Spotlight uses a Gel to cast the Horizontal Slats pattern on everything in its illumination path.*

Figure 6.39 *The type of light casting the PICT Gel makes a difference; in this case, a Square Spotlight was used.*

venetian blinds. This allows you to get the benefit of the presence of objects in a scene by their shadow, with the actual object not having to be present. See Figures 6.38 and 6.39.

Procedural Texture Gels

The entire Material Presets Library is at your disposal for using Texture Gel patterns, as are your own customized textures. The benefit of using procedural textures as Gel data includes the ability to resize the Gel information in the Materials Lab. All of your Deep Texture Editing skills can also be incorporated when customizing Gels. See Figures 6.40 and 6.41.

Figure 6.40 *A Spotlight with an Object Front mapped Yellow Noise Texture Gel casts patterns on objects and ground.*

Figure 6.41 *The same Spotlight using the same Texture Gel as in Figure 6.40. The difference is that Spherical mapping and a higher size setting were configured in the Materials Lab.*

 Silhouetted Gels work best on objects that are mapped with color alone, while Procedural and Image Gels work well on objects that have any Material content mapped to them, resulting in a blended Material look. Turn Ambience off and Diffusion down on objects that are to receive Gel targeting. Keep in mind that rotating the light will also rotate the Gel.

Parallel Light Projections

Parallel Lights are used to project Gel data that is meant to be perceived as a slide on a screen. See Figure 6.42.

Parallel Lights are perfect when you need to keep the illuminated area square. This is the light type to select for projecting window lights, or for creating pseudo slide shows and movies within your scenes.

FIGURE 6.42 *The Parallel Light casts a rectangular projection, and throws its illumination in a specific direction. The edges of the illuminated area can be customized to remain completely square, perfect for projecting images like this Crosshatch Window Gel.*

Materials and Lights: An Alternate Method

You can use an alternate method to place a material texture on a light. Simply click the Material button ("M") in the light's Attributes list to bring up the Materials Lab, and select a material preset or design your own, just as you would for any other object.

 If you use this option, do not use Volumetric options, *or your system may crash.*

Chapter 6 Infinite Planes and Lights

The best light type to use for this option is the Radial light. The material will be transmitted to objects in the vicinity as expected. This way of applying a Texture Gel is more direct than going through the Light Edit dialog. The best materials to use are those with drop-out Alpha textures, since this will project symmetrical patterns on objects. If you increase the size of the texture in the Transformations dialog of the Materials Lab, you will start to see interference patterns being projected. This can be very effective for emulating energy strikes on material—like a pebble being cast into a pond—and is a great animation tool. Set the light intensity to 100, and the blur to 50. See Figure 6.43.

For more information on Bryce animation options and controls, see the author's Bryce 3D Handbook *from Charles River Media.*

The color of the plane you map your interference patterns on should not be too dark. A Red color darkened to a reddish black looks good. This technique does not work with textures in the material, only color. Choose lighter colors to tint the Radial Light in its Edit dialog. Try using "No Falloff" in the Radial Light's Edit dialog if the projected texture is too light, and if moving the light closer to the material has little or no effect. Moving the Radial Light closer to the object sharpens the projected image.

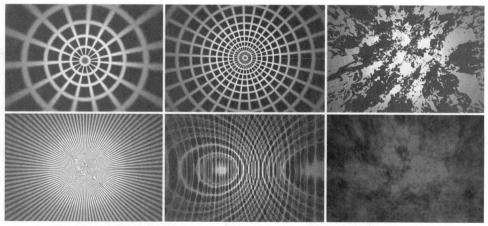

Figure 6.43 *The materials used to achieve these Radial Light interference patterns are (upper left to lower right): Gilded Cage, Gilded Cage resized to 3x, Peeling Paint, Carnival Tent, Rainbow, and Volcano Heart.*

RADIAL LIGHT F/X SAMPLES

Let's look at a few visual examples of radial light F/X. Under each graphic is a detailed description of how the effect was created. Note that the Gilded Cage material was used on all examples. You may select another preset textured material, or create your own. See Figures 6.44 to 6.49.

 Work in the Edit dialog first, followed by the Materials Lab. Do not return to the Edit dialog, because all of the Materials Lab settings will be undone if you do.

To achieve the effect shown in Figure 6.44, do the following:

1. In the Edit dialog: Set Intensity and Fuzziness to 100. Make it a Volume Light with Linear Falloff.
2. In the Materials Lab: Assign the Gilded Cage material. Use the Channel 1 marker only in the Transparent Color row and the Transparency Optics row. Select the Blend Transparency type. Wrap the material to the light in Object Space.

To achieve the effect shown in Figure 6.45, do the following:

1. In the Edit dialog: Set Intensity and Fuzziness to 100. Make it a Surface Light and Infinite.
2. In the Materials Lab: Assign the Gilded Cage material. Use the Channel 1 marker only in the Diffuse and Ambient Color rows (with slider settings of 80 and 30, respectively), in the Bump Height Value row, and the Transparency Optics row. Select the Blend Transparency type. Wrap the material to the light in Object Space.

FIGURE 6.44 *This is our first example. The Radial Light has a textured material applied, but the beam casts only a normal light.*

FIGURE 6.45 *In this example, the Radial Light is wrapped with the material and projects the same material.*

FIGURE 6.46 *In this example, the Radial Light is wrapped with the material and projects the same material. It is also fuzzed out and soft in appearance.*

To achieve the effect shown in Figure 6.46, do the following:

1. In the Edit dialog: Set Intensity and Fuzziness to 100. Make it a Volume Light and Infinite.
2. In the Materials Lab: Go to the Volume controls, and assign the Gilded Cage material. Use the Channel 1 marker in the Diffuse Color and Base Density rows only. Input the following settings: Diffuse Value = 80, Ambient Value = 30, Specular Value = 22, Base Density = 55, Edge = 100, Fuzzy factor = 300, Quality/Speed = 30. Select the Flat Shaded type. Use Spherical mapping, and wrap the material to the light in Object Space.

To achieve the effect shown in Figure 6.47, do the following:

FIGURE 6.47 *In this example, the Radial Light is a standard Volumetric with no material mapped to it. Note that using a solid black sky emphasizes the light's contrast.*

1. In the Edit dialog: Set Intensity and Fuzziness to 100. Make it a Volume Light and Infinite.
2. No need to do anything in the Materials Lab.

To achieve the effect shown in Figure 6.48, do the following:

FIGURE 6.48 *In this example, the Radial Light is a Volumetric with a Pict Gel, Watery Reflections, mapped to it. Some settings were altered in the Materials Lab.*

1. In the Edit dialog: Set Intensity and Fuzziness to 100. Make it a Volume Light and Infinite. Click on Pict Gel, and load the Watery Reflections item from the Gel folder in the Bryce 3D folder.
2. In the Materials Lab, do the following: Make it a Volume material with Full Shading. Place the texture marker in the Diffuse Color row and in the Diffusion Value row (setting = 100). Set Ambience Value to 50. Give it a base Density of 16, and a Fuzzy factor of 100. Set Quality/Speed to the center (Air).

 Normally, you would not see the light itself, just the fractal Watery Reflections. The customization we did in the Materials Lab made the light visible. See Chapter 8, "Helpful Handshaking," for water f/x to appreciate this example in an animation. Turning Atmosphere Off in the Sky and Fog toolbar enhances all projected light effects. If you need clouds, add them on an infinite cloud plane.

FIGURE 6.49 *Four sculpted street lamps provide all of the light in this scene.*

Which Light Type Is Best to Use with a Gel?

There is no hard-and-fast answer to this question, because it depends upon what the project demands and how you configure the nearly infinite variables involved. There are a few guidelines, however:

- Use Radial Lights when you want the Gel to influence objects that surround the light source, and the other types for targeted objects.
- Use Parallel Lights when you want to emulate slide and movie projectors in your scene.
- If you want to apply silhouetted light/dark images to objects, use Silhouetted Gels. If you want to apply color washes, use Texture Gels.
- Consider the use of Alpha channel data when using Silhouetted Gels when the image contains more than two colors (black and white).
- Use colorful materials when opting for Procedural Gels, because that will enhance your targeted objects more.

ADDENDUM LIGHT TOPICS

A few more points concerning lights need to be made before we move on to the next chapter. These are Preset Lights, Object Lights, and Grouping Lights to false light objects.

Material Preset Lights

There are two Material presets that I use constantly to target to spheres, for use as stars or false sun objects (the term *false* is used to distinguish these objects

from the Bryce default Sun). These are the GreenLit and Marley's Ghost presets in the Complex Materials Library folder. GreenLit can be easily customized and colored. Bring it up on your system now, and explore how it is put together in the Materials Lab.

Object Lights

Any object in Bryce 3D can be made into a light, or at least an element that has some of the attributes we expect from lights. This does not include illuminating other objects directly, but through a perceptual trick. What is the trick? Transparent objects that cause everything that we see through them to look brighter, fooling the eye into thinking they are lights. The three most common objects used for these pseudo-lights are spheres, cones, and very thin cylinders.

False Spherical Lights

These objects can be used effectively as suns, and mapped with plain color or more evocative materials for use as background planets. Used for this purpose, they are not usually transparent, but just fuzzy around the edges. If they are made transparent, they can be used as ghostly lights that can be placed anywhere in the scene. When you create a false spherical light, make sure you do the following (see Figure 6.50):

- Make them Volumetric objects. This gives them more dimension.
- Use Flat Shading on them, which allows you to pay more attention to their color than their contents.
- Play with the Base Density slider to achieve the opacity or transparency you need.

FIGURE 6.50 *False spherical lights can act as effective stand-ins for suns and planets.*

- Set the Diffuse Color slider to whatever color you want; and the Diffusion value to 100%. Set Ambience to zero.
- Resize and place the object as needed in your scene.

False Conic Lights

Simply use a cone and select the Light Shading option in the Materials Lab (Surface Material). Turn down Ambience on all objects that the false conic light will seem to touch, or the image will lose contrast and the effect will be lost. Place the cones at an angle, so they appear to be emanating from the same source. In the Materials Lab, the Volume Color determines the color of the rays, and Transparency Optics controls density. Move the Transparency slider to at least 65%, and even higher for more subtle effects. Make sure to pay attention to light directions and specular highlights in your scene, so the rays are coming from the same direction. This same effect can work for rays streaming from a globe, or even a Radial Light source. It can also be used for searchlights and spotlights, as long as true lights are grouped with the false ones. See Figure 6.51.

False Laser Lights

Bryce contains the perfect object for exquisite laser beam emulations. In the Imported Objects folder of the Objects Library is a screw. Its threads act to give a light object just the right touch or variance and randomness. When stretched out, you can no longer tell what the object is, because the threads are stretched into flowing curves. Look at Figure 6.52. There is a lot going on here with different lights—let me describe some of the elements involved.

FIGURE 6.51 *Rays from a false sun illuminate a landscape.*

FIGURE 6.52 *A laser blast*.

In Figure 6.52, because the Bryce sun is illuminating this scene from the back, objects tend to be on the dark side. This being the case, the Ambience channel value was raised to 100%. This allows various parts of the material to literally glow in the dark. The Specularity of the simple color material used on the ship was raised as well, to pop it out of the dark. The internal glow emanating from the bottom of the ship is a Radial Light. It is toned down by the torus that surrounds it, shielding the buildings from the light. A Screw object is used as the beam. The beam is textured with the Volumetric Red Laser Beam as a Volume Material. Additive Shading with a Volume Altitude Blend is used. The sliders are set to 100 for Diffusion, 17 for Ambient Value, a Base Density of 17, an Edge Softness of 50, a Fuzzy factor of 142, and Quality/Speed at 5. Two volumetric flames rise up from the target, while the ground is mapped with the fiery material. See Figure 6.52.

Grouping Lights to Objects

When you use false lighting of any kind, it usually helps to place a "real" light at the point the beam seems to be coming from. This allows you to use the false light at its maximum effectiveness, while using the real light to cast shadows in the mix. The light coming from the bottom of the space ship in Figure 6.52. has a Radial Light grouped with the laser light. The creative use of lights carries us into the next chapter.

TRAVELING ON

In this chapter, we detailed important facts concerning Infinite Planes and Lights. Part Two deals with addendum considerations you should know about, and then it's on to Part Three and the complex scenes tutorials.

PART II

External Modeling Applicatons

CHAPTER 7
3D Modeling Tools

Bryce itself does not contain the necessary variety of modeling tools you need to create all of the components for the worlds we will explore in Part Three of this book. For that reason, it is suggested that you purchase and learn how to use one or more professional 3D applications devoted to the creation of 3D models. You should select an application, if you do not already own one, that contains a variety of modeling options and tools. Suitable choices include 3DS Max, LightWave, Maya, Carrara, Cinema 4DXL, Rhino, Animation Master, Real3D, and similar applications. This chapter concerns itself with detailing the modeling tools and options used to create the Bryce worlds in Part Three of this book, so that you know what these tools and processes are called, what you can do with them, and exactly how they work. Some of the names of the tools may change from one application to another, and some will have different options and parameter controls. All of them, however, will be represented in your 3D application in some way. Understanding and using these tools is an absolute requirement if you plan to work through the tutorials in Part Three. Unless you are already working-familiar with these tools and processes in a 3D application, you must prepare by doing the following:

- Purchase a 3D application and develop a level of expertise the tools and processes.
- Learn the terms associated with these tools and processes, so in later tutorials you understand what it means when you are asked to do something with a tool or process in your 3D application.
- Become familiar with how to save models and images created with these tools and processes in a 3D file format that Bryce can import.

Although this chapter deals with tools and processes common to a number of 3D applications, I have used 3DS Max to detail tool usage in the accompanying illustrations.

EXTRUSION

Extrusion is the operation of dragging a 2D shape through space to create a 3D volume. For instance, if you drag a circle through space on a straight line perpendicular to the circle's surface, the resulting 3D object will be a cylinder. Extrusion commonly takes place along the shape's *Normal*. The Normal is an imaginary line that is perpendicular to the 2D shape as you are looking at it face on. The term *Normal* is usually reserved for talking about a polygon, but is used here to get the general concept across. The resulting 3D volume may or may not have surfaces that cap the ends, so a variety of cylindrical forms can result. Extrusion is a vital tool that is not present in Bryce 3.x.

Chapter 7 3D Modeling Tools 117

TUTORIAL

Creating an Extruded and Deformed Column for Bryce

If you wanted to create a column for a Bryce edifice, it would be easy as long as the object was cylindrical. Bryce allows you easy access to Cylinder Primitives in the Create toolbar. Even if you need a more complex columnar object, you can create the Top View in the Terrain Editor and take it from there. Problems arise when the column design has more convoluted parameters. Do the following in your 3D application:

1. Create a 2D shape in your 3D application that resembles the one shown in Figure 7.1.
2. Find the Extrude control in your 3D application, and activate it. Make the extrusion large enough to create a column-sized object. See Figure 7.2.

FIGURE 7.1 *Use the drawing tools specific to your 3D application to create a 2D shape in the Top View.*

FIGURE 7.2 *This is a Front View of the extruded column.*

3. Somewhere in your 3D application is a tool that allows you to Taper an object. Find that tool, and use it to taper the top of your column. See Figure 7.3.
4. Export in a file format that Bryce can import. Import into Bryce. Go to the Materials Lab, and select the Iceberg material from the Planes & Terrains Library. Select Object Space mapping, and apply the material. See Figure 7.4.
5. Duplicate the object to create a row of columns, and place on an Infinite Ground Plane. Add a sky, and place a elongated textured cube on top of the columns. See Figure 7.5.
6. Group the columns and the expanded cube. Name it Columns_01, and save to your User Objects Library.

ADVANCED BRYCE CREATIONS

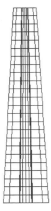

FIGURE 7.3 *Taper the top of the column.*

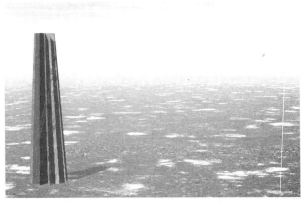

FIGURE 7.4 *The textured, extruded, and deformed column as it appears in a Bryce rendering.*

7. Duplicate three more column rows, or place three more in the scene from the User Objects Library. Configure to form a larger edifice. See Figure 7.6.

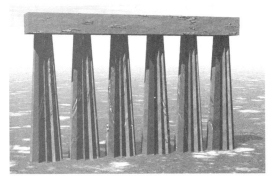

FIGURE 7.5 *A row of columns in a Bryce world.*

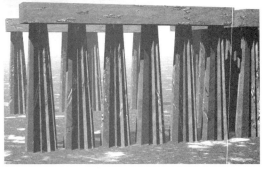

FIGURE 7.6 *With more similar objects placed in a scene, your Bryce world takes on the complexity of a real environment, which can be viewed from any angle.*

LATHING

Lathing is a process that creates *objects of revolution*. Lathing spins a 2D shape on an axis, with the result being a 3D volume. If the degree of revolution is set to 360, a completely symmetrical object will result. Lathing is commonly used to create columns for buildings, pipes, bottles, glasses, bowls, and other symmetrical objects. There are two important ways you can use Lathing to create objects

that are more diverse. The first is to move the 2D shape at some distance from the axis it is to use as a revolution reference. This can result in all manner of wheels and wheel-like objects. The second consideration is the degree value of the revolution. The default value is 360 degrees, resulting in a perfectly symmetrical object. If the degree value is 180 degrees, however, the resulting form will be half an object of revolution with a flat side or base. Other degree values create various segments of a completely symmetrical form. Lathing, and having control over its parameters in your 3D application, is an important tool for creating diverse objects.

OTHER LATHING PARAMETER EXPLORATIONS

There are two less common ways that you can apply Lathing to a 2D shape to create more diverse 3D forms: rotating the Axis of Revolution, and adjusting the number of "segments." You should explore both in your 3D application:

Rotating the Axis of Revolution

By rotating the Axis of Revolution, you alter the pivot around which the 3D form is created, thereby influencing the form's final shape and volume.

The best way to do this in your 3D application is to create your original shape at an angle in the first place. In many applications, the object's axis is glued to the object, so rotating the axis doesn't do the trick. Creating the original shape at an angle effectively sets the axis of revolution according the screen's (or in some cases, "world") axis.

Adjusting the Number of Segments

Segments determine how many sides a Lathed object has, so the form can be radically altered by using different segment values. The lowest segment value that can be set is three (top, bottom, and center). The higher the segment value, the more the Lathed object will tend toward the cylindrical. When it comes to developing mechanical parts for a model, using lower segment values in a Lathing operation creates objects that are more angular. Be sure you understand all of these Lathing capabilities in the 3D application you are using, since Lathing is a very important tool for creating Bryce content.

LATHING A COMPLEX TOWER FOR BRYCE

Do the following to create a complex tower for export to Bryce, using your favorite 3D application. Make sure you know how to use the Lathing tool in that application.

1. Create a shape that resembles the one shown in Figure 7.7. This will be the central tower in your model. Make sure the Pivot Point (called the Origin Point or Object Axis in some 3D applications) is set to the right edge as indicated.
2. Create a shape at the bottom of the previous shape for a base of the tower. Make sure to move its Pivot Point to line up with the axis of the previous shape. See Figure 7.8.
3. Add three shapes as displayed in Figure 7.9 for balcony railings. Make sure all of their Pivot Points line up with the main tower Pivot Point. See Figure 7.9.

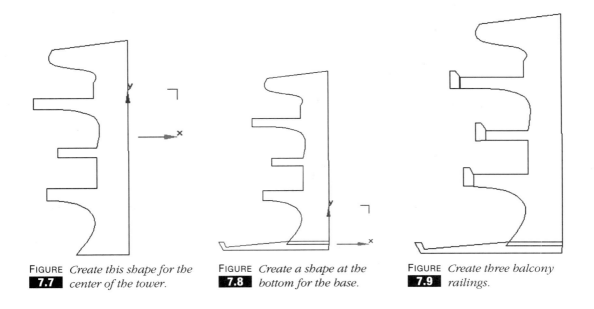

FIGURE 7.7 *Create this shape for the center of the tower.*

FIGURE 7.8 *Create a shape at the bottom for the base.*

FIGURE 7.9 *Create three balcony railings.*

4. Create a roof shape, with the Pivot Point moved to the same position as the other components. See Figure 7.10.
5. Create one final shape at the top to act as the lathing form for a spire. Move the Pivot Point as before. See Figure 7.11.
6. Remember that all of the components share the same Pivot Point axis position for a vertical lathing operation. With this in mind, Lathe all of the components. All should be lathed at 360 degrees, but segments should be set as follows: Spire segments to 24; main Tower segments to 4; Roof segments to 8; Balcony segments to 24; Base segments to 4.
7. Do a test render. Your tower should resemble Figure 7.12.

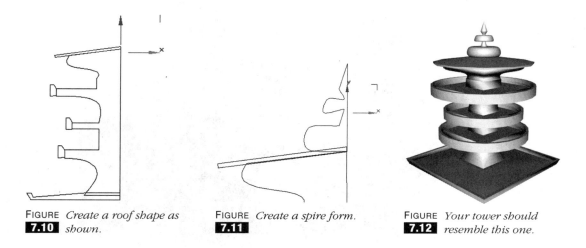

FIGURE 7.10 *Create a roof shape as shown.*

FIGURE 7.11 *Create a spire form.*

FIGURE 7.12 *Your tower should resemble this one.*

8. Save the Grouped model in a format that Bryce can import. Open Bryce, and create an IGP and a Sky backdrop. Import the Tower model, and adjust the placement so it is visible in the Camera View. See Figure 7.13.
9. Now for making use of the grouped components. You grouped the components so that you could apply separate materials to them in Bryce. Ungroup the model. Apply the following materials to the components: Spire = Simple&Fast/Warm Gold; Roof = Complex FX/Copper Bump; Main Tower = Wild&Fun/Office Building at Night; Balcony = Wild&Fun/Dali Bee Stripes; base = Wild&Fun/Robot Fungus. Render. See Figure 7.14.
10. Regroup the components. Duplicate the model, and map with your own choice of different materials. Place the duplicate behind the original, and increase the vertical scale by about 20%. Delete its base component.

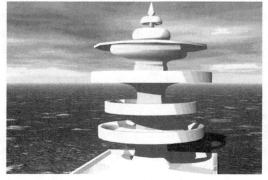

FIGURE 7.13 *The Tower model is imported into Bryce.*

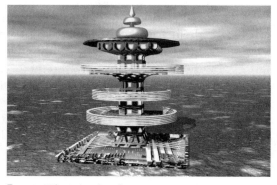

FIGURE 7.14 *The completed tower.*

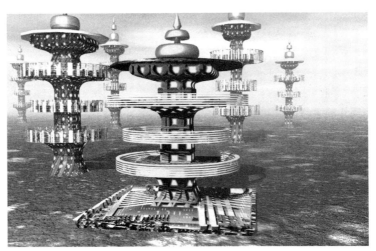

FIGURE 7.15 *An arrangement of towers.*

Repeat this step as many times as you like. Now you have the beginnings of a city. See Figure 7.15.

 Adding a Haze of 70+ to a Bryce scene that depicts objects on an IGP reinforces the photorealism of the rendering. The haze blurs background objects, just as you expect when you observe background features in the everyday world.

BOOLEAN OPERATIONS

Boolean operations are tremendously important in the creation of 3D models. Using Booleans, you can create mathematical composites of objects, adding them together to create one surface, subtracting one from another to create holes and scoops, or combining one with the other to create an object based on the intersections between them. In all cases, Boolean operations create one contiguous surface shared by all of the objects involved, perfect for unified texture mapping.

The three Boolean operations are usually called Union (Add), Subtraction, and Intersection (or Difference), but these operations may have different names in your 3D application. Boolean Difference operations are less important than the other two options; Boolean Subtraction being the most important Boolean operation of all. This is because Boolean Subtraction allows you to create negative spaces, holes and scooped areas, on any model. This is vital when it comes

CHAPTER 7 3D MODELING TOOLS

to developing a wide array of complex 3D modeling components. The Boolean operations offered in Bryce are not as suitable for use as those found in other professional 3D applications. Find out where the Boolean operations are in your 3D application, and learn how to use them.

CREATING A BRYCE BOOLEAN MYSTERY DOOR

TUTORIAL

Make sure you know where the Boolean tools are located in your 3D application, and how to use them. Do the following:

1. Create a large rectangular block as the start for a door. See Figure 7.16.
2. Create four panels for the door with smaller blacks. See Figure 7.17.
3. Use Boolean Union to cement all of these forms together.
4. Use another block, the same size as the panels, and create an indentation in the door by using Boolean Subtraction. See Figure 7.18.

FIGURE 7.16 *Create a large rectangular block.*

FIGURE 7.17 *Create four panels.*

FIGURE 7.18 *Create an indentation on the door by Boolean Subtraction.*

5. Create a circular window at the top of the door by using Boolean Subtraction and a cylinder. See Figure 7.19.
6. Use spheres and Boolean Union and Subtraction to create the head form displayed in Figure 7.20.
7. Create a nose form with four spheres connected with Boolean Union. See Figure 7.21.
8. Use a Boolean Subtraction operation, and use a rectangular solid as the cutter to even out the bottom of the nose. See Figure 7.22.
9. Use Boolean Union to attach the nose to the rest of the head. See Figure 7.23.

FIGURE 7.19 *Create a circular window with Boolean Subtraction.*

FIGURE 7.20 *Create this head form with spheres, and connect it together with Boolean Union and Subtraction (for the eye sockets).*

FIGURE 7.21 *The initial nose form.*

10. Use two hemispheres to create the mouth, and use Boolean Union to connect it to the head. See Figure 7.24.
11. Resize and place the head in the cutout in the door. Select both the door and the head, and Group. Save in a format that Bryce can import. See Figure 7.25.
12. Import the model into Bryce. Ungroup, and map the head with a Gold material, and the door with the Wood Plank material from the Simple&Fast Li-

FIGURE 7.22 *Even out the base of the nose with Boolean Subtraction.*

FIGURE 7.23 *Use Boolean Union to attach the nose.*

FIGURE 7.24 *The finished head.*

CHAPTER 7 3D MODELING TOOLS

brary. Add a little Bump mapping to the gold for the head to give it a rougher look. See Figure 7.26.

13. Use two bright-red spheres in the eye sockets, and another sphere in the circular hole in the door. Use a Combo Colored Glass material from the Glass Library on that sphere. Place a Torus on the bottom of the head as a doorknocker, using the same Gold material as on the head. Use a gold Squashed Cylinder primitive for a door handle. Group everything, and save. See Figure 7.27.

FIGURE 7.25 *The head is placed in the cavity in the door.*

FIGURE 7.26 *Import and texture in Bryce.*

FIGURE 7.27 *The completed Mystery Door.*

LOFTING

The Lofting process requires two components: a shape (called the *cross section*) and a spline (called the *path*). The Lofting operation extrudes the cross section along the path. The path can be closed or open, and the cross section can be closed or open, so a great variety of 3D components can be generated. The path can exist in 2D or 3D space. Most 3D applications offer you the opportunity to edit the Lofted object by adjusting the size of the cross section at any point along the path, resulting in a variety of possible 3D objects. Locate the Lofting tool in your 3D application, and make sure you understand how to create Lofted objects.

TUTORIAL

THE SPRING

The Spring is a Loft based on a circular cross section and a helical path. Do the following to create a spring object for Bryce:

1. Some 3D applications contain a tool for creating a 3D helical path or spline, while other 3D applications require that you create the helix on

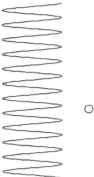
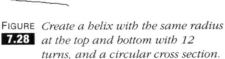

FIGURE 7.28 *Create a helix with the same radius at the top and bottom with 12 turns, and a circular cross section.*

FIGURE 7.29 *A Lofted spring.*

your own. See what your 3D application does, and create a helix that has the same radius at the top and bottom. This is your path. Next to it, create a circular cross section. See Figure 7.28.

2. Loft the circle to the helical path. The spring is created. See Figure 7.29.
3. Go to the tool or menu selection in your 3D application that allows you to deform the cross sections on different points along the lofted object's path. Alter the diameter of random cross sections to create a spring with different thickness at random points along its length. See Figure 7.30.
4. Save the spring in a 3D format that Bryce can import. Import into Bryce, and duplicate to create three springs. Place the springs on a reflective water plane, and place a sky in the scene. Map the springs with the Copper metal from the Metals Library. Your surrealist painting may resemble Figure 7.31 when rendered.

FIGURE 7.30 *Alter the thickness of the spring at random points along its length.*

FIGURE 7.31 *Springs on a water plane.*

CHAPTER 7 3D MODELING TOOLS

DEFORMATION F/X

Every 3D application contains a number of Deform F/X, with the most common ones being Bend, Twist, and Taper. The higher-end applications contain dozens of Deform F/X, and are open to many more when you add specific Deform F/X plug-ins.

When we refer to Amorphium *from Electric Image in the next chapter, you will see that it greatly expands the Deformation F/X available in most other 3D applications. Bryce lacks Deformation F/X.*

Deformation F/X can help to give your models that extra touch of reality, and are especially useful when you need to create warped and dented objects. 3DS Max, as an example, lists a variety of Deformation F/X in its Modifiers. Where are Deform F/X located in your 3D application? Find them, and explore their use. That way, when we incorporate one or more Deform F/X in a later tutorial, you'll know exactly where to go and what to do.

DEFORMED OBJECTS FOR BRYCE

You can think about object deformations in two ways when it comes to Bryce. First, objects can be created in your external 3D application, deformed, and ported to Bryce. Second, since Bryce is able to export Terrains and Terrain objects, you can create the initial object in Bryce' Terrain Editor. It can then be ported to your external 3D application and deformed, after which you can port it back to Bryce again. Here are two examples.

BOOLEAN DEFORMS TO BRYCE

Here's an example showing how deformed objects can be created and deformed in your external 3D application, and then ported to Bryce for texturing and rendering. Do the following:

1. Create an object composed of a Cube, Sphere, and Cone. Use Boolean Union to connect all components, and duplicate two times. See Figure 7.32.
2. Select the first object. Locate your Deformation tools, and bend the object on its vertical axis by 122 degrees. See Figure 7.33.
3. Select the second object. Add a Twist deformation of 230 degrees on its vertical axis, and a Noise deformation of 15 degrees on each of the XYZ axes. See Figure 7.34.

FIGURE 7.32 *Three Boolean constructs.*

FIGURE 7.33 *Bend the first object by 122 degrees on its vertical axis.*

4. Select the third object and add a Ripple deformation. Play with the parameters until you are satisfied with the result. Next, add a Taper deformation so that the object is larger at the base than at the top. See Figure 7.35.
5. Group all three objects and export in a format that Bryce can import. Ungroup in Bryce, and compose a surrealist scene, with your choice of materials applied to each object. See Figure 7.36.
6. Now for deforming a Bryce Terrain object. Delete everything from the previous scene, or open a new blank scene. Place a Symmetrical Lattice in the scene. Go to the Terrain Editor, and select New. Create the image shown in Figure 7.37 in the Elevation View. Don't worry about getting it exact. See Figures 7.37 and 7.38.

FIGURE 7.34 *Twist and Noise deformations are added to the object.*

FIGURE 7.35 *Ripple and Taper deformations added to the object.*

Chapter 7 3D Modeling Tools

FIGURE 7.36 *An electric Surrealist painting. Dali would love Bryce!*

FIGURE 7.37 *Create the image shown here in the Elevation View.*

7. Export the object in a format your external 3D application can Import.
8. Import the object into your external 3D application.
9. The first thing we'll do is to create a cube and use it in a Boolean Subtraction operation to even out the top of the Terrain object. See Figure 7.39.

FIGURE 7.38 *The object when rendered.*

FIGURE 7.39 *The top of the imported Terrain object is evened out in a Boolean operation.*

10. You have to know how your external 3D application performs Vertex Editing (sometimes called Mesh Editing) to do this step. Use your Vertex Editing tools to deform the object so it is transformed to look similar to the object shown in Figure 7.40.
11. Export in a format Bryce can import. Import into Bryce, and create a surrealistic composition. See Figure 7.41.

FIGURE 7.40 *Deform your object to resemble this image with your Vertex Editing tools.*

FIGURE 7.41 *No doubt that your composition will differ from this example.*

VERTEX-LEVEL EDITING

Except for non-polygon 3D structures (which are rare), a polygon is the basic component of a 3D model. Polygons are constructed from two components: edges and vertices. The term *vertex* is a common substitution for *vertice* in computer graphics. Edges connect one vertex to another to create a closed polygon. Some 3D applications allow only three-sided polygons to be used in objects, while other applications allow more. An imaginary line extends from the center of the polygon at a perpendicular angle. This line is called the polygon's *normal*. Normals are used to set various parameters of the polygon, including how texture maps are applied. The normals have to be pointed away from the polygon for it to be visible, so many 3D applications have a *"Reverse Normals"* command, just in case a model's polygon normals are pointed the wrong way. When the inside of a model is to be seen, the command *Render two-sided* is also included in your command set in most cases. This allows the normals to be pointed both outward and inward, so you can see the outer and inner surfaces of the object.

When we use the term *Vertex Editing* (or more commonly, *Vertex Level Editing*), we mean the capability of adding, deleting, and otherwise manipulating both vertices and edges of any polygon or group of polygons on a model. It is strongly suggested that you become very familiar with the Vertex Editing tools and processes that your 3D application contains. Vertex Level Editing is especially valuable when you are creating organic models, especially creatures and human heads. Be sure to read your software documentation and practice to sharpen your skills in these areas. We recommend that you take the time to fully explore Vertex Level Editing in your external 3D software.

Chapter 7 3D Modeling Tools

Lattice Objects

TUTORIAL

Since we just spoke about polygon components as edges and vertices, it is fitting that we mention Lattice objects here, because a Lattice object relies on edges and vertices for its construction. Lattice objects are special objects created by applying a Lattice transformation to any polygonal object. Your external 3D application may or may not allow you to create lattices. Lattice objects import very well to a Bryce scene. Lattice objects allow you to create 3D models that appear to be constructed from gridwork. There are some Bryce materials that create lattices when they are applied to an object; however, this is just a texture effect (look at the *Dali Bee* material as an example). True Lattice objects are created in an external 3D application that features a lattice plug-in or modifier. 3DS Max has a Lattice option in its Modifiers list. If you use 3DS Max, do the following:

1. Create a sphere in 3DS Max with a radius of 12 and 24 segments.
2. Go to the Modify panel and select Lattice.
3. Export the model in a format that Bryce can import. Import in Bryce, and use in a scene. See Figure 7.42.

FIGURE 7.42 *A Lattice sphere as it appears in Max after a texture is applied.*

LINKING AND GROUPING

Grouping and Linking are different operations, and you must know where and when to use them.

When you use Boolean Union in your external 3D application to connect object components, everything is welded into one object with one surface. Unless you activate an Undo operation, there is no way to select and modify any of the previous singular components that were fused to construct the Boolean United object. This differs greatly from using a Boolean Union operation within Bryce, since the separate objects are always available for modification. When you apply either the Grouping or Linking options in Bryce or your external 3D application, Grouped objects can be UnGrouped and Linked objects can be UnLinked. One determining factor decides whether to select Grouping or Linking to join the parts of a model: Movement.

When you create a 3D model with diverse parts in Bryce, and have no need to animate any of their component movements, select Grouping to connect them. When you need to show movement for a specific part, like a character's arm, Link that part to its *parent* object. When you move the object, always select the highest parent in the hierarchy, and the rest of the object will dutifully follow along. Be careful when resizing or rotating parent objects in a Linked hierarchy, however, since the children will also be modified in the same manner unless you switch that option off. With a Boolean operation in most external 3D applications, the separate component elements no longer maintain their individual textures. When you use Grouping or Linking, all of the separate textures for individual components remain intact.

Make sure you know where the Grouping and Linking controls are in your 3D application, and how to use them. Both of these operations are called for in this book.

Optimize your models!—*Any model you create in any 3D application starts out with more polygons than are needed to display the form. The polygon count can always be reduced without affecting the appearance of the model. The optimal amount of reduction may vary greatly, based on the complexity of the forms involved and the type of texture being used on the parts. Some models can have their polygon count reduced by as much as 70% without affecting the appearance of the model, while other models can achieve only a 5% reduction. All professional 3D applications have an* Optimize *option—though it may be named differently—that shows you the present polygon count as a first step in the process. From there, you explore possible reductions by entering a lower polygon count or a percentage of reduction. Standard Optimize operations may just decide what is a good reduction automatically,*

CHAPTER 7 3D MODELING TOOLS

but I prefer having control over this operation so I can judge and compare the results. If you are a 3DS Max user, you should investigate the Digimation plug-in called MultiRes *(www.digimation.com). This optimization plug-in was created especially for game designers, who always need to reduce the polygon count in models so that they respond faster during play, while keeping their details. In Bryce, it is essential that you optimize external models before importing them. The higher the model count in Bryce, the more you have to be concerned about optimization, or the scene will require a much higher amount of RAM, and all modification operations will slow down dramatically.*

DEFORMATION MAPPING

Unlike other Mapping Channel data, the Deformation Channel affects the geometry of the targeted object. For this reason, very small alterations in the value of this component are preferred. Large values tend to create chaotic results. Deformation Mapping is an option you should be aware of, even though it is not offered in Bryce. In many 3D applications, you can apply a Deformation map, and then "snapshot" the object. This translates the Deformation map from a texture to a 3D mesh object, which can then be imported in Bryce with its geometry properly deformed. Remember that a Deformation map is not a Bump map, because Bump maps do not really deform an object's geometry. If your external 3D application features both Deformation mapping and the ability to snapshot an object, do the following.

DEFORMATION SNAPSHOTS FOR BRYCE

I am using 3DS Max as a referenced 3D application here, but you may apply this tutorial to any 3D application that allows Deformation Mapping and Snapshotting. Note that Deformation maps are called Displacement maps in 3DS Max. Do the following:

Deformation maps work best on high polygon count objects, so this is a case when reducing the number of polygons is not suggested. For that reason, you will want to avoid too many Deformation-mapped objects in a Bryce scene.

1. Open your external 3D application, and place an object in the scene. In this case, I am using 3DS Max and a teapot object. See Figure 7.43.
2. Apply a Deformation (Displacement) map to the object. The one I am using is displayed in Figures 7.44 and 7.45.

FIGURE 7.43 *Place an object in the scene.*

FIGURE 7.44 *For this example, I used this texture. The white areas will cause a "higher" displacement of the polygons.*

3. Save in a format that Bryce can import, and import to Bryce. The object appears, but there is no Deformation mapping applied! What happened? Deformation mapping is a texture. It deforms the geometry only in the external 3D application, or in another application that allows Deformation maps (in which case, you would also have to save out the map). However, there is a way to get results in Bryce.
4. Go back to your external 3D application, and save the Deformation-mapped object as an image that Bryce can use as a texture. Make sure the background is white.
5. In Bryce, click on the 2D Picture Object icon, which opens the Picture Editor. Locate the saved image, and load it. See Figure 7.46.
6. Compose your scene. See Figure 7.47.

FIGURE 7.45 *The result of the mapping on the object.*

FIGURE 7.46 *The image is loaded into the Picture Editor.*

CHAPTER 7 3D MODELING TOOLS 135

FIGURE 7.47 *The finished scene.*

PARTICLE SNAPSHOTS FOR BRYCE

Particle Systems are used to create a wide array of special animation effects in many 3D applications—smoke, fire, and other swarm-based events. If your external 3D application features Particle System options, and you have Snapshot capability, you can tap into both to create some interesting modeling options for Bryce.

CREATING BRYCE PARTICLE ARRAYS

Do the following to create a Bryce Particle Array:

1. Open your external 3D application, and locate the controls for any of its Particle Systems.
2. Create a Particle System. Don't use too high a particle count. Keeping the count below about 40 is suggested.
3. Go to a frame that shows the particle swarm in an arrangement you like, and Snapshot. See Figure 7.48.

Some Particle System applications allow you to replace the particle points with a selected object (spheres, etc.), which is preferable for Bryce work.

4. Save the Snapshot object in a format that Bryce can import, and import into Bryce. See Figure 7.49.

Although a Particle System contains a number of cloned objects, there is no Grouping involved. The entire Snapshot is one object, and cannot be UnGrouped in Bryce. You can prove this further by going to Convert Selection To, *and converting the array of particle objects to a Bryce primitive. Only one object will be substituted.*

136 **ADVANCED BRYCE CREATIONS**

FIGURE 7.48 *Snapshot a frame that displays the particle swarm in an arrangement you like. The particles shown here have been referenced to a Torus.*

FIGURE 7.49 *The Snapshot appears in Bryce.*

5. Map the Snapshot with a favorite Bryce material. See Figure 7.50.
6. Duplicate the Snapshot, and use the duplicates to create a structure in Bryce. See Figure 7.51.

 The simple Bryce project illustrated in Figure 7.51 weighs a whopping 11.5MB. It took 20 minutes to render on an 800-MHz system.

FIGURE 7.50 *Map the Snapshot with a favorite material.*

FIGURE 7.51 *Duplicated Snapshots were used here to create a vertical array, with a cylinder at the center. This composition resembles chaotic and random chain links.*

TRAVELING ON

In this chapter, we focused on the tools and processes common to most 3D applications that can help you create modeling content for Bryce projects. The next chapter looks at specific external 3D software and utilities that can make your photorealistic Bryce adventures much more doable and enjoyable.

CHAPTER 8
Helpful Handshaking

Advanced Bryce Creations

This chapter includes a series of tutorials that focus on Bryce handshaking with other potential content software applications. This is in addition to a professional 3D application that contains the modeling tools mentioned in the last chapter for the 3D application of your choice. By *handshaking*, I am alluding to the output of other software developing content that can be imported into Bryce. Given that Bryce is able to import a variety of 2D image and 3D modeling formats, this could include dozens of applications. I have narrowed the list down, however, to include some specific applications that I consider to be vital for high-end Bryce work. My list includes Amorphium from Electric Image, Tree Professional from Onyx Software, Poser from CuriousLabs, Organica from Impulse Software, Deep Paint 3D from Right Hemisphere, and PhotoPaint and Painter from Corel (including some very specific plug-ins).

The tutorials in this chapter are meant for those readers who own and use these products, but can also provide some motivation to invest in them for readers who want some detailed examples of how they can be used with Bryce.

Amorphium

Amorphium, from Electric Image, is a very valuable modeling application when it comes to customizing and deforming models used in Bryce scenes. There is no other 3D software quite like it. Amorphium should be thought of as a supportive addition for all other 3D applications. What makes Amorphium unique is its intuitive real-time clay modeling features and its array of deformation options. You must own and already have an understanding of how Amorphium works to do this tutorial.

Amorphiumizing a Terrain

TUTORIAL

In this tutorial, we will explore how to use Amorphium to customize a Bryce Terrain. Do the following:

1. In Bryce, place a Symmetrical Lattice in the scene. Go to the Terrain Editor, and click New.
2. Click on the Pictures tab. Click Load to access your path directory, and open the Terrain Maps folder in the Bryce directory. Select Mayan Pyramid from the list. See Figure 8.1.
3. Write the object to the scene. *Convert Selection To* a terrain. Figure 8.2 shows the result.
4. Export the model in Wavefront OBJ format to hard disk.
5. In Amorphium, import the same model. See Figure 8.3.
6. At the bottom of the Amorphium Preview window, select New and then MeshMan. Click on Quad, and close the window. This gives you four times

Chapter 8 Helpful Handshaking

FIGURE 8.1 *The Mayan Pyramid elevation map appears in the Terrain Editor.*

FIGURE 8.2 *The Mayan Pyramid object, mapped with the High Frequency Stone Wall material.*

as many polygons, which is valuable when working on a complex model in Amorphium. See Figure 8.4.

7. Click OK to accept the Quad option. In Amorphium, apply a Mask so that just the top of the model is selected for modification. Under Tools&Distorts, click on Stretch to increase the vertical height of the unmasked section of the model, and then apply a 100% Smooth. The result should resemble Figure 8.5.
8. Unmask everything. Go to the Bottom View and apply Twirl at 50%. See Figure 8.6.
9. Export the model in the Wavefront OBJ format. Import in Bryce, and apply a Mech Map material in Object space from the Miscellaneous

FIGURE 8.3 *The model as it appears in Amorphium.*

FIGURE 8.4 *Use the MeshMan Quad option to multiply the polygons.*

FIGURE 8.5 *Stretch and Smooth the top of the model.*

FIGURE 8.6 *A 50% Twirl is applied.*

FIGURE 8.7 *The finished scene.*

Library. Compose a scene that shows the model sitting on a water surface. See Figure 8.7.

Mechanical Parts

Here's another Amorphium/Bryce exercise. Do the following to create a machine part:

1. In Bryce, place a Symmetrical Lattice in the scene. Go to the Terrain Editor, and click New.
2. Click on the Pictures tab. Click Load in the second window to access your path directory, and open the Terrain Maps folder in the Bryce directory. Select Mayan Pyramid from the list. Click Load for the first window, and choose the Brass Circle Island Terrain Map. Click Apply. The object you

Chapter 8 Helpful Handshaking

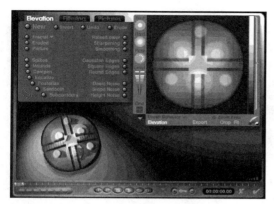

FIGURE 8.8 *The object is created in the Terrain Editor.*

FIGURE 8.9 *The rendered object as it appears in the scene.*

have created is a blend of both Terrain Maps, resembling a complex gear. Apply Round Edges at 100% twice to get rid of most of the edge. See Figures 8.8 and 8.9.

3. Export in OBJ format to disk. Import the object into Amorphium. See Figure 8.10.
4. Select one of the router nubs with six-point symmetry on, and cut away a portion of the outer rim of the object to form gear teeth. See Figure 8.11.
5. Export as an OBJ model, and import into Bryce. Create a scene that incorporates the model. See Figure 8.12.

FIGURE 8.10 *The object is imported into Amorphium, as seen in the Top View.*

FIGURE 8.11 *Form the gear teeth.*

ADVANCED BRYCE CREATIONS

FIGURE **8.12** *Incorporate the model in a Bryce scene.*

 There are literally thousands of ways to create and customize models in Amorphium for Bryce placement. I consider Amorphium essential for complex Bryce work.

TREE PROFESSIONAL

Tree Pro from Onyx Software is a valuable add-on for Bryce creations. A plug-in version of Tree Pro, *Tree Storm*, is available for 3DS Max users as well. When you need to create trees for a Bryce scene that have your own personalized stamp, use TreePro to do it. TreePro allows you to alter the parameters of any preset tree form, or create your own tree and/or bush model from scratch. The presets include both real-world trees and fantasy models, any of which can be customized to any extent you need. Models can be saved out in a number of 3D formats for Bryce incorporation, including LightWave, Wavefront, and DXF. If you have TreePro, do the following to explore handshaking with Bryce:

1. Open TreePro, and load the *Romulus 106* preset found in the Romulus Series folder, which contains Fantasy trees. See Figure 8.13.

Chapter 8 Helpful Handshaking

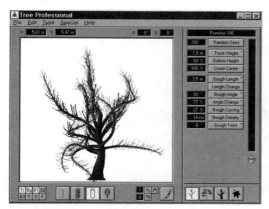

FIGURE 8.13 *The Romulus 106 model parameters cause this tree to appear on the TreePro preview screen.*

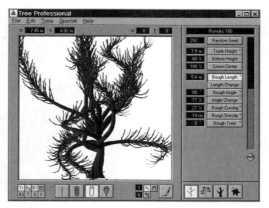

FIGURE 8.14 *Set the Bough Length slider to about 50% as shown.*

2. Set the Bough Length slider to about 50% as displayed in Figure 8.14.
3. Set Branch Density as displayed in Figure 8.15, and switch on the parameters as displayed at the bottom left.
4. Set Trunk Mold as displayed in Figure 8.16.
5. Export in a format Bryce can import. Import to Bryce. UnGroup to apply different materials to component parts, and Group again. Create a scene using the tree. See Figure 8.17.

To conserve storage space for a Bryce scene, use TreePro images mapped to a Picture Plane instead of 3D trees.

FIGURE 8.15 *Set Branch Density as shown.*

FIGURE 8.16 *Set Trunk Mold as displayed here.*

144 ADVANCED BRYCE CREATIONS

FIGURE 8.17 *A Bryce scene with TreePro trees.*

Because TreePro models cannot be saved and given to you because of copyright laws, you will have to own TreePro in order to create and save the models. Therefore, this Bryce scene is not included on the CD that accompanies this book.

TreePro and Amorphium

Amorphium can be used to customize a TreePro model, stamping your personal signature on it. Do the following:

1. Create a tree model in TreePro, and save it as a Wavefront OBJ file. Import into Amorphium. See Figure 8.18.
2. Go to the Top View and add a 75% Twirl. See Figure 8.19.

FIGURE 8.18 *Import a Tree Pro model into Amorphium.*

FIGURE 8.19 *Add a 75% Twirl from the Top View.*

Chapter 8 Helpful Handshaking

FIGURE 8.20 *A 20% Bend is added in the front view.*

FIGURE 8.21 *Add a 1% Noise deform.*

FIGURE 8.22 *Add a Belly deform.*

3. Add a 20% Bend in the Front View. See Figure 8.20.
4. Add a 1% Noise deform from the Front View. See Figure 8.21.
5. Add a −60% Belly deform from the Front View. See Figure 8.22.
6. Export as an OBJ file, and import into Bryce. Create a scene that involves this object. See Figure 8.23.

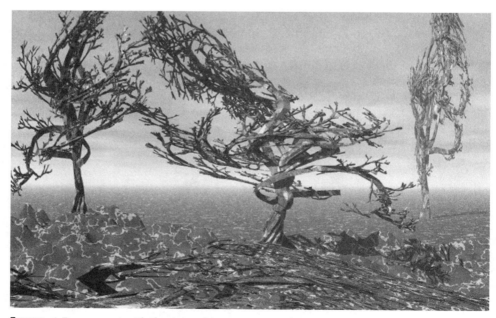

FIGURE 8.23 *A Bryce scene with the Amorphium-customized tree.*

146 ADVANCED BRYCE CREATIONS

Most Bryce scenes can benefit from just one tree model to create a veritable forest. All you have to do is duplicate the original and resize it as many times as needed.

CURIOUSLABS' POSER

Poser is vital to complex Bryce environment creations when it comes to adding sculptural components that emulate anatomical data. This book concerns itself with Bryce environments and not developing creatures from Bryce worlds, but there are still many places that you can use Poser output for creating nonliving elements.

THE STATUE

Whether you need a small model of a sculpture that sits at the center of a reflection pool, or a larger model of an iconic god figure that sits on a giant throne in a temple, Poser is the application you need. You have to own Poser to do this tutorial. Do the following:

1. Go to the People/Figures library, and place the P4 Nude Woman figure in the scene. Go to the Poses/Sculpture Sets library, and select the Venus pose. See Figure 8.24.
2. Go to the Hair/Hair Types Library, and select Female Hair 1 to place hair on the model's head. See Figure 8.25.

FIGURE 8.24 *The Nude Woman model in the Venus pose appears in a Poser scene.*

FIGURE 8.25 *Hair is placed on the head of the model.*

Chapter 8 Helpful Handshaking 147

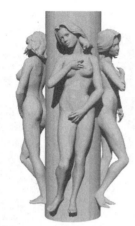

FIGURE 8.26 *An arrangement of Poser models around a cylinder.*

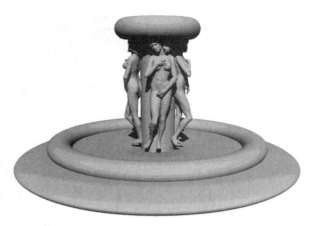

FIGURE 8.27 *The top and bottom of the fountain are added.*

3. Export as an OBJ model, and import into Bryce. From the Top View in Bryce, configure four duplicated models around a central cylinder, and map all with the Simple&Fast Terra Cotta material. Group everything. See Figure 8.26.
4. Use three scaled Torus primitives to create the bottom and top of the fountain. Group everything. See Figure 8.27.
5. Place a Squashed Cylinder primitive in the pool to emulate water. Map it with a suitable water material (Backyard Pool works well). Use Random mapping.
6. Go to the Imported Objects library, and select the screw. Make sure it is upside down, and scale to create a water stream coming from the top of the fountain. Add a water material with 100% transparency, and then place and duplicate. Add any refinements that suit your taste, and create a surrounding scene. Refer to Figure 8.28.

Go No Further!

Here's another Poser/Bryce project to try. Do the following to create a warning marker, perhaps something to alert a visitor that there is danger ahead:

1. In Poser, go to the Figures/Animals Library, and select the Wolf. See Figure 8.29.
2. Export the following body parts as an OBJ file: Neck 1 and 2, Head, and L and R Ears. Import in Bryce.
3. Apply a Copper Bump material from the Complex FX Library to the neck, head, and ears. Apply a yellowish white material to the teeth. Apply a red material to the eyes. Render to preview. See Figure 8.30.

FIGURE 8.28 *The finished fountain.*

4. Duplicate and flip the head on the X-axis. Create a Sphere and a Stretched Pyramid primitive, and group with the head as displayed in Figure 8.31.
5. Add a pole of your own design, and Group everything. See Figure 8.32.

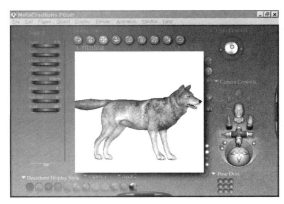

FIGURE 8.29 *The Wolf appears in a Poser scene.*

FIGURE 8.30 *The Wolf head as it appears in Bryce after texturing.*

CHAPTER 8 HELPFUL HANDSHAKING 149

FIGURE 8.31 *Create this grouped object.*

FIGURE 8.32 *The finished warning marker.*

6. Create a cave (Boolean Subtraction) in a mountain, and place two of these markers at the entranceway. Use a suitable IGP, and an interesting sky. Place a Spotlight in the foreground if the scene isn't properly lit. There are limitless compositions waiting to be created when you use these components. See Figure 8.33.

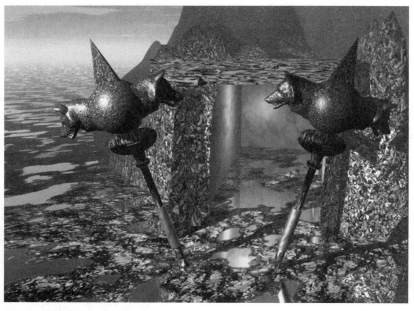

FIGURE 8.33 *The finished scene.*

Advanced Bryce Creations

Customizing Poser Textures

All of the models that ship with Poser, and all of the extra models that various developers create for Poser, come with Textures. Some models have Texture Templates as well. Textures and Texture Templates are laid out in 2D so that they map to every part of a model correctly. This gives you the opportunity to alter the texture bitmap in any bitmap painting application (Corel's PhotoPaint, for instance). Let's walk through a texture painting exercise. You will need Corel's PhotoPaint (or another 2D painting application) and Poser to follow along. Do the following:

In later chapters, when the directions ask you to paint a texture map for a Poser figure, refer to this tutorial.

1. Open your 2D painting application.
2. Open your Poser folder, and go to Runtime/Textures, P4 Textures. Load P4 Man Texture.tif. See Figure 8.34.
3. Select the background with the Magic Wand tool, causing a marquee to appear. Select Inverse, so that the marquee appears around all of the non-background content. This will allow you to paint only the image areas.
4. Carefully paint all of the image areas with any colors or patterns you prefer. It's best to zoom in on the detailed areas like eyes, mouth, and teeth. I prefer creating a separate layer to do this, which allows me to delete any errors quickly. When complete, save the image to the same folder under a new name. See Figure 8.35.

FIGURE 8.34 *The P4 Man Texture.tif file.*

FIGURE 8.35 *Paint an altered texture and save.*

Chapter 8 Helpful Handshaking

FIGURE 8.36 *The customized texture creates an entirely new personality.*

5. In Poser, load the P4 Man model. In the Materials window, load the texture you just saved. Do some test renders. Tweak the model as needed. See Figure 8.36.

TUTORIAL

Impulse's Organica

Metaball modeling is a unique way of creating object content. Applications, of which there are many, that allow Metaballs generate models from "sticky" spheres and other forms. When a Metaball primitive moves in proximity to another Metaball primitive, it affects the surface of the target Metaball primitive. If the Metaball primitive being moved has a positive influence, the Metaballs stick together. If the Metaball being moved has a negative influence, the surface of the targeted Metaball primitives are pushed inward. Although your external 3D application of choice may offer Metaball modeling, the best Metaball application by far is Organica from Impulse Software. This tutorial is for those readers who either own Organica or who may be interested in an introduction to it. Do the following to create parts for a bridge model in Bryce:

1. Open Organica. Place three Hourglass MetaBlocks, as displayed in Figure 8.37.
2. Add a Torus, two Bent Bars, and a Box MetaBlock as displayed in Figure 8.38. Add two more Bent Bars, and two Bent Rods. Add one more large Box. See Figure 8.38.
3. Save in a format your external 3D application can import. Import into your external 3D application. Optimize to reduce the polygon count, and export

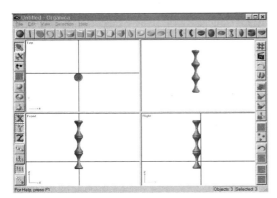

FIGURE 8.37 *Place three Hourglass MetaBlocks as shown here.*

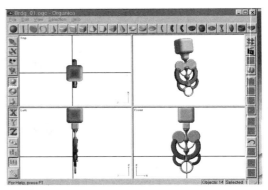

FIGURE 8.38 *Refer to this figure for the design so far.*

in a format Bryce can import. Import into Bryce. Rotate 180 degrees on the Z-axis, and map with the Rustic Vein material from the Wild&Fun Library. Use Object Space mapping. See Figure 8.39.

4. In Organica, create the form shown in Figure 8.40 with a Barrel and two Bent Rods.
5. Add a Wedge, two Torii, and a Cone as shown in Figure 8.41.
6. Add two more Torii at the top. Add two Bent Rods as shown in Figure 8.42.
7. Create another Torus. Bring up the Deformation controls (press Return). Apply the following Deformations: Stretch X 100%; Taper Y 100%; Twist Y 100%. Place this component on top of the stack of other components.

FIGURE 8.39 *The first part of the bridge.*

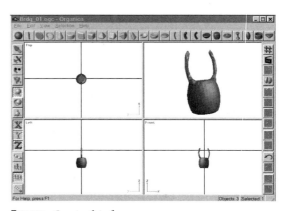

FIGURE 8.40 *Create this form.*

Chapter 8 Helpful Handshaking

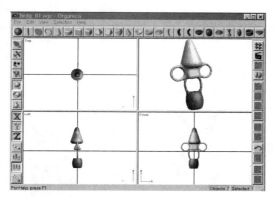

FIGURE 8.41 *Create this form.*

FIGURE 8.42 *Add two more Torii and two Bent Rods.*

Place a sphere on top, and add some cylindrical connecting arms. The model is complete. See Figure 8.43.

8. Save in a format your external 3D application can import. Import into your external 3D application. Optimize to reduce the polygon count, and export in a format Bryce can import. Import into Bryce. Map with the Archeological Find material from the Rocks&Stones Library. Use Object Space mapping. See Figure 8.44.
9. Select the first Organica construct and duplicate. Move on the Z-axis. Place a cylinder through the holes of the top Torii, connecting the two objects. Use any material you like on it, and Group the three components. See Figure 8.45.
10. Create two duplicated components, and move apart equidistantly to form the base structure. See Figure 8.46.

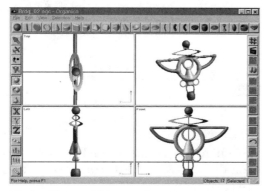

FIGURE 8.43 *The model is complete.*

FIGURE 8.44 *Import into Bryce and add a texture.*

FIGURE 8.45 *Create this element.*

FIGURE 8.46 *Create the base structure.*

11. Create a roadway, Object Space map it with Multi-beveled Blocks from the Miscellaneous Library. See Figure 8.47.
12. Use six of the Organica 2 objects as vertical struts, and use a very thin cylinder to create some cross-bracing. See Figure 8.48.

FIGURE 8.47 *Create a roadway.*

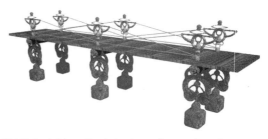

FIGURE 8.48 *Add vertical struts and cross-bracing.*

13. Use some stretched cubes to add guard structures at each end of the bridge, so no one is in danger when they cross. Create a composition that uses the bridge. See Figures 8.49 to 8.51.

Chapter 8 Helpful Handshaking

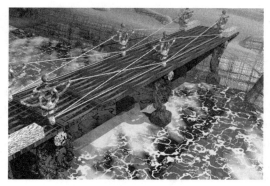

FIGURE 8.49 *The bridge to Pleasantville.*

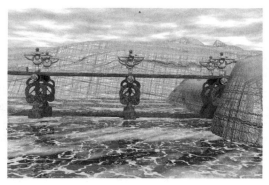

FIGURE 8.50 *Altering the camera angle and placement allows you to float down the river.*

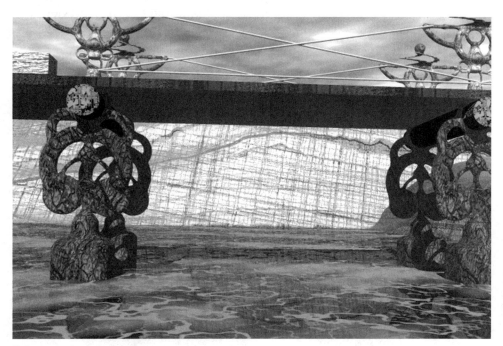

FIGURE 8.51 *A closer look.*

156 **ADVANCED BRYCE CREATIONS**

2D BITMAP F/X

Whether you use Corel Painter, Corel PhotoPaint, or Photoshop, there are plug-ins and features in all of these applications that you can use to generate content for Bryce projects. We will touch on many of these features and plug-ins in Part Three of the book, as we proceed with the project tutorials. There are some items, however, that should be mentioned here; items that stand out for first-priority Bryce-associated handshaking.

PLUG-INS FOR BITMAP APPLICATIONS

When it comes to image-processing plug-ins, there are three ways that Bryce can reference them:

- Image-processing plug-ins can be incorporated as image modification data in the Picture Editor. The Picture, Alpha, and Combination Image each have a control (the small triangle at the upper right of their preview windows) that allows you to access a targeted plug-ins directory. See Figures 8.52 and 8.53.

Always remember the "C-A-B" acronym for Bryce Materials, or Color-Alpha-Bump. The data in the third preview window in the Picture Editor (for the Combination Image) is the "B" or Bump Map setting.

- Using the Filter tab in the Terrain Editor, you can create 3D models from Terrains or Symmetrical Lattices (I prefer the latter). The Filter tab has two preview screens. The data in the first window is a modifier for the data in

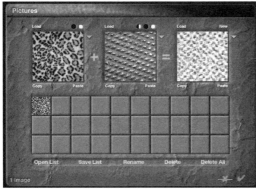

FIGURE 8.52 *Using the Picture Editor, a Leopard image was loaded into the Picture slot, and a Steel Plate image into the Alpha slot.*

FIGURE 8.53 *The result of the configuration displayed in Figure 8.52 is this texture, shown here mapped to a sphere.*

Chapter 8 Helpful Handshaking

Figure 8.54 *Using the same Color and Alpha images as detailed in Figure 8.52, a Photoshop Glowing Edges plug-in is applied to the Alpha image data, which alters the Combination Image data.*

Figure 8.55 *Altering the Alpha channel with the Glowing Edges plug-in causes banding when the material is mapped.*

the second window. The data in the second window is an Elevation map created from a plug-in. Here's how it works:

1. Place a Symmetrical Lattice in the scene. Open the Terrain Editor, and select New.
2. Go to the Filter tab. Leave the curve in the first preview window at its default. Click on the downward pointing arrow at the bottom right of the second window, bringing up your plug-ins list. Select a plug-in that creates rather than modifies content. KPT3 Gradient Designer is a good choice, and it is what I selected here. In Gradient Designer, bring up a Bullseye Gradient. See Figure 8.56.
3. Accept it. Back in the Terrain Editor, click Accept. The plug-in creates an Elevation map, which in turn creates a 3D model. You can tweak and customize from there if you like. See Figures 8.57 and 8.58.

Figure 8.56 *Bring up the Bullseye Gradient in KPT3 Gradient Designer.*

FIGURE 8.57 Apply the Elevation map created in the Filter tab to create the model.

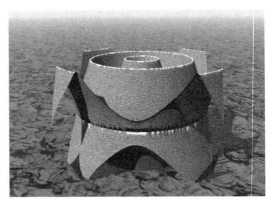

FIGURE 8.58 The rendered model as seen in Bryce.

- The third way to use plug-ins to develop Bryce content is to develop the required image for a material and/or an Elevation map in an external 2D painting application. Then you can bring it into Bryce's Picture Editor or the Terrain Editor's Picture tab. I prefer using Corel PhotoPaint or Painter to do this, but you can use any 2D painting application you like. Here are the general steps:

1. Open your 2D painting application. Create a new image. Use 24-bit color if it is to be used for an image map, or 8-bit grayscale if it is to be used for an Elevation map (though you can also explore using the same image for both). If the image is to be used to create Alpha Channel data, use only pure black and pure white. It doesn't matter which is the background as far as Bryce is concerned, since you can always invert. Stay away from pure black or pure white if you are working in color. See Figure 8.59.

FIGURE 8.59 Here is an example of an image you can create. The data is solid white in this case, and the content is solid black. A medium-gray fill was added inside the circles. This will be used as an Elevation map in the Terrain Editor's Picture tab.

FIGURE 8.60 *The image is warped with a Pinch distortion.*

FIGURE 8.61 *The finished and rendered model.*

2. Use a Pinch distortion filter to reshape the image. See Figure 8.60.
3. Place a Symmetrical Lattice in the scene. Open the Terrain Editor, and select New.
4. Go to the Pictures tab. Import the image you just created to create an Elevation map, which in turn creates the 3D model. See Figure 8.61.

THE PAINTER IMAGE HOSE

If you are a Corel Painter user, you are familiar with the Image Hose. The Image Hose literally sprays image content based on a selection of "Nozzles." The Nozzles in Painter include dozens of unique brushes that reference all kinds of data, from abstract patterns to flora and fauna. Image Hose-influenced paintings are best used in Bryce on a Picture Plane object, cutting down on the memory required when you need to fill a scene with background components that look photorealistic without having to be 3D models. Here's an example:

1. Open Painter, and create a new image 512 × 512 pixels at 72 dpi.
2. Select the Paint Brush tool, and then the Image Hose. Choose a nozzle that contains some flower or leaf content. Spray the content with the Image Hose to create a composition. Be sure to stay away from the edges of the image. See Figure 8.62.

Although you can use any of the Nozzles that ship with Painter, I highly recommend the Jungle 3D CD from DigiArts Software. This heavy collection of Image Hose Nozzles is made especially for Bryce work, and should not be overlooked by any Bryce user. Jungle 3D has over 1000 Nozzles, with 50 different plants and trees. They're perfect for Bryce because Alpha channel data is built in. Find out more at www.gardenhose.com.

FIGURE 8.62 *An image created with the Image Hose in Painter, and the Poinsettia and Daisy flower Nozzles from the Jungle 3D collection.*

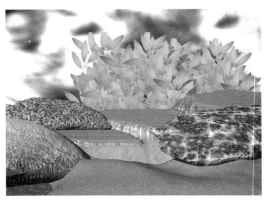

FIGURE 8.63 *The image is integrated into the scene.*

3. Save and import the image onto a Picture Object. Place the image where you want it in the scene. See Figure 8.63.

Some of the projects in Part Three call for the use of Painter's Image Hose and the Jungle 3D collection.

PLUG-INS YOU JUST GOTTA HAVE

Every computer graphics user has a list of plug-in favorites. Here are a few image-processing plug-ins that I highly recommend to every Bryce user . . . and why.

THE COREL KPT COLLECTION

You should purchase and install KPT 3, 5, and 6 in your 2D painting application's folder if you haven't already done that, in order to do some of the tutorials in Part Three. As a Bryce user, you should own and be familiar with these plug-ins in any case. Each of these plug-in collections offers you a variety of options not available anywhere else (www.corel.com). See Figure 8.64.

KPT3

Although there is something for everyone in the vintage KPT3 collection, there are specific plug-ins that are more vital than others when it comes to Bryce work, especially for the tutorials in Part Three of this book. These plug-ins include Gradient Designer and Texture Explorer.

Chapter 8 Helpful Handshaking

FIGURE 8.64 *The following plug-in illustrations use this image as a reference.*

Gradient Designer

TUTORIAL

Gradients are textures built upon repeated content and the transition of one or more colors. Use Gradients to create 2D Picture content in Bryce. Gradients work well in any Material channel. Do the following:

1. Open PhotoPaint (or your alternate image-editing application) and create a new image 512 × 512 pixels at 72 dpi.
2. Access the KPT3 plug-ins, and select Gradient Designer. Its interface appears. Choose the Morning Star Gradient (#100). See Figure 8.65.
3. Accept the default settings and save. Open Bryce. Create a Symmetrical Lattice and go to the Terrain Editor. Click New, and go to the Pictures tab. Load the image you just created into both the Color and Alpha slots. Click Apply, creating the model. See Figure 8.66.

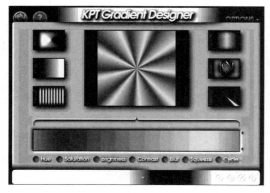

FIGURE 8.65 *The KPT3 Gradient Designer interface with the Morning Star selection loaded.*

FIGURE 8.66 *Load the image into the Terrain Editor's Picture tab.*

FIGURE 8.67 *Add a Gaussian Edge, Smooth, and add a hole.*

FIGURE 8.68 *The completed form appears in the scene. In this case, it was mapped with a Gold material.*

4. Go to the Elevation tab, and add a Gaussian Edge. Add Smoothing. Drill a hole at the center that goes all the way through. See Figure 8.67.
5. Accept the modifications. The form appears in the scene. See Figure 8.68.
6. *Convert Selection To* Terrain, and reduce the vertical scale by half. Return to the Terrain Editor, and add some small "bolts" with Elevation painting. See Figure 8.69.
7. Create a "tire" from a Torus primitive, and close its hole by Editing it (Objects>Edit Object). Your Terrain object is a wheel well. Create another Torus. Make it very thin, and use it as a rim around the wheel well. Place a small blue metal sphere at the center. Group everything. The finished object is shown in Figure 8.70.

FIGURE 8.69 *Add some bolts.*

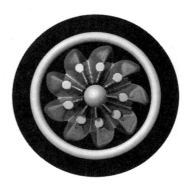

FIGURE 8.70 *The finished tire. This model weighs less than 350 kb.*

CHAPTER 8 HELPFUL HANDSHAKING 163

TUTORIAL

TEXTURE EXPLORER

Use this plug-in when you need to create 3D models from Terrain Editor data, or to develop materials for your models. As an example, do the following:

1. Create a new image 512 × 512 at 72 dpi in PhotoPaint (or your other painting application). Open the KPT3 Texture Explorer plug-in. Select texture #130 (Melted Sunglasses) from the list. Do no modifications, and accept it. See Figure 8.71.
2. In Bryce, create a flattened sphere. Map it with Bryce Terracotta material for the Diffuse component. In the Bump channel, select the Picture Editor. Load the image you just created in step 1. Use Parametric Scaled mapping, and increase the quantity to 40. Increase the Bump amount to 777. The result is the beautiful design shown in Figure 8.72.

FIGURE 8.71 *The Texture Explorer interface with the Melted Sunglasses texture loaded.*

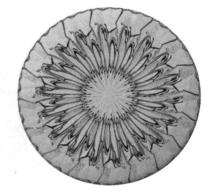
FIGURE 8.72 *Placing the Texture Explorer image in the Bump channel, combined with Parametric Scaled mapping, created this mandala design.*

KPT5

Two plug-ins in this collection are especially valuable for Bryce work. The first is FraxSplorer, which creates fractal designs. The second is my favorite: FraxFlame.

FraxFlame

1. Open your painting application, and make sure KPT5 is installed in the Plug-ins folder. Create a new image 512 × 512 pixels at 72 dpi. Choose the KPT5 FraxFlame plug-in. Select an option from the presets. See Figure 8.73.
2. The FraxFlame image is created. See Figure 8.74.

FIGURE 8.73 *The FraxFlame interface with a preset image selected.*

FIGURE 8.74 *The resulting FraxFlame image.*

3. Save this image and select the background color. Make it solid black. Make the rest of the image solid white. This is Alpha channel data. Save under a new name.
4. Use the Alpha Data in a Picture Editor, and map it to a flattened sphere's Transparency channel. Duplicate the object three times to create a model that shows horizontal and vertical symmetry, and Group all. See Figure 8.75.
5. Duplicate three more times and form an arrangement for a totem pole. Group with a cylinder. See Figure 8.76.
6. Place in a scene of your own design. See Figure 8.77.

FIGURE 8.75 *The finished model takes its personality from the FraxFlame Alpha/Transparency data.*

FIGURE 8.76 *The finished totem pole.*

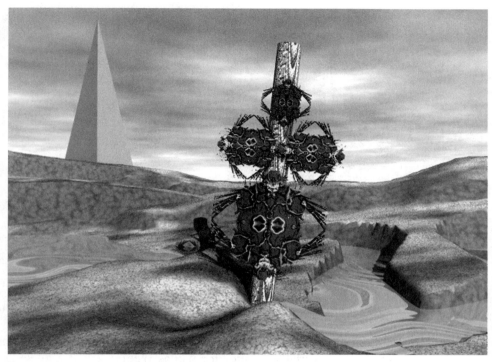

FIGURE 8.77 *The totem signifies a sacred space.*

KPT6

My favorite Bryce-associated content plug-ins in the KPT6 collection are Lens Flare, Sky Effects, and Turbulence. Here's a unique way to use Sky Effects for a Bryce scene:

1. Open PhotoPaint (or your painting application of choice). Create a 512 × 512 pixel image at 72 dpi. Make sure KPT6 is installed.
2. Open the KPT6 Sky Effects filter. Configure any sky you like by tweaking the controls, or load a sky preset. Apply, and save the image. See Figure 8.78.
3. In Bryce, place a Picture Object in the scene. Map it with the sky image you just created, and make sure all transparency settings in the Material Lab are off. Enlarge the Picture Object to fill the Camera View. Turn all shadow casting and receiving off, and make sure the sun is shining straight at the object.
4. Place two head models (from Poser or elsewhere) in the scene. Embed each of them to a different degree in the Picture Object plane. Map as you like. See Figure 8.79.

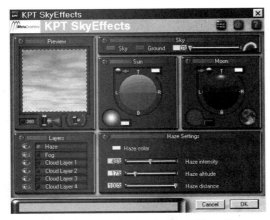

FIGURE 8.78 Configure a sky in the Sky Effects filter.

FIGURE 8.79 There are times when a standard cloud plane will not do to achieve certain effects quickly.

EYECANDY 4000

The Eye Candy 4000 filters contain quite a few plug-ins; too many to cover in detail here. For Bryce-associated work, I recommend that you look at the following ones first: Marble, Weave, and Wood. All three of these filters create spectacular and variable images for use as picture textures in Bryce. Here are two short tutorials that allow you to create Woven Wood and Marbleized Wood:

1. Open PhotoPaint (or your painting application of choice). Create three 512 × 512 pixel images at 72 dpi. Make sure EyeCandy 4000 is installed.
2. Open the EyeCandy 4000 Marble, Weave, and Weave filters one at a time, and create three images (one from each filter) on the three blank images. Filter. Configure any sky you like by tweaking the controls, or load a sky preset. Make each image according to your designer's eye, tweaking the controls as necessary. Save all three images. See Figure 8.80.
3. Open Bryce if it not already open. Place a cube primitive on the screen. Duplicate the cube so that you now have two cubes. Move them apart so you can see both.
4. First, we'll create a Woven Wood texture for the cube on the left. With the cube on the left selected, open the Materials Lab, and then the Picture Editor. Load all three textures, each in its own slot. Click on the Wood texture's slot. Apply the Wood texture to the Diffuse channel.
5. Place a button in the Texture B value for the Bump channel. Go to the Picture Editor, and place the Weave texture in that slot. This channel (Bump) needs an Alpha value, so copy/paste the same Weave image in the Alpha preview. Give the Bump a value of –100. Note that both Textures A and B are mapped parametrically with the Scale Control set to 0%.

CHAPTER 8 HELPFUL HANDSHAKING **167**

FIGURE *Three images are created from EyeCandy*
8.80 *4000 filters: Marble, Weave, and Wood.*

6. Select the other cube. Open the Materials Lab. Hold down the Shift key and place a button in both the Texture A and B slots for the Diffuse channel. Place a button in the Texture A Transparency channel. This causes the Marble image to determine where the object will be transparent.
7. Apply these settings. In the scene, with the second cube still selected, Duplicate. Scale the duplicated cube 99% on all axes; this creates a smaller cube inside the first one. Apply a Yellow material to the smaller cube, and group with the larger one from which it was duplicated. This will act as a background for the larger cube with the transparent textured mapped on it. See Figures 8.81 and 8.82.

FIGURE *The cube on the left displays a Weave*
8.81 *Bump on a Wood texture. The cube on the right is more complex, showing both a Marble and a Wood Diffuse content and transparent areas over a separate color backdrop.*

FIGURE *The Woven Wood material also lends*
8.82 *interesting surface attributes to floors and walls, rather like a corrugated parquet.*

Xaos Tools Terrazzo

One of my all-time favorite image-processing plug-ins is Terrazzo from Xaos Tools. Terrazzo, as the name suggests, allows you to select a portion of your image from which exquisite tiled images can be built. A library of patterns allows you to vary the composited arrangement. Bryce palaces and temples are often in need of a tiled floor, and Terrazzo is the perfect way to create them. Terrazzo is a necessary plug-in for you to own if you want to follow along with the tutorials in Part Three of this book. See Figure 8.83.

Do the following to create an awesome tile:

1. Open your image application, open any color image, and select the Terrazzo plug-in. You could also select a grayscale image and create content for a Terrain Editor model.

 PhotoPaint has its own Terrazzo plug-in that is resident in the Plug-ins folder. PhotoPaint also comes with KPT5 plug-ins, including FraxFlame.

2. When the Terrazzo interface appears, select an area of the image that will be referenced by moving the image selection outline. Select one of the Symmetry options to organize the pattern. Scale as necessary. Move the image in the preview window until it is centered. Apply the results.
3. Clip the image so that you cut away any extraneous data, and save it to disk. See Figure 8.84.

FIGURE 8.83 *The Terrazzo interface.*

FIGURE 8.84 *A Terrazzo image.*

CHAPTER 8 HELPFUL HANDSHAKING

4. Open Bryce. Place a Symmetrical Lattice in the scene, and open the Terrain Editor.
5. Select New, and then Invert. This creates a solid block.
6. Use Lower to decrease the vertical scale of the block by about 75%. Use a Gaussian Edge to create beveled edges. Convert Object to a Terrain, and decrease the vertical scale of the block by half. See Figure 8.85.
7. Create a Cube primitive and resize as closely as possible to the top of the beveled tile. Place on the beveled tile, and map with the image you created in step 2. Group with the tile when complete. See Figure 8.86.

FIGURE 8.85 *The beveled tile.*

FIGURE 8.86 *The completed tile.*

8. Duplicate/Replicate to create a tiled floor. See Figure 8.87.

FIGURE 8.87 *The tiled floor idea can also be used for creating the walls of a temple with photorealistic results. Be careful not to make these tiles too large in relation to any characters walking on them. They may stumble and bring a lawsuit. These tiles are also useful for fancy counter and table tops.*

 If you need to tile a very large surface, it's best to export these tiles to a 3D application that can optimize them first. Then, import back to Bryce and add textures.

Traveling On

By now, you should have completed a detailed refresher course for Bryce, working through the tutorials in the first eight chapters. Now... get ready to create some fantastic photorealistic worlds!

PART III

Eight StoryWorlds

CHAPTER 9

The Great Blue-Ice Throne Room

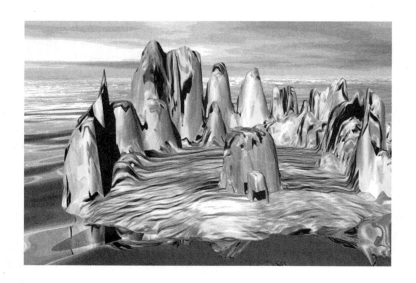

Hemingway said that a writer must draw upon his or her own experience when it comes to creating stories. A fantasy writer has to do the same, even though the topic may be far afield from any possible waking experience. A fantasy writer and artist must learn how to dream-on a topic, to imbue it with suspected experience and reality. To do this, you have to imagine yourself in the environment you want to create, or draw upon a similar environment that resides in your life experiences memory. In this project, I didn't have to look far to engender a wealth of ideas about what it might be like to live in a frozen world, a world with a permanent ice desert. In many ways, I live in just such a place, at least for seven months of the year.

Vermont may be a picture postcard when it comes to a tourist's impressions, but for those of us who live here there are just two seasons: cold, and preparing for the cold. I didn't have to spend too much time fantasizing the parameters of this frozen world. If you reside in more temperate climes, however, you may have to prepare your imagination in other ways to shape what you are about to create. Perhaps your sense of a frozen world can be fed by a journey you took to the North, or even from tales told to you by a friend or relative. You might even rely on dedicated research to embellish your intuitions. After all, dozens of travel and other documentaries, and even feature films and novels, center on this specific topic in one way or another.

The one thing that all frozen lands exhibit is a sense that in order to survive, you must find shelter. That is in part what our ice palace is all about. We will want to create a sense of sanctuary from an inhospitable environment, using all of the suitable Bryce tools and processes. Before you sit down at the computer with Bryce, and no matter what resources are feeding your imagination, it would be a good idea for you to sketch your rough ideas. Try to draw the general components that you see as essential ingredients of this project. See Figure 9.1.

As you can see from my sketch in Figure 9.1, I roughed out some components for both the external and internal Blue-Ice Throne Room environments. I usually work from the outside in, preferring to set the general parameters before I do any specifics. Since I look at the externals first, let's develop the external environment.

THE EXTERNAL ENVIRONMENT

Look at the top part of Figure 9.1. This is a sketch of the eternal environment for this project. You will notice that it contains the following components: a sky, distant mountains, a flat plateau, the sea, and the Blue Palace structure's encasement. If you know Bryce, then each of these components brings some exact tools and processes to mind. However, we have a question that must be answered first . . .

CHAPTER 9 THE GREAT BLUE-ICE THRONE ROOM

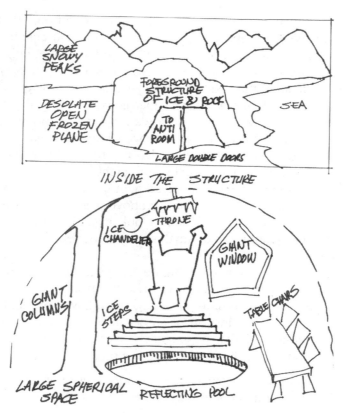

FIGURE 9.1 *When I sketched the initial idea, I jotted down some items that stood out as necessary in the modeling of the environment.*

HOW WILL MY CAMERA APPRECIATE THIS WORLD?

There are many ways to construct worlds in Bryce, all dependent on how they will be viewed. For instance, you could construct a world like a movie set, relegating everything except the core components to props. This would mean that you could concentrate on a narrow window of reality, and not bother with anything outside of a specific camera view. Just think of a movie soundstage. The camera may be shooting a very realistic snow scene, but if the camera strays too far to the left or right, you can see the snow machine and the camera and lighting technicians, and you can also see out the window to a busy California boulevard. Perhaps there is a hut in the background, with a door through which actors enter and exit. If the camera follows an actor through the door, however, you see that the whole building is just a flat façade, with the studio wall on the other side. If we were to set up our project like that, we would create another scene to show the inside of the palace, moving in effect to another "soundstage."

But what if you wanted the camera to show the scene from 500 feet in the air at some point? Well, I suppose you could create a soundstage for every different camera angle you needed, but that would become rather tedious. Wouldn't it be better if you could create a whole world at once, so that one scene could provide all of the needed camera angles on one stage? That is how I approach most of my Bryce work, and that is exactly why Bryce is such a magical application. Because you can work with infinite ground, water, and sky planes, you can actually set up a scene that covers hundreds, and in some cases thousands, of square miles or kilometers! Do not try that with other applications. This will be the way I lay out all of the eight worlds in this part of the book, so that there is literally more involved than meets the eye. That way, if I want to create an animation that starts far above a scene, resolves down to ground level, and then flies into a habitat to look around, I can do exactly that. It calls for a bit more planning, but anything of value demands an investment of time and energy.

With that in mind, look at the top of Figure 9.1 again. Now we have to decide more things. Does the mountain range encircle the palace on all sides? Is the palace and the mountain range sitting on a large island, with water all around? If not, is the water a large river instead of an ocean? Do we want to create anything beyond the mountains that we might fly over on the way to the palace? Here are the decisions that I dreamed-on for this project:

- The palace and the mountain range do indeed sit on a large island. This means that the island is composed of one or more flattened terrains, and not an infinite plane.
- The mountains do not fully encircle the island, but only three-quarters of it. One-fourth of the island opens to the sea.
- The water is a sea (an infinite water plane), and not a large river. On the side of the island that opens to the sea, there are strange towers rising from below the water in the distance, and a few icebergs as well.

TUTORIAL

CREATING THE EXTERNAL ENVIRONMENT

Now that we have a better idea of the global design and parameters, we can set about the creation of the external environment.

The Sea and Sky

To create the sea, we will use an infinite water plane. Do the following:

1. Place an infinite water plane in the scene.
2. With the water plane selected, go to the Materials Editor. Select the Deep Sea material from the Waters and Liquids Library. Set the parameters as displayed in Figure 9.2.

Chapter 9 The Great Blue-Ice Throne Room

FIGURE 9.2 *Set the Deep Sea material to use these parameters.*

FIGURE 9.3 *I wound up with this sea and sky combination.*

When you create water, you must create any needed sky at the same time, because water reflects the design and color of the sky.

3. In the Sky&Fog tools, set a Darker Sky type. Play with the design controls for the sky until you achieve something pleasing by doing test renders. Use a medium-blue Haze of 5 to get a blend at the horizon. I used a Cloud Cover of 20 and a Height of 3 for the image in Figure 9.3.

The Island

You never want to use a standard Terrain to create an island. Why? Because the water plane always has a degree of transparency, and a standard Terrain sits on a square planar surface. When you immerse the Terrain in the water plane, unless you push it down very deep, you will tend to see this square base through the water and ruin the believability of the scene. To create an island, always start with a Symmetrical Lattice. Do the following:

1. Place a Symmetrical Lattice in the scene, and go to the Terrain Editor. Click New to delete the model.
2. Make sure the Grid is set to 1024 (Massive Resolution). We are going to create the entire island, mountain ranges and all, with one elevation image.
3. Start by painting a basic mound with a large Elevation Brush. See Figure 9.4.
4. Lower the elevation of the mound to create a flatter surface. Use a small Elevation brush with the lowest Level setting, and chew away parts of the round edge of the island to make it look less symmetrical.

FIGURE 9.4 *Paint a basic mound.*

FIGURE 9.5 *Your painted Elevation map should now resemble this one.*

5. Click on the Mounds effect, and then on Undo. Now select the Effects Brush. Paint Mounds around three-quarters of the outer edge of the island.
6. Click on the Sub-Plateaus effect, and the mounded range will get some more definition. Click on Blob Maker, and then on Undo. Now paint some blobby effects in the mountain range. See Figure 9.5.
7. Accept the Elevation map. Convert the Symmetrical Lattice to a Terrain. Place it on the water plane. Use an Iceberg material from the Planes and Terrains Library on it. Boost the Bump amount to 150, and XYZ Size to 80. Your island has emerged from the depths. See Figure 9.6.
8. Place another Symmetrical Lattice in the scene, and click New in the Terrain Editor. Use an Elevation Brush to add height to it, transforming it into a mesa-like structure. See Figure 9.7.

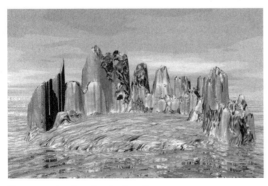

FIGURE 9.6 *The finished island.*

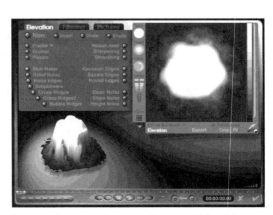

FIGURE 9.7 *Create a structure that resembles this.*

CHAPTER 9 THE GREAT BLUE-ICE THRONE ROOM

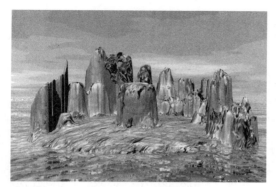

FIGURE 9.8 *The palace enclosure is completed and placed on the island.*

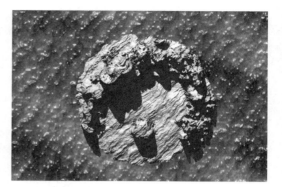

FIGURE 9.9 *A top view of the island with the palace enclosure at the bottom-center.*

9. Accept it, and *Convert To Terrain*. Reduce the vertical size by 30%, and place it at the front-center of the island. Map it with the same Iceberg material you used for the island. See Figures 9.8 and 9.9.
10. Time to place some icebergs in the sea. Place a Symmetrical Lattice in the scene, go to the Terrain Editor, and select New. In the Picture tab area, load the Iceberg.tif from the Bryce Terrain Maps folder. See Figure 9.10.
11. Accept the settings. Place the iceberg offshore from the open beach of the island. Duplicate it, move the duplicate farther away, and make it about five times as large. Repeat this action again to create a third iceberg. Rotate each so they look different, and resize as desired. Map all with the Iceberg material. Render a view from the island looking out at the icebergs. See Figure 9.11.

FIGURE 9.10 *Load the Iceberg.tif elevation map from the Bryce Terrain Maps folder.*

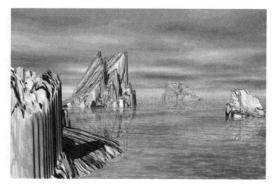

FIGURE 9.11 *Looking out at the three icebergs. The island is at the lower left.*

12. Time to optimize the icebergs to reduce their polygon count. Select each one and Export Object. In the Export Terrain dialog, use the polygon reduction slider to reduce the polygons, keeping an eye on how various settings look. Use Adaptive Triangulation, which tries to keep the overall form the same. When the iceberg looks OK and the polys have been reduced a considerable amount, save the new iceberg object to disk. Then, re-import and replace the original. Do this for each of the three icebergs, and you should see a great reduction in the total polygon count (displayed by the polygon count numbers at the bottom-left of the Bryce interface). We don't need massive detail for the icebergs, since they are background objects. In this step alone, I was able to maintain the looks of the forms while reducing each iceberg from 8000 polygons to under 400! See Figure 9.12.
13. One more object should undergo polygon reduction or optimization. Click on the island and read its polygon count. When I did this, the calculation reported over 2 million! That's far too high. Optimize the island in the same way you did the icebergs. My optimized island had fewer than 10,000 polygons, a huge reduction that will allow me much more detail on the inside of the palace and throne room later. Later, the same process will be used on the palace enclosure, which at this point has about a half-million polygons. See Figure 9.13.

If you notice too much detail lost as a result of an optimization process, you can sometimes make up for much of it by readjusting the parameters of the material, especially by increasing the Bump map value if there is a Bump map involved.

FIGURE 9.12 *Reduce the polygon count of the icebergs in the Export Terrain window.*

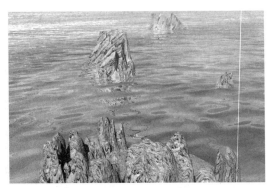

FIGURE 9.13 *A view high above and behind the island, looking over the island to the three icebergs.*

14. There's one more object we need to create to complete the external environment: a bizarre structure out in the water. We never know what this is. It could be a tower somehow connected to the island, or something far more ancient and strange. The exact form of this structure is left to your design, as are the tools you use to create it. I created a lathed object in 3DS Max, added a bend to it, and saved it as a 3DS file for import to Bryce. Once imported, I placed it farther back than the icebergs, and enlarged it. It's there just to add interest and mystery in case I want to pan around the scene. See Figures 9.14 and 9.15.

FIGURE 9.14 *The strange object is placed in the scene, adding some visual interest and mystery.*

FIGURE 9.15 *Another view from behind the island looking out to sea over the beach.*

THE INTERNAL ENVIRONMENT

TUTORIAL

Having finished the components and placements for the external stage, it's now time to pay attention to the palace construction, especially the throne room. Do the following:

1. The first step is to prepare the Enclosure object for export, in order to perform specific Boolean and other operations on it. Bryce Booleans are better used (in most cases) for animation, and do not provide the quality of Boolean operations we need to have with this component. Export the Enclosure object in a file format that your external 3D application can read (typically either DXF or OBJ, with OBJ as the first choice). See Figure 9.16.
2. Import the Enclosure object into your external 3D application. See Figure 9.17.
3. Create a duplicate of the object. Make the duplicate 98% of the size as the original, and then 5% taller. Boolean Subtract the duplicate from the original, resulting in a hollow object. See Figure 9.18.

FIGURE 9.16 *Export the Enclosure object.*

FIGURE 9.17 *Here, the object is shown imported into 3DS Max.*

4. Duplicate the object. Reduce the size of the duplicate by 65%. Use Boolean subtraction to delete a cubic form from the bottom of the object, evening it out. Use this same procedure to delete the back of the object (the side facing the original enclosure) by about 40%, evening out the back. The small duplicate will be stitched for the entrance way, in which we will place doors.
5. Use a cubic object to cut a Boolean hole in the Enclosure that is a bit less wide and less tall than the small duplicate you just created. This forms the entrance into the larger room. See Figure 9.19.
6. Attach the smaller object to cover the hole in the Enclosure. See Figure 9.20.

FIGURE 9.18 *The result is a hollow enclosure.*

FIGURE 9.19 *Cut a hole in the Enclosure.*

Chapter 9 The Great Blue-Ice Throne Room

FIGURE 9.20 *Attach the two objects together.*

FIGURE 9.21 *Cut away a cubic space for the doors at the front.*

7. Cut another cubic object away from the front of the smaller part of the Enclosure for the doors. Make it about half as tall as this component, and move it up about 20%. Remember that this whole Enclosure will be sunk in the island part way. Do not be concerned about any holes showing where the two Enclosure components meet, since we will place a big rock there in Bryce. See Figure 9.21.
8. One more cut to make. Create a large pentagon, and extrude it. Duplicate. One will be used to cut a window in the back of the Enclosure, and the other will be used as the window itself. See Figure 9.22.
9. Group the window with the rest of the model, and save. Import the finished model into Bryce, and replace the original Terrain Enclosure with it. Place it on the island. I decided to make this object larger, so the ring of "distant" mountains now looks more like an ice wall in proportion. See Figure 9.23.

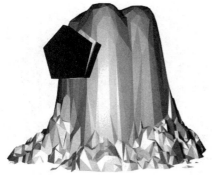

FIGURE 9.22 *Cut a pentagonal window in the Enclosure as shown, and place the other extruded pentagon somewhere nearby.*

FIGURE 9.23 *Place the new enclosure on the island.*

FIGURE 9.24 *Finish the entrance.*

10. Use Bryce Rocks to cap any holes and to build up the entrance. See Figure 9.24.
11. Use a Medium Glass material on the pentagonal window, and move the window into place. Duplicate the structure, and delete the window from the duplicate. Resize the duplicated structure to about 98% of the original size, and adjust the placement so that it forms an inner skin for the Enclosure. We are doing this because although the Iceberg material looks good on the outside, it shows too many polygons when viewed close up on the inside. Use the Dali-esque material on the inner skin—you'll find it in the library. Place a light-blue light with an intensity of 15 at the top center of the inside of the Enclosure. See Figures 9.25 and 9.26.

FIGURE 9.25 *Viewed from the inside of the palace, you can see through the pentagonal window.*

FIGURE 9.26 *From the back, you can see through the large pentagonal window to the Dali-esque material on the walls. You can also see out into the ocean, where the strange object and the icebergs exist.*

CHAPTER 9 THE GREAT BLUE-ICE THRONE ROOM

FIGURE 9.27 *This grouped object has two components: the stepped throne base and the floor with the Boolean hole in it.*

FIGURE 9.28 *The throne room construction is underway with the floor and the throne base established.*

12. Open your external 3D application, and use cylinders to create the grouped object shown in Figure 9.27. Save.
13. Import the group you just created. Place the floor and throne-base group into the enclosure at the bottom. Use the Ice Crystals material from the Rocks and Stones Library on the throne base, and tiles on the floor. Place a cylinder in the hole and resize for a reflective pool. Map with a reflective water material (Backyard Pool works well). See Figure 9.28.
14. Time to create a throne. I prefer doing this in an external 3D application, so I can use a wider range of modeling tools. Use Lofting and Extrusion operations to create a throne (Lofting for legs and arm rests, and Extrusion for a seat and back). One example is shown in Figure 9.29.

FIGURE 9.29 *This is one example of a throne. You can attempt to emulate this one, or use your own design.*

15. Vertex Edit the throne in any way you like. Place a flattened sphere as a cushion, and group. Export in a format Bryce can read, and import into Bryce. Place the throne on the throne base in the palace enclosure, and map with the Ice Crystals material used for the base. Make the cushion dark blue. See Figure 9.30.
16. Place some columns around the base of the throne. Use the Bryce Boolean column in the Objects Library. See Figure 9.31.
17. With the throne in place, the more I looked at the tiled floor, the less pleased I became. It looked like it belonged in a 1950s kitchen. I wanted something more spectacular. Here's what I did, and you can do it as well. I grabbed a section of an image that contained the Dali-esque texture in PhotoPaint, and used the Xaos Terrazzo filter on it. This created the tile shown in Figure 9.32.
18. After creating a bitmap tile, access it in Bryce Picture Editor. Mapped to the floor, it looks much more regal than the previous tiled pattern. See Figure 9.33.
19. One more thing was bothersome: with the new tiled floor, the back of the throne looked too basic. When you want to re-edit a model, just go back to your external 3D application and Vertex Edit it. See Figure 9.34.
20. Back outside, place some boulders around, mapped with the Mud and Snow material from the Rocks and Stones Library. Build a door from a cube, and move it into place. Use the Alien Sandstone material on the door with Object Space mapping. Rotate the material 90 degrees on the Z-axis so that the grain runs vertically. The easiest way to open and close this door is to use Resizing to bring the bottom up or down. See Figure 9.35.

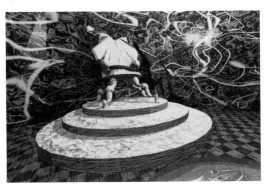

FIGURE 9.30 *The throne is in place.*

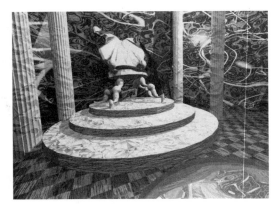

FIGURE 9.31 *Place some columns around the base of the throne. The columns look distorted here because of the camera angle.*

Chapter 9 The Great Blue-Ice Throne Room

FIGURE 9.32 *This tile was created with the Terrazzo plug-in that ships with PhotoPaint.*

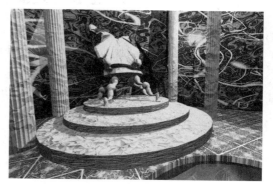

FIGURE 9.33 *Yes! This is what I wanted!*

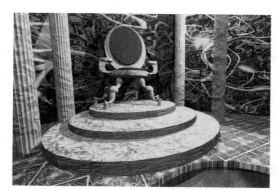

FIGURE 9.34 *A new back is placed on the chair with vertex editing in the external 3D application.*

FIGURE 9.35 *Open or close the door by scaling the bottom of the door up or down. When the door is open, you can see the throne.*

FINALIZING THE COMPOSITION

Although my initial sketch called for a table and chairs in the throne room, I decided against it. After I saw some preview renders of the room, I didn't want to add more clutter. However, I did want to add the chandelier. Do the following to create the chandelier:

21. Using Lathing and Lofting in your external 3D application, create the components of the chandelier as shown in Figure 9.36. Lathe objects so they have no more than six sides. This keeps the poly count low, and emphasizes the faceted nature of crystals. See Figure 9.36.

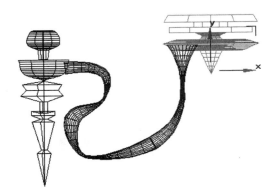

FIGURE 9.36 *Lathe and Loft these shapes.*

FIGURE 9.37 *Create six arms.*

22. Rotate the arms around the center to create a total of six. See Figure 9.37.
23. Create a thin cylinder for the chandelier to hang from, and group all. Export in a format that Bryce can read. See Figure 8.38.
24. In Bryce, import the chandelier and place it hanging from a flat cylinder on top of the columns. You can go through the process of placing a light on each arm if you want to. Use any materials you prefer on the components of the chandelier. See Figure 9.39.

 Glass materials create beautiful shadows and transparent effects, but they add long rendering times in Bryce.

One More Item

I love to place animal sculptures in a Bryce 3D scene. The Zygote Media Group makes a great bear model for Poser. If you have this model, and have Poser as

CHAPTER 9 THE GREAT BLUE-ICE THRONE ROOM 189

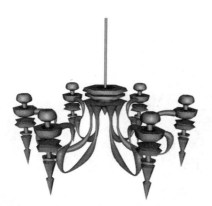

FIGURE 9.38 *The completed model.*

FIGURE 9.39 *The finished chandelier is in place above the throne.*

FIGURE 9.40 *Place the head of the Zygote bear over the door.*

well, export the head and neck of the bear model. Import into the Bryce scene and place over the door as a signal that the bear clan resides here. See Figure 9.40.

That's it, kids and squids. This scene has 178 objects and 80,250 polygons. The file weighs in at 9.63MB—not so heavy for a winter world. The file is on the CD in the Projects folder. All that's left is to place the camera in some interesting places and render away. See Figure 9.41.

FIGURE 9.41 *A collection of renders from the Great Ice-Blue-throne Room project.*

TRAVELING ON

In the next chapter, we'll build the domain of the Sand Masters, just in case you caught a chill from this project.

CHAPTER 10
The Temple of the Sand Masters

ADVANCED BRYCE CREATIONS

From one extreme to the other. In the last chapter, we froze. With any success in this chapter, we'll roast. When I had the original idea for the construction of the Temple of the Sand Masters, I envisioned one structure: a temple. However, as the idea simmered away in my brain, it metamorphosed into something else more extensive. What changed was the overall priority of the components. I would still place a temple in the scene, but now it would become part of a site of ruins. The ruins would now be balanced by another structure, this one more recent than the date of the ruins: a fortress. Between the fortress and the ruins, or close by, I wanted to create an oasis. With no access to water, even the fortress would be a ruin. In the fortress are two more detailed structures to concentrate on: a tower room that looks out over the desert world, with some sparse furnishings, and a small armory. The armory is used to store the ancient weapons of the nomadic inhabitants, except for a cannon that sits atop a fortress wall. You can immediately appreciate that this is a rather complex series of design challenges for Bryce.

As in the last chapter, we are going to separate external and internal environment components. The external components will include the ground, sky, oasis, and ruins. The internal environment will include the fortress and the detailed parts, and the temple in the ruins. I always start with a rough sketch and idea sheet. See Figure 10.1.

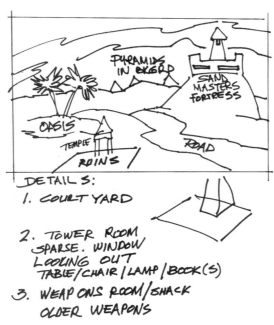

FIGURE 10.1 *The rough sketch for the Sand Masters project.*

CHAPTER 10 THE TEMPLE OF THE SAND MASTERS 193

THE EXTERNAL ENVIRONMENT

TUTORIAL We'll first focus on the ground, sky, oasis, and ruins.

GROUND

By the *ground*, we mean to include both the Infinite Ground Plane and any hills in the scene. Do the following:

1. Place an Infinite Ground Plane in the scene. Open the Materials Lab, and select the Marbled Sand Texture from the Sand Library (accessed by clicking the Texture Library button at the upper right of the Materials Lab Texture ABCD column). Set XYZ Scale to 2.2, and Bump height to 100. See Figure 10.2.

Now for some background dunes. Just in case we want to pan around this world, or have the option of making a 360-degree panoramic movie, we want to ring the scene with background dunes. The moment you get the idea that multiple Terrain objects are needed in a scene, that's when to take care concerning the polygon count involved. Bryce Terrain objects and Symmetrical Lattices are created with huge polygon counts, much higher than you would ever require for a background object. If you created the ring of dunes that are required for this scene, and left all of the dune terrains as they are, your file size would increase greatly. As dune terrains, my system reported that over half a million polygons were being used! That means that the storage requirements for this file are tremendous, adding tens of MB even before any detail is created. You want to do this for most Terrain objects, especially those that are to be used as background elements. Export each Terrain object in a file format that Bryce can import. Save to a temporary folder. In the Export window, reduce the polygon count by at least 50%, and sometimes as low as 10% if the object will be placed

FIGURE *The sandy plane starts the composition.*
10.2

far in the distance and you won't be visiting it close up. Import the saved terrain, and replace the original Terrain object. In doing that simple step with all background terrains, what started out as 500,000 polygons was reduced to less than 10,000! That's a reduction of 98%, and leaves lots of room for storing the rest of the components in the scene. When I ask you to perform this operation in this book, I will call it the *Export-Reduce-Import* operation.

2. Create a Dune object in the Terrain Editor after placing a terrain in the scene. Create the dunes by using the PaintEffect Brush with the Blobs effect. See Figure 10.3.
3. Export-Reduce-Import.
4. Create a ring of dunes around the camera, as seen from the Top View. Scale randomly and add some stretch. Rotate a few to create diverse dune objects. Map all with the same Sand material used for the ground plane. See Figure 10.4.

FIGURE 10.3 *Create dunes by using the PaintEffect Brush with the Blobs effect.*

FIGURE 10.4 *Create a ring of dunes, as seen in the Top View.*

5. Now, no matter how many degrees you rotate the camera on its vertical axis, dunes will appear in the background. Create some random pyramid primitives. Place some on a dune, and others behind it. Do this at different points on the ring of dunes. See Figure 10.5.

SKY

Create a Sift Custom Sky in the Sky&Fog toolbar. Give it a Haze setting of 1 with a light-yellow color. This adds to the feeling of unbearable heat. Turn Strata off. Set the Cloud Cover color to a light orange. Make the Sun color a light yellow. Since the dunes are so far in the distance, this should effectively blur them out quite a bit, and give the scene a decidedly yellowish cast.

Chapter 10 The Temple of the Sand Masters

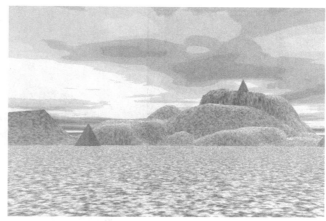

FIGURE 10.5 *No matter which way the camera revolves on its vertical axis, there are always background dunes and at least one pyramid in the distance.*

Oasis

Before you create the oasis, it is important to locate it first. To do this, go to the Top View. Consider that the fortress will be placed at the center of the dune ring. In the Top View, rotate the camera so that it faces toward the top of the screen. The oasis will be placed about one-third of the way from the fortress to the dune ring, and slightly to the right. The fortress, when we create it, will be placed about two-thirds of the way from the fortress to the dune ring, and slightly to the left. That way, a view from the fortress tower window will take in both the ruins and temple on one side, and the oasis on the other. Knowing this, do the following to create the oasis:

1. Place a Symmetrical Lattice in the scene, and go to the Terrain Editor. Click New.
2. Click once on the Blob Maker effect, and a rounded form will appear in the preview window. Lower the elevation by about 50%. Use an Elevation Brush set to the lowest level to carve out a depression in the center of the blob. See Figure 10.6.
3. Accept the form, Convert To Terrain, and reduce the height by 60%. You now have a circular form with a depression at the center. If we created our oasis from this form, it would look rather cartoonish, since it is so symmetrical.
4. Export the form to your external 3D modeling application. Using your Vertex Editing tools (Max users can select the FreeForm Deformation modifier), reshape the oasis into a less symmetrical form. See Figure 10.7.

FIGURE 10.6 *Carve out a depression in the mound as shown.*

FIGURE 10.7 *Reshape the oasis into a less symmetrical form.*

5. Export, and import into Bryce. Place the oasis at the position previously noted. Map it with the Storybook Grass material in the Miscellaneous Library. Duplicate, and raise the duplicate just a bit above the surface of the original, and map with the Foliage II material from the same library. The Foliage II material is transparent in places, so the two objects look like one with a 3D grass texture. See Figure 10.8.

6. Return to your 3D application, and draw a shape that matches the water cavity in the oasis. Extrude, and export to Bryce. Insert the water form in the oasis, and map it with the Caribbean Resort water texture. See Figure 10.9.

7. Create a Symmetrical Lattice, and go to the Terrain Editor. Lower and Smooth it until it is almost flat. Accept it, and resize it about 150% larger than the oasis pool. Place it under the pool. Map it with the Spring Wild-

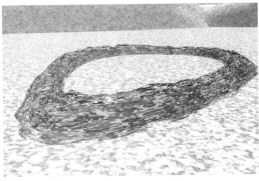

FIGURE 10.8 *The oasis is placed, and materials are added.*

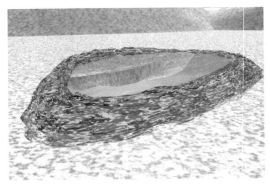

FIGURE 10.9 *The water is added to the oasis.*

CHAPTER 10 THE TEMPLE OF THE SAND MASTERS

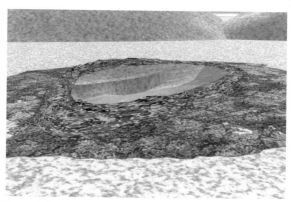

FIGURE 10.10 *Create a grassy base for the oasis pool.*

flowers material from the Planes&Terrains Library. Use Object Top mapping, and XYZ Scale set to 100%. See Figure 10.10.
8. Place some rocks in the grass. Place a few trees around the oasis, taken from the Tree folder in the Objects Library. See Figures 10.11 and 10.12.

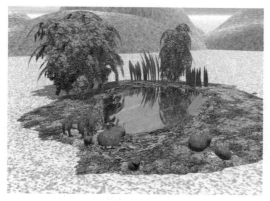

FIGURE 10.11 *Place some rocks and trees around the oasis to complete it.*

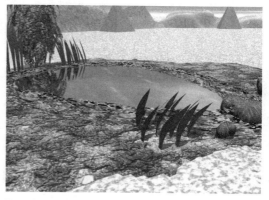

FIGURE 10.12 *Every camera angle looks good when you take the time to get things right.*

RUINS

The ruins are created in the Terrain Editor. Do the following:

1. Place a Symmetrical Lattice in the scene, go to the Terrain Editor, and click New.

 The next undocumented step was shared with me by Celia Ziemer, a veritable Bryce master user.

2. With no object in the Terrain Editor's Elevation Map preview, hold down the Control + Alt keys (Mac users, Cmd + Option), and click on the button to the left of the Picture control (this is on the Elevation tab under the New button in the Terrain Editor). This jumps you to the Deep Texture Editor, where you can now use any of the textures you create there, or any of the presets in the libraries. Go to the Basic Library and select the Techno Basic preset. Accept it, and you are transported back to the Terrain Editor, with the Techno Basic image in the Elevation Map preview window.
3. Add some Fractal/Weathered Dikes and Fractal/Fractured effects to the Elevation Map. Using the Erosion brush, paint some random strokes on the Elevation Map. You have just created the ruins of an old city. See Figure 10.13.
4. Once placed on screen, Export-Reduce-Import. Map with a Techno-City Bump and a Terracotta Diffuse map. The completed ruin is shown in Figure 10.14.

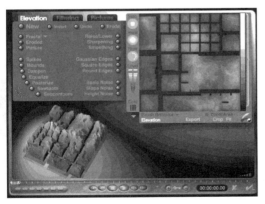

FIGURE 10.13 *The ruins are created in the Terrain Editor.*

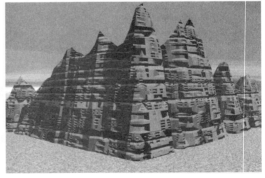

FIGURE 10.14 *The ruins hold the ghosts of the past.*

THE OLD TEMPLE

By "old," I mean ancient, not decaying. Truth be known, the nomadic tribes that traverse this desert have always kept this temple in pristine condition, even though the surrounding buildings have deteriorated badly. Do the following to create the temple:

1. Open PhotoPaint or another suitable 2D bitmap image application.
2. Create the facade of the temple. This can be accomplished by drawing and painting, by manipulating small sections of suitable photographic images, or both. In the example shown in Figure 10.15, small sections of digital images the author took while in Florence and Rome were used to create a composited final image.
3. When you are satisfied with the image, save it both as an RGB color image and as a grayscale image. Then select the image background, and Invert the selection to select everything but the background. Make sure the background is solid black, and the rest of the image data is solid white. This will be your Alpha channel image data. Save it to disk along with the RGB and grayscale images. Exit the application.
4. In Bryce, place a Symmetrical Lattice in the scene, go to the Terrain Editor, and click New. Set the Grid to 64 (Simple). Use the grayscale image you just created and saved, and use it as Elevation map data. Lower the elevation by about 80%, and apply some smoothing. Apply the changes by clicking on the check mark.

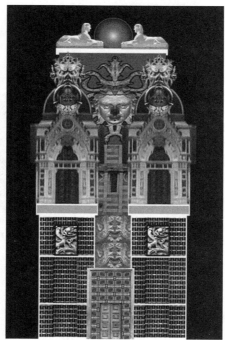

FIGURE 10.15 *This image was created by taking elements from a collections of photographs of sacred and ancient sites in and around Florence and Rome, Italy.*

FIGURE 10.16 *The completed temple sits next to the ruins.*

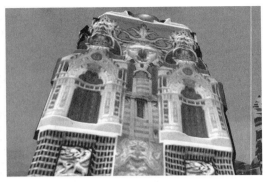

FIGURE 10.17 *Looking up at the temple from below.*

5. What you have now is a facade for the temple. Setting the Grid to 64 reduces the number of polygons to a manageable level. Scale in perspective to the ruins, and place on the left of the ruins as seen in the Front View. Create a four-sided structure, with each side being the facade of the temple. Place an elongated rectangular solid in the center, and cap with a spherical dome. See Figures 10.16 through 10.19.

FIGURE 10.18 *The temple doors.*

FIGURE 10.19 *A view from overhead.*

THE INTERNAL ENVIRONMENT

The base of the fortress, a flat mesa, is included in the Internal Environment components because it is a part of the fortress elements. Altogether, these components consist of the flat mesa, the fortress enclosure, a weapons shed, and the tower with a observation room at the top.

Chapter 10 The Temple of the Sand Masters

The Flat Mesa

Do the following to create the mesa:

1. Place a Terrain in the scene, go to the Terrain Editor, and click New. Click on the Blob Maker to create a conic terrain. Flatten the top with a large Elevation Brush with the highest Level setting.
2. Use the Erosion Brush to create cracks and indentations on the sides. See Figures 10.20 and 10.21.

FIGURE 10.20 *Create the mesa in the Terrain Editor.*

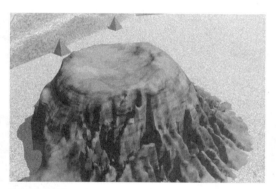

FIGURE 10.21 *Place the mesa in the scene, making sure its flat base is submersed below the ground plane.*

We are going to create a tunnel in the mesa that goes from ground level to the top. This is a secret tunnel, so it will be closed by large rocks on either end. The tunnel provides both access and an escape route to and from the fortress, should they be needed. Do the following:

3. Create a large Torus primitive, and intersect the mesa with it. This will be our Boolean cutter. Make it a Negative Boolean. See Figure 10.22.
4. Make the mesa a Positive Boolean, and group with the Torus to create the tunnel. Place three blue radial lights in the tunnel, just in case you want to travel through it sometime. See Figure 10.23.
5. Place a flattened Sphere primitive object over the tunnel entrance and exit mapped with the same material as the mesa. See Figure 10.24.

The Fortress Enclosure

The fortress has no access to the outside except through the tunnel, so the mentality of the inhabitants is one of defense against a siege. When your Bryce world is getting as complex as this one is, it's best to create succeeding compo-

FIGURE 10.22 *Create the Torus Boolean tunnel cutter.*

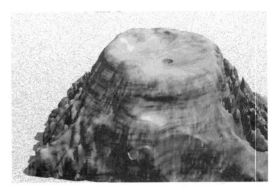

FIGURE 10.23 *The tunnel is cut. One end is displayed at the top of the mesa, and the other is pictured in the lower center of this image.*

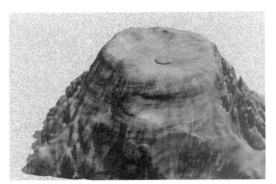

FIGURE 10.24 *Cap the tunnel at either end. The weapons shed will sit on top of the top end of the tunnel.*

nents in a new Bryce document, save them to the Objects Library, and then place them in the composited scene later. That way, you won't have the frustrating experience of having to work around all sorts of other objects. This is how the fortress will be created, and placed only after it has been saved to the Objects Library. Do the following:

1. Open your external 3D application to create the fortress components for later export to Bryce.
2. Draw a cross section of the fortress wall, and move its pivot point as shown in Figure 10.25.
3. Lathe the cross section with 12 sections. This creates the wall with a top walkway. See Figure 10.26.

CHAPTER 10 THE TEMPLE OF THE SAND MASTERS

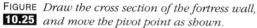

FIGURE 10.25 *Draw the cross section of the fortress wall, and move the pivot point as shown.*

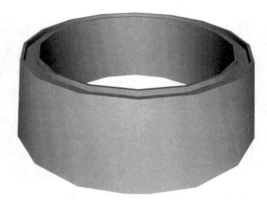

FIGURE 10.26 *The Lathed wall.*

4. Use a Boolean operation to cut two notches in the inner wall of the walkway. This allows a ladder to provide access to the walkway. See Figure 10.27.
5. Cut an opening in the front of the wall for observation and defense. See Figure 10.28.
6. On the inside wall, create a platform just below the opening you just cut. This is for observation, and possibly a cannon. Use Extrusion to create the platform shape and two braces. See Figure 10.29.
7. Lathe a shape to create a side tower, and use a Boolean operation to cut a tunnel through it so the walkway passes through. Duplicate the side tower for another one on the opposite side. See Figure 10.30.

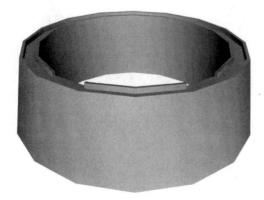

FIGURE 10.27 *Cut two access notches in the upper wall.*

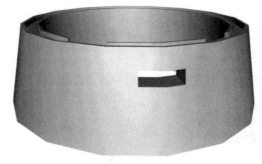

FIGURE 10.28 *Cut an opening in the front of the wall.*

FIGURE 10.29 *Create a platform.*

FIGURE 10.30 *Create the side towers with tunnels to allow walkway access.*

8. Lathe a shape to create a parapet of your own design, and duplicate for the other tower. See Figure 10.31.
9. The Fortress enclosure is complete. Select all and Group. Save in the Wavefront OBJ format for export. Import into a new document in Bryce. Add materials as you like. I used Alien Rock for the wall, Marble-Bronze Fusion for the parapets, and Polished Walnut for the platform. Save the completed fortress enclosure to an Objects Library folder. See Figure 10.32.

FIGURE 10.31 *Create the parapets.*

FIGURE 10.32 *Import into Bryce, add material textures, and then save to the Objects Library. The fortress enclosure is now available to any Bryce scene you create.*

CHAPTER 10 THE TEMPLE OF THE SAND MASTERS

WEAPONS SHED

The weapons shed is a separate component of the fortress, acting both as a storage place for weapons and as an enclosure that guards the fortress end of the secret tunnel. Do the following to create it:

1. Open your external 3D application. Use an extruded square as the front and back walls, and an extruded sloped shape for the left and right walls. Refer to Figure 10.33.
2. Add the sloped roof. Create a grid of window holes by using Boolean Subtraction with a cylinder array. Place a frame around the holes. Cut a hole for the door, and place a rectangular door in it. Refer to Figure 10.33.
3. Create a basic table and bench from rectangular solids, and place them in the shed. Group everything as Weap_Shed, and save in a format Bryce can import. See Figure 10.33.
4. Import into Bryce. Use any materials on the shed components that you prefer. Place a radial light inside the shed, and Group all. The light will allow you to see other items you might place in the shed. See Figure 10.34.

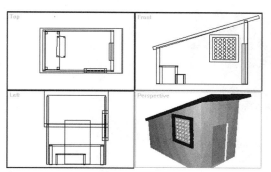

FIGURE 10.33 *The construction of the weapons shed follows this plan.*

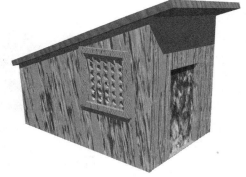

FIGURE 10.34 *The weapons shed as it appears after materials are assigned in Bryce.*

5. Place the camera in the shed and do some test renders. See Figure 10.35.
6. Either create some weapons using your modeling skills in your external 3D application, or import from a commercial 3D models CD collection. Arrange the weapons in the weapons shed. Group everything, and save the entire weapons shed to your Objects Library. See Figure 10.36.

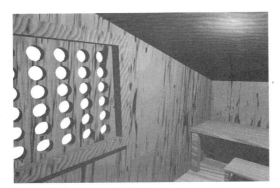

FIGURE 10.35 *A test render inside the weapons shed, displaying the window and the table and bench.*

FIGURE 10.36 *Arrange a group of weapons around the shed.*

CANNON

The cannon is modeled with the same modeling techniques with which you are now familiar. You can refer to Figure 10.37 and model it on your own from the illustration, or simply load the CH10_01 project from this book's CD-ROM. See Figure 10.37.

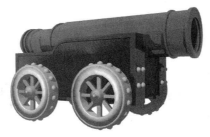

FIGURE 10.37 *The cannon is modeled and saved to the Bryce Object library.*

THE TOWER

In many ways, the tower is the co-star of this production. The tower and the temple represent the working duality of a temporal earthly power in the present and the durability of an ancient non-temporal force. One is centered on control by intimidation, and the other on control by ritual, superstition, and symbol. Endless discussions can be entertained as to which is the dominant force, though in truth they are each necessary shadows of the other. The tower and its observation room are modeled in your external 3D application. Do the following:

1. Create the shape shown in Figure 10.38. Please note the internal cutout shapes, since this creates a hollow space in the soon-to-be lathed object. Also notice that a central "pole" is created in the tower at the same time.

CHAPTER 10 THE TEMPLE OF THE SAND MASTERS 207

2. Lathe the shape with four segments. This creates a four-sided tower.
3. This step can be performed in Bryce or in your external 3D application—I prefer to do it externally. Use Boolean operations to create a door and a window in the tower room (these will face the rest of the scene), and Boolean-cut a doorway at the tower base. See Figure 10.39.
4. The last step is to use a cylinder to create a hole in the tower room floor. This allows the person on watch (and there is always someone on watch) to let down a rope so the next watch person can climb up. See Figure 10.40.
5. Export in a format Bryce can read, and import into Bryce. Apply texture that consists of a Terra Cotta material in the Diffuse channel, and a Stucco Bump in the Bump channel (at 175 with Cylindrical mapping).
6. Create two doors, upper and lower, from scaled cubes, and map with the Wood Plank material. Create a window frame by Boolean Subtracting one cube from another. Scale and place relative to the upper window. Place a radial light in the room, and another two at the top and middle of the tower base. Group all. Save to the Objects Library as Tower_01. See Figure 10.41.
7. These next steps only make sense if you are going to place a camera in the tower room to do some rendering from the inside. Otherwise, it just adds polygons to the scene for no reason. Create a table from a Symmetrical Lattice in the Terrain Editor by creating the Elevation Map shown in Figure 10.42. After you place it in the scene, Convert To Terrain, and scale as necessary.
8. When the table is placed in the scene, put any objects from any folder that you prefer on top of it. Do some test renders, and when all is satisfactory, Group all and save as Table_O_Stuff to your Objects Library. Next, move the table inside the tower room under the window. Place a cylindrical flag pole on top of the tower, and use a squashed cone primitive as a flag—you

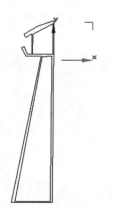

FIGURE *Create this shape.*
10.38

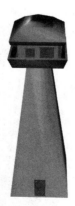

FIGURE *Cut holes for a*
10.39 *window and two doors.*

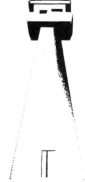

FIGURE *The tower as it appears*
10.40 *in the external 3D application.*

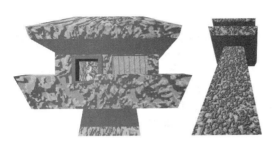

FIGURE 10.41 *The tower as it appears in Bryce, with texture mapping, doors, and a framed window.*

FIGURE 10.42 *Create this Elevation Map from a Symmetrical Lattice object, using the Terrain Editor.*

may prefer to create the flag externally as I did. Group all. Save this arrangement to your Objects Library as Tower_02. Now you can select which tower to place in a scene, depending on your needs. See Figure 10.43.

9. Place the camera inside the tower, and do a test render. See Figure 10.44.
10. One more item to create and add to your Objects Library: a ladder. Create a ladder with 40 rungs from cylinder primitives. Duplicate the second rung, and then MultiReplicate 38 times for the other evenly spaced rungs. Group all, and save to your Objects Library. See Figure 10.46.

Finishing Up

You have done a lot of work if you have completed this tutorial to this point, so now comes the easy part. Since you have all of the extended components for

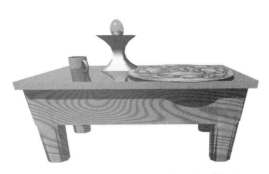

FIGURE 10.43 *One version of the completed Table 'O Stuff.*

FIGURE 10.44 *The table as seen from inside the tower room, with the window and door visible.*

CHAPTER 10 THE TEMPLE OF THE SAND MASTERS 209

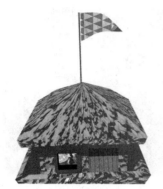

FIGURE 10.45 *The tower with the added flag and flagpole.*

FIGURE 10.46 *Create a ladder, and save to your Objects Library.*

this project in your Objects Library, it's time to place them and take some pictures. Do the following:

1. Load the project that you saved previously. It should contain the mesa, ruins, temple, oasis, and dunes.
2. Go to the Objects Library folder where you stored the other components. Load the fortress. Scale it, and place it on the mesa. Make sure the weapons platform is facing the scene. See Figure 10.47.
3. Load a ladder from the Objects Library folder you placed it in, and set it inside the fortress so that it leans against the platform on the front wall. See Figure 10.48.
4. Duplicate the ladder, and move it up and out of the way. Set all rotations to zero. Duplicate the duplicate, and move vertically to create a ladder that is double the height of the original. Group both sections, and name it Big Ladder. Place the big ladder on the ground so that it leads to one of the

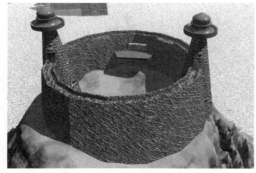

FIGURE 10.47 *The fortress is added to the scene, and placed on the mesa.*

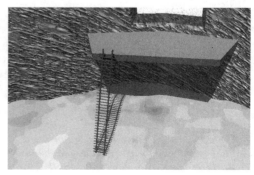

FIGURE 10.48 *Load a ladder and position it as shown here.*

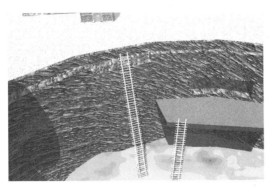

FIGURE 10.49 *The large ladders allow access to the walkway.*

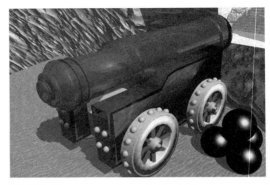

FIGURE 10.50 *The cannon is ready for action.*

notches in the walkway on the wall. Duplicate, and move the duplicate to the other notch. See Figure 10.49.

5. Place the cannon from your Objects Library on the platform, so that it is facing out of the viewport. Place a few cannon balls next to it. See Figure 10.50.
6. Place the Weapons Shed from the Objects Library in the scene. Resize as needed. As I placed this component, I realized that my proportions comparing the shed to the tunnel opening were off, so I decided to shrink the size of the shed and place it alongside the tunnel opening. The tunnel, as it turns out, is large enough to drive a chariot through. See Figure 10.51.
7. Load the Tower_02 object (the tower with the table and items) from the Objects Library. Scale as needed. Place the tower at the center of the fortress on the mesa, with the window facing the same direction as the cannon on the platform. See Figure 10.52.

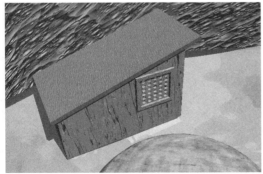

FIGURE 10.51 *Place the weapons shed in the scene, inside the fortress and beside the tunnel opening. The stone that caps the tunnel opening can be seen in the lower foreground, as a size comparison.*

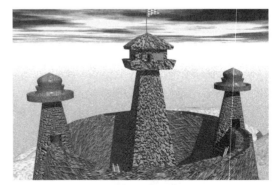

FIGURE 10.52 *The tower and its observation room are placed in the fortress on the mesa.*

Chapter 10 The Temple of the Sand Masters

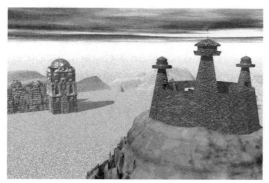

FIGURE 10.53 *A view from behind the fortress, taking in the temple and the ruins. Looking closely, you can see the cannon poking through its viewport.*

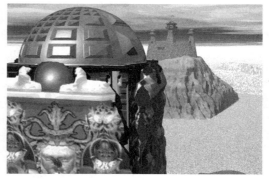

FIGURE 10.54 *A view from behind the temple, looking toward the fortress.*

This project has 537 objects, 301,257 polygons, and takes up 23.4MB on disk. Now all that remains is for you to place the camera at different vantage points in this desert world, and snap some renderings. See Figures 10.53 through 10.56.

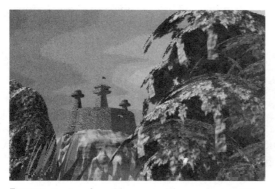

FIGURE 10.55 *A view from the oasis. The camera FOV (Field of View) is set to 45.*

FIGURE 10.56 *A view of the temple and ruins from behind the tower flag.*

Recapping Important Matters

Before we move on, let's recap some of the important things you learned in this project and the previous one:

- *Other 3D applications can provide modeling assistance for complex Bryce projects.* Although you are free to model all of the components for your

complex Bryce within Bryce itself, using the Terrain Editor, this is not suggested. As you have seen, there are a number of modeling processes in other 3D applications that make your Bryce work a lot easier, less time consuming, and more fun. Each of these first two projects, as an example, took about three days to create. Using only the Terrain Editor and Bryce-limited Booleans to create these models would have taken weeks instead of days. Of course, realizing that there are Bryce users who consider it non-purist to create anything outside of Bryce, you may elect to spend the time in Bryce itself. For professional designers on a budget and with severe time constraints, however, the author stands solidly behind the decision to use diverse tools to get the job done.

- *Export-Reduce-Import*. You learned that this instruction asks you to Export a Terrain or Symmetrical Lattice, Reduce its polygon count and save it to disk, and Import it back into Bryce for placement. This is especially useful when you have a scene with hundreds of objects, and the item in question is to be used in the distant background. This shorthand instruction will continue to be used for the rest of the projects in this book.
- *Lattice>New>Create>Convert*. For the balance of this book, we will use this shorthand instruction. It means place a Symmetrical Lattice in the scene, go to the Terrain Editor, click New, create your new Elevation Map, and Convert To Terrain and resize as needed. This allows you less reading, since you understand this process by this point, and it saves wear and tear on the author's typing fingers.
- *Save to the Objects Library*. When a project starts to get too complex (Bryce will slow when this happens), create your components in new Bryce documents, and save them to the Objects Library. Doing this will speed things up, since you can easily load them in the required project for placement, and allows you to incorporate these objects in limitless new Bryce scenes.
- *Camera FOV*. Explore different FOV settings before you do final renders. A good range to stay within, to avoid major distortion, is 45 to 75.

Traveling On

In this project, you learned how to develop a sandy, hot world in Bryce. The next project immerses you in cool water, and is called *Sanctuary of the Sargasso*.

CHAPTER 11
Sanctuary of the Sargasso

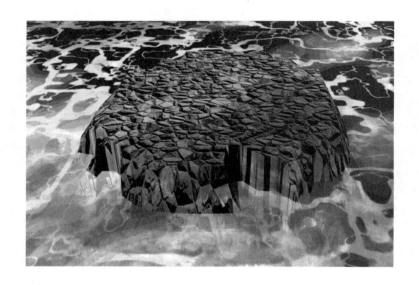

When I first thought of this project, the idea for the design was far different from what was finally created. It's always best to sleep on ideas for a while anyway, since an initial idea is often only an invitation for your creative juices to start flowing. You can always tell if an idea is being imposed instead of being allowed to blossom, since imposed ideas cause you to run into far more problems and frustrations than you would normally face. It's time to alter a design when nothing you attempt seems to be going smoothly, and you get that constant feeling that you are far off track and nothing about the design pleases you. Then, you may either start over, or just scrub those elements that are especially displeasing.

The whole idea behind Sanctuary of the Sargasso was to create an underwater world to investigate Bryce tools and processes that could be explored in no other realm. Before we begin this tutorial, however, I need to say a few words about *Volumetrics* in Bryce. Most readers will be familiar with this term, since it was cautioned early on that in order to make use of this book, you have to go through the Bryce documentation first. Volumetrics are adequately covered in the docs. What is not emphasized in the documentation, however, is the punishing rendering times the use of Volumetrics demands. Volumetrics allow you to place volume materials on objects so that you can render a camera placed inside the object. This has value when, for example, you place a volumetric cloud material on a cloud form, and fly the camera through it. It is unfortunate, however, that Bryce version 4.x does not take advantage (or very little advantage) of high-speed processors when it comes to rendering volumes. This translates into rendering times that take many hours for a single image that contains large volumetric objects. In comparison, the same object mapped with a non-volumetric material may take minutes to render. Except for smaller objects, I stay away from applying volumetric materials. Transparent objects always take longer to render than opaque objects in Bryce, and volumetrics make heavy use of transparency calculations.

What has this to do with this particular project? Well, creating a water world might tempt you to apply a volumetric material to a water object, especially if you wanted the camera to show items underneath the watery surface. I would not suggest (and this tutorial does not recommend) that you do that. When the whole view is centered on a volumetric object, and you are inside of that object (with very little importance placed on the speed of your computer), rendering will proceed in something like geological rather than human time. Then, if you need to tweak the entire render for some reason, you may have to do it all over again. Except for those of you who are not concerned with deadlines or temporal matters, this is unsatisfactory. Future versions of Bryce may solve this problem, but now you should consider the use of large volumetric objects in your scenes very carefully, and avoid their use whenever possible, unless there is no other way to achieve a needed effect.

CHAPTER 11 SANCTUARY OF THE SARGASSO

THE ROUGH SKETCH

As with the previous projects in this part of the book, I advise starting with a rough sketch of your ideas. You can rough out components that are never incorporated into the final design, and that's OK. On the other side of the coin, you will most certainly incorporate elements that extend the rough ideas beyond your original intent, and that's expected. After all, Bryce is the medium that is the message, so Bryce tools and tricks always lead you to new and exciting areas for exploration.

The real Sargasso Sea is a place of mystery and myth. There are two reasons for this. The first is that it is choked with seaweed, and seaweed has its own dark and entangling aspect. The second is that there are times when the winds become completely calm over the Sargasso, so that any sailing vessel caught in the calm, with no other means of power, is trapped and in trouble. The stories of ships doomed in the Sargasso emerged long before global positioning systems and modern communications. Recently, contemporary fantasy writers have suggested that the Sargasso might hide an extraterrestrial underwater base, a place where unwelcome visitors are taken and perhaps imprisoned, never to be seen again.

This Sanctuary of the Sargasso project takes several of these historical and fantasized components and blends them with other elements, requiring the application of specific Bryce tools and ways of doing things. My very rough sketch lays out these ingredients. See Figure 11.1.

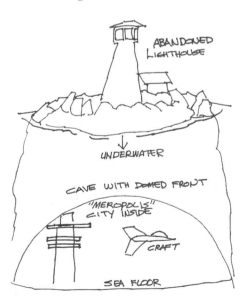

FIGURE 11.1 *A rough sketch showing the general components involved in the Sargasso project.*

Looking at the rough sketch in Figure 11.01, I listed the components that needed to be modeled for this project (adding a few items that came to mind after the rough was drawn) and decided how I would approach the modeling. Here's the initial result:

- **Sky**: This will be a customized Infinite Sky Plane (ISP) created in Bryce.
- **Water**: Bryce users may want to use a volumetric water plane here, but for the reasons presented previously, I would suggest staying away from that option. Instead, we will use several Infinite Water Plane (IWP) layers to achieve the effects we need.
- **Sea Floor**: The floor of the sea will be represented by an Infinite Ground Plane (IGP).
- **The Sea Mount**: As you can appreciate from the rough sketch, this object has two personalities. The part that lies above the water acts as an island for the abandoned lighthouse. When we observe the sea mount from below, however, we see that it also houses the domed cave that hides the city. A Bryce Terrain is the obvious choice for the initial sea mount, though we will go through the Export>Reduce>Import process to reduce the polygon count, and do the Boolean cutaway for the cave externally. There are good reasons for staying away from a Bryce Boolean here, which will become obvious when we get to that part of the tutorial.
- **Abandoned Lighthouse**: This model will be created as a Lathed object outside of Bryce, and then imported. The lighthouse shack, however, will be created using the Terrain Editor.
- **Meropolis**: Meropolis (which literally means "Sea City") is a city inside the mount cave where alien beings go about their business. We will create it from a couple of Elevation maps in the Terrain Editor. The dome at the entrance to Meropolis is a Bryce component that uses transparency mapping.
- **Craft**: The undersea/oversea craft will be created in the Terrain Editor.
- **Sunken Ship**: Though not part of the rough sketch, I later had the idea that a sunken ship in the background would provide user interest and further nail down the environment as an undersea world.

All other details that may be added will relate to these major components. Instead of separating the design tasks ahead into *External/Internal* components as we did in the last chapter, we will place the components in this project into either *Surface* or *Undersea* categories. That works out as follows:

- **Surface**: ISP and IWP layers, The Sea Mount (excluding the creation of the cave below), Abandoned Lighthouse and Shack, other components of the "island" aspect of the Sea Mount, including all internal elements found in the Lighthouse or Shack and on the island.
- **Undersea**: Cave, Meropolis, Dome, Craft, and Sunken Ship.

CHAPTER 11 SANCTUARY OF THE SARGASSO

TUTORIAL

SURFACE COMPONENTS

Here is how to create each of the components identified as being elements of the *Surface* in this project.

ISP AND IWP LAYERS

There are separate challenges to address with each of these Infinite Plane types, as they are configured for this project.

The ISP

In this project, we will use two Infinite Sky Planes. The first one is the default sky plane addressed by the Sky Lab, while the other is an added ISP.

Configuring the Default ISP

The default ISP, as you already know, is configured in the Sky&Fog toolbar, with the option for further customization in the Sky Lab. Do the following:

1. Go to the Sky Lab, and access the Cloud Cover page. Click Edit at the right-bottom of the Cumulous thumbnail to access the Deep Texture Editor. The default cloud material is visible in the Combination thumbnail. See Figure 11.2.
2. Click the Filter button at the bottom of the Deep Texture Editor. Change the Filter Type from None to SawWave (Xa + b). See Figure 11.3.
3. Click Phase to bring up the Phase Controller. Set the Phase value to 300. At the upper left of the Phase Controller is an activation switch that turns green when you pass over it. Click on this area to bring up the Phase

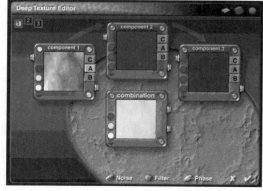

FIGURE 11.2 *The Deep Texture Editor is accessed from the Sky Lab. The default cloud material is displayed.*

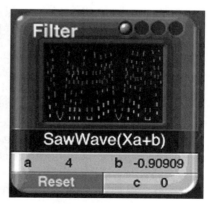

FIGURE 11.3 *Set the Filter Type in the Filter controls.*

Controller dialog. Set the Type to Voronoi Distance 4, and the Mode to Auto-Phased. Click on 3D at the bottom of the dialog. Leave the rest of the settings at their default values. See Figure 11.4.

4. Accept these settings. Back in the Sky Lab, on the right of the Cumulous thumbnail, are four small buttons. Click the top button (with the plus sign) three times. This adds a level of chaos to the Cumulous Clouds. Turn Strata off on the thumbnail next to Cumulous. The resulting sky is shown in Figure 11.5.

FIGURE 11.4 *The Phase Controller dialog.*

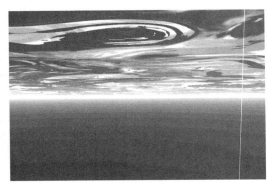

FIGURE 11.5 *The resulting sky looks like this.*

Configuring the Added ISP

Now it's time add another ISP. No added ISP can be higher in altitude than the default ISP, so this added ISP is lower in altitude and will reveal the default ISP you just customized only through any holes in the added ISP. Do the following:

1. Go to the Create toolbar, and place an ISP in the scene. In the Right View, move this ISP to the top of the document.
2. Go to the Materials Lab with this ISP selected, and then to the Deep Texture Editor. The settings displayed are for the standard values for an added ISP. Alter the Bridge mode that connects the first and second component so that it reads *Difference*. This means that the combination material will be created as the difference between the first and second component. See Figure 11.6.
3. In the Combination thumbnail, change the second color swatch on the left to a medium violet. Back in the Materials Lab, set the XYZ Scale to 10.2, and the mapping type to Object Space. This adds a layer of violet-edged clouds to this eerie sky. See Figure 11.7.

CHAPTER 11 SANCTUARY OF THE SARGASSO

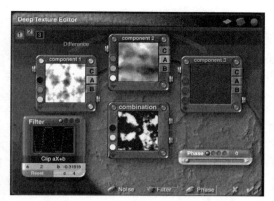

FIGURE 11.6 *Alter the Bridge type so that it reads Difference.*

FIGURE 11.7 *The sky is now composed of two cloud layers.*

The IWP

This project requires four separate Infinite Water Planes, for reasons we will detail as we go. If you were able to understand and work through the previous ISP configurations, you will have little trouble customizing the water materials. Place four IWP layers as displayed in Figure 11.8, as seen in the Right View.

FIGURE 11.8 *Place the four ISP layers as shown here.*

The Top IWP

The top IWP is a water material that has transparent areas so that you can see through to the layer below.

1. Select the top IWP, and go to the Materials Lab. Select the Foamy Seawater material from the Water&Liquids folder. Reduce the Reflection to 10%, and place a button in the Transparency Optics slot for channel 1.
2. Render to preview, and tweak the settings until you get what you like.

The Second IWP

This is a "seaweed" layer.

1. Select the second IWP, and go to the Materials Lab. Select the Storybook Grass Map material from the Miscellaneous folder. Reduce the XYZ Scale to 15, and place a button in the Transparency Optics slot for channel 1. Push the Diffusion slider up to 100%, and set the Ambience to 65%. This causes the seaweed to glow in the dark a little.
2. Render to preview from above, and you should see dim patches of seaweed through the top IWP layer.

The Two Lower IWP Components

These IWPs act to thicken the perceived density of the water planes, and mirror the materials of the IWPs above.

1. Copy the material of the top IWP to the third IWP, and copy the material of the second IWP to the bottom IWP.
2. Place a Radial Light in the space below the IWP layers.
3. Render to preview from above and below. See Figures 11.9 and 11.10.

When you look down on the water from above, the more vertical the camera angle, the more you will notice the seaweed, just as in the real world. See Figure 11.11.

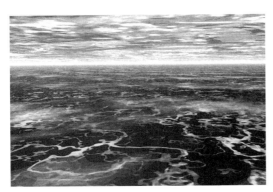

FIGURE 11.9 *The water as seen from above the surface, with a hint of the seaweed visible.*

FIGURE 11.10 *The water as seen from below the surface, with clumps of seaweed clearly visible.*

FIGURE 11.11 *A view looking straight down on the water from above gives you a better view of the seaweed beneath the surface.*

THE SEA MOUNT

Our interest here is attending to the very top of the sea mount, which is an island. Do the following:

1. Place a Symmetrical Lattice in the scene, and go to the Terrain Editor. **DO NOT** click New. Instead, we will use the default lattice as the basis for the development of the sea mount. All you need to do in the Terrain Editor is to use a Top Level Elevation Brush, about one-sixth the size of the width of the Elevation preview window, to create a flattened area at the top of the object. Select the Simple Grid to reduce the polygons, and accept the object. See Figure 11.12.
2. Convert To Terrain back in the scene. Scale so that your sea mount matches the proportions of the one shown in Figure 11.13, when compared to the size of the Camera icon.
3. With the sea mount selected, go to the Materials Lab. Go to the User folder in the presets, and load the RockyRock.mtl file. You'll find it on this book's CD in the Projects>CH_11 folder. I created this rocky texture in the Deep

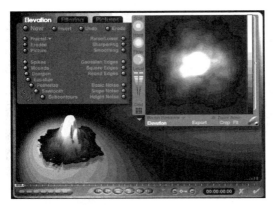

FIGURE 11.12 *All it takes is a little tweaking to develop the needed Sea Mount object from the default Symmetrical Lattice form.*

FIGURE 11.13 *Scale the sea mount as shown. Notice the small amount that rises above the IWP layers.*

Texture Editor, and it is free for your use. Use Parametric mapping with an XYZ Scale of 450 and a Bump value of –450. See Figure 11.14.

FIGURE 11.14 *The island is visible from the surface, while the sea hides the huge sea mount below.*

ABANDONED LIGHTHOUSE AND SHACK

The abandoned lighthouse and shack are the only two structures on the island. We'll create the lighthouse in an external 3D application, and the shack in Bryce.

Chapter 11 Sanctuary of the Sargasso

Lighthouse

The lighthouse has been vacant for over a century, and there have been only a few visitors during that time. All of the visitors have mysteriously disappeared. Do the following to create the lighthouse:

1. Open your external 3D application. Create the shapes shown in Figure 11.15.
2. Lathe all three shapes with 24 segments each. See Figure 11.16.
3. Use two rectangles to Boolean Subtract parts of the top of the lighthouse to create windows. Do the same to create the guard rail (Max users can select the Lattice modifier with Struts Only chosen). Group, and export as a model Bryce can read. See Figure 11.17.
4. Back in Bryce, set the Fog to 86/67 and the Haze to 10.

FIGURE 11.15 *Create these three shapes. Note that they share the same vertical pivot point.*

FIGURE 11.16 *Lathe all three shapes.*

FIGURE 11.17 *Cut away parts of the lighthouse to create the windows and guard rail.*

5. Import the lighthouse and place it on the island. Use a white diffuse material for the lighthouse tower, with a Mossy Bump map set to a value of 40. Use the same Bump map with a dark-red Diffuse hue for the lighthouse top, and the same Bump map with a light-brown Diffuse hue for the guard rail. See Figure 11.18.
6. Embed a dark-brown resized cubic primitive at the bottom of the lighthouse for a door. I had no plans to take any pictures inside the lighthouse tower, so I left it empty. If you want, you can place a Radial Light in the tower and build a spiral staircase from an array of squashed rectangular stairs around a cylindrical pole. See Figure 11.19.

FIGURE 11.18 *The lighthouse on the island.*

FIGURE 11.19 *A view standing behind the lighthouse guard rail, looking out at sea, fog, and sky.*

Shack

Unlike the sturdy lighthouse that still stands, weather and time have been less kind to the shack. Our goal is to build a small lighthouse shack that appears to have been harshly battered by wind, storm, and the ravages of time. Do the following:

1. Open a new Bryce document. Lattice>New>Create. Use the Elevation Brush to create a new Elevation map similar to that shown in Figure 11.20. Use the Pocked Fractal effect to deteriorate the structure.

 One way of maximizing the quality while keeping the polygon count low on your Terrain and Lattice objects is to adjust the Grid. Work with a 512 or 10_4 Grid when creating the Elevation map, and reduce to a 128 Grid before writing the object to the scene.

2. Place in the scene, and Convert To Terrain. Reduce the height by 50%. Apply a light-gray Diffuse material to the house, with a Black&White Bump map set to a value of 22. See Figure 11.21.
3. Use two scaled cubes to create a set of rafters. See Figure 11.22.
4. Duplicate/Replicate to create the rest of the rafters, and create and place the connecting beams. See Figure 11.23.
5. Group all, and save to the User folder in the Objects Library.
6. Open the Sargasso project. Load the shack from the Objects Library User folder. Scale and place. See Figures 11.24 and 11.25.

Chapter 11 Sanctuary of the Sargasso

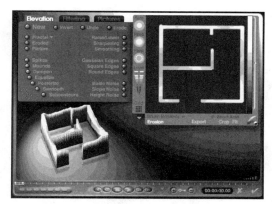

FIGURE 11.20 *Create a new Elevation Map that resembles this one.*

FIGURE 11.21 *The deteriorated house has a material applied to it.*

FIGURE 11.22 *Build a set of rafters.*

FIGURE 11.23 *The completed damaged shack.*

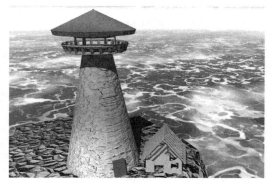

FIGURE 11.24 *Place the shack in the scene next to the lighthouse.*

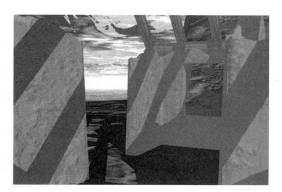

FIGURE 11.25 *Looking out toward the sea through a window in the shack.*

OTHER SURFACE COMPONENTS

If you like, you can place other items in the scene where the camera will take notice of them. For example, the Table 'O Stuff that you saved to your Objects Library from the last chapter can be placed in the shack. You can also place rocks on the island, or even a gnarled leafless tree. See Figure 11.26.

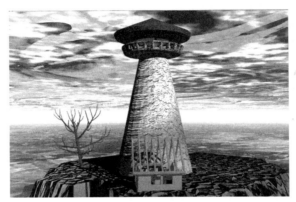

FIGURE 11.26 *One tree stands alone at the edge of the island.*

UNDERSEA COMPONENTS

Here is how to create each of the elements identified as being elements of the *Undersea* environment.

SEA-BOTTOM PLANE

1. Place an IGP in the scene just a little above the bottom of the sea mount. Map it with a Arizona/Mars material from the Sand Library. Set Diffuse to 100%, Ambience to 13.5, and Bump to 333 with World Space mapping.
2. Place a Square Spotlight in the scene. Set Intensity to 15 and Edge Blur to 25. Use a blue-green hue. Turn Cast Shadows off. Place the Square Spotlight below the surface of the water, rotated as shown in Figure 11.27. Place the camera as shown.
3. Render to preview. See Figure 11.28.

CAVE AND DOME

1. Make the sea mount a Positive Boolean. Create a large sphere, and name it Cutter. Make it a Negative Boolean. Move it so that it intersects with the sea mount just above the sea bottom.

CHAPTER 11 SANCTUARY OF THE SARGASSO

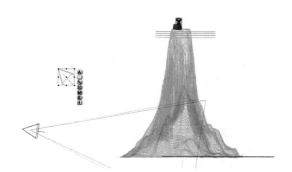 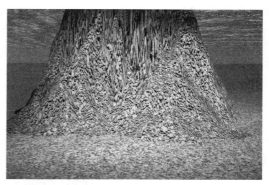

FIGURE 11.27 *Rotate the Square Spotlight as displayed here.*

FIGURE 11.28 *The rendered underwater view of the sea mount and the sea bottom, illuminated by the Square Spotlight.*

2. Duplicate the sphere, and make it Neutral. Use a Green Glass material on it from the Glass Library. Name this sphere Dome, and make it about 5% larger than the Cutter sphere. Group the sea mount with both spheres. See Figure 11.29.

 Don't be surprised if your rendering time increases when you place a glass object. Any object whose material contains a good deal of transparency will render slowly in Bryce. That's why Bryce has a Plop Renderer. *Once you render a scene with a large object that evidences transparency, and you need to place something else in the scene, use the* Plop Renderer *on just that section of the image.*

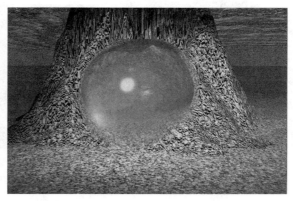

FIGURE 11.29 *The bubble is ready for the creation and placement of Meropolis.*

Meropolis

Now it's time to create the hidden city of Meropolis. Do the following:

1. Lattice>New. Go to the Picture tab, and load a City map from the Bryce Terrain Maps folder into slot one. Apply it.
2. Customize the map by first lowering it, and then paint your own towers with Elevation Brushes of random heights. See Figure 11.30.

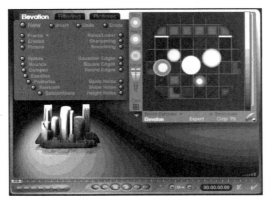

FIGURE 11.30 *Create the Elevation map for the city in the Terrain Editor.*

3. Convert To Terrain, and place Meropolis in the dome. Use a Tyrell Building material from the Wild&Fun Library with Object Mapping on it. The glass bubble will cause it to distort in interesting ways, adding to the mystery. See Figures 11.31 and 11.32.

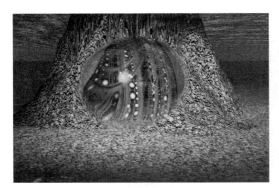

FIGURE 11.31 *Meropolis, the undersea city.*

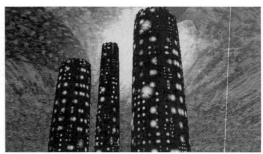

FIGURE 11.32 *A view from inside Meropolis looking out through the bubble. Notice that there is a reflection of the buildings on the upper left, and that the Square Spotlight appears like a moon through the glass.*

CHAPTER 11 SANCTUARY OF THE SARGASSO

CRAFT

If I was doing an assigned piece of work with this project, I would probably create the craft in an external 3D application, because of the lack of a wider range of modeling tools in Bryce. However, I wanted to accept the challenge to create the craft in Bryce for this book, since that allows us to explore the Terrain Editor in a different manner than we have so far. Do the following:

1. Open a new Bryce document, and Lattice>New.
2. First, create a wing for the craft by using the Elevation Brush to create the shape displayed in Figure 11.33.
3. Squash the height of this component about 95%. Scale and use a Blue Metal material from the Simple&Fast Library on this component. Duplicate, scale the duplicate down, and duplicate that element. Position as shown in Figure 11.34.

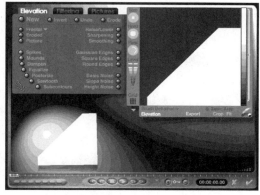

FIGURE 11.33 *Create a wing.*

FIGURE 11.34 *Create and position these components.*

4. Lattice>New. Create the main body of the craft. Work in a 1024 Grid, and reduce the Grid to 128 when you are finished. Use Elevation Brushes. Refer to Figure 11.35.
5. Place two of these components on either side of the central part of the craft, leaving a space in the center. Refer to Figure 11.36.
6. Lattice>New. Apply the following in this order: Blob Maker, Smoothing, Equalize, and Gaussian Edges. You component may not look exactly the same as that shown in Figure 11.37, but it should look similar.
7. Place it with the other components so that the whole model resembles Figure 11.38.
8. Save to the Object Library, and close the document. Open the Sargasso document, and place two of these crafts in the scene. See Figures 11.39 and 11.40.

FIGURE 11.35 *You can explore your own design, or use this Elevation map as a reference.*

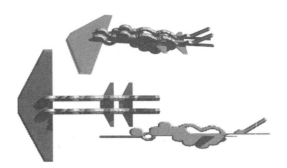

FIGURE 11.36 *Arrange the components as shown in these views.*

FIGURE 11.37 *Create an Elevation map that appears similar to this.*

FIGURE 11.38 *Refer to this illustration.*

FIGURE 11.39 *Place two crafts in the scene.*

FIGURE 11.40 *Here, the craft is set to dive into the deep, to return home to Meropolis.*

THE SUNKEN SHIP

This model does not have to be too detailed, since it represents a decayed sailing ship that has been at the bottom of the sea for hundreds of years. What it does in our scene is emphasize when the camera is at the bottom of the sea, or at least it helps to do so. Do the following:

1. Start PhotoPaint, or your other comparable 2D painting application.
2. Paint a solid silhouette of a ship. It does not have to be smooth or exact, since some ragged edges will indicate the aged effect we are looking for. See Figure 11.41.
3. Magic Wand select the background (which should be pure white, or 255, 255, 255 as RGB values). Invert the selection so that nothing but your silhouette is selected.
4. Set your foreground color to a grayish white, and create a horizontal gradient from the center of the ship that goes from grayish-white to dark gray. We are creating an Elevation map. See Figure 11.42.

FIGURE 11.41 *Paint the silhouette of a ship.*

FIGURE 11.42 *Create this gradient.*

5. Select>Invert, and Shift>Select the right side of the ship. Invert the selection again, so that now just the left side of the silhouette is selected. Create a gradient from light to dark from the center to the far left of the silhouette. Make the background solid black (RGB = 0, 0, 0). You should now have a image that looks like Figure 11.43.
6. Save the image. Open Bryce and Lattice>New. Load the image you just saved into the Picture slot. Smooth and Lower. Accept the Elevation map.
7. Do not convert to a terrain. Lower the Z dimension by about 60%, and rotate the model on its X-axis by 90 degrees. You have just created the hull of a ship! See Figure 11.44.
8. Use a scaled cube as a cabin. Create masts from scaled cylinders. Place and Group. Save the ship to the Objects Library. See Figure 11.45.
9. Open the Sargasso project, and place the ship at the bottom of the sea. See Figure 11.46.

FIGURE 11.43 *This is what your image should look like.*

FIGURE 11.44 *The hull of a ship appears.*

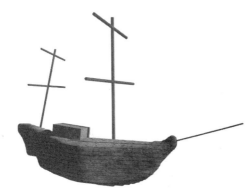

FIGURE 11.45 *Save the ship to your Objects Library.*

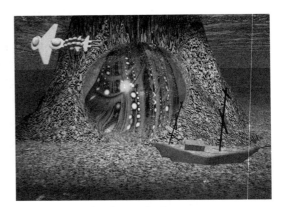

FIGURE 11.46 *Place the ship at the bottom.*

LOD AND FISH

LOD (Level of Detail) refers to the inability of the human eye to discern detail in objects that are far in the distance. All of the images of the undersea realm in this project show that great distances are involved—just compare the size of the ship to the Meropolis dome. If we were to place fish, even a whale, in this scene, it would look fairly small compared to the other components. We would have to zoom in, or create very tiny streaks for a school of fish. That's a further challenge you might consider.

TRAVELING ON

In this project, we used Bryce to evoke a water world, both on the surface of the sea and below it. In the next project, we will create The Cave of the Faerie Queen.

CHAPTER 12
The Cave of the Faerie Queen

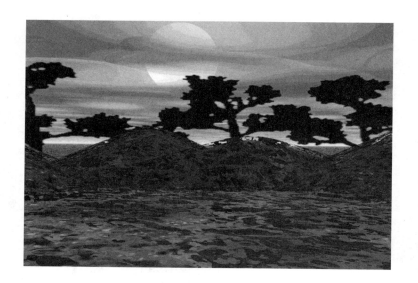

From times more ancient than civilization or writing, the most powerful symbol used in ritual and myth has been that of the tree. Whether it be the trees in the fabled garden of Eden, or the magic trees venerated by the Celts and Druids, or the tree-tunnel as pictured in *Alice In Wonderland*, there is a sense of magic and the unknown associated with these rooted beings. In this project, we will use a tree as the connecting symbol that bridges the world above the surface with that below.

THE ROUGH SKETCH

As has been the case with the precious projects in this book, it's a good idea to lay out the rough components to be used as parts of this Bryce world. You should create your own rough sketch for this project, though it should be somewhat based on the sketch shown in Figure 12.1.

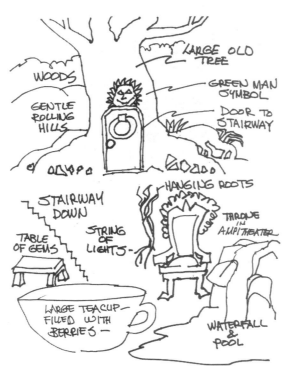

FIGURE 12.1 *The rough sketch created by the author for this project.*

Chapter 12 The Cave of the Faerie Queen

As you can see in Figure 12.1, there are quite a few distinct components required in this project. Let's list the components that need to be modeled.

Surface Components

The following Surface components need to be created: ISP, IGP, Woods, Rolling Hills, Large Old Tree, Door, Symbol above Door, Plants and Grass.

- **ISP**: The Infinite Sky Plane is a Bryce object.
- **IGP**: The Infinite Ground Plane is a Bryce object.
- **Woods**: We have several options when it comes to creating the woods in the background. We could create many objects, but is only necessary if you plan to take the camera into the woods for some images. Using tens or perhaps hundreds of 3D objects for the woods, however, can easily add 100MB or more to the project file. It's best to use 2D picture mapping for this component in most situations.
- **Rolling Hills**: This component definite suggests Bryce Terrains or Lattices. These hills shouldn't be too high, since we'll want to see the forest behind them. You may want to add two additional components that do not appear in the rough sketch. The first is some mountains far in the background, to emphasize the 3D distances involved. These can be either objects or 2D picture maps. Second, you may want to create a brook in the foreground, since some reflections always provide an extra touch of photorealism while evoking viewer interest.
- **Large Old Tree**: Creating a tree foreground object with a detailed personality is not something that can be accomplished in Bryce, so this component will call for the use of your external 3D application. I am especially interested in displaying a gnarly root system for the tree, calling to mind specific 3D modeling tools such as Lofting.
- **Door**: The door is in the tree, which calls for a Boolean operation. The door itself is best modeled externally, though it will evidence Bryce materials.
- **Symbol above Door**: The exact design of this symbol will be of your own choosing. It will call for a scanned image, 2D image manipulation, and export to Bryce's Terrain Editor for 2D/3D translation.
- **Plants and Grass**: These components add a final touch of supportive detail to the composition. Depending on how your camera is to be placed to take pictures, and what 3D tools and applications are available to you, you can design these extra elements using a number of options.

Cave Components

The cave-related components include the following: Cave, Stairway Down, Throne in an Amphitheater, Hanging Roots and Vines, Waterfall and Pool, Table of Gems, Teacup of Berries, and Lights.

- **Cave**: The cave itself has to be an enclosure of some sort, a hollowed-out object. This definitely calls for a Boolean operation, either internal or external to Bryce.
- **Stairway Down**: The stairway has to be constructed so that it joins the tree entrance with the floor of the cave. This tells us that the stairway enclosure has to be a hollow form, calling for a Boolean operation in the process.
- **Throne in an Amphitheater**: An amphitheater is a structure usually associated with the Greeks and Romans, although there are natural amphitheaters as well. An amphitheater is a structure that allows seating around the rim in order to focus on an element placed at the center. A stadium is a contemporary amphitheater. One type of amphitheater is called *sunken*, because its top level is even with the ground level of the area around it. We will use this type of structure in this project, and create it in Bryce.

 The Throne of the Faerie Queen has to be designed so that it looks like a magical place of power. This will require your external 3D application.

- **Hanging Roots and Vines**: When you visualize roots and vine elements, the first modeling process that should come to mind is Lofting. You can also use a professional metaball environment to create the necessary curves and strands. Whichever process you select, it will be an external 3D application that offers you the necessary tools.
- **Waterfall and Pool**: Bryce is the perfect environment for creating these components and the necessary textures.
- **Table of Gems**: The components that rest on the table of gems make use of Bryce transparent and refractive materials.
- **Teacup of Berries**: For a Faerie, a teacup is a giant container, and a single berry can feed a large gathering. We will rely on your external 3D modeling application to create these components.
- **Lights**: This project uses two types of lights. The first example is the light or lights that cannot be seen, but are placed to control certain needed illuminations. The other light type we will create sits on a tripod. This component uses a visible light effect.

SURFACE COMPONENTS

It's time to begin putting this world together. We'll focus on the Surface components first.

ISP

A typical or standard sky will not do at all for this world. We are developing an environment that faeries and other mythical creatures of the twilight and dawn inhabit, so the sky has to invoke the same level of mystery. To do this, you will require a working knowledge of the Deep Texture Editor, although we'll walk you through the process:

1. Go to the Sky&Fog toolbar, and select Custom Sky under the first thumbnail.
2. Set the three Custom Sky colors to bright red, medium purple, and light blue.
3. Use the following values for the rest of the settings: Shadow = medium purple of 75, Fog off, Haze = blue-white of 1, Cloud Height 22 with a Sky Dome color of bright red, Cumulous color of light blue and a value of 40.
4. Switch Stratus off, and open the Sky Lab.
5. Go to the Cloud Cover page. Click Edit under the Cumulous thumbnail.
6. In the Deep Texture Editor, go to the Combination thumbnail, and load a new texture. Select the Toad Rock texture from the Rocks Library.
7. When the Toad Rock texture is loaded, it will appear in Component 1. Copy it to Component 2, and add Noise. The colors for Component 1 remain at their defaults, but the colors for Component 2 are changed to tan, dark green, and dark red. The two Components are connected in Parallel. Component 1 has Color, Alpha, and Bump on, while Component 2 is only Color and Alpha. Refer to Figure 12.2.
8. Accept these settings. Back in the Sky Lab, go to the Sun & Moon page. Set the sun at the upper part of the placement sphere, which will create a backlighting effect. Refer to Figure 12.3 for the rest of the settings.

FIGURE 12.2 *Refer to these settings for the Deep Texture Editor.*

FIGURE 12.3 *Use these settings on the Sun & Moon page.*

238 ADVANCED BRYCE CREATIONS

9. Accept the settings, and do a preview render. The sky should look as if it has oval holes in the greenish whispy clouds, through which you can see the rising sun. See Figure 12.4.

IGP

In the cycle of the seasons, this project is set to midsummer, a time when Shakespeare set the stage for his *Midsummer Night's Dream*. This tells us that we will want some lush vegetation as a component. Setting the materials for a ground plane (in this case, two grouped IGPs) begins this process. Do the following:

1. Create two IGPs. Move them fairly close together as shown in Figure 12.5.

FIGURE 12.4 *This sky is perfect for the faerie scene.*

FIGURE 12.5 *Create two IGPs fairly close together.*

2. The bottom IGP should use the Toad Rock material with the following parameters: XYZ at 4.2%, World Top Mapping, Bump Height and Diffusion set to 100.
3. The top IGP should use Foliage material, with World Space mapping and the sliders set as displayed in Figure 12.6.
4. When you sandwich two IGP layers together, with the top layer having Alpha transparency involved, the result will be a ground look that looks far more three dimensional than any single material can create. In this case, the result is a ground that appears to show low-lying brush, with areas that look decidedly like fungus or mushrooms underneath, perfect for the start of the surface environment for this project. Group and do a test render. See Figure 12.7.

CHAPTER 12 THE CAVE OF THE FAERIE QUEEN

FIGURE 12.6 *Use these settings.*

FIGURE 12.7 *The result of the two-layer ground components.*

ROLLING HILLS

As happens many times, I had a strong inclination to alter my original sketch. Instead of hills, I would place smaller mounds around the site where the tree would sit. This would give the impression that the tree held a special importance, since it would be at the center of a geological depression. Do as follows:

1. Lattice>New. Create the Elevation map by using a large Blob Maker object with the Grod set at 32. Lower the Elevation and apply Smoothing twice. Your Terrain Editor display should resemble Figure 12.8.
2. Once the mound is placed in the scene, duplicate it. Scale the duplicate to 90% of the original. Place the bottom IDP texture on the smaller mound, and the top IGP texture on the larger mound. Group the mounds. Duplicate as many times as needed to create a ring of mounds around a clearing. See Figure 12.9.

FIGURE 12.8 *Your Terrain Editor display should resemble this illustration.*

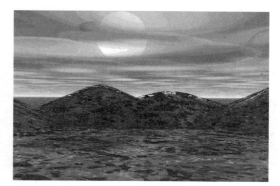

FIGURE 12.9 *The mounds ring a clearing.*

Woods

In order to follow along for this part of the tutorial, you need to own Tree Professional. You can use another tree creation plug-in for your external 3D application, but nothing compares with Tree Professional. You will also need PhotoPaint or another suitable 2D bitmap application. Do the following:

1. Open Tree Professional, and load the parameters for any selected tree from the Broadleaf Library. See Figure 12.10.
2. Go to File>Save Image as. . . , selecting an image format that you prefer. Make sure Antialiasing and Alpha Channel are checked, if the image format permits an Alpha Channel. Save the image. See Figure 12.11.
3. Repeat steps 1 and 2 about 15 times, altering the parameters and/or the rotation of the same tree. This results in a collection of 16 different images of the same tree, which we will use to build a forest.
4. Open PhotoPaint, or your other 3D application. Import one of the saved tree images. Place it on a canvas that is 15 times as wide, and about one-

FIGURE 12.10 *Load a tree parameter into TreePro.*

FIGURE 12.11 *Make sure Anti-aliasing and Alpha Channel are checked in the Save Parameters window.*

fourth taller than the current tree image. Place all of the tree images next to each other on the same canvas. Save the image as *Trees*. See Figure 12.12.

FIGURE 12.12 *The resulting image with 16 trees.*

CHAPTER 12 THE CAVE OF THE FAERIE QUEEN 241

FIGURE *The Trees Alpha image.*
12.13

5. Create a black-and-white version of the same image to use as an Alpha Channel image in Bryce. Save it as *TreesA*. See Figure 12.13.
6. Open a new document in Bryce, and place a cylinder in the scene. Map the cylinder with your saved Trees image, loading the TreesA image as an Alpha channel. Use the settings shown in Figure 12.14.

FIGURE *The settings for the cylinder mapped with*
12.14 *the Trees image.*

FIGURE *The rendered cylinder looks like a circle*
12.15 *of two-dimensional trees.*

7. You now have an object that looks like Figure 12.15 when rendered. Save the cylinder to your Objects Library.
8. Open your Faerie Queen project in Bryce. Open the Objects Library, and import the Trees cylinder. Place in the scene, surrounding the clearing. Resize and adjust the placement as needed. Do a test render. The trees are displayed as silhouettes because of the backlighting. See Figure 12.16.
9. Duplicate the Trees cylinder, and increase its diameter by about 5%. This creates another layer of trees behind the first Trees cylinder. Select Blend Transparency under Material Options in the Materials Lab. Use Foamy Water as a Texture B material. Rotate in the Top View so that the second layer of trees looks different from the first. Save the project. See Figures 12.17 and 12.18.

ADVANCED BRYCE CREATIONS

FIGURE 12.16 *The scene with a Trees cylinder added.*

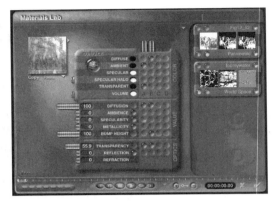

FIGURE 12.17 *The parameter settings for the second layer of the Trees material.*

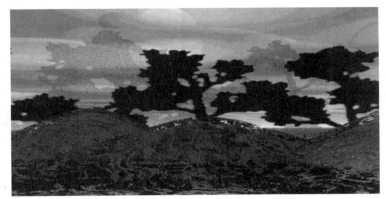

FIGURE 12.18 *The scene with layers of trees in the background. Note that the transparency added to the second tree layer makes them look shrouded in mist.*

THE BIG OLD TREE

The tree model should be created in an external 3D application. Do the following:

1. Before opening your external 3D application, place a Spotlight in the scene pointing vertically down at the clearing. This will be used to pop out the tree from the rest of the rendering. In the Spotlight settings, use these parameters: Intensity 45, Edge Blur 100, with a light blue hue. Use *No Falloff*, and a Watery Reflection Gel.

CHAPTER 12 THE CAVE OF THE FAERIE QUEEN 243

2. Time for the tree itself. Open your external 3D application. As an important modeling exercise, we are going to build this tree from scratch instead of relying on any tree plug-ins you may have. To do this, your external 3D application has to allow Lofting.
3. Draw a shape to represent the Lofting path for a branch. Make it curvy, because older trees tend to have more wind-curved elements. Loft a circular cross section to it.
4. Use this single branch to create the rest of the tree, except for the trunk and roots. You do this by duplicating and rotating the duplicates, and putting an interesting-looking branch together. Once you have an interesting branch, the parts are glued together, and the whole branch is duplicated and rotated to continue the process.

This process is similar to that which allows computer programs to create objects in nature, like trees and clouds. It is a fractal process, based on the principle of self similarity.

5. When the branches are in place, glue them all together. This operation goes under different names, depending on the 3D software you are using. In 3DS Max, it is known as *Attach*.
6. Create the trunk and the above-ground visible roots, and glue to the rest of the tree. Your tree will look unique because of the initial curves you created. The author's example is shown in Figure 12.19.
7. This model will no doubt have too many polygons, so optimize to reduce the polygon count.

FIGURE 12.19 *Though your tree will look unique, here is one example.*

8. Hollow out the tree at the bottom with a cylindrical Negative Boolean, and create a rectangular opening at the front for the door with an appropriately sized rectangular Boolean. See Figure 12.20.

I prefer to use this tree in the project without leaves, to contrast with the background trees that do have leaves. If you want to create leaves for it, use a particle system in your external 3D application, and substitute leaf shapes for the particles. Then freeze as a mesh before export. 3DS Max allows you to do this, and your 3D application may allow it as well. After the leaves are created and placed in your 3D application, group with the tree before exporting the entire object.

9. Export the tree to a new Bryce document. Create the bark material by selecting a light-brown Diffuse color and a Waves Bump set to 222, with Object Space mapping. Use an Ambience value of 27. Save to your Objects Library. See Figure 12.21.

Remember that in Bryce, the Ambience value does the same thing that a Glow value does in other 3D applications, and makes objects visible in the dark to the degree that the value is increased.

10. Open your main project, and place the tree in the clearing, with the doorway facing the camera in the Front View. Save the scene. See Figures 12.22 and Figure 12.23.

FIGURE 12.20 *Create a doorway opening and a cylindrical hollowed-out space inside.*

FIGURE 12.21 *The tree as it appears in Bryce after a bark material is applied.*

CHAPTER 12 THE CAVE OF THE FAERIE QUEEN 245

FIGURE 12.22 *Place the tree in the scene.*

FIGURE 12.23 *A close-up of the tree texture.*

THE DOOR

The door for the tree will be created in Bryce as a new document, and then the object will be saved to the Objects Library. Do the following:

1. Open a new Bryce document. Create a doorframe from four stretched Cube primitives. Group all. Use a dark wood material to texture map it in Object Space. See Figure 12.24.
2. Create the door, and set it in the frame. Use a Plank Wood material from the Simple&Fast Library to texture it, using Object Front mapping. See Figure 12.25.
3. Use a Sphere and Torus for the knocker, and a duplicated and scaled-down Sphere and Torus for the door handle. Make the door handle black, and the knocker gold. See Figure 12.26.

FIGURE 12.24 *Create the door frame.*

FIGURE 12.25 *Add the door.*

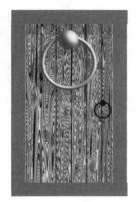

FIGURE 12.26 *Add the handle and knocker.*

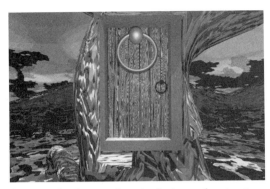

FIGURE 12.27 *The door is placed relative to the opening in the tree.*

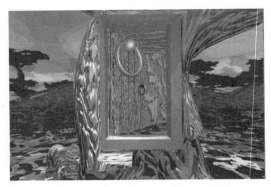

FIGURE 12.28 *The open door leads to the cave below.*

4. Group all, and save the door to your Objects Library.
5. Open your main document. Place the finished door from your Objects Library onto the opening in the tree. You will have to rescale it first to fit. Place a small Radial Light with a yellow hue and a intensity value of 5 in front of the door to illuminate it. See Figures 12.27 and 12.28.
6. Place a large boulder (rock) under the tree so that it appears that the tree is growing out of the boulder. This adds to the effect, and allows us to drill the tunnel effectively later. See Figures 12.29 and 12.30.

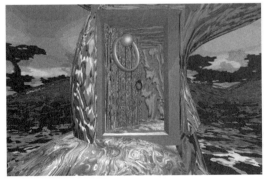

FIGURE 12.29 *Place a large boulder under the tree. This one uses a Moon Rock Bump and an Alien Rock material in the Diffuse channel.*

FIGURE 12.30 *A wider angle view of the scene so far.*

The door can be opened and closed because the door itself, knocker, and handle were first grouped as one. The group's pivot point was then moved to a hinge position.

CHAPTER 12 THE CAVE OF THE FAERIE QUEEN

SYMBOL ABOVE THE DOOR

The actual design of the symbol above the door is your own choice, although I will walk you through the process used to create the one that was used here. The symbol that I used was scanned from a small plaster souvenir, purchased at Westminster Cathedral in London. It is taken from the carvings inside, and depicts the ancient Celtic figure of the head of the Green Man. The Green Man is the Earth Father of lore, balancing the archetype of the Earth Mother figure. The actual plaster cast is hanging in my studio, and it is a perfect symbol for use in this project. Whether you scan in a 3D sculpture as I did, or grab an image from a photograph, here's what to do next:

1. Scan in your image or 3D reference object. Import the resulting image into your painting application. See Figure 12.31.
2. This next step is vital when you intend to translate a symmetrical object, like a face, into a 3D object in Bryce. Select one half of the image vertically. Copy, Paste, and Flip Horizontally. Marry the flipped half to the initial image, so you have a perfectly symmetrical image. If you don't do this, the lights and darks of the image, which create the height data for an Elevation map, will be distorted. See Figure 12.32.
3. Save the image, and open a new document in Bryce. Lattice>New. Import the image you just created. Smooth and Lower the elevation. See Figure 12.33.
4. Do a test render. See Figure 12.34.

FIGURE 12.31 *The scanned image as it appears in my painting application.*

FIGURE 12.32 *Now the image is perfectly symmetrical on the horizontal plane.*

ADVANCED BRYCE CREATIONS

FIGURE 12.33 *The image is translated into 3D elevation data in the Terrain Editor.*

FIGURE 12.34 *The rendered Green Man face is now a 3D object.*

FIGURE 12.35 *Scale and place the Green Man in the scene, just above the tree door.*

5. Save the model to your 3D Objects Library, and open the main project. Place the Green Man just above the doorway on the tree. Note that scaling will have to be done first. See Figure 12.35.

STREAM

Adding a reflective stream on the surface heightens user interest in the resulting images. Do the following:

1. Lattice>New. Draw the stream as an Elevation map in the Terrain Editor. Add some chaos on the edges with a Erosion Brush to chew up the symmetry a bit. Accept the model, and Convert To Terrain. See Figure 12.36.
2. Flatten the stream. Place the stream so that it is partly visible in the scene, sinking it into the surface by 50%. See Figure 12.37.

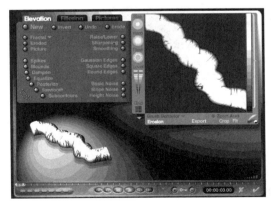

FIGURE 12.36 *Create a stream Elevation map image.*

FIGURE 12.37 *The stream reflects part of the scene, adding viewer interest.*

PLANTS AND GRASS

In my designer's eye, adding more surface elements would clutter the scene, but you may see things differently. If you wanted to add grasses and other flora to the surface in this project, I highly recommend three methods:

- Use Corel Painter to paint these elements on the finished rendered images. The tool you would use is the Image Hose. A large library of Image Hose Nozzles are available from DigiArts at www.gardenhose.com. The collection is called GardenHose, and consists of flowers, trees, shrubs, branches, and other elements.
- Use picture plane or other 3D mapping object targets in Bryce to add the desired components. If you do this, then consider preparing the images in Corel Painter, using the Jungle 3D collection from DigiArts (see previous address). This collection is especially made for creating picture maps in Bryce, and comes complete with Alpha channel mapping layers.
- Create the elements as actual 3D objects. Be careful here, because too many 3D calculations in a scene can slow Bryce renders and other operations tremendously. So far, this scene already has 47 objects with over 85,000 polygons. If you are a 3DS Max user, I highly recommend the Grass-O-Matic plug-in from Sisyphus Software (www.sisyphus.com). Using Grass-O-Matic, you can quickly create fields of grass and wheat, including bends and twists, and export as a mesh that Bryce can integrate in a scene.

CAVE COMPONENTS

TUTORIAL

Having completed the above-ground elements of this Bryce world, it's time to travel underground. I originally thought that I would create all of these components in Bryce, but decided against it. They were created in 3DS Max and imported to Bryce for placement and texturing, which I found easier and quicker. You may use your external 3D application, or may even elect to use Bryce.

THE CAVE

What I originally envisioned as a single cave space evolved into a suite of connected rooms. This, of course, gives the camera much more content to snap pictures from. I would advise using the tried-and-true method we have already used many times, in the following order:

1. Use your external 3D application to develop the components, grouping where necessary.
2. Import the finished components into a new document in Bryce, texture, and save to your Objects Library.
3. Open the main scene, and place the component from the Objects Library to the scene, scaling as needed.

This is one of the best ways to work with Bryce, since it allows you to take advantage of modeling processes that Bryce does not offer, while at the same time creating final images that build on the top Bryce features.

To create this suite of underground rooms, do the following:

1. The first room to create is the main room, the home of the sunken amphitheater. Lathe the form displayed in Figure 12.38 in your external 3D application. Notice the position of the pivot point.
2. Lathe with eight segments. This creates an octagonal room with a sunken amphitheater at the center, and seats around the sides. See Figure 12.39.

FIGURE *Draw this 2D shape.*
12.38

FIGURE *The octagonal main room.*
12.39

CHAPTER 12　THE CAVE OF THE FAERIE QUEEN

FIGURE 12.40　*Create the two shapes, and Extrude the shape on the left.*

FIGURE 12.41　*Cut the doorways.*

3. Create the two equilateral triangle shapes displayed in Figure 12.40. The one on the left is extruded thicker than the wall of the room, and will act as a Boolean cutter for doorways. The second shape will be used as a cross section for a lofted operation later, to create corridors and passageways. See Figure 12.40.
4. Duplicate the extruded shape two times, and use all three of these extruded forms as Boolean Subtractors to cut the doorways displayed in Figure 12.41.
5. One doorway leads to the treasure room, where the crystals are stored. Another leads to the tunnel that connects the room to the door in the tree. The third leads to the feast room, where the cup full of berries is. Select the second triangle shape.
6. Resize the second shape so that its inner triangle is close to the same size as the hole in the walls of the octagon room. Use this triangle as a cross section to build three passageways with a lofted operation on a straight line path for the two end holes. Refer to Figure 12.42.

FIGURE 12.42　*Build two passageways that lead away from the two end door cuts.*

FIGURE 12.43 *The passageway for the stairs has a slope that leads to a straight section for the room.*

FIGURE 12.44 *Slice off the top of the stairwell.*

7. The third passageway is a little more complex because it holds the stairway to the door in the tree. When you loft the triangular cross section, refer to the finished passageway shown in Figure 12.43.
8. Use a Boolean operation to subtract a cubic form from the top of the stairwell passage, making it parallel to the horizontal plane of the room, and thereby also parallel to the ground plane in Bryce. See Figure 12.44.
9. Go to a view that displays the stairwell from the side. Create a shape that can be extruded to create the stairs, and extrude so that it is just a bit wider than the stairwell. The stairs will protrude a little from the sides of the stairwell, but this is okay, since the only camera view will be from inside the stairwell. See Figure 12.45.
10. Lathe two octagonal side rooms, and Boolean-cut the triangular doorways as before. Connect to the side passageways. See Figure 12.46.

FIGURE 12.45 *Create the stairs inside the stairwell.*

FIGURE 12.46 *Create and place the two side passageways.*

Chapter 12 The Cave of the Faerie Queen

FIGURE 12.47 *Create ceilings for the rooms.*

FIGURE 12.48 *Apply the materials and save to your Objects Library.*

11. Attach all components together. Extrude octagonal shapes for ceilings, but do not attach them. Instead, group them with the rooms so that they may be removed if needed, and also so that they can be textured different from the rest of the rooms in Bryce. See Figure 12.47.
12. Save in a format Bryce can import. Import into a new Bryce document. Apply the same material to the Rooms object as was used on the rock that supports the tree, or select Bryce TerraCotta from the Fast&Simple Library. Apply a Marble/Bronze Fusion material to the roofs (Rocks&Stones Library). Add to your Objects Library. See Figure 12.48.
13. Do some test renders to get a feel for the spaces involved. See Figure 12.49.
14. Open the project, and place the underground cave rooms relative to the surface components. See Figure 12.50.

FIGURE 12.49 *Do some test renders.*

FIGURE 12.50 *Place the rooms in the scene as shown.*

Lights

As you might imagine, trying to snap an image in an underground room far below the surface results in a blank image, so we have to create some lights to illuminate the surroundings. We will create a special lamp, used by the faeries to bring a special glow to their secret domicile. Do the following:

1. Open a new Bryce document, and create a tripod from three stretched cylinders. Do this by setting the pivot point about one-fifth of the way down from the top of the stretched cylinder, duplicating, and rotating (top view). Then repeat these steps once more. Refer to Figure 12.51.
2. Place a sphere at the top of the tripod, and map it with a Steel Cage texture from the Miscellaneous Library. See Figure 12.52.

FIGURE 12.51 *Create a tripod from three stretched cylinders.*

FIGURE 12.52 *Add a sphere mapped with the Steel Cage texture.*

3. Place another sphere at the center of the first sphere, but about 20% smaller. Map it with the Glass Bubble #3 material from the Glass Library.
4. Place a Radial Light, about 10% smaller than the inner sphere, at the center of the smaller sphere. Make the light Volume Visible with No Falloff. Give it a light-blue color with an intensity of 25 and an softened edge of 100. Place a small cube where the tripod rods cross. Group and save to your Objects Library. See Figures 12.53 through 12.56.

CHAPTER 12 THE CAVE OF THE FAERIE QUEEN 255

FIGURE 12.53 *The finished tripod light. Note that this light casts a shadow of the surrounding cage on all objects that intersect with the path of its beams, like the golden sphere, floor, and walls shown here.*

FIGURE 12.54 *In a completely dark environment, like an enclosed room, the effect is heightened. In this case, the sun color is solid black, but the room is open.*

NOTE

If you are going to use a Material on a light (which is obviously a physical impossibility in the real world), try different mapping types to explore the results. If you want to do this while making the actual material invisible on a visible light, turn Self Shadows *off in the Material Options list in the Material Lab, and switch the material to a* Light *type in the same list. By the way, just to make things even more interesting, the materials used on lights can be either procedural or bitmap image based.*

FIGURE 12.55 *Using more than a single light creates interesting shadow patterns.*

FIGURE 12.56 *Ultimate complexity is achieved in the shadows when you map a material (not a Gel, but a material) to each Radial Light. In this case, the Stone Wall material was used with Object Space mapping. This creates FX lights.*

Throne in an Amphitheater

The throne of the Faerie Queen is unlike any earthly throne. Her throne sits in the air, floating above the pool at the center of the amphitheater. Do the following to create it:

1. Open a new Bryce document. Lattice>New. Create a basic butterfly wing as an Elevation map, and apply a Gaussian edge to it. This adds a scoop to the lattice. See Figure 12.57.
2. Back in the document, make the object as thin as possible. For a texture, go to the Deep Texture Editor. Select the Clipped Rock material from the Rocks Library, changing the color of the large oval components to light blue. See Figure 12.58.

FIGURE 12.57 *Create a butterfly wing form.*

FIGURE 12.58 *The textured butterfly wing.*

3. Lattice>New. Create the shape displayed in Figure 12.59 as an Elevation map.
4. Place this form in relation to the wing you just created. Map with a blue material. See Figure 12.60.
5. Group, duplicate, and flip on the X-axis to create the other half. See Figure 12.61.
6. Open your Objects Library, and place the Green Man object in the scene. Rotate and size as needed, and place this component at the top of the wings component. See Figure 12.62.
7. For the seat, create a squashed sphere mapped with the Mushrooms material from the Psychedelic Library, and place it on a gold Torus. Group all, and add to the Objects Library. See Figure 12.63.

CHAPTER 12 THE CAVE OF THE FAERIE QUEEN

FIGURE 12.59 *Create this shape.*

FIGURE 12.60 *The two components are placed.*

FIGURE 12.61 *The object thus far.*

FIGURE 12.62 *The Green Man is placed.*

FIGURE 12.63 *The finished throne.*

Hanging Roots

Create the hanging root forms in your external 3D application, using similar design tools and procedures you used previously to create the tree. Save to your Bryce Objects Library. See Figure 12.64.

FIGURE 12.64 *Hanging roots, ready to place.*

Waterfall and Pool

We'll create the pool when we put everything together later. The pool lies at the bottom of the sunken amphitheater. As for the waterfall, do the following:

1. Open a new Bryce document. Lattice>New. Create an Elevation map that looks like Figure 12.65. Add a Pocked Fractal and Square Edges. This will be the sides of the waterfall. Use a Pitted Concrete material on it from the Rocks&Stones Library. See Figures 12.65–12.67.

FIGURE 12.65 *Create this Elevation map.*

CHAPTER 12 THE CAVE OF THE FAERIE QUEEN

FIGURE 12.66 *Create this Elevation map.*

FIGURE 12.67 *The completed waterfall is ready to place.*

2. Create another Lattice Elevation map that looks similar to Figure 12.66. Create it from a duplicate of the previous lattice. This is the water.
3. Map the water with the Backyard Pool water texture in Object Top mapping. Place the rock walls on either side of the water component and Group. Save to your Objects Library.

TABLE OF GEMS

This component of the scene will be placed in one of the side rooms of the cave suite. Do the following:

1. Open a new Bryce document. Either create a table in the Terrain Editor, using the skills you attained by doing the same thing in the Sand Masters project, or open your Objects Library and import the table you saved from that project.
2. If you import the previous *Table 'O Stuff* from the Sand Masters project, delete all of the elements placed on the table. We will create new stuff to place on the table.
3. For our crystals or gems, you can use scaled cubes. I actually prefer a more crystal-looking geometry, so I used the Cubic Octahedron primitive from 3DS Max 3.1. Whichever you select, use any of the Glass materials from the Glass Library to map it. Scale and alter the hue to create a group of crystals, and place them on the table.
4. Place a collection of other objects on the table as you prefer. You might select any of the Boolean or Imported objects that come with Bryce in the Objects Library. Create an interesting arrangement. Render to preview. When you like what you see, Group all and save to your Objects Library as *Table 'O Stuff2*. See Figure 12.68.

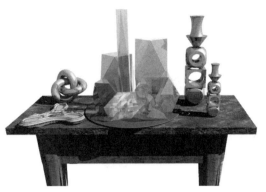

FIGURE 12.68 *Create a new* Table 'O Stuff.

TEACUP OF BERRIES

Because this cup requires a lofted element, a external 3D application is used. Do the following:

1. Open your external 3D application. Create the body of the cup by Lathing, or by Boolean operations.
2. Loft a fancy handle. Join the parts, and export in a format Bryce can import. Refer to Figure 12.69.
3. Since you already have your external 3D application open, let's create a berry here as well. Place a sphere in the scene, and elongate it vertically so it looks more like a grape.
4. Create the stem by lofting a circle, and shape to give it some character. Group, and export in a format Bryce can import. See Figure 12.70.
5. Open PhotoPaint, Painter, or your alternate image application, and paint a loose flower design on a 256 × 256 pixel canvas. Save the image. Refer to Figure 12.71.
6. Open a new document in Bryce, and import the Cup object. Go to Objects>Edit Object to smooth the polygons.

FIGURE 12.69 *The cup.*

FIGURE 12.70 *The grape or berry.*

FIGURE 12.71 *Paint a loose flower design.*

CHAPTER 12 THE CAVE OF THE FAERIE QUEEN

FIGURE 12.72 *The textured cup.*

FIGURE 12.73 *The full cup.*

7. Go to the Materials Lab, and select a Picture texture type. In the Picture Editor, import the flower painting you saved. Use Spherical mapping and an XYZ Scale of 60%. Render to preview. Save to your Objects Library. See Figure 12.72.
8. Import the grape. If you want this to be a grape, just use a purple material on it and brown on the stem. If you want it to be a berry, make it rounder and use an appropriate texture. Some berries, like raspberries, can be emulated by using a Bump map that displays columns and rows of spheres. I'll leave it as a grape for this exercise.
9. Duplicate and place enough grapes (berries) in the cup to make it look full, remembering that every extra object adds polygons to the total. See Figure 12.73.
10. Group all, and save to your Objects Library as *Cup 'O Grapes* (or *Cup 'O Berries*).

JUST ONE MORE THING

I just couldn't resist one final idea. As I was thinking about the room with the giant teacup, I wondered how the company of faeries would enjoy their repast. Would they all stand around the cup grabbing at the berries or grapes? I doubted that. After all, faeries are supposed to represent the ultimate in mini-world etiquette. A table was obviously needed. Here's how to complete this final modeling challenge:

1. In your external 3D application, create the attached shapes shown in Figure 12.74 and lathe with seven sections. Note where the pivot point is.
2. This creates a seven-sided table with an attached bench. See Figure 12.75.
3. The design is okay, but something is amiss. How can these little beings squeeze onto the benches? They could climb or fly, but that might invite chaos. So, let's separate the benches with some space. Use a rectangular series of extruded shapes as Boolean Subtractors to cut spaces between the seven benches. See Figure 12.76.

FIGURE 12.74 *Lathe these attached shapes.*

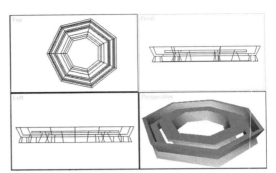

FIGURE 12.75 *The table and attached bench.*

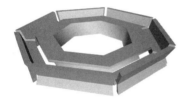

FIGURE 12.76 *The benches now allow space to sit down.*

FIGURE 12.77 *The textured table and benches.*

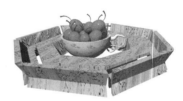

FIGURE 12.78 *Table, benches, and the cup of delights.*

4. Export, and import to Bryce. Map with a suitable wood texture. Save to your Objects Library as STbl_01. See Figure 12.77.
5. Load the Cup & Grapes/Berries from the Objects Library, and place at the center of the table opening. Scale as needed. Group and save to the Objects Library as FTbl_02. See Figure 12.78.

COMPLETING THIS PROJECT

Take a moment to ponder how to proceed before completing this project. What is left to do? The task at hand is to place the following items in the cave rooms: Lights, Throne, Hanging Roots, Table of Gems, Waterfall and Pool, Cup and Table. You could just open the main project and place these items, one by one, in the scene—but it would not be a pleasant task. The main project is already packed with items, so your new items would move very slowly in response to

Chapter 12 The Cave of the Faerie Queen

FIGURE 12.79 *Place the four lights in the cave rooms.*

your mouse movements, and exact placement would be very difficult to say the least. Wouldn't it be better to place these items in a separate project that has just the Cave Rooms in it, so you could move with ease and place things exactly where they belong? That way, you could delete the cave rooms already in the main project, import the completed cave rooms with everything in place, and be done. Besides, if you want to move the camera around inside the cave rooms, better to do that in a separate project anyway. That's exactly what we are going to do. Do the following:

1. Open a new Bryce document. Load the Cave Rooms from your Objects Library. Load, Scale, and place the lights with their tripods. One light goes in each of the side rooms, and two lights are placed in the amphitheater room. See Figure 12.79.
2. Scale and place the Throne from the Objects Library so that it floats above the pool space. See Figure 12.80.
3. Scale and place Hanging Roots from the Objects Library, so that three of these components hang from the ceiling behind the Throne in the main room. See Figure 12.81.
4. Scale and place the Table of Gems (stuff2) from the Objects Library into the side room at the bottom of the screen as you look from the Top View. See Figure 12.82.
5. Scale and place the Waterfall from the Objects Library so that it flows into the well at the bottom of the amphitheater. Place a flattened cube at the bottom of the amphitheater, textured with a reflective water material. See Figure 12.83.

FIGURE 12.80 *Scale and place the Throne.*

FIGURE 12.81 *Scale and place the Hanging Roots.*

6. Scale and place the Cup and Table from the Objects Library into the second side room. See Figure 12.84.
7. That's it!!! Move the camera where you like and take some pictures. See Figures 12.85 through 12.90.

FIGURE 12.82 *Scale and place the treasure table.*

FIGURE 12.83 *Place the Waterfall and a water surface in the scene.*

Chapter 12 The Cave of the Faerie Queen

FIGURE 12.84 *Scale and place the Table and Cup group.*

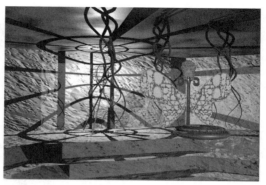

FIGURE 12.85 *The light in the main room shines behind the throne, which sits above the amphitheater.*

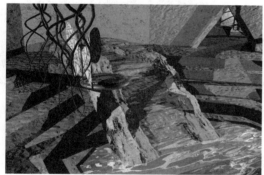

FIGURE 12.86 *A view from the side of the throne. You can see the waterfall and the pool. If you look through the passageway at the upper right, you can also see the room with the cup.*

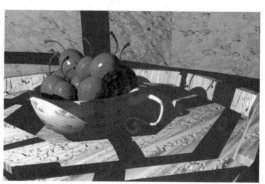

FIGURE 12.87 *In the feast room.*

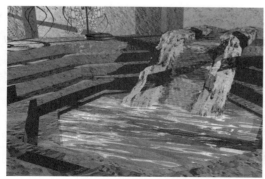

FIGURE 12.88 *Another view of the amphitheater and waterfall.*

FIGURE 12.89 *In the passageway to the treasure room, where the table of crystals awaits.*

FIGURE 12.90 *The table of treasures.*

Save this as a separate project. You can either merge it with the surface project, or simply call it up on its own when it's time to create images of the underground content.

TRAVELING ON

In this project, we built the world of the Faerie Queen and her secret underworld domain. The next project concerns a less friendly environment: *House of the Fire Eaters*.

CHAPTER 13
House of the Fire Eaters

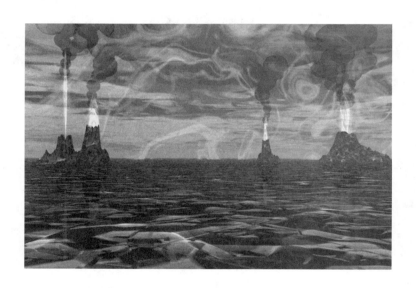

Advanced Bryce Creations

Fire has a double nature: It provides warmth in the cold, but can at any moment consume everything in sight. To live in a land of fire requires special protective habitats, as well as beings who can take the heat. Until very recently, it was assumed that nothing could live, much less thrive, close to the heat vents connected to active volcanic sources. Then, deep sea investigators found that a number of previously unknown creatures actually preferred living and propagating in and around the volcanic vents. This chapter pushes the possibility of life forms in fire to a fantastic edge, creating a world where larger life forms thrive in the midst of ferocious heat. Whether this world is from the past or future, or even a place hidden in the present, is left up to the reader and viewer. In exploring the creation of this new and unusual world, we will use new Bryce tools, processes, and materials.

THE ROUGH SKETCH

As already established in previous projects, this adventure starts with a rough sketch, a collection of visual ideas that warm up our intuitive processes. See Figure 13.1.

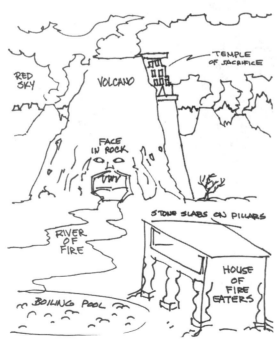

FIGURE 13.1 *The rough sketch depicts some of the main elements of this world of heat and smoke.*

Chapter 13 House of the Fire Eaters

Remember that your rough sketch only acts as a generating force for developing your Bryce project, not as a cage that imprisons your ability to sacrifice more detailed ideas as you become immersed in the creative process. Most of the time, the elements depicted in your rough sketch will find their way into the finished project. Sometimes, however, these elements become so radically altered in the finished project that they almost can't be compared with the way they are pictured in the rough sketch. Both of these eventualities are perfectly OK. The ways that you work will be unique to who you are and what creative modalities are comfortable for you. There is no "correct" way to bring a project to life. There is only your familiarity with the tools, expectations, and intuition.

Look at Figure 13.1. This is the initial rough sketch for this project. Like the projects you have completed so far, there are two basic environments. There is the Fireworld itself, and there is the House of the Fire Eaters. The house exists in the Fireworld, but is also its own enclosed space. This means that we will have to set about creating two somewhat separate spaces for the scaling and placement of the components. Our concerns when creating the global Fireworld environment (sans house) will be the sky, smoke and fire, volcanoes, ground, the head that is part of the volcano, the temple at the top of the foreground volcano, the river of fire and bubbling pool, and the other possible fill-in elements. When we get to the creation of the House of the Fire Eaters, we are going to want to take care not to place the house too close to the volcano. We are also going to want to place articles of interest in the house, so we can place the camera at different vantage points in the house to take some pictures.

Proportions and Miniatures

There is an important concept that we will apply in this project that is important to point out and detail: the application and principle of *Proportions and Miniatures*. When sets are designed for the movies that must depict giant scenes, scenes that take in overviews of large spaces and complex world views, the principle of Proportions and Miniatures is always applied. This concept, simply defined, means that various aspects of a scene can be built at different scales. After all, if every part of a movie set had to be built to scale, there wouldn't be enough money in the world to finance a film. Everything has to do with LOD—Level of Detail. If a film is being made about the Roman Empire, and the only camera views of Rome show it from a window in a palace, then the city can be built in miniature and placed so that it is seen from a window, because no real close-ups will be needed. If one or more buildings in the city will be used as

internal sets for action, then only those buildings, or parts of buildings, need be built to scale.

Many times, elements of a set are built in several scales, so that scenes can be shot as needed, with whatever scaled model appropriate for that shot. For example, if one scene calls for a long shot of a palace, another of a guard standing on one of its walls, and a third of the throne room, this would probably call for three different set constructions. It is only when you intend that the camera be used to show one continuous flow from one part of a modeled element to the next that everything has to be built proportionally to scale. For instance, using the previous example, if you needed to have the camera show the throne room, move in a continuous flow to the guard on the wall, and then fly upward to show the palace as it exists in the surrounding environment, you might have to build all or most of the model in exact proportions. Even then, there's a way around this extensive challenge. At certain points in the movement you could edit in the start of a separate flow, making it seem as if the palace is real and built to scale, while using editing magic to fool the viewer's perception. You have to take all of this into your plans before building a model, especially the question "what do I want the camera to do?"

One way that this works in Bryce is that different structures can be created at separate proportional scales. In this project, for instance, the scale of the Temple of Sacrifice on the edge of the volcano and the House of the Fire Eaters are not created at the same scale. The general rule is this: The more detail that has to be shown in a component of a scene, the larger that component should be. This allows you to position the camera more effectively when it's time to take a tour of the complex environment, while creating other components that are to be used more as backdrops at a smaller scale. This has another advantage as well. Smaller props that depict large objects, like a background mountain or volcano, trick the eye into seeing them as massive objects set in the far distance. All of this has to be practiced. After all (to paraphrase a famous quote), a movie model of Rome can't be built in a day.

The Fireworld

The Fireworld is unmerciful and unforgiving. It is a place of permanent heat, laced with the thick clouds created by the smoke and ash that continually permeate the atmosphere. This fact affects everything that we set out to model, from geometry to materials. The components of the Fireworld, as indicated in the rough sketch, immediately bring to mind certain tools and processes (although this can change once we actually become involved in the modeling processes).

- **Sky**: Although we will use a standard ISP for a background sky, the eerie nature of this world will require more than that. This will be achieved by a special geometry and mapping method.
- **Smoke**: Exactly what does "smoke" mean? There are two ways to emulate smoke in Bryce. The first is to add a Haze value, because smoke, especially on a volcanic scale, dirties the atmosphere. Added to that are the visible smoke trails emanating from the volcanoes themselves.
- **Fire**: Fire and fire f/x are usually created in 3D applications by relying on Particle Systems. A Particle System generates points from a source point or object, and these resulting points can be set to variable geometries and materials. The second way that fire f/x are sometimes created is to map images, animations, and fire-emulating materials to targeted geometry. Since Bryce doesn't have its own Particle System, we are left with two options: either use the mapping method and forget particle f/x, or use both, finding a way to lend particle f/x to Bryce.
- **Volcanoes**: Terrains are natural solutions for volcano creation in Bryce. In the Terrain Editor, you can generate a limitless number of unique volcano forms.
- **Ground**: The most obvious way to create a ground in Bryce is to apply a standard IGP. In this project, however, we will use a Volume IGP, since we will need to carve it out a bit.
- **Head**: The head carving in this project is welded to the foreground volcano, and acts as a pressure release from which a river of lava flows, making the volcano less likely to explode. You can use Poser or a number of other anatomy creation tools and methods for generating the head, although Poser is the first choice suggested here.
- **Temple**: At the top of the foreground volcano is a special construct, a Temple of Sacrifice. Like the worshippers of the fire goddess *Pele* in Hawaii, the inhabitants of this world believe that it is necessary to propitiate the powers of the underworld by a sacrificial offering at certain times of the year. There should be enough detail used in the construction of this temple to make camera snapshots interesting. This may require the use of an external 3D application.
- **River of Fire**: The River of Fire is a lava flow that is emitted by the foreground volcano at its base, preventing a more serious eruption and explosion. This allows the temple at the edge of the calendra to exist. We will depend mostly on a suitable material to emulate the lava, although geometry is also involved.
- **Bubbling Pool**: As the River of Fire flows into the pool, it is transformed into a boiling mass of superheated water and boiling mud. This effect can be simulated in Bryce, with special geometry and materials.

- **Fill-in Elements**: Rocks and dead trees might be added to this scene. Both can rely on Bryce for their existence, or external 3D applications can be used to good advantage.

THE FIRE EATERS' HOUSE

The only sanctuary from the ravages of the Fireworld is to escape to the domain of the Fire Eaters, and there is no real safety there for the voyeur or tourist, except through the lens of the Bryce camera. Although the rough doesn't detail any of the elements inside the house, here's what will be added:

- **The Structure**: The house sits on pillars, elevating it above the ground. Entrance is through a ladder and trap door. You should already have a ladder in your Objects Library from the Sand Masters project. The rest of the house and pillars will be created in Bryce. A Bryce Boolean is used to create the trap door in the floor of the house. The walls, floor, and roof are created from flat Bryce Stone primitives.
- **Large Windows**: It is important that the occupants have a full view of the outside, alerting them when the main volcano speaks. Bryce Booleans can be used to create the windows.
- **Metal Blast Shutters**: Although the main volcano is vented by the River of Fire to control major eruptions, the volcanoes in the distance are not. The blast shutters can be instantly lowered to prevent damage, since the house itself is able to withstand intermittent blasts. The blast shutters are created in Bryce.
- **Three Rooms**: The house contains an observation room at the front, with communal sleeping quarters and an eating area at the rear. There is a telescope in the observation room, along with a few seats and a panel of electronic gear (purpose unknown). Cots populate the sleeping quarters. In the kitchen are storage cabinets and a table and chairs. On the stove is a pot for making the staple food of the Fire Eaters: Fire Soup. A bowl of Fire Soup sits on the table to cool. A mix of Bryce and external 3D tools are used to model these components.
- **On the Roof**: Another ladder leads from the main room to an evacuation door on the roof. On the roof sits a special heli-vehicle for normal travel and emergencies. The heli-vehicle will be modeled in Bryce.

CHAPTER 13 HOUSE OF THE FIRE EATERS 273

FIREWORLD COMPONENTS

TUTORIAL

OK. Put on your asbestos gloves. Time to start creating the Fireworld.

SKY

The sky for this project consists of two separate planes. First is the ISP associated with the Sky&Fog tool set, so you will be creating general atmospheric parameters as well. The second sky plane will be created by surface mapping a giant sphere that covers the entire scene . . . and then some.

Sky&Fog Parameters

Do the following to set the Sky & Fog parameters:

1. Select Custom Sky from the Sky Mode thumbnail list in the Sky&Fog tool set, and open the Sky Lab.
2. Select the Indian Summer preset. This is a good sky to start with, because it features a lot of reds and yellows.
3. On the Sun&Moon page, set Shadows to 100%. Set the Ambient and Sky Dome values to a deep red. Change the sun's color to bright yellow. All of these alterations emphasize the heated sky effect. See Figure 13.2.
4. Go to the Cloud Cover page. Alter the following parameters. In the Stratus thumbnail settings, change the green hue to yellow, and click 5 times on the top-right plus button. In the Cumulous thumbnail, click 15 times on the top-right plus button, and change the bottom color on the left to deep red.
5. On the same page, at the bottom left, click the Spherical Clouds button to activate it. Set Frequency and Amplitude to 100. See Figure 13.3.

FIGURE **13.2** *Customize the parameters on the Sun&Moon page of the Sky Lab.*

FIGURE **13.3** *Customize the parameters on the Cloud Cover page.*

274　　　　　　　　　　　　　　　　　　　　　　　　　**ADVANCED BRYCE CREATIONS**

FIGURE 13.4　*Customize the parameters on the Atmosphere page.*

FIGURE 13.5　*The sky should look like this so far.*

6. Go to the Atmosphere page to customize parameters. Set the Haze Density to 10, and Haze Thickness to 25. Haze color should be a deep red. See Figure 13.4.
7. Back in the document, move the Sun Control so that it is at the bottom-center. Render the sky for preview. See Figure 13.5.

A Spherical Sky Plane Layer

You will have to have the KPT5 plug-in for PhotoPaint (or your alternative 2D painting application) installed to do this step. Do the following:

1. Open your 2D painting application. Create a new image that is 1024 × 1024 pixels in size, as a grayscale image type. Open the KPT5 FraxFlame filter.
2. Select the Horseshoe style with a red and yellow gradient. Go through the preset shapes until you find one that is rather stringy. Refer to Figure 13.6.
3. When you are satisfied with the pattern, accept it, so that it renders to the image. Save the color image. Create a grayscale image from the color image. The grayscale image will be used in the Transparency channel in Bryce. Save this in the Alpha/Transparency image. See Figure 13.7.

NOTE　*The KPT5 FraxFlame filter is not optimized for rendering speed, so be prepared to wait while it renders the image. It might be a good time for a tea break.*

4. Return to Bryce. Create a sphere that is about 100 times as large as the Camera icon as seen in the Top View, and center it on the scene.
5. Map the sphere with the FraxFlame image you created, using the color image for Diffuse content and the grayscale for Alpha. Set up your Materi-

Chapter 13 House of the Fire Eaters

Figure 13.6 *Find a stringy pattern in the FraxFlame filter.*

Figure 13.7 *The image created by the KPY5 FraxFlame filter.*

als Lab for this texture as shown in Figure 13.8. Use an XYZ scale of 0%, and Random mapping.

6. The result will be a series of vaporous tongues reaching into the sky. See Figure 13.9.
7. Lock the sphere in its Attributes window, and save the project.

Ground

Time to create the ground as a base for other components. Do the following:

1. Create a Volume-type IGP (Bryce also calls this a "slab"). We will use a Boolean operation later to cut away part of this slab.

Figure 13.8 *Set the Materials Lab parameters like this.*

Figure 13.9 *Vaporous tongues of noxious gases reach into the sky.*

FIGURE 13.10 *Use these settings.*

FIGURE 13.11 *The rendered image with the IGP slab in place.*

2. Go to the Materials Lab, and use the following settings for the slab: Fool's Gold from the Rocks&Stones Library, with an XYZ Scale of 2.2%. Use the parameter settings shown in Figure 13.10.
3. Render to preview. See Figure 13.11.

VOLCANOES

This landscape is dotted with volcanoes. There is a main one in the foreground with the Temple of Sacrifice at the top, and a few in the background (very far from the camera). All are quite active, which accounts for the pyrotechnics in the sky. Do the following to create them:

1. We'll create the far background volcanoes first. Lattice>Terrain Editor. Use the default lattice that appears, and flatten its top with an Elevation Brush (highest Level). Create a hole in the top by using another Elevation Brush (lowest level). Use a Grid of 32 (Course) since these objects will be far away. See Figure 13.12.
2. Use this single volcano to create a series of duplicates. Place each at a different distance from the camera, and rescale and rotate on the vertical axis to provide some variation. Map with the same material used on the IGP. See Figure 13.13.
3. Now for some flames. Place a sphere in each volcano, and sink it about half way down. Stretch on the vertical about 400%. Map each sphere with the same texture you used for the large sphere. Alter the parameters as shown in Figure 13.14.
4. Render to preview. See Figure 13.15.

CHAPTER 13 HOUSE OF THE FIRE EATERS

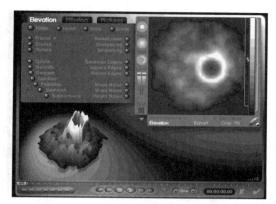

FIGURE 13.12 Create a volcano in the Terrain Editor.

FIGURE 13.13 Background volcanoes are added.

5. Open your external 3D application, and create an arrangement of co-planar spheres as shown in Figure 13.16. Attach all with Boolean Unions, and export to a format that Bryce can read.
6. This is our smoke object. Use the following mapping parameters after importing into the Fire Eaters scene: Black preset with all Shadows off. Use the Waves preset in the Transparency Channel in Object Space. Set the XYZ scale to 5.5%. See Figure 13.17.
7. Use the smoke object, or a couple of them, on each volcano flame top. Vary scale and direction for variation. See Figure 13.18.

FIGURE 13.14 Set the parameters as shown here.

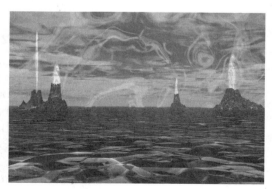

FIGURE 13.15 Flames spout from each background volcano.

FIGURE 13.16 *Create an arrangement of spheres similar to this in your external 3D application.*

FIGURE 13.17 *Use these material mapping parameters for the smoke object.*

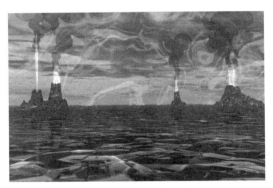

FIGURE 13.18 *Smoke is added to each volcano.*

Main Volcano

The main volcano is a central focus of this project. Do the following:

1. Save the Fire Eaters project, and open a new Bryce document.
2. Lattice>New. Load the Mayan Pyramid Elevation map from the Terrain Map folder. Apply Erosion to rough it up, and give it Round Edges. Use an Elevation Brush to create a crater at the top. See Figure 13.19.
3. Use an Elevation Brush about three notches down from the Top Level to create a landing at the top where the Temple will be placed. See Figure 13.20.
4. Accept the model. Place a yellow Spotlight about one-fourth of the way down the crater, pointing up. Make it a Visible Light. Set intensity to 40, and Edge Blur to 50. Save to your Objects Library. Map with the same material as the IGP slab, but in Object Space. See Figure 13.21.

CHAPTER 13 HOUSE OF THE FIRE EATERS

FIGURE 13.19 *Create a unique volcano object.*

FIGURE 13.20 *Create a platform at the top, next to the crater.*

FIGURE 13.21 *The central volcano, with the platform near the top.*

THE TEMPLE OF SACRIFICE

The Temple of Sacrifice is created in a new document and saved to the Objects Library as well. Do the following:

1. Create a new document. Lattice>New. Create the Elevation map shown in Figure 13.22 in a 2D painting application. Use a 512 × 512 image size. The background is solid black, and the image solid white. See Figure 13.22.

You can either create an image like this by hand (a tedious and time-consuming task), or you can use components from the Classic Ornament Texture Kit CD-ROM from Eni Oken (www.oken3d.com). The Classic Ornament Texture Kit is essential for serious Bryce users. The latter option was selected by the author.

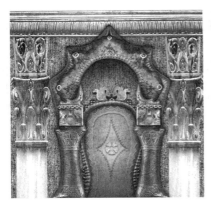

FIGURE 13.22 *Create this image in your 2D painting application.*

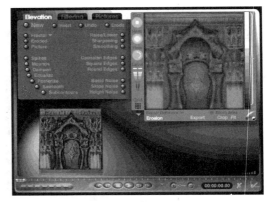

FIGURE 13.23 *Apply the grayscale image as an Elevation map in the Terrain Editor.*

2. Save a grayscale of the same image after you save the RGB.
3. In the new Bryce document, Lattice>New. Apply the grayscale image you just created as an Elevation map on a Grid of 32 (Course). Apply square Edges. See Figure 13.23.
4. Apply the RGB image as a material for this object in the Materials Lab, using the Diffuse and Ambient channels with Parametric mapping. See Figure 13.24.
5. Create a 3D box using this object on all four sides, and use a squashed cube for the roof. See Figure 13.25.
6. Group and duplicate, placing a smaller box on top of the large one. Group all, and save to your Objects Library. See Figure 13.26.

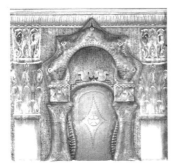

FIGURE 12.24 *The rendered 3D object is one side of the Temple of Sacrifice.*

FIGURE 12.25 *Create a box from the facades, and add a cubic roof.*

FIGURE 12.26 *The finished Temple of Sacrifice.*

CHAPTER 13 HOUSE OF THE FIRE EATERS

BACK TO THE CENTRAL VOLCANO

I used CuriousLabs' Poser to create the head for the main volcano. You can create the head with any software or plug-in available to you, or sculpt your own. If you have Poser 4, do the following:

1. Open Poser 4, and select the Carson character from the Characters-Male folder in the Figures library. Sculpt the character's features by using the parameter dials, so the result resembles Figure 13.27.
2. Export the head in a file format that your external 3D application can read. Use the Vertex Editing tools in your 3D application to alter the head as shown in Figure 13.28. Note that the bottom back of the head has been removed.
3. Save the customized head in a format that Bryce can import.
4. Open a new Bryce document, and import the main volcano from the Objects Library. Import the customized head from the Objects Library. Place the head at the bottom-front of the volcano so that the dividing line between its upper and lower mouth roughly lines up with the base of the volcano, and push the head back until it intersects with the volcano.
5. Make the volcano and head Positive Booleans, and create a cylinder that cuts away the volcano as seen from the Front View, so that the area behind the mouth will be empty (for the River of Fire). Make the cylinder a

FIGURE 13.27 *Alter the features so the character looks something like this.*

FIGURE 13.28 *Customize the head model to look something like this.*

Negative Boolean, and Group all. Save this new volcano structure to your Objects Library. See Figure 13.29.
6. Open the Fire Eaters project, and place the volcano and head object from the Objects Library in the scene. Scale as needed, and sink the main volcano group in the slab just a little lower than its base.
7. Import the Temple of Sacrifice to its place on the volcano platform, and scale as needed. See Figure 13.30.

FIGURE 13.29 *The volcano with the head object, cut away for the River of Fire.*

FIGURE 13.30 *The volcano, head, and temple are in place.*

RIVER OF FIRE

The River of Fire begins inside the main volcano and extends outward, through the head's mouth. This river of molten rock was created by the Fire Eaters as a vent, to prevent the main volcano from erupting and destroying the Temple of Sacrifice at the top. Do the following:

1. Lattice>New. Create an Elevation map for the River of Fire. The Grid = 64. See Figure 13.31.
2. Place the River of Fire so that one part exits the mouth of the head, and the other heads for the front of the scene. Duplicate.
3. Move the duplicate straight up and out of the way. Make the original a Negative Boolean with Transfer Material off.
4. Make the slab a Positive Boolean, and Group with the original River object to create a channel in the ground.

CHAPTER 13 HOUSE OF THE FIRE EATERS

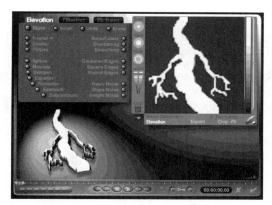

FIGURE 13.31 *Create the Elevation map for the River of Fire in the Terrain Editor as shown.*

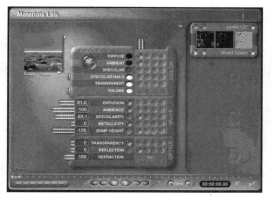

FIGURE 13.32 *Set the parameters as shown here.*

5. Move the duplicate River down so that it sits just below the top of the slab into the cut channel.
6. Place a red Radial Light in the mouth with Cast Shadows off. Give it an Intensity of 45 with no Edge Blur. This lights up the inside of the mouth.
7. Use the Volcano Heart material from the Planes&Terrains Library with World Space mapping, an XYZ Scale of 9.7%, and the parameter settings shown in Figure 13.32 on the River of Fire object.
8. Do a test render of the scene so far. See Figure 13.33.

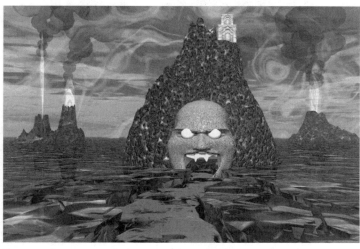

FIGURE 13.33 *The scene with the River of Fire added.*

Bubbling Pool

The Pool lies at the end of the River of Fire, collecting the melted rock. From there, it seeps into a cavern below the ground. Do the following to create it:

1. Lattice>New. Use the Blob maker and Smoothing, then Rounded Edges, to create a rounded mound. See Figure 13.34.
2. Use the Rounded Mound as a Negative Boolean to cut the pool cavity from the slab.
3. Create a large flattened cylinder for the melted rock that fills the pool. Scale and position so that the top is even with the top of the River of Fire.
4. Use the same material on the pool as used on the river, with one exception: use a Bump map for Texture B created from the Moon Rock material. Scale the XYZ to 320 with Random mapping. Set the other parameters as shown in Figure 13.35.

FIGURE 13.34 *Create a rounded mound in the Terrain Editor.*

FIGURE 13.35 *Use these settings for the pool texture.*

5. Select a rendering view that displays the pool at the end of the River of Fire. Create a low-polygon hemisphere in your external 3D application. Import into Bryce, and Duplicate and Scale to create bubbles in the pool. Map with the red material in the Simple&Fast Library. See Figure 13.36.

Fill-in Elements

Although you might elect to place rocks and trees at various positions in the scene, I decided against it in this case. I didn't want anything to detract from the heated elements already created.

CHAPTER 13 HOUSE OF THE FIRE EATERS 285

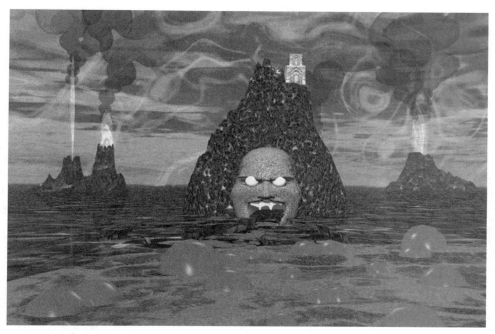

FIGURE *The bubbling collecting pool.*
13.36

TUTORIAL

THE FIRE EATERS' HOUSE

It's a good idea to create this collection of components as a grouped element, and to place it in the Objects Library. That way, all you have to do is drop it in the finished scene.

THE STRUCTURE

The house sits on pillars, elevating it above the ground. Entrance is through a spiral staircase from the Objects Library (this object is included with Bryce). The rest of the house and pillars will be created in both Bryce and your external 3D application. A Boolean operation is used to create the trap door in the floor of the house. The initial walls, floor, and roof are created from flattened and stretched cubes, attached externally in your 3D application. Do the following:

1. Open a new Bryce document. Lattice>New. Create the Elevation map shown in Figure 13.37.
2. Accept, and Convert to Terrain. Export in a 3D file format your external 3D application can import.
3. Open your external 3D application. Import the house you just exported from Bryce.

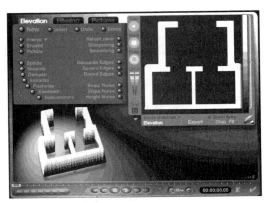

FIGURE 13.37 *Create this Elevation map for the basic floor plan and partitions.*

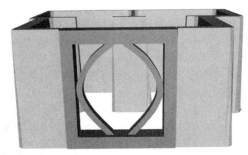

FIGURE 13.38 *A window frame is added to the house.*

4. Create a front window frame. You can use any modeling methods you care to. The pictured window frame was created with a Boolean operation and extrusion. See Figure 13.38.
5. Create a floor that follows the outline of the external perimeter of the house, and Extrude. Use a cylinder as a Boolean operator to create a hole in the floor, and place a cylindrical doorway over the hole. See Figure 13.39.
6. Create a rectangular roof that is larger than the house, so that the helivehicle has a place to land. Cut a Boolean cylindrical hole in the roof, and cap with a squashed cylindrical door. See Figure 13.40.
7. Group all. Save in a 3D object file format that Bryce can import. Import to Bryce, and do a test render. See Figure 13.41.

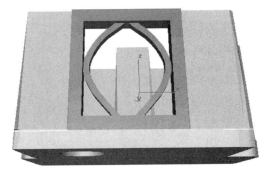

FIGURE 13.39 *Create the floor and a circular entrance way in the floor.*

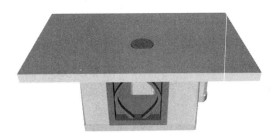

FIGURE 13.40 *Create the roof and a cylindrical doorway.*

Chapter 13 House of the Fire Eaters

Figure 13.41 *The house is test rendered in Bryce.*

Figure 13.42 *Create an image that will be mapped to the roof.*

8. We have to take a small side path before applying textures in Bryce. Open your 2D painting application.
9. First, we'll create a bitmap image for the roof. Create an image size that roughly matches the proportions of your roof, as seen in the Bryce Top View.
10. Create image content that looks like some symbols for a heli-vehicle landing area. This can be anything that suits you, and can include lettering as well. Stay away from the edges of the image, because we will use Object Top mapping. Save the image. See Figure 13.42.
11. Use Object Top mapping to place the image on the house roof in Bryce. See Figure 13.43.
12. Although the main volcano is vented by the River of Fire to control major eruptions, the volcanoes in the distance are not. The blast shutters can be instantly lowered to prevent damage, since the house itself is able to withstand intermittent blasts. Create the Blast Door texture in your 2D painting application at 512 × 512 pixels. It should resemble armored plates with rivets. See Figure 13.44.

 The EyeCandy 4000 filters were instrumental in creating this texture (www.alienskin.com).

13. Import the Blast Door image into Bryce, and use as a texture map for a rectangular Blast Door that hinges above the window. See Figures 13.45 and 13.46.

FIGURE 13.43 *The image is rendered on the roof of the house in Bryce. A Techno 2 Object Space map has also been added to the top doorway (open).*

FIGURE 13.44 *The Blast Door texture.*

14. Use your own texturing choices for the walls, floor, and window frame. Place a Radial Light at the top center of each of the three rooms (Intensity 12 with minimum Edge Blur). See Figure 13.47

FIGURE 13.45 *The hinged Blast Door is partway open, displaying the Parametric mapped texture on its surface.*

FIGURE 13.46 *The Blast Door closed.*

15. Draw a girder in your external 3D application and extrude it. Place a solid black at the base, and Group. Save. See Figure 13.48.
16. Import the girder group into Bryce. Scale and Duplicate, and then place. Add the textures you prefer. Refer to Figure 13.49.

Chapter 13 · House of the Fire Eaters

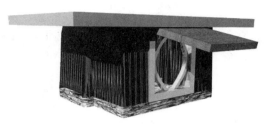

FIGURE 13.47 *Add textures to the walls, floor, and window frame, and place Radial Lights inside.*

FIGURE 13.48 *Extrude a girder and create a rectangular footing.*

17. Go to the Objects Library. In the Imported Objects folder is a Spiral Staircase object. Add it to the scene. Scale so that it reaches from the bottom of the footings to the bottom trap door of the house. Place a cylinder around it, and map with the Steel Cage material from the Miscellaneous Materials Library. See Figure 13.50.

 You will have to resize the left-front girder footing to make this all fit.

18. Group all of the elements, and save the finished house to your Objects Library.

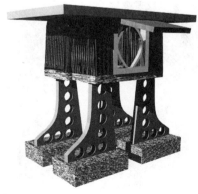

FIGURE 13.49 *Add the supports under the house.*

FIGURE 13.50 *The staircase and cage are added.*

Using your modeling skills, you can create various artifacts and place them in the house. You can also add any objects to the inside of the house that come from the Objects Library folders, including any of the objects you created for previous projects. What you add, or if you add nothing, will depend on what images you want to render with the camera. After all, if all of the images you plan to take will include only those on the outside of the house, why bother creating artifacts for the inside? If you change your mind, they can always be created and/or imported later.

THE HELI-VEHICLE

One more item has to be developed for this scene. On the roof sits a special heli-vehicle for normal travel and for emergencies. The heli-vehicle will be modeled in Bryce's Terrain Editor with Lattice parts. Since you are by now well aware of how to proceed using Symmetrical Lattice elements for a model, the explanatory text for this final model will be brief. Instead, the images of the necessary Elevation maps will tell most of the story. Do the following:

1. Create this grayscale image in your painting application. See Figure 13.51.
2. Create a color map of the same image, using whatever colors and mapping detail you prefer. This is a wing, and a tail section. See Figure 13.52.
3. Open Bryce. Lattice>New. Import the grayscale wing as an Elevation map. See Figure 13.53.
4. Accept and flatten. Apply the image texture. See Figure 13.54.
5. Tilt down and Duplicate. Flip on X, and move to mirror the wings.
6. Group and Duplicate. Scale the duplicate group down by about 40%. This is the tail element. See Figure 13.55.
7. Lattice>New. Create the fuselage as an Elevation map. See Figure 13.56.

FIGURE 13.51 *Create this image.*

FIGURE 13.52 *Create a color map for a texture.*

Chapter 13 House of the Fire Eaters

FIGURE 13.53 *The elevation map of the wing.*

FIGURE 13.54 *The textured wing.*

8. Accept. Scale and move into place. Map with the Blast Door texture, using an XYZ Scale of 9. See Figure 13.57.
9. Create the wheel well and strut as an Elevation map from a Lattice. See Figure 13.58.
10. Scale and place three of these elements. See Figure 13.59.
11. Duplicate the tail section, scale to about 2/3, and Flip on the X-axis. See Figure 13.60.
12. Create the wheels from a black Torus grouped with a copper cylinder. See Figure 13.61.
13. Create a rotor column from two scaled cylinders. Group and place. See Figure 13.62.
14. Open your external 3D application to create the rotor assembly. Create a rotor shape and extrude it. See Figure 13.63.

FIGURE 13.55 *The wings and tail elements are ready.*

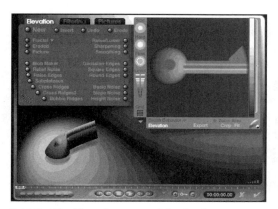

FIGURE 13.56 *The Elevation map of the fuselage.*

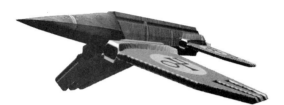

FIGURE 13.57 *The fuselage is in place.*

FIGURE 13.58 *The wheel well and strut.*

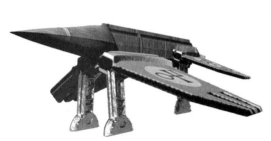

FIGURE 13.59 *Three wheel units are added.*

FIGURE 13.60 *A second tail section is added.*

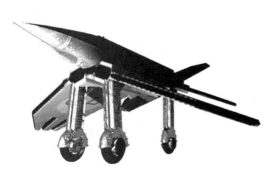

FIGURE 13.61 *Wheels are added.*

FIGURE 13.62 *Add the rotor column.*

FIGURE 13.63 *Create this rotor shape and extrude.*

FIGURE 13.64 *Create a four-blade array.*

15. Bend by 30 degrees on the X-axis, because rotors are floppy when they are at rest.
16. Create an array of four blades. See Figure 13.64.
17. Export to Bryce, and place on the arm. See Figure 13.65.
18. Create a teardrop form from a sphere in your external 3D application. Export to Bryce. Map with the Gilded Cage material from the Wild&Fun Library. Group all of the heli's elements, and save to your Objects Library. See Figure 13.66.
19. The heli is completed. See Figure 13.67.

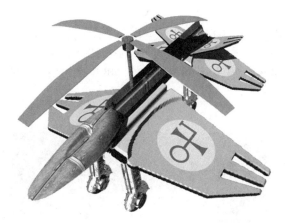

FIGURE 13.65 *Place the rotor blade array in position.*

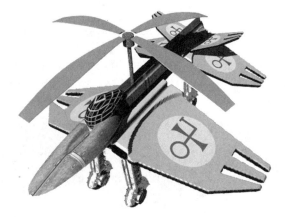

FIGURE 13.66 *Add the cockpit.*

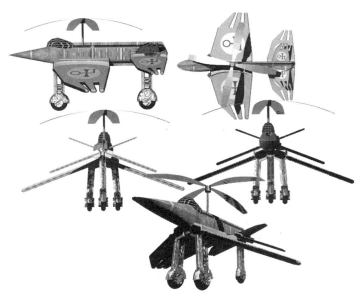

FIGURE 13.67 *Alternate views of the completed model.*

FINISHING UP

The last step is to open the Fire Eaters project, and place the house and heli in the scene. Place the house down from the pool, and place the heli on the roof. All that remains is to move the camera to find some neat shots, and render away. See Figures 13.68 through 13.73.

FIGURE 13.68 *The house is uncomfortably close to the River of Fire and the deadly pool.*

FIGURE 13.69 *Looking down on the heli as it sits on the roof.*

Chapter 13 House of the Fire Eaters

FIGURE 13.70 *Looking down at the house from just behind the Temple of Sacrifice, as it perches high on the central volcano.*

FIGURE 13.71 *The house as seen from the ground, looking at the front through the observation window.*

FIGURE 13.72 *The mouth of the River of Fire.*

FIGURE 13.73 *Abstract patterns result from the mapped sphere.*

Traveling On

This chapter allowed us to explore a flaming world, one that has very few attractions for the vacationer. In the next chapter, we move on to the sixth world, one that offers more peace and serenity than any world so far: the land of the *Jade Pagoda*.

CHAPTER 14
The Jade Pagoda

When I look out the window of my studio, I see the big rock that dominates the yard. At different times of year, the rock assumes a variety of guises. Framed by the background dark woods, the rock can present itself in a moss-covered skirt, as a collecting place for the red and yellow autumn leaves, or be completely enveloped in a blue-white mantle of snow. There are times when I realize that a single contemplative visual experience can suffice to take the mind into a realm that moderates, and sometimes even erases, all of the chaos that enters a busy twenty-first-century life. When I set out to create this project, it was with that quality of visualization in mind, so that the visuals could be used as potential devices to quiet the mind.

In addition to developing lands of fire and ice, Bryce is the perfect creative tool for generating subtle virtual places of great beauty. Whether you print the rendered images and hang them on the fridge, use them as pictures for a calendar, or view them in an electronic frame, a well thought-out 3D world crafted in Bryce is open to thousands of potential rendering variations. This the main difference between 2D art and a 3D construct. Once you paint a 2D picture, the position of the camera (your eye) remains in the same place forever. When you create a 3D sculpture, the potential 2D paintings you create are almost limitless. All you have to do is move the camera around, customize the light sources, tweak a few other customizable settings, and render an image. You can even create a seamless flow of images by moving through your Bryce world in an animation.

In this project, we will incorporate two additional pieces of software that we haven't mentioned in other projects: Macromedia Flash (you can substitute Adobe Illustrator or Macromedia FreeHand for this option). You will also need CuriousLabs' Poser. If you don't have these software applications in your resource library, you can purchase them, attempt to substitute other applications you do own and use, or skip this project (or the parts that make use of these applications). It remains important to realize that the best Bryce creations are enhanced by the way that Bryce can incorporate components developed outside of Bryce and imported. Bryce's ability to handshake with a number of external 2D and 3D applications is one of the underlying technical themes of this entire book.

THE ROUGH SKETCH

To remain methodologically consistent, we begin this one with a rough sketch. The rough sketch is not a detailed blueprint of where you might go or how you might get there, but it does start your dream engines spinning, also acting to narrow your focus of infinite possibilities. Put another way, the rough sketch presents

CHAPTER 14 THE JADE PAGODA

aspects of the "problem" that you have to solve (although at times you may select to ignore items indicated in the rough sketch as well). See Figure 14.1.

Let's split this project into two parts. The first part will consist of everything but the Pagoda Enclosure and its components, which will be called the Environment. The second part will be devoted to the Pagoda enclosure.

As you look at the sketch (Figure 14.1), locate the following items in the Environment: Sky, Ground, Distant Peaks, Foreground Terrain, Waterfall, River, and Village. The Pagoda Enclosure contains the following, as indicated by the sketch: Pagoda (with a detailed first level inside), Wall, Gate, Buddha Statue, Rock Garden, and (not pictured) a Reflecting Pool. Additional elements are also involved, but are not included in the rough sketch.

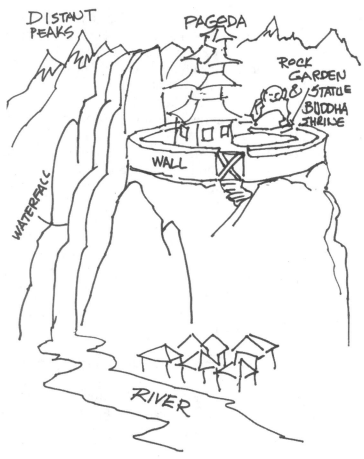

FIGURE 14.1 *The rough sketch for the Jade Pagoda project.*

THE ENVIRONMENT

The Environment needs the following items to be considered:

- **Sky**: In addition to using a default Bryce sky plane to sculpt the clouds, we will also interpose another ISP with its own parameters in the scene.
- **Ground**: In addition to placing a standard IGP in this special world, we will layer it with another IGP to give it some appreciable 3D depth.
- **Distant Peaks**: Obviously, when mountains or other terrain features are involved, the targeted modeling application is Bryce itself.
- **Foreground Terrain**: When we model the Foreground Terrain for this project, the flattened plateau at the top has to be considered, giving the Pagoda Enclosure a base on which to rest.
- **Waterfall**: The Waterfall in this Eastern world is very high, cascading over a series of rocks on its way to the valley below. Both the water and the rocks it washes over use Bryce geometry and materials in their creation.
- **River**: Unlike some of the other rivers we created in previous projects, this one has a perfectly mirrored surface. The only exception is the area where the River intersects with the Waterfall. All of this is internal Bryce work.
- **Village**: We'll use Bryce tools to create the Village and small plots of land used for gardening. The huts can be created with very basic tools, since we won't be going inside them with the camera, or doing any extreme close-up shots.
- **Added Elements**: The most important elements to be added will be a few trees to enhance the landscape. Some will be placed in the valley, and a couple in the Pagoda Enclosure. These will be created external to Bryce and imported and textured.

THE PAGODA ENCLOSURE

The Enclosure contains the following to-be-modeled items:

- **Pagoda**: The structural components of The Pagoda will be brought to life in your external 3D application, with later enhancements added in Bryce.
- **Detailed First Level (inside)** : The first floor's internal items will be both Bryce and non-Bryce components. All texturing and placement will be a Bryce task.
- **Wall**: There is a circular wall around the Pagoda compound, modeled in the Terrain Editor.
- **Gate**: In the wall is a door, starting from a simple Bryce scaled cube.
- **Buddha Statue**: A large statue of Buddha looks down on the Rock Garden. Since we may want to walk around it with the camera, it's important that it be created as a full 3D model. You can use any application you like to do this (including modeling it from scratch in your external 3D application), although I prefer CuriousLabs Poser as the tool of choice.

CHAPTER 14 THE JADE PAGODA

- **Rock Garden**: At one end of the Enclosure is an artfully crafted Rock Garden, used for meditation and contemplation. A series of benches rings the garden, and at the center is a tree. These components are created in your external 3D application, although the garden itself and the rocks are Bryce objects.
- **Reflecting Pool**: The Reflecting Pool is inside of the Pagoda, ringed by a simple circular wall of Bryce rocks..
- **Additional Elements**: Other items are to be added to the Pagoda Enclosure, both inside and outside of the building. We have already mentioned the trees involved. There is also a fountain at the center of the Reflecting Pool.

THE ENVIRONMENT COMPONENTS

TUTORIAL

Now that we have itemized all of the components that will contribute to this scene, it's time to dig in and model them for placement.

SKY

First, we'll generate the parameters for the default sky. Do the following:

1. Open a new Bryce document, and go to the Sky&Fog tools.
2. Set the following parameters for the Sky&Fog components:
 - Custom Sky Colors to white, blue, white
 - Shadows to medium violet
 - Fog to None
 - Haze to 1 and white
 - Cloud height to 35
 - Sky Dome color to dark blue
 - Cloud Cover to 100
 - Cumulous Color to pink
3. In the Sky&Fog options, turn Spherical off, and make sure both Stratus and Cumulous are checked.
4. Open the Sky Lab. On the Cloud Cover page, set Frequency to 32, and Amplitude to 350. See Figure 14.2.
5. Do a test render. See Figure 14.3.
6. Create an ISP for the second cloud layer.
7. Go to the Materials Lab, and then open the Deep Texture Editor. Select the Cumulous Summer Clouds preset. Set the XYZ Scale to 3.7%, and Transparency to 25%. Do a render. See Figure 14.4.

Advanced Bryce Creations

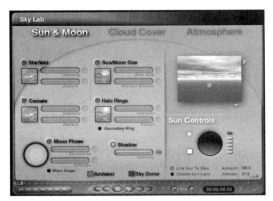

FIGURE 14.2 *Set the parameters in the Sky Lab.*

FIGURE 14.3 *The default sky.*

FIGURE 14.4 *A second layer of clouds is added.*

GROUND

Now for the ground. Do the following:

1. Create an IGP Slab. Go to the Materials Lab, and then to the Deep Texture Editor. Select the Rain Forest material preset from the Rocks Library.
2. In the Materials Lab, set the Texture Mapping Mode to World Top. Set the Bump height to 150. Set the XYZ Scale to 20%. Do a render. See Figure 14.5.
3. Create a Volumetric IGP. Place it right on top of the Slab IGP, and decrease its height by one-third. Map it with the same texture that you used for the slab, but alter the following parameters: XYZ Scale to 75%, Bump height

CHAPTER 14 THE JADE PAGODA

FIGURE 14.5 *The ground plane is rendered.*

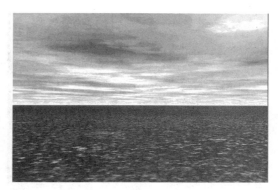

FIGURE 14.6 *The Volumetric IGP is placed over the IGP Slab.*

100%, and World Space mapping. Rotate the Y-axis by 90 degrees, and activate Transparency.
4. Render to preview. You won't see much variation from the previous rendering. See Figure 14.6.
5. Now for some Boolean magic. Make the Volumetric IGP a Positive Boolean.
6. Lattice>New. Create the Elevation map shown in Figure 14.7.
7. Accept the construct. Make it a Negative Boolean, and group with the Volumetric IGP, which is positive. Map it with the Nacra texture from the Deep Texture Library. Use an XYZ Scale of 215 with World Space mapping, and switch Transparency on. Use a Bump height of 100. You have just created a clearing on the Volumetric IGP for the placement of other items. See Figure 14.8.

FIGURE 14.7 *Create this Elevation map. It does not have to be an exact copy of this.*

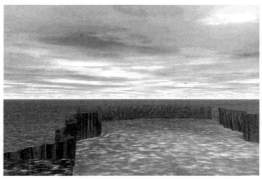

FIGURE 14.8 *You have just created a clearing in the jungle.*

FIGURE 14.9 *Create a random series of splotches.*

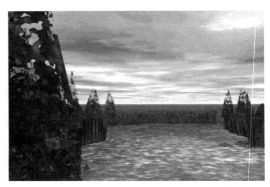

FIGURE 14.10 *The Lattice objects look like trees.*

8. One more step to finish the forest look. Lattice>New. Create a series of random splotches for an Elevation map, using a feather-edged Elevation Brush with a Grid of 32 (Course).See Figure 14.9.
9. Map with the Foliage 2 material in the Miscellaneous folder. Duplicate three times in the Top View, and move to the edge of the clearing on the left. Group.
10. Duplicate the group and Flip on the X-axis in the Top View. Move to the edge of the clearing on the right. Render to preview. See Figure 14.10.

DISTANT PEAKS

Mountains are a Bryce specialty, from their geometry to the materials used to give them a personality. Do the following:

1. Every artist's mountain range will look different, so don't be afraid to experiment here.
2. Use the default mountain and customize it, or load another terrain map. When satisfied with the design, accept it.
3. Place the mountain far back from the camera. Use the Spring Snow material from the Planes&Terrains Library on it, tweaking the parameters as you prefer.
4. Either create three or four more mountains, or duplicate and rotate the one you already have. Create a mountain range in the background, all mapped with the same material. Make sure the mountains are tall enough to poke through the lower ISP, since that will cause clouds to soften their crowns. Render to preview. See Figure 14.11.

CHAPTER 14 THE JADE PAGODA

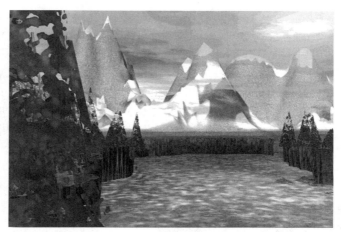

FIGURE 14.11 *The mountain range is added. The layer of clouds also casts realistic shadows on the mountains.*

FOREGROUND TERRAIN

This is the mesa on which the Jade Pagoda will rest, so it should have a flat crown. Do the following:

1. Create this object from a Lattice with the Elevation Brushes you are by now familiar with in the Terrain Editor. Each reader's mesa will differ a bit. See Figure 14.12.
2. Place the completed mesa at the far end of the clearing. Map it with the Mossy Rock material in the Planes&Terrains Library, using Object Space mapping. See Figure 14.13.

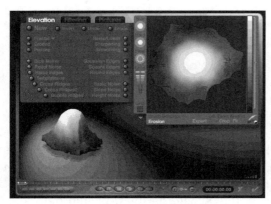

FIGURE 14.12 *Create the mesa's Elevation map.*

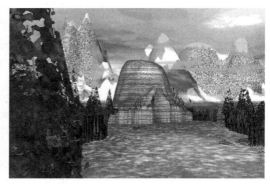

FIGURE 14.13 *The mesa is placed in the scene.*

RIVER

The river is a central focus of the scene, both because of its beauty and because it remains a world symbol for meditation, part of what this scene is about. Do the following:

1. Lattice>New. Create the Elevation map shown in Figure 14.14.
2. This is the river. Scale and place it so that it runs from the mesa toward the camera. Map the river with a Mirror material from the Simple&Fast Library. Cut Reflection from 100% to 80%, and increase the Ambience to 30% with a light-blue hue. See Figure 14.15.

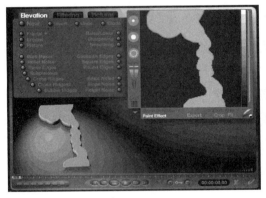

FIGURE 14.14 *Create this Elevation map.*

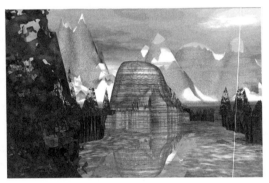

FIGURE 14.15 *The river is placed.*

BRIDGE

This object is not indicated on the rough sketch, but the more I looked at the river, the more pressing it became to add a bridge across it. Do the following:

1. This step requires Macromedia Flash 5. You can substitute for Flash with Adobe Illustrator or Macromedia Freehand, although I prefer the smoothing options in Flash. Open Flash. Click on the Pencil tool.
2. Set the Pencil Mode to Smooth.
3. Draw a shape similar to the one shown in Figure 14.16. The best way to do this is to draw half the shape, Duplicate, and Flip Horizontally. If you have Snap To Objects on, the two halves will join seamlessly. Fill the shape with a solid color, and Group. See Figure 14.16.
4. Go to File>Export Image, and export the image as an Adobe Illustrator (.ai) file.

CHAPTER 14 THE JADE PAGODA

FIGURE 14.16 *Draw this shape.*

FIGURE 14.17 *The extruded shape becomes a 3D object.*

5. Import the ai file into your external 3D application, and Extrude. See Figure 14.17.
6. Add cylindrical columns to the sides. See Figure 14.18.
7. Return to Flash. Draw a filled shape like that shown in Figure 14.19.

FIGURE 14.18 *Add columns.*

FIGURE 14.19 *Draw this shape.*

8. Duplicate, Align, and Group with an extended rectangle to create the image shown in Figure 14.20.
9. Export in the ai format, and import into your external 3D application. Extrude. See Figure 14.21.
10. Duplicate the railing, and place on the other side. Refer to Figure 14.22.

FIGURE **14.20** *Create this image.*

FIGURE **14.21** *Extrude for a section of railing.*

11. The bridge should be three railings in length, with an archway on either end. Create it by duplicating and placing the present elements, as shown in Figure 14.23.

FIGURE **14.22** *Create the opposite railing.*

FIGURE **14.23** *Create this configuration by duplicating and moving the present elements.*

12. In a Front View, create the shape that will act as a cross section for the walkway and supports. Refer to Figure 14.24.
13. Extrude to create the form shown in Figure 14.25.

FIGURE **14.24** *Create the cross section for the walkway and supports.*

FIGURE **14.25** *The walkway is added.*

CHAPTER 14 THE JADE PAGODA

FIGURE 14.26 *The bottom archways are added.*

FIGURE 14.27 *Create two sets of stairs.*

14. Boolean Subtract two large cylinders from the bridge walkway bottom to create the form shown in Figure 14.26.
15. Create stairs at both ends of the bridge by extruding the appropriate shape. See Figure 14.27.
16. Create the shape shown in Figure 14.28. All of the internal shapes are attached to the outer shape, so they will be cut-outs.
17. Extrude. Place duplicates of the railings on either end of the two sets of stairs. See Figure 14.29.
18. Group all. Export the model in a format Bryce can read.

FIGURE 14.28 *Create this shape, or use it as a general reference to customize your own.*

FIGURE 14.29 *Place the duplicate railings.*

19. Open a new document in Bryce, and import the bridge model. Don't be shocked if the parts come in jumbled up. Bryce sometimes has difficulty keeping a complex imported model together. Fix any misplacements of elements by ungrouping and repositioning as required.
20. Apply any textures and materials you like, remembering to make this bridge fairly colorful. See Figure 14.30.

FIGURE 14.30 *The materials and textures are applied in this rendering.*

FIGURE 14.31 *The bridge is placed in the scene.*

21. Save this object to your Object Library, and open the Jade Pagoda project. Open the Objects Library and place the bridge over the river. You will have to scale it in proportion to the rest of the scene. See Figures 14.31 and 14.32.

FIGURE 14.32 *A closer view.*

Chapter 14 The Jade Pagoda

Village

It would be easy to create a group of cubes to emulate houses. As long as the camera remained far in the distance, they would work fine. You can do that if you like, but I prefer a little detail. Having houses with just a bit more detail enhances any image you create where they are seen, and also allows you the later option of furnishing one or more and going inside. Do the following:

1. Only one house needs be created as the archetype for this village. Lattice>New. Create the Elevation map displayed in Figure 14.33.
2. Accept the design, and add some Boolean windows and a rectangular floor. Group all. Use a Stone material to map it. See Figure 14.34.
3. Add a door created from a scaled cube, and map it with the Walnut material from the Simple&Fast Library. See Figure 14.35.

FIGURE 14.33 *Create this Elevation map.*

FIGURE 14.34 *The house so far.*

FIGURE 14.35 *The door is added.*

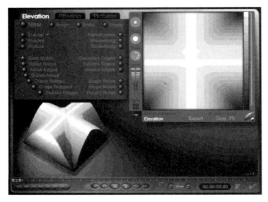

FIGURE 14.36 *The roof is designed.*

FIGURE 14.37 *The material creates a look much like thatch.*

4. Now for the roof. Lattice>New. Do the following in this order: Cross Ridges, Square Edges, Cross Ridges 2, Square Edges. This creates an interesting roof. See Figure 14.36.
5. Accept the design. Scale and place. Use the Sandstone 2 material from the Deep Texture presets. Apply with Object Space mapping, and set the Bump to –200. See Figure 14.37.
6. Group all, and save to your Objects Library.
7. Open the Jade Pagoda project. Using your Objects Library, create a collection of six or so houses on the right side of the bank, as you are looking at the scene from the Front View. Scale as needed. See Figure 14.38.

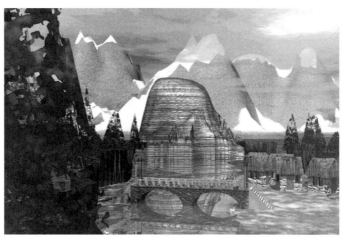

FIGURE 14.38 *The village is added.*

CHAPTER 14 THE JADE PAGODA

WATERFALL

This waterfall starts at just below the top of the mesa, and falls all the way to the river below. Do the following to create it:

1. The first thing we'll do is to build the shell of the waterfall with large rocks. Open a new Bryce document.
2. Locate the Stone icon on the Create toolbar, and use it to create two columns of stones, each with about a dozen members. See Figure 14.39.
3. Select each column, and elongate the Z-axis dimension by about 400%. This allows the columns to be deep enough to sink into the mesa when we place the waterfall.
4. Lattice>New. Create the Elevation map shown in Figure 14.40. Use a Lava effect from the Lava list on the form.
5. Use the Deep Blue material from the Water&Liquids Library to texture the water, and Rotate, Scale, and Place as shown in Figure 14.41.

FIGURE 14.39 *Create two columns of stones.*

FIGURE 14.40 *Create this Elevation map.*

6. Group all. Save the model to your Objects Library.
7. Open the Jade Pagoda project, and place the waterfall in the scene, importing it from your Objects Library. Scale and Rotate as needed. See Figure 14.42.
8. To create mist as the water strikes the river, place a sphere at that point. Map the sphere with a cloud material (Volumetric Clouds are best). You'll have to explore the best Transparency values. In general, keep them around 20% to make the mist visible. Turn Cast Shadows and Receive Shadows off. You may also want to duplicate the sphere and overlay it on itself to create interesting effects. See Figure 14.43.

FIGURE 14.41 *Place the water between the columns as shown here.*

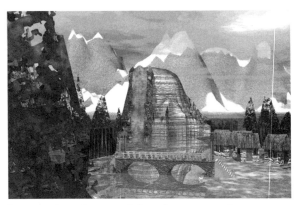

FIGURE 14.42 *Place the waterfall in the scene as shown.*

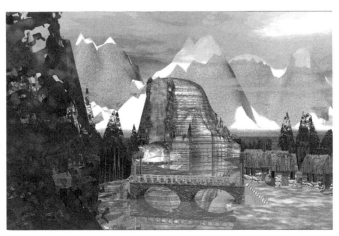

FIGURE 14.43 *The mist is added.*

ADDITIONAL ELEMENTS

You can add various extra components in the scene if you want to. For instance . . .

Garden

To create a small garden plot, do the following:

1. Lattice>New>Invert. Grid to 256. Then apply Lower to the maximum and Square Edges.
2. Draw the Elevation map shown in Figure 14.44 with a very gray brush.

FIGURE 14.44 *Create this Elevation map.*

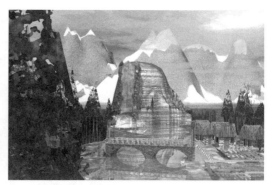

FIGURE 14.45 *Gardens are added.*

3. Convert To Terrain, and decrease the height by about 80%. Map with a Storybook Grass map from the Miscellaneous Library (Object Space mapping). Duplicate, and place next to the river and below the village. See Figure 14.45.

Tree

You can create a tree in your external 3D application, or place any tree or trees from the Objects Library in the scene. For example:

1. Open the Objects Library, and place the Faerie Tree you created previously in this scene. See Figure 14.46.
2. After placement, be sure to save the project.

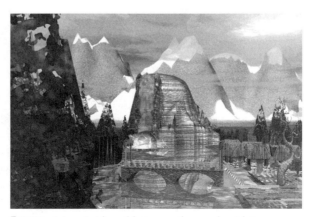

FIGURE 14.46 *A tree is placed between the garden plots.*

River Boulders

Place rocks in the scene from the Create toolbar:

1. Click the Rocks icon to create as many rocks as you like.
2. Place them on the river bank across from the village. See Figure 14.47.

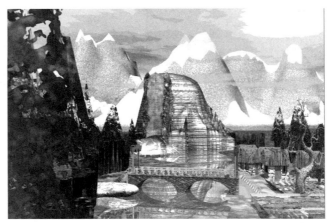

FIGURE 14.47 *Place some large rocks on the river bank.*

THE PAGODA ENCLOSURE

Now it's time to create the Pagoda Enclosure.

PAGODA STRUCTURE

The Jade Pagoda is so named because it sits on a base of purest jade, a slab that supports the entire enclosure. This is where we start.

1. Open a new Bryce document. Place a cube in the scene, and Duplicate. Scale the cubes as shown in Figure 14.48.
2. Group the scaled cubes, and apply the Kryptonite material from the Rocks&Stones Library. Set the XYZ Scale to 50%, and Rotate on X to 45%. Set the other parameters in the Materials Lab as detailed in Figure 14.49.
3. Render to preview. Your stacked blocks should look like Figure 14.50.
4. Duplicate the group, and create six columns to support the original blocks. See Figure 14.51.
5. Open your Objects Library, and find the ladder that you saved from the Sand Masters project. Add it in the scene, and Duplicate. Place as shown in Figure 14.52.

Chapter 14 The Jade Pagoda

FIGURE 14.48 *Scale the cubes like this.*

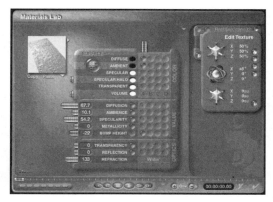

FIGURE 14.49 *Set these parameters for the Kryptonite material.*

FIGURE 14.50 *The blocks should look like this.*

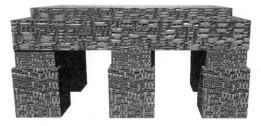

FIGURE 14.51 *Create this arrangement.*

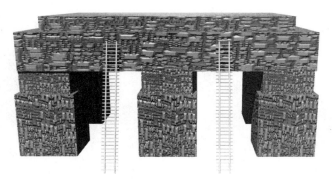

FIGURE 14.52 *Add two ladders as shown.*

6. Find the Temple of Sacrifice model from the Fire Eaters project in your Objects Library, and add it to the scene. Place it between the columns as seen from the front, and duplicate to create another on the other side. Place Radial Lights in each enclosure to display the designs on the temples (Intensity of 18 with Squared Falloff). Move the ladders so you can see everything. See Figure 14.53.
7. Duplicate the cube group at the top of the structure, and use the duplicate as a base. Resize as needed. This base can be sunk into the somewhat rounded top of the mesa without affecting the Jade Pagoda content on top. See Figure 14.54.

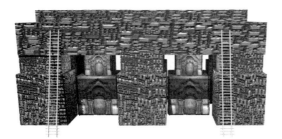

FIGURE 14.53 *Place two Temples of Sacrifice as displayed here.*

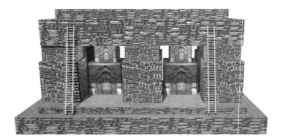

FIGURE 14.54 *Create a base from the top group, and scale to size.*

8. Import the bridge from the Objects Library, and ungroup it. We will use parts of it for the Jade Pagoda. This will also tie the design of the Jade Pagoda to the bridge below. Take the entrance gates to the bridge, Scale, and position to create the three similar components shown in Figure 14.55.
9. Place one of the railings of the bridge on top of the present model Delete all other components of the bridge. See Figure 14.56.

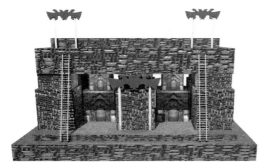

FIGURE 14.55 *Use these components of the bridge for the Jade Pagoda.*

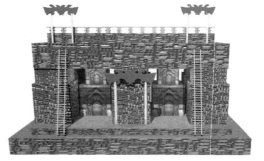

FIGURE 14.56 *Place a railing at the top.*

CHAPTER 14 THE JADE PAGODA

10. For safety's sake, duplicate and place the duplicate railing at the back.
11. Import the Tower from the Sand Masters project and the Volco House from the Fire Eaters project from your Objects Library. Place and scale as indicated in Figure 14.57. Use Blue Metal for the walls, Gold for the window frame on the house (Simple&Fast Library), and use the same material you used on the base for the tower.

 Now you can understand why the Objects Library is so useful in Bryce. Any object saved there can be used as a building block for another project.

12. Place an ornament of your own design on top of the tower. See Figure 14.58.

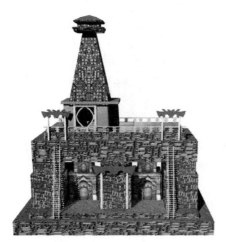

FIGURE 14.57 *Place the objects as shown.*

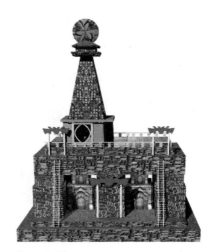

FIGURE 14.58 *Place an ornament on the tower.*

DETAIL INSIDE

I decided at this stage to do away with a reflecting pool inside of the room, and instead substitute another object from the Objects Library. Do the following:

1. Open the Objects Library, and import the Table 'O Stuff, saved there from the Sand Masters project.
2. Scale and place this object in the room by the window. Place a Radial Light in the room as well.

BUDDHA STATUE

The idea of a rock garden suddenly seemed far too cluttered to me as I looked at the rest of the components. My decision was to fill the balance of the courtyard space with a giant golden Buddha figure. Do the following, though it requires that you have Poser.

1. Open Poser. Select the Nude Man figure from the main Figures library (this opens by default).
2. Go to the Poses Library, and select the Floating meditation pose. Make the scale of the abdomen of the figure larger, and increase the size of his head. Give him a wide smile, and a downward glance. See Figure 14.59.

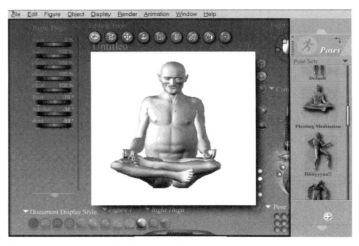

FIGURE 14.59 *Create this 3D figure in Poser.*

3. Export in a format Bryce can import (3DS is good). Import into your present Bryce project.
4. Duplicate the base of the temple, and scale and place in the courtyard at the top. Import the Buddha model. Scale and place on the pedestal. Select all and Group, and save as a project file. See Figures 14.60 and 14.61.

ADDITIONAL ELEMENTS

Originally, I was thinking that at least a tree should be added to the Jade Pagoda grounds, but actually seeing what this structure looked like after its creation changed that. I didn't want to add one more item.

CHAPTER 14 THE JADE PAGODA

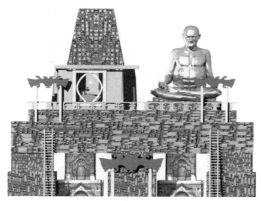

FIGURE 14.60 *Scale and place the Buddha. You can also see the Table 'O Stuff through the small window at the left.*

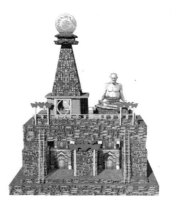

FIGURE 14.61 *A view of the whole Jade Pagoda.*

PUTTING IT ALL TOGETHER

Now comes the fun part. After all of your effort, and the completion of all of the components, it's time to put everything together and place the camera at interesting render points. There's one more task, however...

1. Open the main Jade Pagoda project. Select Merge from the File menu, and merge the actual Jade Pagoda that you just created into the main project.
2. Scale and place on top of the mesa.
3. OK! Render time. Place the camera at interesting positions, and tweak the settings until everything looks right. Keep an eye on the Nano view to see a rough approximation of the rendering. Render away. See Figures 14.62 through 14.69 for some rendered examples.

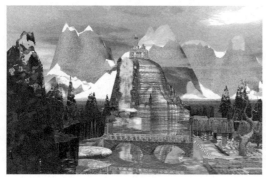

FIGURE 14.62 *Although the Jade Pagoda dominates the valley, it looks tiny in this view.*

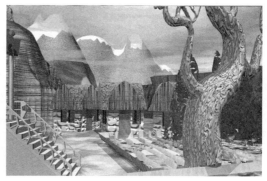

FIGURE 14.63 *A closer look at the village.*

FIGURE 14.64 *A view from the bridge. A Haze setting of 3 helps to increase the depth effect.*

FIGURE 14.65 *The Buddha above and the valley below.*

FIGURE 14.66 *Looking out the window of the temple room at the scene in the distance. You can see the winding river at the lower-right of the window, though the bridge is very tiny from this distance. All of this emphasizes the huge scope of the scene.*

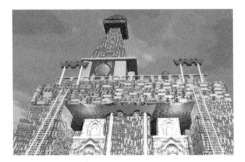

FIGURE 14.67 *Standing at the top of the mesa and looking up at the Jade Pagoda.*

FIGURE 14.68 *A bird's-eye view of the river valley and surroundings, seen through the cloud layer. The Jade Pagoda enclosure and environs can be seen at the lower center.*

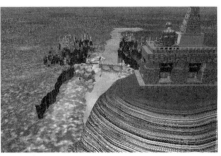

FIGURE 14.69 *Breaking through the clouds and moving closer, while maintaining the same camera orientation as Figure 14.68 (and decreasing the Haze from 3 to 1), provides a clearer view of the landscape below. This is exactly what happens in the "real world."*

CHAPTER 14 THE JADE PAGODA 323

> **Solving the Pagoda Question**
>
> One of my core reasonings for writing this chapter the way it was done was to emphasize the point that every item in your Objects Library can be used as a building block to create an entirely new scene. I believe that this has been successfully accomplished. However, one design problem has been introduced by doing this. The term *pagoda* brings a very specific architecture to mind for most people, and architecture different from the Object Library components I used provides. You may want to substitute a more traditional pagoda for the creative version I constructed here. Allow me to visually walk you through a way to do that. Once created, the traditional pagoda need only be substituted for the tower used on top of the viewing room. Alternatively, you may delete both the tower and viewing room in order to place the traditional pagoda in their place. See Figures 14.70 through 14.74.

FIGURE **14.70** *Create the two shapes displayed.*

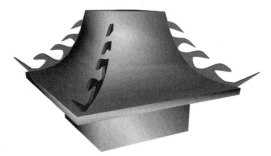

FIGURE **14.71** *Lathe the shape on the right with four sections. Extrude the shape on the left, and duplicate three times to form embellishments.*

Do the following to create more traditional pagoda architecture. This task requires your external 3D application's tools.

 This is a basic pagoda. You are free to make it much more complex than this.

ADVANCED BRYCE CREATIONS

FIGURE 14.72 *Duplicate and stack*

FIGURE 14.73 *Create a peak, then lathe and export to Bryce.*

FIGURE 14.74 *Map with materials in Bryce and customize as desired.*

NOTE

Don't forget to take creative advantage of the Plop and Spray renderers in Bryce when you want just selected areas to be anti-aliased. There are many times when a material may look more realistic before anti-aliasing, while some element placed inside of a area, mapped with a different material, may benefit from full anti-aliasing. The whole concept of selective rendering with different anti-aliasing parameters remains unique to Bryce.

TRAVELING ON

Now that you have worked through this tutorial project, and the Jade Pagoda exists in your computer, it's time to move on to the next modeling adventure: *Abode of the Lizard Master*.

CHAPTER 15
Abode of the Lizard Master

In this project, we investigate yet another type of world, one in which fog, haze, and mist play a dominant role. The place is somewhere in Central America, a place where Mayan ruins dot the terrain. Our interest, however, is not in the ruins, but on a high outcrop nearby. On the top of this flattened mountain exists a mysterious patch of thick jungle, and surrounded by that jungle is the Abode of the Lizard Master. The terrain below is covered in steam and mist, obliterating most of the details of the land features.

In order to create this project's elements precisely, you will need the following: Bryce 4, an external 3D application suitable for professional level modeling, CuriousLabs Poser (or another application or plug-in capable of creating a 3D head), Amorphium from Electric Image, Corel Painter, and the Jungle 3D volume of Image Hose nozzles for Painter (available from www.gardenhose.com).

THE ROUGH SKETCH

As is customary for the projects in this book, we start with a rough sketch. See Figure 15.1.

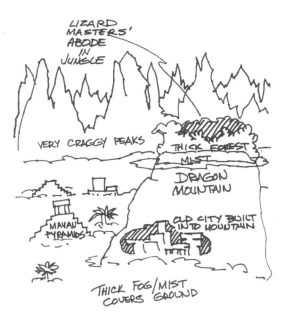

FIGURE 15.1 *A rough sketch of the components of this project.*

Looking at the sketch, we can discern the separation between two component categories: the Abode that draws our detailed interest and the surrounding territory and features, which we will call the Supportive Environment. The Supportive Environment includes the Sky, Ground, Ground Fog/Mist, Distant Craggy Peaks, Items on the Ground (Mayan Pyramids, trees . . .), Dragon Mountain, Old City, and the Mist around the mountaintop. The Abode consists of the jungle, and whatever we decide to place in the jungle.

SUPPORTIVE ENVIRONMENT

The Environment requires that the following items be included:

- **Sky**: In addition to using a default Bryce sky plane to sculpt the clouds, we will also interpose another ISP with its own parameters in the scene.
- **Ground**: Most of the Ground texture will be hidden, but enough of a hint will poke through to make the material design important to consider.
- **Ground Fog/Mist**: This is a very important feature of this world, adding mystery and calling attention to the Abode itself, which is not enshrouded by mist or fog.
- **Distant Peaks**: When mountains or other terrain features are involved, the targeted modeling application is Bryce itself. These peaks will be more pointed than those created in other projects.
- **Items on the Ground**: We will use a variety of resources to create the objects placed on the ground.
- **The Old City**: The old city is placed in a cave midway up the mountain. It is uninhabited, and like similar sites in the American Southwest, little is known about those who built it and lived there.
- **Mist around the Mountaintop**: Bryce is the perfect creative environment when it comes to generating clouds and mist.

THE ABODE

The Abode will contain the following to-be-modeled items:

- **The Jungle**: When you need to create a patch of forest or jungle in Bryce, you should immediately be alerted to stay away from doing it all with 3D models. Having as few as 10 3D trees in a scene can bog down rendering and create huge files when stored. That's why we will focus on picture plane rendering for this component.
- **Habitat**: The sketch does not detail what this will be, so it will be determined along the way. It will call for some external 3D modeling alternatives.
- **Alter**: Everything about any culture that exists in Mayan lands hints at some sort of religious ritual, and religious rituals often invoke the

ADVANCED BRYCE CREATIONS

construction of an altar. A variety of modeling alternatives will be used to create this model.
- **Water Source**: There must be a water source so the inhabitants can survive, so we will add one.
- **Stockade Fence**: Just to keep onlookers and beasts of prey at bay, and perhaps to protect the outside world from the enclosed population. This will be a model whose parts are created in an external 3D application.

TUTORIAL

SUPPORTIVE ENVIRONMENT COMPONENTS

Now that we have itemized all of the components that will contribute to this scene, it's time to model them for the project.

SKY

In addition to using a default Bryce sky plane to sculpt the clouds, we will also insert another ISP with its own parameters in the scene. Do the following:

Default Sky

Configure the Default ISP as follows:

1. Open a new Bryce document, and go to the Sky&Fog settings. Make sure both Stratus and Cumulous clouds are checked on. Use the following settings: Custom Sky with colors of white, dark pink, and dark red; Shadows of dark blue; Fog off; Haze of 2 with a light blue hue; Cloud Height of 22 and dark red; Cloud Cover 15 and pink.
2. Open the Sky Lab. Select the Wavey material preset from the Basic Library, Edit the Stratus clouds in the Deep Texture Editor, and change the blue hue to pink. Select the Red Layers material preset from the Sand Library, and Edit the Cumulous clouds in the Deep Texture Editor. See Figure 15.2.
3. Preview the sky; your rendering should look like Figure 15.3 with a deep red cast.

Second ISP

Now it's time to place another ISP layer. Do the following:

1. Create another ISP layer in the scene. This one need not be used to obliterate or diminish any ground content, so place it far above the potential ground plane position. Use a Left or Right View.
2. Make sure Spherical is checked under Sky&Fog Options. With the new ISP selected, go to the Deep Texture Editor in the Materials Lab. Select the Bump folder and then the Polychrome Bump material. Set XYZ Scale to 6%

CHAPTER 15 ABODE OF THE LIZARD MASTER

FIGURE 15.2 *Edit both the Stratus and Cumulous materials.*

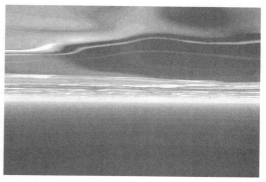

FIGURE 15.3 *Your rendered sky should look like this.*

with Parametric mapping. Set Bump to 0% and Transparency to 17%. Use an orange Ambient hue, and set Ambience to 100%. Render to preview. See Figure 15.4.

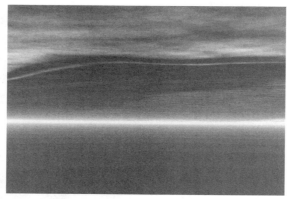

FIGURE 15.4 *Your sky should now closely resemble this illustration from the Camera View.*

GROUND

Most of the Ground texture will be hidden, but enough of a hint will poke through to make the material design important to consider. Do the following:

1. Create an IGP.
2. Go to the Materials Lab, and select the Natureal material from the Bump Library. Use an XYZ Scale of 175% with Random mapping. Set the other parameters as shown in Figure 15.5.
3. Do a test render. See Figure 15.6.

FIGURE 15.5 Set the parameters as shown.

FIGURE 15.6 A test render with the IGP added.

This is all you need for a ground, since it provides a nice patterned green that can be detected through any mist.

GROUND FOG/MIST

This is a very important feature of this world, adding both mystery and calling attention to the Abode itself, which is not enshrouded by mist or fog.

1. Add a Volumetric IGP (Slab). Place it as shown in Figure 15.7, using the Camera icon as a size reference.
2. Use the Bright&Bumpy material from the Clouds&Fogs Library. Set the XYZ Scale at 10%, and use a World Space mapping. See Figure 15.8 for the other parameter settings.

FIGURE 15.7 Add a Slab.

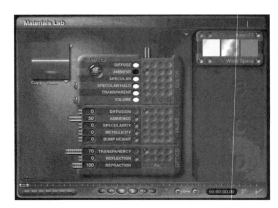

FIGURE 15.8 Use these material settings for the Slab.

CHAPTER 15 ABODE OF THE LIZARD MASTER 331

FIGURE 15.9 *Almost no ground can be seen when you view the scene from above this atmospheric layer.*

FIGURE 15.10 *Placing the camera inside the Slab, pointed down at a 22-degree angle, creates another more interesting view of the mist-shrouded ground.*

3. Do a test rendering. See Figures 15.9 and 15.10.

DISTANT PEAKS

These peaks will be sharper than those created in other projects in this book, making them seem to act like a wall to keep intruders from exploring the Lizard Master's Abode. Do the following:

1. Lattice, and go to the Terrain Editor. We will use the default Lattice as the basis for this component. Use a Grid Size of 32 (Course).
2. Apply the Relief Noise and Raise Edges effects. Use the Erosion Brush to add some fractures at the sides. Your Elevation map should look like the one shown in Figure 15.11.
3. Accept the model, and place it far in the background. Open the Materials Lab, and select the Mountain Rocks material from the Rocks Library in the Deep Texture Editor with World Space mapping to add a texture to the peak.
4. Duplicate and Scale/Rotate to create other peaks. For peaks moved farther back, add a purple Ambient hue with an Ambience value of 50%, and apply a Transparency of 30%. This forces the eye to see them as more distant than they are.
5. Go to the Top View and make sure this range of peaks forms a crescent, just in case you want to view the background from a different angle later. See Figure 15.12.

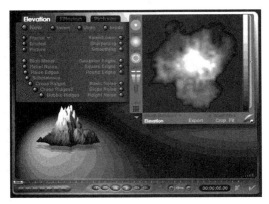

FIGURE 15.11 *The Elevation map for the scraggly peaks.*

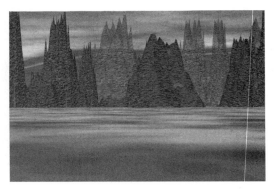

FIGURE 15.12 *The background peaks are added.*

NOTE

Always lock the components in your scene that are to remain in one place after you create them. Name them so you recognize what the object is, and name groups as well. That way, when complexities result from numerous objects in a scene, you can always locate and customize any object without accidentally selecting anything else.

ITEMS ON THE GROUND

Just to emphasize the fact that the mist is not a cloud plane, and to create some elements that assure the viewer where this scene is located geographically, we will place some Mayan-like structures in the scene. We'll also add a few trees poking above the mist. Do the following:

1. Lattice>New. Go to the Pictures tab, and load the kk Maya Pyramid.tif image from the Bryce Texture Maps folder. See Figure 15.13.
2. Scale this object, and place it on the ground so that it rises above the mist. Use a TerraCotta material with a 12% GoldenBump map (Bump Library). Duplicate, and place the second pyramid farther in the background. See Figure 15.14.
3. Create a wall around the foremost pyramid from scaled cubes, and map it with the same color material as the pyramid. Use a Stone Wall Bump map (Rocks&Stones Library), with a XYZ Scale of 50 and a Bump Height of −444. See Figure 15.15.

CHAPTER 15 ABODE OF THE LIZARD MASTER 333

FIGURE **15.13** *Load the Maya Pyramid Elevation map.*

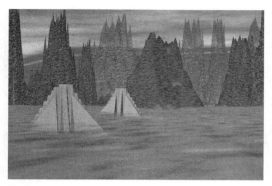

FIGURE **15.14** *Two Maya Pyramids are added.*

4. Go to your Objects Library. Find the folder where your Hanging Roots from the Faerie project is stored, and place in the scene. Turn upside down, and Duplicate, creating a wonderful top for trees. See Figure 15.16.

FIGURE **15.15** *A patterned wall can be seen breaking through the mist.*

FIGURE **15.16** *Twisted tree tops accent the mist.*

THE MAIN MOUNTAIN

This is the stage for the Lizard Master's Abode, so relative size and placement are very important. Before proceeding, move the Camera View back so that you have more visibility, and the pyramids look smaller. See Figure 15.17.

Then do the following:

1. Create your mountain in the Terrain Editor from a Lattice, and make sure it has a flattened top. Use your own design judgment. See Figure 15.18.

FIGURE 15.17 *Move the camera back so that you have a wider view of the scene.*

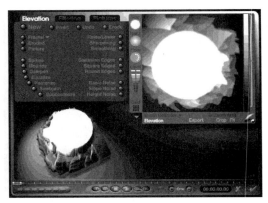

FIGURE 15.18 *Create an Elevation map of your own design for your mountain.*

2. Export in a format your external 3D application can read. See Figure 15.19.
3. Import in your external 3D application. Optimize to reduce the polys. See Figure 15.20.
4. If you want to, use your Vertex Editing tools to widen the base. See Figure 15.21.
5. Use a hemisphere as a Boolean cutter to create a cave. See Figure 15.22.
6. Export. Back in Bryce, delete the terrain. Import the mountain you just created, and use an Etched Rock material on it with all defaults as is (Planes&Terrains Library). See Figure 15.23.

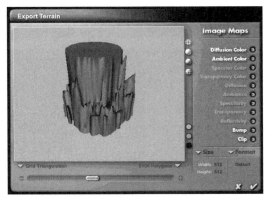

FIGURE 15.19 *Export the terrain.*

FIGURE 15.20 *Import the terrain in your external 3D application.*

CHAPTER 15 ABODE OF THE LIZARD MASTER

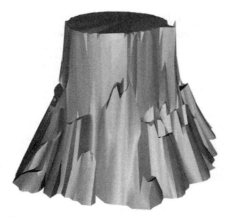

FIGURE 15.21 *The base is widened*

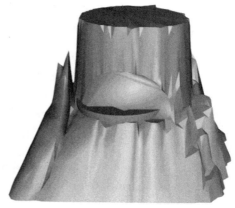

FIGURE 15.22 *Create a cave.*

7. Place a Radial Light at the top-front of the cave to light it up a bit. Use Cast No Shadows, and make the Intensity 50 with a soft edge of 30. The hue should be yellow, and Falloff is Squared. See Figure 15.24.

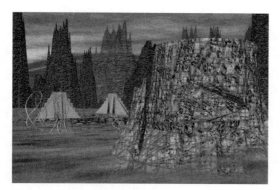

FIGURE 15.23 *The mountain with a cave.*

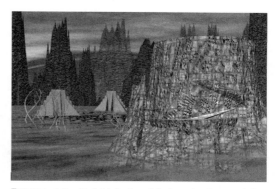

FIGURE 15.24 *A Radial Light is added to the front of the cave.*

THE OLD CITY

The old city is placed in the cave in the mountain. It is presently uninhabited. If you intend to spend time inside of it with a camera, then you will want to model the buildings accordingly, giving them some appreciable detail. If not, and your plan is to only use the city as a backdrop, then all you need to do is construct the buildings from basic cube primitives. I have selected the second option.

 The Bryce primitive objects have too many polygons in many instances. It is wise to consider modeling similar objects in your external 3D application and exporting to Bryce, placing them in the Objects Library. That way, when you need a basic primitive, you can use one that adds less memory requirements to a scene.

1. Open your external 3D application, and create a large array of diverse primitives, whatever the software has to offer. Group all, and export to Bryce. See Figure 15.25.
2. Create a new Bryce document. Bring the Primitive group into Bryce, and UnGroup. One by one, add each to your Objects Library. Now you have a whole collection of primitive forms with fewer polygons, available to every Bryce project you do. See Figure 15.26.
3. Delete all of the primitives from the document. Let's build the city here.
4. Place an imported cube primitive in the scene. Duplicate and resize until you have a basic city look. Map with a white Diffuse hue and the Techno City 2 Bump from the Bumps Library. You can cut Boolean windows if you plan to take extreme close-up shots. Group all. See Figure 15.27.
5. Place this model in your Objects Library, and open the Dragon Masters project.
6. Scale and place the city that you just created from the Objects Library into the cave. See Figures 15.28 and 15.29.

FIGURE 15.25 *Create a diverse array of primitive objects.*

FIGURE 15.26 *Now you have instant access to an array of lower polygon primitives.*

CHAPTER 15 ABODE OF THE LIZARD MASTER 337

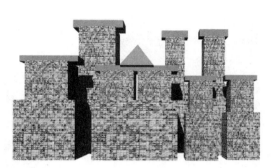

FIGURE **15.27** *The basic city is constructed, ready to be placed in the cave.*

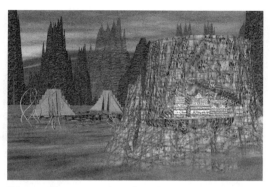

FIGURE **15.28** *The city is placed in the cave.*

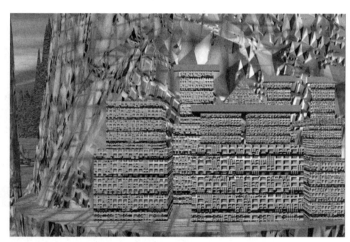

FIGURE **15.29** *A closer look.*

MIST AROUND THE MOUNTAINTOP

Bryce is the perfect creative environment when it comes to generating clouds and mist. Here's how to create this component:

1. Place a large Torus about two-thirds of the way up from the city to the top of the mountain, completely encircling it.
2. Use a Cotton Ball material from the Volume Library on the Torus, with an XYZ Scale of 355 in World Space mapping. Set the rest of the volumetric parameters as shown in Figure 15.30.
3. Do a test render. See Figure 15.31.

FIGURE 15.30 *Set the parameters as shown here.*

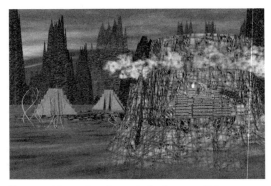

FIGURE 15.31 *Misty clouds encircle the top of the mountain.*

SOMETHING BORROWED

Let's select an item created for a previous project that is stored in your Objects Library, and add it to the scene.

1. Open the Objects Library, and locate the Temple of Sacrifice object that you created for the Fire Eaters project.
2. Add this object to the Lizard Master's scene in the lower left as seen from the front. Scale as needed. See Figure 15.32.

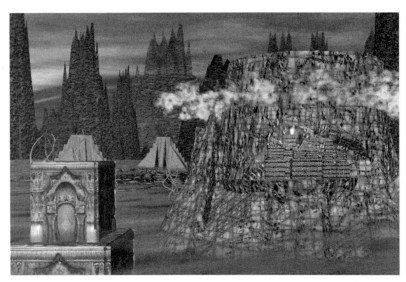

FIGURE 15.32 *Add the Temple of Sacrifice to this scene.*

THE ABODE

The most detailed 3D geography in this project relates to the elements to be placed on top of the mountain, which is the center of the Abode of the Lizard Master. Everything else we have created so far for this project can be considered a group of supporting actors, although some very wonderful images can be rendered from the content thus far. In the Abode, however, we have to plan for more detail. Put another way, if this project was to be used as a set for a movie, the Abode is where the star performers would deliver their important lines.

THE HEDGE

When you need to create a patch of forest or jungle in Bryce, you should immediately be alerted to stay away from doing it all with 3D models. Having as little as 10 3D trees in a scene can bog down rendering and create huge files when stored. That's why we will focus on *3D Picture Plane* rendering for this component. What is a 3D Picture Plane? By now, you are very familiar with 2D Picture Planes, represented in Bryce's Create toolbar by the 2D Picture Object icon. Bit flat 2D Picture Objects are not the only object types that can receive picture/image content, as you are well aware. There have been many instances where you have already applied picture/image content to one or more of the Material channels in a project in this book, most often for the Diffuse and/or Bump channels. Picture Plane objects, however, are unique. A 2D Picture Plane Object is meant to fool the eye into thinking that the 2D Plane is really a 3D Object. The shortcoming is that when the 2D Picture Plane is viewed from any angle not exactly perpendicular to the plane, image distortion results. If you map a tree image to a 2D Picture Object plane, the tree will only look believable if the camera angles are perpendicular to that plane. But what if you want to fly up and over and around the tree at any angle? That's where a 3D Picture Plane comes in.

If you create the image with 3D object mapping in mind, you can map the image to a sphere or cylinder, or many other object choices, and it can trick the eye into seeing a 3D object that can be appreciated from any angle. This is helped by the fact that the contours of the object itself are partially obliterated by the Alpha channel transparency of the image, so that parts of the 3D object's edge drops out. This optical illusion is helped out further by the fact that only the image content, not the transparent areas created by the Alpha channel map, will cast a shadow, so the realism of the overall effect is enhanced. Using 3D Picture Plane mapping is not unique to Bryce, but has become an industry-wide 3D standard. Both 2D Picture Plane and 3D Picture Plane mapping owe their existence to a Disney invention introduced in the 1930s, the Multiplane Camera. Disney discovered that multiple flat planes placed in front of the eye (or the camera) could force the eye to see a 3D environment, mainly because of

the transparent areas present on interleaved 2D planes. The digital revolution simply takes this idea a step farther, making it easy and affordable, without the purchase of a special camera costing tens of thousands of dollars.

Although the concept is not unique to Bryce, few other software applications take as much creative advantage of this technique as Bryce does. This is especially true for creating naturalistic terrains and flora. Bryce is supported by two other applications, designed with this use in mind: Corel *Painter*, and the *Jungle* CD volume from DigiArts. The one tool that is most essential in the creation of naturalistic imagery that can be used to create exquisite 3D Picture Plane maps is the Image Hose brush in Painter. These three applications (Bryce, Painter, and Jungle) are the primary applications that handshake to foster the creation of 3D Image Plane objects. There are workarounds, but none that offer the variety, quality, and believability of this trio of handshaking applications.

To make the best use of this phase of the project tutorial, you should own and know how to use the Image Hose tool in Painter (including how to load Image Hose Nozzles), as well as own the Jungle CD (www.gardenhose.com). A working session would proceed as follows:

DigiArts also markets a volume of flora and other naturalistic Image Hose Nozzles called GardenHose, but the Image Hose Nozzles found on the Jungle CD are best for 3D work. That's because the resulting images are saved with exacting Alpha channels included, so you need not go through the trouble of creating the Alpha layer on your own.

1. Open Painter. Create a new canvas (either 256 × 256 pixels, or 512 × 512 pixels at 72 dpi works best). Make the image background color very dark, so that the Alpha layer will not create a ghost effect (a glow) around the foreground content.
2. Activate the Image Hose.
3. Make the image a Tiled image, so that any content sprayed on the edge is replicated on the opposite edge.
4. Select one of the Jungle Nozzles, and use the Image Hose to spray your design on the image. Lowering the Graininess value below 100% will create partially transparent image content. When Graininess is set to 0%, the image content sprayed will be invisible. This is because you are altering the grayscale values of the image at that point.
5. Save the image in a format that Bryce can read, and make sure the image format includes the Alpha channel layer.
6. In Bryce, 3D Image Plane mapping works best on a sphere, although using this process with other targeted objects should also be explored. Create a sphere in Bryce.

FIGURE 15.33 *A Jungle image, created in Painter, is loaded into the Picture Editor in Bryce, Note that the Alpha layer is automatically loaded along with the color image.*

FIGURE 15.34 *Wrapped to a Torus, the object becomes a believable hedge. There is a good amount of detail for close-up renderings.*

7. Go to the Materials Lab, and then to the Picture Editor. Load the image you just created, and its Alpha channel should show up as well.
8. Map the image to the sphere. A 0% XYZ scale with Parametric mapping usually works best, but you can explore other options as well. See Figures 15.33 and 15.34.

OK. Now that you know the process, it's time to create a dragon-hedge, a protective wall around the Abode. Do the following:

1. Create two leafy textures in Painter, using the Jungle Nozzles. Make them 512 × 512 pixels at 72 dpi. Save them, along with their Alpha channels.
2. In a new document in Bryce, create two Torii. Use one of the images you created on each Torus, so the two Torii have different image maps. In the case of the Torus, World Space mapping seems to work best.
3. Place the Torii just a little off center from each other, which will blend the image maps.
4. Place a few of the Vines you created in with the blended Torii, turning them upside down first. Map them with the Warm Gold material from the Simple&Fast Library.
5. Stick a few tree models from the Rocks&Trees Objects Library in the Torii, giving the group more of a jungle look. Group all, and save to your Objects Library. This wall of flora will be placed on the mountain. See Figures 15.35 and 15.36.
6. Open the Lizard Master project. Go to your Objects Library and add the Hedge you just created to the scene. Scale as needed, and place on the mountaintop. See Figure 15.37.

FIGURE 15.35 *Your hedge will look unique, but here is one example.*

FIGURE 15.36 *A view from the inside.*

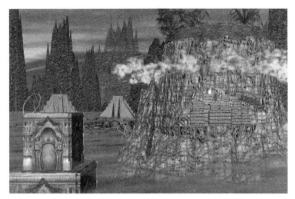

FIGURE 15.37 *Add the hedge object to the top of the mountain in the foreground.*

Habitat

The word *abode* indicates some manner of habitat, and the Abode of the Lizard Master must look as evocative as the name. For this reason, both the geometry and the texture maps will have to be unique. Do the following to create the Lizard Master's habitat:

1. Open PhotoPaint or your other 2D painting application. This step will require that you have the Eni Oken Classic Ornament Texture CD (the same texture collection used to create the Temple of Sacrifice façade for the Fire Eaters project).
2. Start a new image that is 512 × 512 pixels at 72 dpi.
3. Use the Eni Oken textures to create an interesting façade. Repeat this step two more times, so that you have three facades. See Figures 15.38

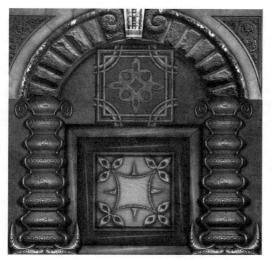

FIGURE 15.38 *Facade 1.*

FIGURE 15.39 *Facade 2.*

through 15.40 for my examples, although your creations will probably look different.

4. Go to your external 3D application. Use your imagination to create a unique habitat, unlike anything you have ever created before. Pretend you're an alien. The only ground rule is that it has to contain two cubes. The one shown in Figure 15.41 has a lathed top, two cubes below that, and lofted legs.

FIGURE 15.40 *Facade 3.*

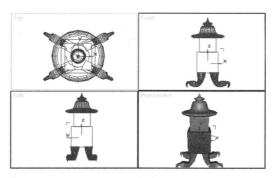

FIGURE 15.41 *Create a strange habitat.*

5. Export to a new Bryce document. Texture any way you like except for the cubes. Use the three images you created to generate Elevation maps for Lattices. Paste the Elevation objects to the cube faces and scale to size.
6. As a last step, add the bridge from the Objects Library. Ungroup. Delete everything but one set of stairs and railings, and use them for your habitat (that is, if you need them to reach a doorway in your design). Group all, and save to your Objects Library. See Figure 15.42.

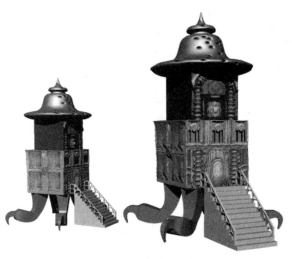

FIGURE 15.42 *Here is one unique habitat design.*

ALTAR AND WATER SOURCE

Any culture that exists in Mayan lands hints at the incorporation of a religious ritual, and religious rituals often invoke the use of symbols and the construction of an altar. At first, it was my intention to create an altar and a water source separately. Then I had the idea that water itself would be sacred to any tribe that lived high on a mountain in such a desolate land. I had planned to use Poser for this part of the project, but decided that you might appreciate using Bryce native tools and processes to create this component—a hand. Do the following:

1. Open a new Bryce document. Place two spheres in the scene. Scale them so that when placed in position, they resemble Figure 15.43.
2. Group the two spheres, and move the common Origin Point to the center of the sphere on the left, the smaller one.

FIGURE 15.43 *Place and scale the two spheres as shown.*

FIGURE 15.44 *The grouped and textured component.*

3. Map the group with a Warm Gold material from the Simple&Fast Library. Change the default red Diffuse hue to dark green. Render to preview. See Figure 15.44.
4. This is the first section of a stylized finger. Create another two sections by duplication to attach to the first section in a chain, making each about 12% smaller than the preceding one. Link the second section to the first, and the third to the second. See Figure 15.45.
5. The linked sections of the finger are now linked, and pass their movements, scaling, and rotations down to their child sections. Go to a Front View, and use rotation on the Z-axis to reshape the finger as shown in Figure 15.46.
6. Create a fingernail from a stretched pyramid, and link it to the end finger section. See Figure 15.47.
7. Use a squashed sphere for the hand. Duplicate, rotate, and scale the finger to create the other fingers. Link all fingers to the hand. See Figure 15.48.

FIGURE 15.45 *Create and link the sections.*

FIGURE 15.46 *Create this rotated example.*

FIGURE 15.47 *Add a fingernail.*

FIGURE 15.48 *Create the other fingers and link all fingers to the hand.*

8. Create the parts of the thumb and link to the hand, repeating the procedures used to create the initial finger. See Figure 15.49.
8. Create a tapered and slightly bent cylinder in your 3D application, and Export in a Bryce-compatible format. Use this object in Bryce as the arm, linking the hand to it. See Figure 15.50.
9. Duplicate and Flip the arm on its X-axis to create a second symmetrical arm. Link both arms to a sphere at their base. See Figure 15.51.
10. Place a bowl (Organic Boolean #3) from the Boolean folder in your Objects Library into the hands. See Figure 15.52.
11. Place a low wall around the base of the structure, and map with the Sandstone material from the Rocks&Stones Library. Place a squashed cylinder inside the walls and scale to form a pool. Map with the Xanades Lake material from the Waters&Liquids Library. Duplicate and scale the water cylinder to place water in the bowl. See Figure 15.53.
12. Lattice>New. Create the Elevation map displayed in Figure 15.54.
13. Convert to Terrain. Use this object to add a falling stream of water from the bowl into the pool. Place a floating sphere above the bowl for a little magic. Use eight thin Bryce Torii to create an ornamental fence around the pool. See Figure 15.55.

FIGURE 15.49 *Create and link the thumb.*

FIGURE 15.50 *The arm is added.*

Chapter 15 Abode of the Lizard Master

FIGURE 15.51 *Create this multiple form.*

FIGURE 15.52 *Place a bowl in the hands.*

FIGURE 15.53 *Add water and a Sandstone wall.*

FIGURE 15.54 *Create this Elevation map.*

FIGURE 15.55 *The final touches.*

Putting It All Together

Now it's time to add the Habitat and Altar-Pool to the scene. Do as follows:

1. Add three Habitats from your Objects Library to the scene. Scale and place within the protective hedge on top of the mountain. See Figure 15.56.
2. Scale and place the Altar-Pool within the hedge, so that it faces the three Habitats. See Figure 15.57.

FIGURE 15.56 *Add three Habitats with the hedge.*

FIGURE 15.57 *Place the Altar-Pool within the hedge.*

A Necessary Correction

Often, some aspect of a Bryce world will not become visible until all of its surrounding contents are in place. This was the case for me when I looked at the city in the cave, surrounded by all of the other elements in the scene. It just didn't look right. There was comparatively less color, and it seemed to be out of place. This component had to change. My decision was motivated by the way the Temple of Sacrifice, the Habitats, and the Altar-Pool appeared. They were far more colorful and detailed, all thanks to the Eni Oken Classic Ornament collection, which was responsible for the Lattice-based objects and their texture maps. See Figure 15.58.

Here's what I did to create new content for the city in the cave. You will have to have the Eni Oken Classic Ornamental Texture Kit for your 2D painting application to follow along:

1. Open a new canvas in your 2D application. Make it 1024 × 512 pixels by 72 dpi. Make it solid black (RGB = 0, 0, 0).
2. Use the components of the Eni Oken application to create the facade for a city. See Figure 15.59.

FIGURE 15.58 *The city in the cave looks out of place when compared to other surrounding elements.*

FIGURE 15.59 *Create a facade painting, using the Eni Oken components.*

3. Lattice>New. Import the city image you just created as an Elevation map into a new document in Bryce. Use it to create a 3D facade for the city in the cave, mapped with the color image as a picture texture. Scale and place in the cave in the project document. See Figures 15.60 and 15.61.

FIGURE 15.60 *The image is used to create the Elevation map.*

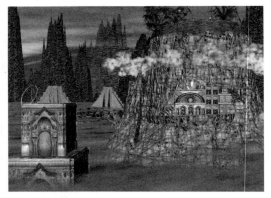

FIGURE 15.61 *The new city in the cave is placed, and the project is completed.*

FINAL RENDERS

Time for some renderings. Place the camera in the scene to frame some points of interest, and render away. See Figures 15.62 through 15.67.

FIGURE 15.62 *A close-up view of the city in the cave.*

FIGURE 15.63 *Looking down on this vast scene from the front.*

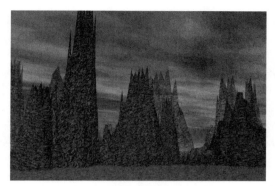

FIGURE 15.64 *The brooding peaks against the sky.*

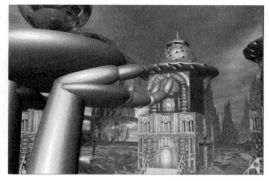

FIGURE 15.65 *Altar and Habitat.*

FIGURE 15.66 *Habitat detail.*

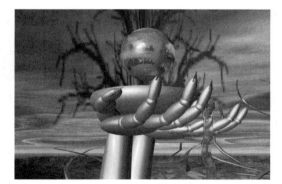

FIGURE 15.67 *Altar-Pool detail. Notice the realistic transparency of the falling water.*

TRAVELING ON

By now, you probably feel that you deserve bonus flyer miles for visiting so many diverse Bryce worlds. But hold on to your parachute, because we have one more place to explore—the Hall of Clouds.

CHAPTER 16

The Hall of Clouds

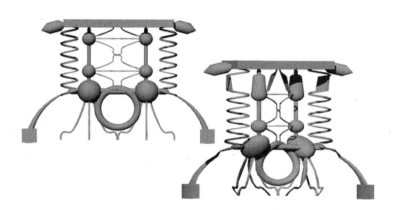

354 ADVANCED BRYCE CREATIONS

This is the last of the eight projects in this book, and provides you with yet another very different environment to create, along with new tool use and techniques. The great Hall of Clouds floats above an island in the North Pacific, the location of which has been discovered by very few. Even from the island, all you can see when looking skyward is a great cloud. The cloud shifts its form, but never its position. Because of either an unknown cloaking device or a play of the imagination, any aircraft passing overhead also sees only the cloud, and nothing more. The only method of traveling to the cloud is from the teleportation enclosure on the island, a duplicate of which also sits on the cloud.

ROUGH SKETCH

This final project begins, as you by now expect, with a rough sketch. See Figure 16.1.

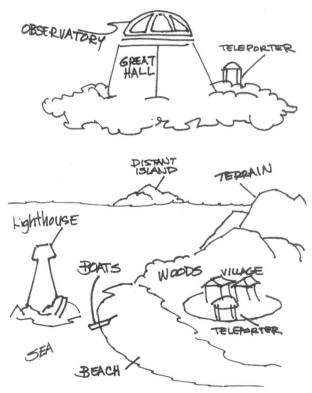

FIGURE 16.1 *The rough sketch for this project.*

Looking at the sketch, you can distinguish two different but connected environments. Let's call them *Supportive Items* and *Cloud Stuff*. We reserve the possibility of adding elements to this project not depicted in the rough sketch, and will certainly add details to the items that are noted. *Supportive Items* includes the Sky, Ground, Sea, Distant Island, a collection of items on the main island, and the Lighthouse. Cloud Stuff includes the Cloud Structure, Teleporter, Great Hall, and the Observatory.

SUPPORTIVE ITEMS

The following Supportive Items will need to be created:

- **Sky**: We will design a default ISP and insert another ISP for the sky. No need to look outside of Bryce for these components.
- **Ground**: This will include the diversity of Terrain elements involved, all Bryce generated. Though we will not use an IGP on top of the water, we will use an IGP for the floor of the sea. Bryce has all the creative tools necessary for these items.
- **Sea**: This is the North Pacific, so we'll have to keep that in mind when assigning the proper material. IWPs, of course, are a Bryce specialty.
- **Distant island**: There may be more than one distant island involved. This sets the scope of a scene. Our distant island(s) will rely on Bryce Terrain Editor for their inception.
- **Undersea Power Source**: Don't bother looking for this in the sketch. It was an afterthought. I'll save the surprise of how we will model this item.
- **Items on the main island**: This will include the following elements: Boats on the beach, Village clearing and path (with a stream also added), houses or huts, and the *Teleporter* unit. Some flora may also be added.
- **Lighthouse**: This will include the small rocky island on which the lighthouse sits plus the lighthouse itself.

CLOUD STUFF

This will include the following items:

- **The Cloud Structure**: This is Bryce created, calling upon some of the skills you used in the last project to create the halo of clouds around the Lizard being's enclosure.
- **Teleporter**: This is a duplicate of the teleporter on the island below.
- **The Great Hall**: There will be a fair amount of detail inside the Great Hall that has to be created in addition to the architecture itself.
- **The Observatory**: This is more than a unit that is added to the top of the Great Hall. It is a separate item with its own internal details. If it were known, the Observatory is really an inter-galactic ship moored to the Great Hall.

SUPPORTIVE ITEMS

OK. Modeling time. Get comfortable, switch your system on, and bring up Bryce.

SKY

Both the default ISP and an inserted ISP have to be configured for the sky.

Default ISP

Do the following to configure the Default ISP:

1. Go to the Sky&Fog toolbar, and select *Custom Sky*.
2. Set the following parameters: Sun Glow Color = white, Sky Color = light violet, Horizon Color = light blue. Shadows at 80% black. Fog off, and Haze at a light blue of 3. Cloud Height at 80% with a Sky Dome Color of Dark Blue. Stratus is on and Cumulous is off.
3. Set Spherical on in the Sky&Fog Options list. You should have a sky similar to the one shown in Figure 16.2.

Inserted ISP

The inserted ISP will provide the Cumulous clouds. Do the following:

1. Place an ISP in the scene. Move it up to a high altitude (675 on the Y-axis). The Hall of Clouds will be placed above this plane later.
2. In the Materials Lab, select the *Looking Down* material from the Clouds&Fogs library, with an XYZ Scale of 3%. Apply with Spherical mapping. Your sky should now look like that in Figure 16.3.

FIGURE 16.2 *Your default sky plane should resemble this one.*

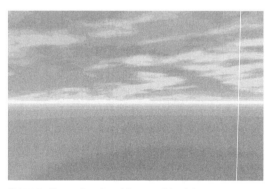

FIGURE 16.3 *Your sky should resemble this one.*

GROUND

This will include the diversity of Terrain elements involved, all Bryce generated. Although we will not use an IGP on top of the water, we will use an IGP for the floor of the sea.

Sea Floor

Just in case we want to take the camera underwater, which is where we will place a "Power Source" object later, it's important to place an IGP to act as the floor of the sea. Do the following:

1. Place an IGP at the appropriate depth for a sea floor. I used a Y-axis of –350.
2. Use the AlienSand material from the Sand Library. Use Random mapping, with an XYZ Scale of –5%. In the Deep Texture Editor, change the light-brown hue to medium blue. Set the other parameters as shown in Figure 16.4.
3. Render to preview. See Figure 16.5.

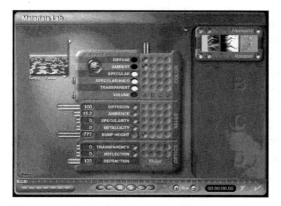

FIGURE 16.4 *Set the parameter values as displayed here.*

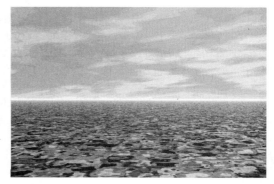

FIGURE 16.5 *Sky and sea floor.*

Sea

This is the North Pacific, so we'll have to keep that in mind when assigning the proper material. Do the following:

1. Create an IWP. Place it at sea level, which equates to 0 on the Y-axis.
2. Use the following Material parameters to create a great ocean texture. Select the Swirling Water material from the Waters&Liquids Library. Set the XYZ Scale to 3, and use World Space mapping. Set the other parameters to the values shown in Figure 16.6.
3. Do a test render to evaluate the scene so far. See Figure 16.7.

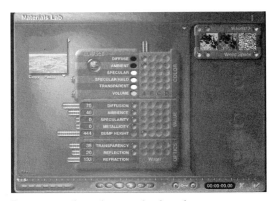

FIGURE 16.6 *Set the values as displayed.*

FIGURE 16.7 *The sea is rendered.*

Beach

The main island has an encircling beach. Here's how to create it:

1. Lattice>New. Invert, which gives you a solid square block. Round Edges to the maximum, which gives you a cylindrical form. Gaussian edges to the max, which creates a conic form. See Figure 16.8.
2. Fractal Lava. This adds features that are more random. The default Grid is set to 128. Change it to 256 temporarily, and select the lowest Level Elevation Brush with the smallest tip to chew away some of the symmetrical edges, randomizing the edge perimeter. A degree of randomness is always appreciated as more natural and "real."
3. Erode, then Lower again. This added some smoothed ripples to the object. Set the Grid back to 128. See Figure 16.9.

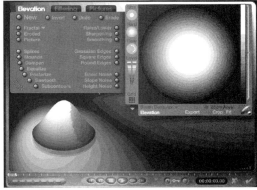

FIGURE 16.8 *The form is now a conic hill.*

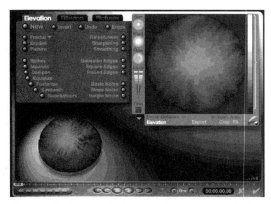

FIGURE 16.9 *The lowered object with erosion applied.*

CHAPTER 16 THE HALL OF CLOUDS

4. Accept the model, and Convert To Terrain. Scale the vertical dimension by 50%. Place in the scene so that the island sinks just a bit below the water line.
5. Use the Cracked Sandy Rock material from the Sand Library on this part of the island. Use a XYZ Scale of 75% with World Space mapping. Set the parameters as shown in Figure 16.10.
6. Do a test render. See Figure 16.11.

FIGURE 16.10 *Set the parameter values as displayed.*

FIGURE 16.11 *The beach is added and rendered.*

Forest

Do the following to create the look of a forest:

1. Duplicate the beach object. Scale to 70%, and then scale the height to 200%. Place in the middle of the island.
2. Use the Foliage 2 material from the Miscellaneous Library, with an XYZ Scale for both textures of 150%. Set both mappings to Object Space.
3. Set the rest of the material parameters as shown in Figure 16.12.
4. Place a few Palm Trees from the Rocks&Trees Objects Library on the edge of the forest, where the beach meets the foliage. See Figure 16.13.

FIGURE 16.12 *Set the parameters as indicated.*

FIGURE 16.13 *The finished forest.*

Hills

At the center of our island are some hills. Create them as follows:

1. Create a ring of hills of your own design from Lattice objects, and place them at the center of the island. Use the Top View for placement, and Object Space map with the Grassy Peaks material at an XYZ Scale of −150. Use a Bump Height of 225.
2. Create one more hill in the center of the ring that has a very flat top and is lower than the rest. This is where the village and Transporter will be placed, since it is more protected than placing it below. See Figures 16.14 and 16.15.

FIGURE 16.14 *A view of the hills from the beach.*

FIGURE 16.15 *An overhead view, displaying the grassy peaks at the top of the hills.*

Chapter 16 The Hall of Clouds

Distant Islands

Distant islands help set the global scope of a scene. Do the following:

1. Create five or six Lattice islands of your own design, and place them far in the distance, encircling the main island. Convert To Terrain.
2. Use the Grassy Peaks 2 material with World Space mapping. This material contains its own beach at low altitudes. See Figure 16.16.

FIGURE 16.16 *Create some distant islands.*

Undersea Power Source

The undersea power source does two things. First, it supplies the power necessary for the Hall of Clouds to remain floating in the air, while it also generates the energy that creates the cloud and cloaking mechanisms. The power source also acts as a base on which the island rests, positioned securely on the sea bed below. Do the following to create it:

FIGURE *Step 1.*
16.17

FIGURE *Step 2.*
16.18

FIGURE 16.19 *Step 3.*

FIGURE 16.20 *Step 4, with optimization to reduce the number of polygons.*

1. Open your external 3D application, and use a collection of Primitive objects, Lofts, and Extrudes to configure the model. Use your imagination. Make it as complex as you like. See Figures 16.17 through 16.20 for one series of possible steps.
2. Optimize and save in a format Bryce can import. If you own PLAY's Amorphium, you can import the model to customize it further before export to Bryce. Using Amorphium, you can add more variation to the model, making it look a bit more convoluted and interesting. See Figures 16.21 and 16.22.
3. Open a new document in Bryce. Import the model (I used the Amorphium-customized model). Add some blocks to the base and top, and apply whatever materials you like. Make sure to increase the Ambience of all materials, since this object can have a glow in the dark. Group all, and save to your Objects Library. See Figure 16.23.

FIGURE 16.21 *Use Amorphium to add more random design to the model if you like.*

FIGURE 16.22 *The same Power Source object before and after applying effects in Amorphium.*

CHAPTER 16 THE HALL OF CLOUDS

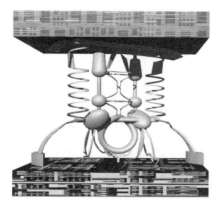

FIGURE 16.23 *The finished Power Source model.*

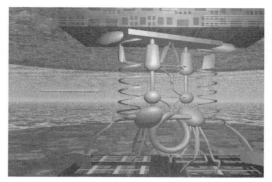

FIGURE 16.24 *The Power Source has an ominous presence when viewed under the sea.*

4. Open the Hall of Clouds project. Place the Power Source object from your Objects Library in the scene. Scale so that the model sits embedded in the sea bottom and supports the base of the island. Save the project. See Figure 16.24.

 You should always darken the color of the Haze when placing the camera under the sea, in order to remove the horizon line from any renderings.

ITEMS ON THE ISLAND

This will include the following elements: Boats on the beach, Huts, and the Teleporter unit. Some flora may also be added. Deviating from the rough sketch, I decided to remove the clearing, path, and stream, and move the village to the flattened center hill.

Boats on the Beach

The boats on the beach are sometimes used by the inhabitants, but their primary reason for being there is to mask the real purpose of the island as a communication and transport outpost for the Hall of Clouds. Do the following to create the boats:

1. Open your external 3D application. Loft the shape shown in Figure 16.25 to a Straight horizontal line.
2. The result of the loft is a channeled form. See Figure 16.26.

FIGURE 16.25 *Loft this shape to the curved path.*

FIGURE 16.26 *This form results from the loft.*

3. Use Vertex Editing tools to adjust the shape so that it resembles something like Figure 16.27. Attach rectangular seats.
4. Export in a format Bryce can read. Open your Hall of Clouds project in Bryce, and place a few boats on the beach. Save the project. See Figure 16.28.

FIGURE 16.27 *The finished form.*

FIGURE 16.28 *Place a few boats on the beach.*

Village Huts

Remember that the village is placed on the central hill, and not in a clearing by the beach. Do the following:

1. You're in luck! You already have the Thatched House in your Objects Library from the *Jade Pagoda* project. Place it in the scene on top of the central hill, and change the roof material to solid white (Simple&Fast Library).
2. Duplicate it, and create a few more houses. See Figure 16.29.

CHAPTER 16 THE HALL OF CLOUDS 365

FIGURE 16.29 *Create a village on the central hill.*

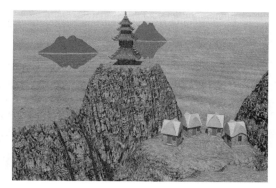

FIGURE 16.30 *The Pagoda sits on another hill.*

3. Place the Pagoda (the second one you created for the Jade Pagoda project) from the Objects Library in the scene. Place it on another hill behind the village. See Figure 16.30.
4. Import the bridge from your Objects Library that was created for the *Jade Pagoda* project. Remove the stairs and stair railings, and decrease the height of the walkway about 80%. Scale and place the bridge so that it connects the village to a hilltop that has nothing on it. See Figure 16.31.
5. Use your own design to create and place a pool and water on the hilltop where the houses are. See Figure 16.32.

 You may find that the most difficult part of the project so far is getting the placement and rotation of the bridge just right. It takes some experimentation and adjustment of the rotation values in both World and Object axes.

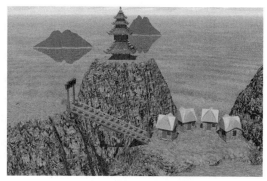

FIGURE 16.31 *The bridge connects the village to another hilltop.*

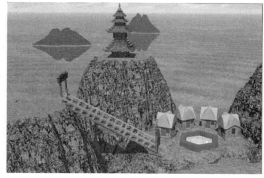

FIGURE 16.32 *Create and place a pool with water on the village hilltop.*

Teleporter

Ready for a little surprise? Remember the strange object that was placed in the ocean in the first project, the *Blue Ice Throne Room*? Now the secret can be told. That very object is our Teleporter! Do the following:

1. Open the *Blue-Ice Throne Room* project, select that object, and place it in your Objects Library.
2. Close the project, and open the Hall of Clouds project.
3. Scale and place the object from the Objects Library on the hill to which the bridge leads. See Figures 16.33 and 16.34.

Don't be concerned that the Transporter is visible to overflying craft; it is capable of employing the same cloaking measures as the Hall of Clouds. Although the task is arduous and some rock climbing is required, a network of bridges now connects all of the hilltop sites.

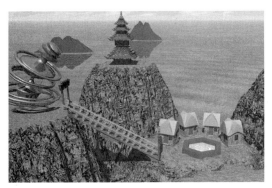
FIGURE 16.33 *A close-up of the Teleporter on the hill connected by the bridge.*

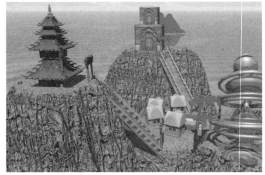
FIGURE 16.34 *A view of the hilltops from behind the Transporter. The Temple of Sacrifice from the* Lizard Masters *project has been placed on another hilltop.*

LIGHTHOUSE

This will include the small island on which the lighthouse sits, and the lighthouse itself. Do the following:

1. Lattice. Flatten the top and accept it. Convert To Terrain. Scale and position, so that the terrain rises above the water only about 5%, while its base sits on the seafloor.
2. Open your Objects Library, and add the Lighthouse to the scene (you already created it for the *Sanctuary of the Sargasso* project. Place it on the rock. See Figure 16.35.

CHAPTER 16 THE HALL OF CLOUDS 367

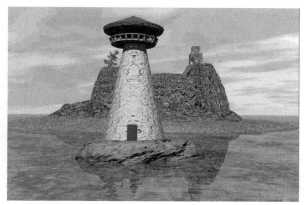

FIGURE 16.35 *The Lighthouse. Don't be fooled by the apparent size of elements. The island is pretty far away.*

 Although we haven't done it here, you are free to place a Spotlight in the Lighthouse to create some night scenes. You can also place the spiral staircase from the Objects/Imported Objects Library inside.

CLOUD STUFF

The cloud is an illusion. It is really a solid object craftily created to resemble a cloud. It is more than strong enough to hold the items placed on it.

THE CLOUD STRUCTURE

As far as creating items directly inside of the *Hall of Clouds* project, the cloud itself is the last to be addressed in this manner. You have probably already noticed that Bryce is slowing considerably, because this world is jam-packed with numerous items. Do the following to create the cloud:

1. The main cloud must meet certain criteria. It cannot be too transparent, or the effect of something sitting on top of it will be lost. The cloud must also have nonsymmetrical edges, and it must be bright enough to stand out against the rest of the sky. As your first task, create a cloud image in PhotoPaint or your other 2D painting application. Make your image size 512 × 512 × 72 dpi. Refer to Figure 16.36 for one example.
2. Save the image in a format that Bryce can read. In your *Hall of Clouds* project in Bryce, Lattice>New.
3. Import your cloud image into the Terrain Editor's Picture tab. Now the cloud image is an Elevation map. Add a Gaussian Edge. See Figure 16.37.

FIGURE 16.36 *Create a cloud image using solid white against solid black.*

FIGURE 16.37 *The cloud image is transformed into an Elevation map.*

4. Accept the model. Convert To Terrain. Scale the Y-axis by about 90% to flatten it a good deal.
5. Apply the Summer Clouds material from the Clouds&Fogs Library. Set the XYZ Scale to 1.7%. Set the rest of the parameters as shown in Figure 16.38.
6. In the Material Options List, check Blend Transparency and Additive. Switch all Shadowing off. Accept the material.
7. Scale and place the cloud object over the hills on the main island, and set the elevation (Y-axis) to 825.
8. Duplicate the Cloud object, and flip on the Y-axis. Move the duplicate up to create a cloud sandwich. This adds some needed opacity to the cloud. Group. See Figure 16.39.
9. Do a test render. See Figure 16.40.

FIGURE 16.38 *Use these parameter settings for the Summer Clouds material.*

FIGURE 16.39 *Create a cloud sandwich.*

CHAPTER 16 THE HALL OF CLOUDS

FIGURE 16.40 *The cloud base for the rest of the project is completed.*

TELEPORTER

This is a duplicate of the Teleporter on the island below. Do the following:

1. Either duplicate the Teleporter already in the scene, or place another from the Objects Library.
2. Scale and position on the main cloud. See Figure 16.41.

FIGURE 16.41 *Place a Teleporter on the main cloud.*

THE GREAT HALL

The Great Hall is a meeting place for artists, poets, musicians, and philosophers from all regions of the galaxy. There is no need for them to land on the planet, since the Teleporter acts as their doorway, even from very far away. The Great Hall is a large open space, where guests can wander and meet. When needed, it

is furnished, but usually remains open and empty. The idea is to design a space that is inspirational, one that invites communion while moderating the differences between diverse races. Do the following to create the Great Hall:

To create the columns for the Great Hall, you will need to know how to create Lofted objects with diverse cross sections in your external 3D application. One example would be circle and squares lofted to the same path. Most professional-level 3D applications can accomplish this, but the processes and tools (and tool names) may differ greatly from one 3D software application to another. If you can't perform this operation, either because your external 3D software is incapable of it or because you don't have the time to master the technique right now, you can substitute much simpler columns for the modeling of the Great Hall, the most basic substitution being simple cylinders. Obviously, the look will be quite different from that illustrated here.

1. Open your external 3D software application, and get ready to design a column from a Loft path that addresses diverse cross sections.
2. Spend a half an hour or so creating different lofted objects that combine square and circle cross sections. See Figure 16.42.
3. Now for your first component for the Hall of Clouds. We are going to create the basis for columnar vaulted ceilings. Having explored the creation of multi-cross-sectioned Lofts, you are ready to take this step. Create a Lofted object that uses both circle and square cross sections to create the object shown in Figure 16.43. You will have to edit the cross-section scale to achieve this form.

FIGURE 16.42 *Explore the creation of Lofted objects that contain circular and rectangular cross sections.*

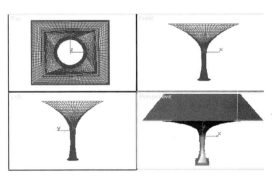

FIGURE 16.43 *Create this form.*

Chapter 16 The Hall of Clouds

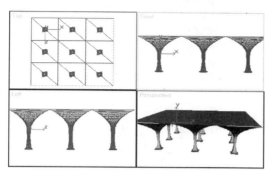

FIGURE 16.44 *Create an array of nine of these forms, and attach all together.*

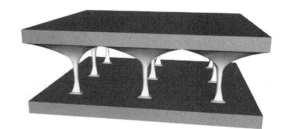

FIGURE 16.45 *A floor and ceiling are added.*

4. You have created a column that rises to form half of an archway. Duplicate to create an array of 3 × 3 attached forms. See Figure 16.44.
5. Place a rectangular floor and ceiling on the columnar model, but do not attach. See Figure 16.45.
6. Create a wall. Use Boolean cylinders to cut two windows, and create and place your own window frame designs in them. Duplicate twice for three walls, and place. The fourth wall will have a door in it. See Figure 16.46.
7. Use your own imagination to create a front wall with a door. Group all, and save in a format Bryce can import. See Figure 16.47.
8. Open PhotoPaint and import a colorful RGB image. Resize to 512 × 512 pixels at 72 dpi.
9. Access the Terrazzo plug-in, and create a tile from your image. Terrazzo is a native PhotoPaint plug-in effects filter. See Figure 16.48.
10. Open a new document in Bryce, and import the Hall of Clouds model. UnGroup. Import the tiled image as a Picture texture, and map to the Hall of Clouds floor. Adjust the number of tiles as needed.

FIGURE 16.46 *Create three walls with windows in them, and place.*

FIGURE 16.47 *A front wall and door are added.*

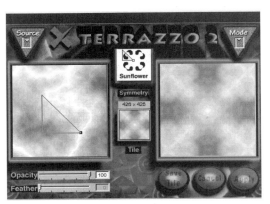

FIGURE 16.48 *Create a tile from your image with Terrazzo from XAOS Tools.*

11. Use any materials that you like on the rest of the components. Group again, and save to your Objects Library. See Figures 16.49 and 16.50.

Don't be fooled into misjudging the size of this structure. When placed in the Hall of Clouds project later, you will see that it is really hundreds of feet high. Perhaps the image shown in Figure 16.51 gives you a better sense of relative sizes. The table and benches in the lower right were created for the Cave of the Faerie Queen *project. You can readily see that the table and benches are dwarfed by the window and the bottom of the column. See Figures 16.51 and 16.52.*

12. You can add whatever additional details you prefer to the inside and/or outside of the Hall of Clouds. Be as inventive as you like. You can always

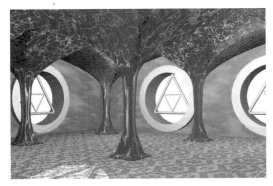

FIGURE 16.49 *Placing the camera inside of the Hall of Clouds provides interesting views.*

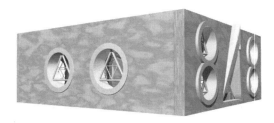

FIGURE 16.50 *A view of the outside after applying textures in Bryce.*

Chapter 16 The Hall of Clouds

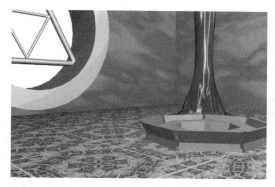 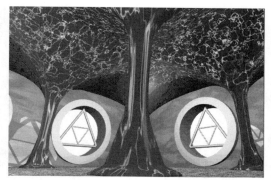

FIGURE 16.51 *The table and benches are tiny compared to the hall itself.*

FIGURE 16.52 *Window and ceiling detail looking up from the floor of the Hall of Clouds. In this image, the Camera FOV (Field of View) was increased from 60 to 90, creating some zoom anomalies.*

save two versions to your Objects Library, one with the details and one without. See Figure 16.53.

FIGURE 16.53 *In this example, more detailed features were added to the front of the structure.*

The Observatory

This is more than just a unit that is added to the top of the Great Hall. It is a separate item with its own internal details. If it be known, the Observatory is really an inter-galactic ship moored to the Great Hall.

1. Use your imagination to create the observatory for the Hall of Clouds. You are free to use external software and export to Bryce, or to use any of Bryce's internal tools and processes.

2. When finished, place on top of the Hall of Clouds, and Group with the Hall. Save in your Objects Library. See Figure 16.54.

FIGURE 16.54 *Use your imagination to create the Observatory for the Hall of Clouds.*

PUTTING IT ALL TOGETHER

Now it's time to finalize the project by importing the Hall of Clouds from your Objects Library, and scaling and placing the Hall of Clouds next to the Teleporter on the main Cloud object. Do that now. When completed, save, and render the Hall of Clouds showing its placement. See Figure 16.55.

FIGURE 16.55 *The Hall of Clouds is placed in position.*

FINAL RENDERS

Time for some renderings. Place the camera in the scene to frame some points of interest, and render away. See Figures 16.56 through 16.61.

CHAPTER 16 THE HALL OF CLOUDS

FIGURE 16.56 *The Hall of Clouds floats in the sky, far above the main island below.*

FIGURE 16.57 *Above and behind the Observatory on the cloud, looking down at the island and the distant lighthouse. You can barely make out the boats moored on the beach.*

FIGURE 16.58 *A view from the Hall of Clouds window, with an island visible in the distance, and a column arch in the foreground.*

FIGURE 16.59 *A global view of the scene from above and behind the lighthouse. The FOV was set to 80 for this camera view.*

FIGURE 16.60 *In the village, looking up at the underside of the cloud on which the Hall of Clouds is sitting.*

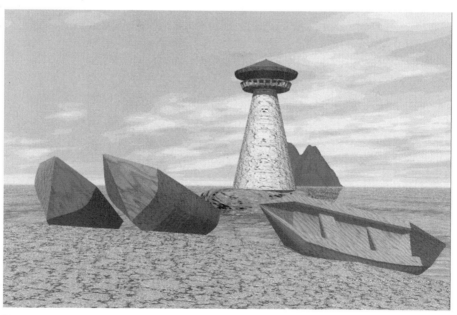

FIGURE 16.61 *Standing on the beach behind the boats, looking out at the lighthouse.*

THE EIGHT WORLDS

Congratulations! You have completed the eight Bryce world projects, and have survived to reach the end of the book. There are a few important items to keep in mind when you become immersed in a Bryce project:

- Bryce works best when you use it in conjunction with other 3D software applications that provide modeling alternatives that Bryce itself does not possess, saving Bryce for applying materials, incorporating the Infinite Planes, and compositing the scenes to be rendered.
- Mastering the use of the Terrain Editor allows you to create thousands of unique models and model components from grayscale image data.
- You can save a lot of time and energy by creating your components separately in new Bryce documents, and saving them to your Objects Library.
- Always Group the parts of a complex model that is created in an external 3D software application before export to Bryce. That way, you can apply separate materials to individual parts of the model.
- In very complex scenes, consider placing characters as rendered images mapped to a plane rather than as imported 3D models. Three-dimensional character models can take up a lot of memory, and Bryce slows considerably when a scene contains too many polygons.
- Save your projects every 15 minutes or so, just in case. Actually, it's also a good idea to save a backup project file as well. That way, you are still safe if one of the project files becomes corrupted.
- Use a Symmetrical Lattice for most of the objects you create using the Terrain Editor. You can always use the Convert To option if you need to transform the completed Lattice into a Terrain later.
- Always do a rough sketch for complex projects.
- Never allow your rough sketch to imprison your creative intuitions if you get better ideas along the way.
- . . . and most importantly . . . enjoy your Bryce endeavors! There is no end to the creative options you can explore and apply in Corel Bryce.

As a way of summarizing the eight Bryce worlds through which this book guided you, see Figures 16.62 through 16.69 for Top View renderings. Looking at these birds-eye views, you will appreciate the scope of the worlds we have created together.

Have Fun!

CHAPTER 16 THE HALL OF CLOUDS

FIGURE 16.62 *The* Great Blue-Ice Throne Room *project (Chapter 8) from above*.

FIGURE 16.63 *The* Temple of the Sand Masters *project (Chapter 10) from above*.

FIGURE 16.64 *The* Sanctuary of the Sargasso *project (Chapter 11) from above.*

FIGURE 16.65 *The* Cave of the Faerie Queen *project (Chapter 12) from above.*

CHAPTER 16 THE HALL OF CLOUDS

FIGURE 16.66 *The* House of the Fire Eaters *project (Chapter 13) from above.*

FIGURE 16.67 *The* Jade Pagoda *project (Chapter 14) from above.*

FIGURE 16.68 *The* Abode of the Lizard Master *project (Chapter 15) from above.*

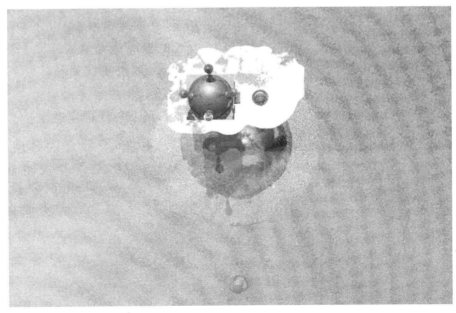

FIGURE 16.69 *The* Hall of Clouds *project (Chapter 16) from above.*

APPENDIX A

About the CD-ROM

The CD included with Advanced Bryce Creations: Photorealistic 3D Worlds contains all the files necessary to complete the tutorials in the book. It also includes the images from the book's color gallery section in full color.

CD FOLDERS

Please look in the specific folders listed for the detailed contents.

COL_PL

Here are the 16 color plates for your viewing pleasure. They are all 300 dpi images, and are in RGB format. You are free to clip them apart and use the resulting image areas as texture maps for your own Bryce endeavors.

MOVIES

This book does not cover the way that Bryce handles animation, but we have included several of the animations from the *Bryce 3D Handbook* in the Movies folder. They are all in the QuickTime format, so you will need QuickTime (or QuickTime for Windows) to play them.

PROJECTS

There is over 400MB of data in the Project's folder on the CD. This includes all of the tutorial projects, plus a number of additional project files. Also included

are image files for texture mapping and more. These files are separated according to chapter, so you should have an easy time locating any of the project files you need. The project files vary in size from less than 1MB to over 40MB, so make sure you have the resources to load them into Bryce.

New materials for Bryce have not been included in a separate folder. Instead, as you load a project, all of the materials used in that project are also configured. If you would like any of the new or customized materials to be accessible to your other Bryce work, you must save them from that object's Materials Library to your own library folder, or export them to another file location. Remember that this can only be done after a project that contains those materials is loaded.

SYSTEM REQUIREMENTS

Windows NT 4.0 (with Service Pack 3+) or Windows 98/2000
- Pentium Processor
- 128MB RAM
- CD/Hard Drive
- A minimum of 100MB free disk space
- QuickTime 3.0 or later
- Corel Bryce
- Any of the addendum software mentioned in this book's tutorials that you need to complete a project tutorial

Mac OS 8.5+
- Power PC
- CD/Hard Drive
- 128 MB RAM (above system requirements)
- A minimum of 100MB free disk space
- QuickTime 3.0 or later
- Corel Bryce
- Any of the addendum software mentioned in this book's tutorials that you need to complete a project tutorial

APPENDIX B

Vendor Information

Creating the detailed models and renderings required by high-end Bryce users demands other software applications whose output can be read and imported by Bryce. We have mentioned quite a few of these applications in detail in this book, and more continue to appear on the market. Although many software applications have been mentioned in this book as valuable to your Bryce work (aside from an external 3D application that contains the necessary range of modeling tools Bryce lacks), the following are considered absolutely essential applications by the author for serious Bryce work. Check the Corel Web site regularly to remain aware of the latest updates.

COREL'S LIST

www.corel.com

These are the most important helper applications. The list includes Painter, PhotoPaint, CorelDraw, all of the KPT plug-ins, as well as other plug-ins for Painter/PhotoPaint.

PAINTER

Painter has a long history as a supportive application for Bryce. Especially noteworthy is the Image Hose tool in Painter. Spraying graphic elements with the Image Hose allows you to create a huge array of valuable color and Alpha content to wrap on 3D objects in Bryce, making it possible to create highly complex and photorealistic scenes without the memory drain associated with adding loads of 3D objects to achieve the same effects.

PhotoPaint

Besides all of the internal effects and image processing found in PhotoPaint, this application includes versions of effects filters that have to be purchased as extras when you use other painting applications. There is a natural partnership between PhotoPaint and Bryce.

CorelDraw

CorelDraw offers the vector artist a wealth of drawing options, and it's easy to port CorelDraw images to your external 3D application. Once there, you can translate the vector art into 3D objects, and export the objects to Bryce.

KPT Plug-Ins

I can't imagine using Bryce without access to the KPT Bryce effects filters. Once installed in your Painter and/or PhotoPaint plug-ins folder, you can access any of the KPT filters directly from Bryce. With the KPT filters, you can create image-processed data for any channel in the Materials Lab, and use the KPT filters to augment your 3D Elevation maps in the Bryce Terrain Editor.

Jungle 3D

If you are interested in developing Bryce scenes that include elements that reference nature (plants, trees, flowers), then you must add the Jungle 3D CD volume to your resource library. Using these special Image Hose nozzles in Painter, and then porting to Bryce as a 2D image that addresses a Picture Plane object allows you to create colorful naturalistic Bryce content that takes up very little hard drive space.

www.gardenhose.com

Other Plug-Ins for Painter/PhotoPaint

I could list a hundred diverse plug-in applications here, but instead I'll point out a few of my personal favorites.

AlienSkin Xenofex and AlienSkin EyeCandy 4000

These are two very hot collections of image effects from one of the best-known effects developers in the world. These effects filters are perfect for Bryce work.

www.alienskin.com

Eni Oken Ornaments Collection

You have already seen what the Eni Oken textures are capable of if you worked through the eight tutorial projects in this book.

www.enioken.com

XAOS Tools Terrazzo

When it comes to creating some of the most beautiful tiles for your Bryce palace floors imaginable, this plug-in does the trick.

www.xaostools.com

DigiEffects Web Euphoria

This is a relatively new set of PhotoPaint/Painter effects filters, though they are based on filters marketed for Adobe AfterEffects by DigiEffects. The fire filter is worth the price of the entire package.

www.digieffects.com

Electric Image Amorphium

I am definitely obsessed, and admit it, when I say that Bryce without Amorphium is like an ice cream sundae without toppings. Amorphium give you the capability to create a huge array of unique objects, or to customize any Terrain Editor object with a wide array of effects and tools. As this book was headed for the shelves, Amorphium version 2 (also called Amorphium Pro) shipped.

www.electricimage.com

CuriousLabs Poser

When it comes to adding characters and anatomical figures to your Bryce worlds, either as full 3D objects or as renders for planar maps, Poser fills the bill.

www.curiouslabs.com

Maxon Computer's Body Paint

When it comes to high-end 3D painting applications, look no farther than Maxon's BodyPaint. Using this software, you can intuitively paint color, Reflection maps, Bump maps, and other channel data directly to an imported 3D object. Use BodyPaint to place extremely detailed image maps on Bryce terrains.

www.maxon.net

Index

A

Abode of the Lizard Master project
 ancient city in cave, 335–337
 components, 327–328
 fog / mist, 330–331, 337–338
 ground plane, 329–330
 habitat on mountain top, 339–348
 Mayan-like pyramids, 332–333
 mountains, craggy peaks, 331–332
 preliminary sketches, 326–327
 sky, 328–329
Adaptive Triangulation, 180
AlienSkin
 EyeCandy 4000, 166–167, 287, 386
 Xenofex, 386
Alpha Channel, Texture Source Editor controls, 55–57
Alpha Images
 mapping data to 3D Objects, 59–60
 panoramas, mapping, 65–66
 stand-alones, 70–71
Ambience values, 68, 244
Ambient color, 67–68
Amorphium (Electric Image), 138–142, 387
TreePro models customized with, 144–146
Amphitheaters, modeling, 250
Anti-aliasing, 324
Applications, handshaking, 138
Architecture
 altars, 344–347
 ampitheater-like rooms, 250
 archways, 17–18, 29
 Classic Ornament Texture Kit (Eni Oken), 179
 columns, 45–46, 117–118, 370–371
 details, 49–51, 199–200, 247—248
 doors, 123–125
 facades, 179, 199–200, 342–344, 348–350
 fortress, 200–211
 fountains, 147–148, 344–347
 great hall, 369–373
 lighthouses, 222–224, 367
 Pagodas, 316–319, 323–324
 partitioned house, 41–43
 primitives to model, 11–18
 pyramids, Mayan-like, 332–333
 ruins, 197–198
 sacred, 192–212, 279–280, 344–347
 shacks, 224–225

Architecture (*cont.*)
 sheds, 205
 stairs, 252
 temples, 192–212, 279–280, 316–319, 323–324
 thatched houses, 311–312
 throne room tutorial, 181–190
 tiled floors, 168–170, 186–187
 towers, 11–14, 119–122, 181
 windows, 42–43, 183–184
Archways
 Boolean operations to create, 29
 primitives to construct, 17–18
Arms, modeling from linked primitives, 5–7
Articulated models, Primitive Man, 4–9

B

Beaches, 84–85, 358–359
Berries, modeling, 259–261
Bitmap materials, 69–73
 bitmapped logos, 72
 bitmap / procedural combination materials, 72–73
 channels, 71
 creation tips, 69–70
Bit maps
 addressing bitmap content to ISPs, 97
 2D bitmap F/X, 156–159
 as image content for sky planes, 94–97
Blistering effect, 68
Blue Palace. *See Great Blue Throne Room project*
Blurring
 background and level of detail, 66
 blurry texture maps, 61
 Haze settings for, 122
Boats
 lofting modeling technique, 363–364
 see also Ships
BodyPaint (Maxon Computer), 387
Boolean operations, 22–30
 Boolean deforms, 127–130
 Chair tutorial, 28–29
 complex Boolean structures, 26–27
 drilling or tunneling through terrain, 24–26
 Intergalactic Ship tutorial, 30
 modeling techniques, 122–125
 natural-looking "cuts," 25–26
 preset objects in Boolean Library, 22–23
 Primitive objects and, 26–27
 saving objects, 23
 Subtraction, 122–123
 window creation with Boolean cutter, 42–43
 Wine Glass tutorial, 27–28
Boulders, 316
Bridges, 365
 Jade Pagoda project, 306–310
 Organica modeling tutorial, 151–155
Buddha statue, 320
Bump maps
 Ambience values and, 68
 restoring level of detail with, 180
 vs. Deformation maps, 133

C

Cameras
 FOV settings, 212
 planning for viewing with, 175–176
Canals tutorial, 85–86
Candle light, 99
Cannons, 206
Canyons, 35–36

INDEX

Caustics, 63
Cave of the Faerie Queen project, 234–266
 ampitheater-like room, 250–251
 door, 245–248
 furnishings, 256–262
 landscaping, 238–242, 248–249
 lights and lighting, 254–255
 planning and components, 234–236
 skies, mysterious or mythical worlds, 237–238
 stairs, 252
 tree, 242–245
Caves
 Faerie Queen's Cave, 235–236
 underwater cave, 226–227
CD contents, 383–384
Centipede-like creature, 9–11
Chairs, modeling
 Boolean tutorial, 28–29
 with Terrain Editor objects, 43–45
 thrones, 185–187, 256–257
Chandeliers, modeling, 188
Characters
 Alpha / image placement, 64–65
 fire eaters, 280–282
Cityscapes
 Meropolis, underwater city, 228
 primitives for modeling, 14–17, 335–337
Classic Ornament Texture Kit, 279
Cliffs, vertical faces, 34–35
Cloning, bitmap / procedural textures and, 72
Clouds
 cloud structure for Hall of Clouds, 367–369
 creating and saving cloud presets, 91–94
 formula for, 76–77
 sky layers, 218
 stand-alone realistic, 77
Columns
 extruded and deformed, 117–118
 lofting techniques for, 370
 Terrain Editor to model, 45–46
Convert Selection To operation, 42
Corel
 applications, 385, 386
 FraxFlame plug-in, 163–165
 Gradient Designer plug-in, 161–162
 KPT Collections plug-ins, 160–166, 386
 Painter, Image Hose, 159–160
 Texture Editor plug-in, 163
 Web address, 385
Cosmic Elephant (painting), *xviii*
Craft, underwater / air, 229–230
Craters
 impact craters, 36–37
 molten-lava filled, 86–88
 volcano calderas, 33, 99
Creativity
 inspirations, 298, *xvii–xviii*
 photorealism and, *xviii*
 preliminary sketches and, 269
 sketches and, 269
 story worlds and real life experience, 174
Creepy Crawler tutorial, 9–11
Cups, lofted, 259–261
Curious Labs, Poser tutorials, 146–151

D

Dali, Salvador, *xvii–xviii*
Deep Texture Editor, key control access, 198
Deformations
 Boolean deforms, 127–130
 Deformation Channel mapping, 133–136

Deserts
 dunes, 193–194
 oases, 195–197
 skies, 194–195
Diffuse Color channel, bitmapping and, 72
DigiArts Software
 Jungle 3D CD, 159, 249
 Web address, 159
DigiEffects Web Euphoria, 387
Domes, 227
Doors
 to Faerie Queen's Cave, 245–246
 Mystery Door tutorial, 123–125
 opening on hinges, 246
 triangular doorways, 251
Dunes, modeling, 193–194

E

Editing
 lights and lighting, 101
 vertex-level editing, 130
Effects
 Deformation F/X, 127–130
 Radial Light sample effects, 106–109
Electric Image software, Amorphium, 138–140
Export-Reduce-Import operation, 193–194, 212
Extrusion, modeling techniques, 116–118
EyeCandy 4000 (AlienSkin), 166–167, 287, 386

F

Facades, 179, 199–200, 342–344, 348–350
Falloff attributes for lighting, 102, 105
File formats
 for importing modeled elements, 18–19
 Tree Professional compatible, 142–146
Filter tab of Terrain Editor, 156–157
Fire
 DigiEffects Web Euphoria filters, 387
 river of, 282–284
Fireworld. *See House of the Fire Eaters project*
Fish, Level of Detail and, 232
Fog, 273–274, 330–331, 337–338
Foliage, mapping to terrains, 62–63
Forests
 cloning tree for, 146
 Lattice to create, 302–304
 modeling, 359
 2D picture mapping for, 235, 240–242
Fountains, modeling, 147–148
Fractals
 duplication and rotation to simulate, 243
 FraxFlame plug-in, 163–165
FraxFlame plug-in, 163–165
 rendering time, 274
Furniture, modeling
 with Terrain Editor objects, 43–45
 see also Chairs
Fuzzy factor, Volumetric materials and, 69
F/X. *See Effects*

G

GardenHose collection, 249
Gears, Amorphium to model, 140–142
Gels
 Image Gels, projecting, 101
 Parallel Light projections, 104

INDEX

Presets, 102–103
Procedural Texture gels, 103–104
Silhouetted Gels, 104
using lights with, 109
Gems, 258–259
Glass
Glass materials, 188
Plop Renderer for, 227
rendering time, 27
Glows, using Ambient color as, 67–69
Gradient Designer plug-in tutorial, 161–162
Grapes, modeling, 259–261
Grass-O-Matic plug-in (Sisyphus Software), 249
Great Blue Throne Room project
island, 177–181
palace, 181–188
polar sea and sky, 176–177
sketch and planning, 174–181
Grouping
described and explained, 132–133
Particle Systems and, 135

H

Hall of Clouds project
beaches, 358–359
boats, 363–364
cloud structure for Hall of Clouds, 367–369
components, 355
islands, 360–361
observatory, 373–374
power sources, 361–363
preliminary sketch, 354
sea floor and surfaces, 357
teleporter, 366
Hands, modeling, 343–347
Handshaking, 138
Haze settings, 17, 122
underwater scenes and, 363
Heat, blistering effect, 68
Hedges, 339–342
Heli-vehicles, 290–294
Hills, modeling, 359–360
dunes, 193–194
faerie mounds, 239
gentle / rolling, 34
House of the Fire Eaters project
components of, 270–272
Heli-vehicle, 290–294
House, 285–290
sky of Fireworld, 273–275
Temple of Sacrifice, 279–280
volcanoes, 276–279, 281–282

I

Icebergs, 179–180
Ice Throne Room project. *See Great Blue Throne Room project*
Icons, 2D Picture Object icon, 54
Image Hose (Corel Painter), 159–160, 385
nozzle collection from DigiArts, 159
Image-processing plug-ins, 156
Importing
from Amorphium, 138–142
3D objects, 19
modeled elements, 18–19
placing objects efficiently, 262–266
Impulse Software, Organica, 151–155
Infinite Ground Planes (IGPs), 82–90, 329–330
layers of, 238–239
multiple, 82–83
sea floor, 357
Infinite Ground Planes (*cont.*)
straight cuts like canals, 85–86
Volumetric and Slab planes, 302–304

Infinite Planes
 Dawn Beach tutorial, 84–85
 layers and, 217–221
 sea-bottom, 226
 Sky Planes, 90–97, 217–219, 274–275, 328–329
 Tunnel of Eternity tutorial, 82–83
 Volume-type (slabs), 90, 275–276
 Water Planes, 84–90, 176–177, 219–221
 see also Infinite Ground Planes (IGPs)
Islands, modeling, 177–181, 360–361
 sea mount, 221–222
 Symmetrical Lattice *vs.* standard Terrains for, 177

J

Jade Pagoda project
 bridges, 306–310
 components described, 300–301
 garden and trees, 314–315
 Ground Planes, 302–304
 houses, village, 311–312
 mesa, 305
 mountains, 304–305
 Pagoda structure, 316–319, 323–324
 river, 306, 316
 sky, 301–302
Jewels, 258–259
Jungle 3D, 159, 249, 386

K

KPT plug-ins, 160–166, 386

L

Ladders, 209
Laminates, 73–74
Landscapes. *See Terrains*

Lasers, 111–112
Lathing, modeling techniques, 118–122
 amphitheater created with, 250
 axis of revolution for, 119
 lighthouse tower created with, 223–224
 parameters, 119
 segments for, 119
 towers created with, 119–122
 walls created with, 202–204
LatticeNewCreate Convert process, 212
Lattice objects, 131
Lava, 86–88, 282–284
Legs, insect-like segmented, 10–11
Level of detail (LOD), 66, 232
 proportions and miniatures, principle of, 269–270
Lighthouses, 222–224, 367
Lighting Technician, Bryce, 98
Lights and lighting
 attributes, altering, 102
 basics about, 97–98
 Bryce Lighting Technician, 98
 candle light, 99
 chandeliers, modeling, 188
 color of planes mapped to and, 105
 conic lights, 111
 editing with Light Edit dialog, 101
 Faerie Queen's lamp, 254–255
 falloff, 102, 105
 false lights, 110–112
 grouping lights to objects, 112
 laser lights, 111–112
 Material preset lights, 109–110
 Materials applied to, 255
 material textures on, 104–105
 object lights, 110–112
 Parallel Lights, 101

INDEX

Radial Lights, 98–99, 106–109
simulating with Ambient Color, 69
spheric lights, 110–111
Spotlights, 100–101
Volumetric Lights, 101–102
Linking
 described and explained, 132–133
 primitives, 5–7
Liquids
 realism and multiple layers, 88
 see also Water
Locking components, 332
Lofting, modeling techniques, 125–126, 370
 boats, 363–364
 tree created with, 242–245
Logos, bitmapped, 72

M

Mapping
 Alpha / image data to 3D Objects, 59–60
 Deformation Channel mapping, 133–136
 foliage to a terrain, 62–63
 panoramas, 65–66
 Parametric or Parametric Scaled types, 97
 Random Mapping, 70
 Random type, 63
 2D Picture Objects, 54
 see also Bitmap materials
Materials
 bitmap materials, 69–73
 C-A-B rule, 156
 creating customized, 66–80
 creative experimentation, 75
 laminates, 73–74
 "materials realism," 76
 "multiples of one," 74
 object *vs.* plane variations, 96
 planet textures, 77–78
 reality, simulating, 75–76
 Surface materials, 67
 surrealistic, 79
 Volumetric materials, 69
Materials Editor, customizing materials in, 66–80
Materials Lab, EyeCandy 4000 filters used with, 166–167
Materials Library, Cloud material formula, 76–77
Mechanical Parts tutorial, 140–142
Memory
 conserving by plane mapping *vs.* 3D, 143
 see also Poly-counts
Meropolis, underwater city, 228
Mesas, 201, 305, 333–335
Metaball modeling, 151–155
Miniatures and proportions, principle of, 269–270
Mirroring, in Symmetrical Lattices, 40
Mist, 313, 330–331, 337–338
 transparency to create, 241–242
Modeling applications, 116
Modeling techniques
 Boolean operations, 122–125
 Deformation Channel mapping, 133–136
 deformation effects, 127–130
 extrusion, 116–118
 lathing, 118–122, 223–224, 250
 Lattice objects, 131
 linking and grouping, 5–7, 132–133
 lofting, 125–126, 242–245
 vertex-level editing, 130
Mold, textures, 61–62
Moss, textures, 61–62
Mountains
 craggy peaks, 331–332

Mountains (*cont.*)
 distant, 304–305, 331–332
 mesas, 201, 305, 333–335
 sea-mount island, 221–222
 see also Volcanoes
Mystery Door tutorial, 123–125

N
Naming components, 332
Normals, 116

O
Oases, modeling, 195–197
Objects
 naming of, 332
 Parent-Child Object relationships, 6
 of revolution, 118
Objects Library, 212
Observatory, 373–374
Oken, Eni, 279
Organica (Impulse Software), 151–155
Organic textures
 foliage, mapping to terrains, 62–63
 Jungle 3D CD for Image Hose, 159, 249
 moss and mold, 61–62
Origin Handles, 8–9

P
Pagoda roofs, 323–324
Painter, Image Hose tool, 159–160, 385
Panoramic backgrounds, image mapping, 65–66
Parallel Lights, 101
 projecting Gel data with, 104
Parapets, 204
Parent Objects, resizing and rotating, 6
Particle Arrays, 135–136

Particle systems, leaves created with, 244
Paths, Lofting splines, 125
Perspective, illustration technique for, 83
Photopaint, 386
Photorealism, *xviii*
Placing objects efficiently, 262–266
Planets
 modeling realistic, 77–78
 types of, 77
Plants
 Grass-O-Matic plug-in for grass, 249
 Image Hose, 249
 Jungle 3D CD for Image Hose, 159, 249
 seaweed, 220
 see also Trees
Plop Renderer, 227, 324
Plug-ins
 for Bitmap applications, 156–159
 Corel KPT Collections plug-ins, 160–166, 386
 EyeCandy 4000 filters, 166–167, 386
 for Painter / PhotoPaint, 386–387
 Terrazzo from Xaos Tools, 168–170, 186, 387
 Tree Storm for 3D Max, 142
Poly-counts
 Adaptive Triangulation and reducing, 180
 Deformation mapping and, 133
 Export-Reduce-Import operation, 193–194
 Grid adjustments and, 224
 multiple Terrain objects and, 193
 optimizing models, 132–133, 180
 primitive objects and, 336
 of spherical primitives, 14
Poser (Curious Labs), 146–151, 387

INDEX

Statue and Fountain tutorials, 146–148
Texture Customizing tutorial, 150–151
Warning Marker tutorial, 147–149
Power sources, modeling, 361–363
Preview window, color of, 41
Primitive Man tutorial, 4–9
Primitives
 Boolean operations and, 26–27
 city modeled with, 335–337
 defined and described, 4
 modeling with, 4–20
 poly-count and memory, 336
Prim Tower tutorial, 11–14
Procedural images, as image content for sky planes, 91–97
Procedural textures, combined with bitmap textures, 72–73
Projects
 Abode of the Lizard Master, 326–351
 aerial views of, 379–382
 Cave of the Faerie Queen, 234–266
 Great Blue Throne Room, 174–190
 Hall of Clouds, 354–377
 House of the Fire Eaters, 268–295
 Jade Pagoda, 288–324
 Sanctuary of the Sargasso project, 214–232
 Temple of the Sand Masters, 192–212
Proportions and miniatures, principle of, 269–270
Pyramids, Mayan-like, 332–333

R

Radial Lights, 98–99
 sample effects, 106–109
Random Mapping, bitmapping and, 70

Realism
 subjective nature of reality, 75–76
 surrealism and, 75–77, *xviii*
Reflection, on water, 248–249
Rendering, glass, 27
RGB Fabric pattern, 68
Rivers, 306
 boulder banks, 316
 of fire, 282–284
 river cuts, 35–36
 water over rocks, 89–90
Roads, quick modeling technique, 15
Rocks, water over, 89
Roofs
 Pagoda design, 323–324
 raftered, 224–225
 thatched roofs, 312
Rust, textures, 63–64

S

Sanctuary of the Sargasso project
 cave and dome, 226–227
 components, 216
 craft, 229
 lighthouse, 222–225
 Meropolis, 228
 sea bottom, 226
 sea mount, 221–222
 sea surface plane, 219–220
 seaweed layer, 220–221
 ship, sunken, 231–232
 sketch, 217–219
 sky, 217–219
Sculpture
 animal motif architectural elements, 188–189
 Buddha, 9, 320
 Green Man, 247–248
 Statue tutorial (Poser), 146–147
 wolf's head Warning Marker tutorial, 147–149
Sea-bottom, 226

Seas, modeling, infinite water planes, 176–177, 219–221
Seaweed, 220–221
Shadows. *See Lights and lighting*
Shape, Lofting cross sections, 125
Ships, boats, lofted, 363–364
Ships, modeling
 sunken ship tutorial, 231–232
 underwater / air craft tutorial, 231–232
Sisyphus Software, 249
Sketches, preliminary
 Abode of the Lizard Master tutorial, 326–327
 Cave of the Faerie Queen, 234
 creativity and, 269
 Hall of Clouds project, 354
 House of the Fire Eaters, 268–269
 Jade Pagoda, 298–300
 Sanctuary of the Sargasso, 215
Skies
 Default Sky, 91–94
 desert skies, 194–195
 Fireworld sky, 273–275
 Haze settings, 177
 infinite sky planes, 90–97
 layers of Sky Planes, 301–302, 328–329, 356
 for mysterious, mythical worlds, 237–238
 procedural image content for, 91–97
 relationship to infinite water planes, 177
 Sky and Fog parameters, 273–274
 see also Clouds
Slabs (Volumetric Planes), 90, 275–276
Slime, textures, 63–64
Smoke objects, creating, 277
Snapshotting
 Deformation snapshots, 133–134
 Particle snapshots, 135
Space ships, Boolean techniques to model, 30
Speed, optimizing models, 132–133
Spherical sky planes, 274–275
Splines, paths for Lofting, 125
Spotlights, 100–101
Spray and Plop renderers, 324
Spring, Lofting modeling tutorial, 125–126
Square Spotlights, 100–101
Stairs, 252
Statues. *See Sculpture*
Statue tutorial (Poser), 146–147
Streams and stream beds, 89–90
Street lamps, 99, 109
Streets, quick modeling technique, 15
Suns, Material preset lights as, 109–111
Surface materials, 67
Surface texture mode, 63–64
Surrealism, 78–79, xvii–xviii
Symmetrical Lattice
 islands, modeling, 177–181, 221–222
 LatticeNewCreate Convert process, 212
 in Terrain Editor, 40–41
System requirements, 383–384

T

Tables, modeling
 Faerie Queen's seven-sided, 261–262
 with Terrain Editor objects, 43–44
Teacups, lofted, 259–261
Teleporter, 366
Temple of the Sand Masters project
 cannon, 205–206

INDEX

399

 desert ground planes, 193–194
 fortress, 201–204
 oasis, 195–196
 ruins, 197–198
 sketch and planning, 192
 sky, 194–195
Temple of the Sand Masters project (*cont.*)
 temple, 198–200
 tower, 206–208
 weapons shed, 205
Temples
 Sand Masters Temple, 198–200
 Temple of Sacrifice on Fireworld, 279–280
Terrain Editor, 32–37
 Architectural details, 49–51
 columns, 45–46
 Convert Selection To operation, 41
 creating moss and mold textures, 61–62
 Filter tab, 156–157
 Fractal list options, 35
 generating non-terrain objects, 40–50
 partitioned house of linear parts, 41–43
 tables and chairs modeled with, 43–45
 Texture Explorer plug-in for 3D modeling, 163
 wheels, complex, 46–48
Terrains
 Amorphium to customize Bryce Terrains, 138–140
 beaches, 84–85, 358–359
 canals, 85–86
 cliffs, vertical faces, 34–35
 craters, 33, 36–37, 86–88, 99
 Dawn Beach tutorial, 84–85
 deserts, 193–198

 drilling or tunneling with Boolean operations, 24–26
 hills, gentle / rolling, 34
 impact craters, 36–37
 islands, 177–181, 221–222, 360–361
 mesas, 201, 305, 333–335
 mountains, 304–305, 331–332
 oases, 195–197
 polar seas, 174–181
 river cuts or canyons, 35–36
 terrain cuts tutorial, 25–26
 volcanos, 32–33
 see also Water
Terrazzo plug-in (Xaos Tools), 168–170, 186, 387
Textures
 blistered effect, 68
 customizing in Poser, 150–151
 2D painting technique, 150–151
 EyeCandy 4000 (AlienSkin), 287
 texture size setting, 68
 Texture Source Editor controls, 2D Picture Objects and, 55–57
Thrones
 Faerie Queen's, 256–257
 Ice Throne, 185–187
Tiles, tiled floor or walls, 168–170, 186–187
Tiling, bitmap textures, 70
Tires, modeling, 161–162
Totem Pole tutorial, 163–165
Towers
 fortress watch tower, 206–208
 lathing to model, 119–122
 lighthouse, 222–224, 367
 parapets, 204
 Prim Tower tutorial, 11–14
Transporter, 366
Tree Professional (Onyx Software), 142–146

INDEX

Tree Professional (*cont.*)
 Amorphium to customize models, 144–146
 forest creation with, 240–242
Trees, modeling, 142–146
 Faerie Queen's tree, 242–245
 hedges, 339–342
 Lattice to create, 302–304
 roots, hanging, 258
 symbolic nature of, 234
 see also Forests
Troubleshooting
 blurry texture maps, 61
 renders, 69
Tunnels, 201
 underwater caves, 226–227
Tutorials
 Amorphium Mechanical Parts tutorial, 140–142
 Amorphium to customize Bryce Terrain, 138–140
 Corel plug-in tutorials, 160–165
 Organica Metaball bridge, 151–155
 Poser (Curious Labs), 146–151
 Poser Texture Customizing, 150–151
 Tree Professional tutorial, 142–146
2D paint applications, plug-ins for, 158–159
2D Picture Objects
 creating content, 57–59
 described, 54

U

Underwater scenes, 89, 214–232

V

Vegetation. *See* Plants; Trees
Vehicles
 Heli-vehicle, 290–294
 underwater- air-craft, 229–230
Vendor information, 385–387

Vertex-level editing, 130
Volcanoes
 Fireworld, 276–279, 281–282
 lava-filled craters, 86–88
 modeling tutorial, 32–33
 Radial Lights placed in caldera, 99
Volume texture mode, 63–64
Volumetrics
 creation tips, 69
 rendering, 88–89, 214
Volume-type planes, 90, 275–276

W

Warning Marker tutorial, 147–149
Water
 altar-pool, 344–347
 Infinite Water Planes, 84–90, 176–177
 over solid surfaces, 89–90
 realism and multiple layers, 88
 sea surfaces, 357
 streams, 248–249
 underwater scenes, 89, 214–232, 361–363
 Volumetrics and, 214
 waterfalls, 258–259, 313–314
 water planes over standard Terrains, 177
Waterfalls, 258–259, 313–314
Weapons shed, 205
Web addresses
 AlienSkin (EyeCandy 4000 and Xenofex), 287
 Amorphium (Electric Image), 387
 Corel Software, 385
 Curious Labs, 387
 DigiArts Software, 159
 Eni Oken, 279
 Maxon Computer (BodyPaint), 387
 Sisyphus Software, 249
 Xaos Tools, 387
Wheels, complex, 46–48

Windows, 42–43, 183–184
 Boolean cuts for, 42–43
 projecting window lights, 104
 throne room, 183–184
Wine Glass tutorial (Boolean modeling), 27–28
Woods. *See Forests*

X

Xaos Tools
 Terrazzo plug-in, 168–170, 186
 Web address, 387

Z

Ziemer, Celia, 198

GRAPHICS RESOURCE CLUB

A complete graphics reference library and resource center right at your fingertips!

With the **Graphics Resource Club** (http://www.graphicsresourceclub.com) from Charles River Media you have access to best-selling graphics books and new, hands-on tutorials every month.

For Just $99 you get over $700 worth of product!

A New Online Book Each Month (12/year) ($600 Retail Value)
- All files in PDF for easy viewing and downloading
- Books are selected from our best-selling graphics titles

3 New, Online Monthly Tutorials (36/year)
- All files in PDF format
- 3 New tutorials each month that can be downloaded or viewed online covering modeling, animation, and digital effects using leading programs including LightWave, 3D Studio Max, Maya, EI, Poser, Bryce, Carrara, Illustrator, Rhino, and more. All tutorials written by best-selling authors. Plus we have "bonus" months that include extra tutorials!

Monthly Newsletter written by Shamms Mortier
- Covers industry news, product information, and useful tips and ideas

One PRINTED book per year – Free shipping ($54.95 value)
- Selected from our best-selling titles

Visit the site and find out how to sign up!
http://www.graphicsresourceclub.com

Color Plate 2 Images from Chapter 9, the Blue-Ice Throne Room project: (top) looking up at the throne enclosure; (bottom) looking down at the throne enclosure and pool.

Color Plate 1 Images from Chapter 9, the Blue-Ice Throne Room project: (top) the entrance to the Throne Room; (bottom) the Throne Room from behind.

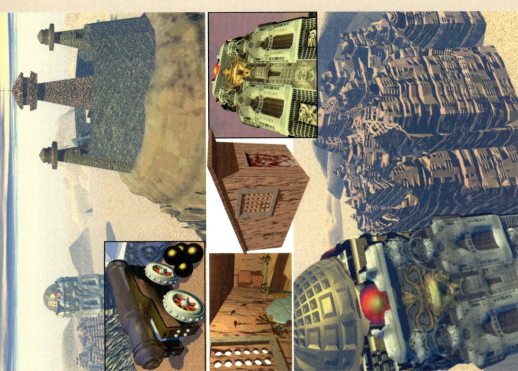

Color Plate 4 Images from Chapter 10, the Temple of the Sand Masters project: (top) the fortress on the hill overlooking the temple; (top inset) the cannon in the fortress; (center left and middle) the inside and outside of the weapons shed; (center right) looking up at the temple; (bottom) the temple and ruins.

Color Plate 3 Images from Chapter 10, the Temple of the Sand Masters project: (top left and right) two perspectives of the oasis; (center) a view of the fortress from the oasis; (bottom) the table next to the window in the fortress tower.

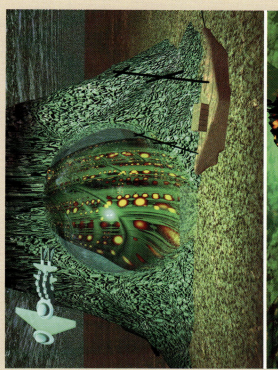

Color Plate 6 Images from Chapter 11, the Sanctuary of the Sargasso project: (top) the undersea city inside the base of the island from outside; (bottom) the undersea city from the inside.

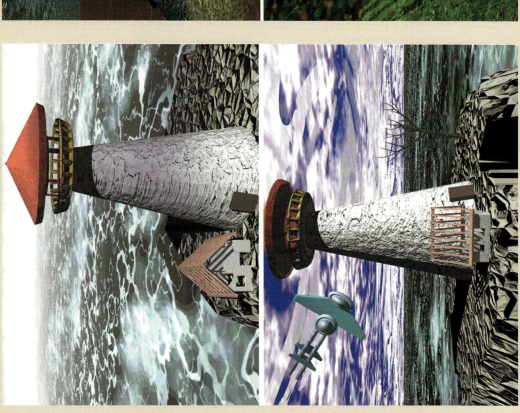

Color Plate 5 Images from Chapter 11, the Sanctuary of the Sargasso project: (top and bottom) two views of the lighthouse.

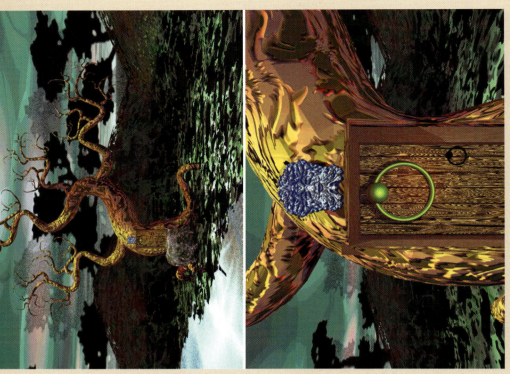

Color Plate 8 Images from Chapter 12, the Cave of the Faerie Queen project: (top) the above-ground environment for the Faerie Queen project; (bottom) a close-up of the tree and the doorway.

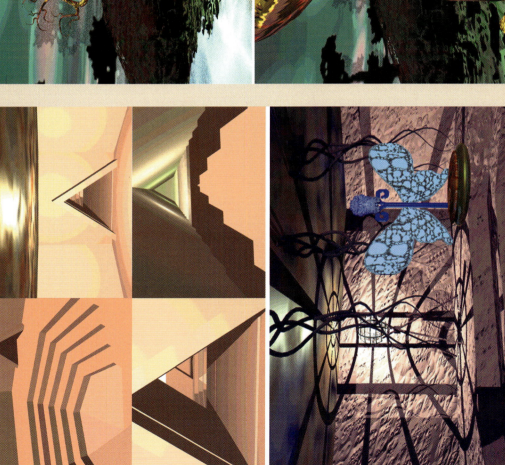

Color Plate 7 Images from Chapter 12, the Cave of the Faerie Queen project: (top) four views of the internal architecture of the cave; (bottom) inside the faerie queen's throne room.

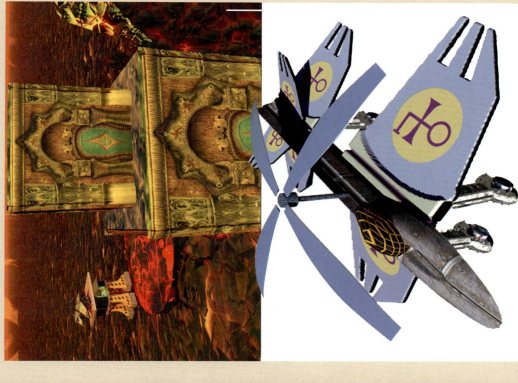

Color Plate 10 Images from Chapter 13, the House of the Fire Eaters project: (top) a view of the Temple of Sacrifice; (bottom) the Heli-craft.

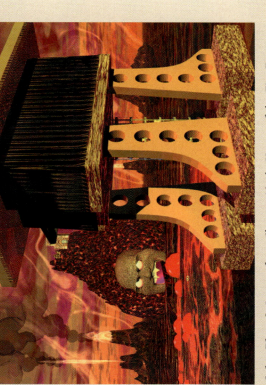

Color Plate 9 Images from Chapter 13, the House of the Fire Eaters project: (top) the fire river and the head structure; (bottom) the house and surrounding area.

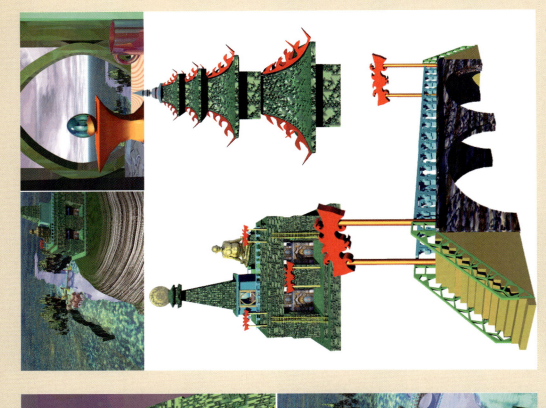

Color Plate 12 Images from Chapter 14, the Jade Pagoda project: (top left) a global bird's-eye overview of the scene; (top right) looking out the window of the Jade Pagoda; (center left and right) alternate Jade Pagoda designs; (bottom) the bridge.

Color Plate 11 Images from Chapter 14, the Jade Pagoda project: (top) looking up at the Jade Pagoda environs; (bottom) looking down on the valley from behind the golden Buddha.

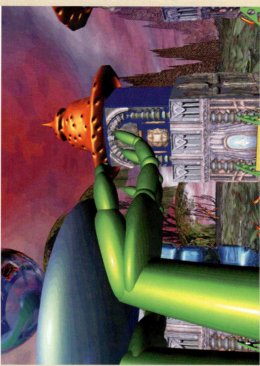

Color Plate 14 Images from Chapter 15, the Abode of the Lizard Master project: (top) the old city in the mountain; (center) the background peaks and the sky; (bottom) looking from the fountain toward the houses.

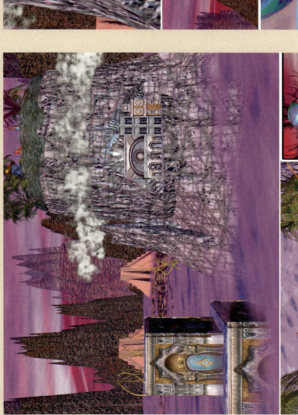
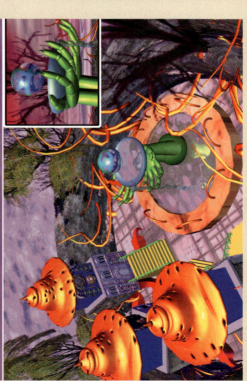

Color Plate 13 Images from Chapter 15, the Abode of the Lizard Master project: (top) a global overview of the scene; (bottom) looking down on the village; (bottom inset) a close-up of the fountain.

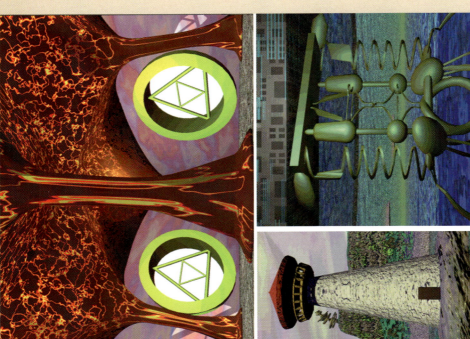

Color Plate 15 Images from Chapter 16, the Hall of Clouds project: (top) the Hall of Clouds floating over the island; (top inset) a closer look at the Hall of Clouds; (bottom) the village on the hilltop, with the Transporter in the right-foreground.

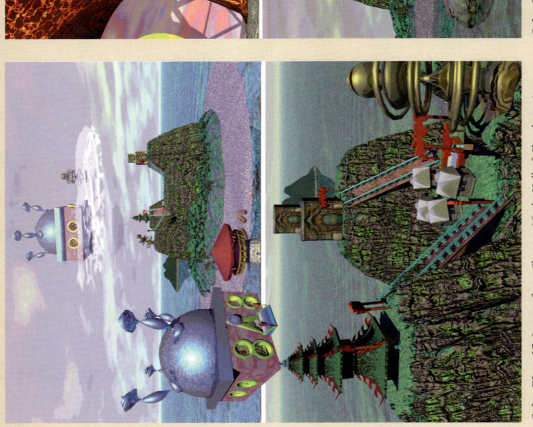

Color Plate 16 Images from Chapter 16, the Hall of Clouds project: (top) inside the Hall of Clouds; (bottom left) the lighthouse with the island in the back; (bottom right) the undersea power source.